JACQUES DE GHEYN

THREE GENERATIONS

VOLUME I

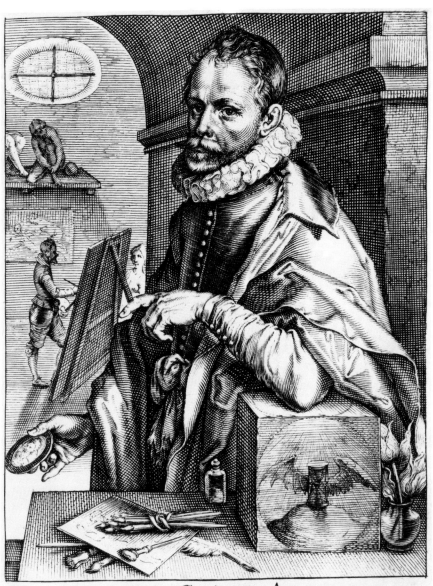

IACOBUS DE GEYN, ANTVERP.
PICT. ET SCULPT.

*Geinius eximius Scalptor, Pic tórque peritus,*
*Inventor felix, judició-que bonus.*
*Et Belli et Pacis pingens Insignia, gratus*
*Ipse Duci Belli qui artibus egregius.*

*Hondius exc. Cum privilegio. 1610.*

# JACQUES DE GHEYN
# THREE GENERATIONS

BY

# I.Q. VAN REGTEREN ALTENA

VOLUME I

TEXT

MARTINUS NIJHOFF PUBLISHERS

THE HAGUE / BOSTON / LONDON

MCMLXXXIII

The publication of this book was made possible by a grant from the
Netherlands Organization for the Advancement of Pure Research (Z.W.O.)

Published under the direction of Ernest Goldschmidt

Edited by A.L.W. van Regteren Altena-van Royen and Jean François van Regteren Altena
Translated by Mary Charles
Designed by Joost van de Woestijne

*Frontispiece: Portrait of Jacques de Gheyn II,*
engraved after his own design and published by Hendrick Hondius.
Rijksprentenkabinet, Amsterdam

Library of Congress Cataloging in Publication Data
Main entry under title:
Regteren Altena, I.Q. van (Iohan Quirijn van), 1899-1980
Jacques de Gheyn, Three generations.
Includes bibliographical references and indexes.
Contents: v.1. Text — v.2. Catalogues — v.3. Plates
1. Gheyn, Jacques de, 1565-1629. 2. Gheyn family. I. Title
N6973.G48R43 1983     759.9492     82-14298

ISBN 90 247 2741 3 (set)

*Distributors for the United States and Canada:*
Kluwer Boston, Inc., 190 Old Derby Street, Hingham, MA 02043, USA
*Distributors for all other countries:*
Kluwer Academic Publishers Group Distribution Center
P.O. Box 322, 3300 AH Dordrecht, The Netherlands

Typeset and printed by Snoeck-Ducaju en Zoon NV, Ghent
Lithography by Tallon Photogravure, Brussels

Printed in Belgium

# Contents

VOLUME III. PLATES

# *Explanatory note*

The only elucidation required by readers of Volume I concerns the marginal references to the descriptions and reproductions of works mentioned in the text at that point. The references usually apply to a description in one of the six catalogues in Volume II which are listed in the table of contents here above. The catalogues are each numbered separately. A reference to a specific work therefore consists of an abbreviation of the relevant catalogue's title followed by the number in that catalogue (*e.g.* cat. II 695). The illustrations (ill.), *i.e.* prints of works by the De Gheyns and works by other artists, are all in this volume; the plates (pl.), *i.e.* paintings and drawings by the De Gheyns are in Volume III, where they are arranged and numbered catalogue by catalogue (*e.g.* pl. 415 following the reference to cat. II 695). Reference is occasionally made to other publications. In that case the catalogue number is preceded by an abbreviation explained in the *List of publications referred to in abbreviated form* on pp. 183-186 of Volume II.

The abbreviations employed in the *Notes* on pp. 173-185 in respect of the cited publications are explained in the same *List of publications* or in the analogous *List of exhibitions* on pp. 187-191 of Volume II.

The titles given in Volume I to works by the De Gheyns do not always correspond to those of the catalogues in Volume II. Only titles that are (almost) identical to those in the catalogues are printed in italics.

The *Index of persons* on pp. 187-191 includes the names of those mentioned in the text of the seven chapters or in the notes.

# *Preface*

The protagonist of this book is the second of three men called Jacques de Gheyn. They represent a first, a second and a final generation, and the period in the history of art to which the three of them belong begins with the grandfather and ends with the grandson. Our attention is focused mainly on the principal Jacques who occupies a position in time between Bruegel, Moro and Goltzius on the one hand, and Rembrandt, Hals and Van Goyen on the other. Among the men with whom he shared the honour of eminence in his own period were the musician Sweelinck — an improviser as impressive as De Gheyn himself — the philologist Scaliger, and the jurist Grotius, the latter two being reputedly the greatest of their kind in modern history and perhaps even the greatest of all times. If the comparison were to be extended beyond De Gheyn's fellow-countrymen to the Southern Netherlands, we would find that the somewhat younger Rubens far surpassed him, but even so the quintessence of his touch could not have been lost on all true art-lovers and connoisseurs. Yet this is what seems to have happened for a long time.

Why has this fascinating period in Dutch art so often been neglected? Perhaps it is because of its unifying factor, the overall patronage of Prince Maurice of Orange-Nassau, as whose illegitimate brother De Gheyn sometimes seems to function. The Prince's personality was hardly engaging enough to succeed in charming us. Yet it was he who created the conditions for the favourable peace treaty needed for the development of a century marked by a rich flowering of the arts, human activity and insight. Prince Maurice, whether attractive to us or not, was after all the real quartermaster of our Golden Age.

Our story begins with the first De Gheyn and is mainly devoted to our hero. In the final chapter, the narrative continues beyond the life of Jacques III to the present day, with its build-up of knowledge about the three Jacques. It has become an unprejudiced chronological summary of the entire family's output which came to an end with the death of the unmarried third Jacques. Fortunately, he had a will drawn up only a few days before his death in 1641 and this provided a lot of information which would otherwise have been lost.

It has always been my desire to write this book. To have deferred doing so for such a long time may have been beneficial, but the delay also caused its almost immodest expansion. The book consists of three volumes, the *first* of which contains the main text and the illustrations supplementing it. These illustrations do not, however, include the actual works of the De Gheyns. These are arranged chronologically in the *third* volume which is devoted solely to plates, with the paintings and drawings all reproduced in separate sections. The *second* volume includes the catalogues of paintings and drawings of each of the three artists. The arrangement of the catalogues, however, is according to subject, and this provides a second criterion for their consideration. One look reveals the professedly very personal choice of Jacques II, and his great versatility. Jacques II's engraved

work has not been catalogued here, as Hollstein's study will remain largely adequate for a considerable time. In the same way, Burchard has relieved me of the task of listing Jacques III's etchings. There is frequent reference to the prints, however, and several of them have been reproduced in the first volume.

It seemed more practical that a general guide to the use of the catalogues should be given at the beginning of Volume II which contains them. But the system adopted for them may be discussed briefly here. The contents are divided almost equally between the paintings and drawings known to exist today, and those we know only from various kinds of literary sources, mainly sales catalogues. Why not separate the two lists, I was asked. I think the question would be justified only if we were unable to distinguish between existing and lost drawings by the method of printing. Now that the titles of the existing examples are printed in bold type and all of these are reproduced, we may dismiss any objections and stress the obvious advantage of not having to look twice. Instead, we can immediately gain a comprehensive view of all items featuring a particular subject: these are, almost without exception, interrelated. I have, therefore, adopted the same system as was used by Hofstede de Groot in his *Verzeichnis* of Dutch 17th century paintings. In the catalogue volume, I have added an index of the places where items with known locations are kept and lists of publications and exhibitions referred to in abbreviated form. The first volume has an index of the names of persons. This is all one needs to know for easy references to this somewhat complicated book.

Now that the book has been completed, one final point arises: that of the limit to our knowledge. It is difficult for an author to admit the possibility that his vision may, on the whole, agree neither with historical truth nor with someone else's concept — it is inconceivable that it should do so entirely — and that it may have to be revised. He obviously believes in it and his sole wish is to correct any imperfections. But there remain a great many instances where he himself is unable to say yes or no. These instances occur mainly in the attributions. I am not the kind of person to be vague about such items or to omit them altogether. That would mean presenting oneself as a more learned person than one really is. It is just too easy to leave out everything one is uncertain about simply because one dislikes to admit one's lack of knowledge.

That is why the titles of a number of items in the catalogues are preceded by question-marks. They indicate my doubts regarding the attributions and save me from having to relegate these doubtful works to the reproductions in the first volume.

Boon, n. 248
Let me give a few examples. There is a figure of a *Walking Bishop* (Printroom, Amsterdam) which, I consider, is unlikely to have been drawn by the second De Gheyn. The direction of the lines is not quite as one would expect him to have drawn them, perhaps with the exception of the head, the anxious look of which is well expressed. No draughtsman is known as yet whose manner is so akin to De Gheyn's, not even the closely related Pynas brothers. But the reverse of the sheet has a Dutch inscription referring to a procession which has been held. It would seem impossible for such an event to have taken place in the Northern Netherlands at the time, and this provides a powerful argument against the robed bishop having been drawn there. I therefore feel unable to accept it and have omitted the drawing from the catalogue.

Cat. II 770, pl. 242
Another case in point is the *Head of a fat man* (Kupferstichkabinett, East Berlin). It is drawn rather too loosely for De Gheyn. I would have preferred to drop it but for the fact that the name was written below it in the 18th century. The handwriting occurs frequently beneath heads by De Gheyn, all of them genuine. I allowed the latter argument to prevail and did not exclude a drawing which benefits of so early an attribution. On the other hand, I did leave out the studies of *Two*

Benesch n. 388
*Nude Young Men* which Otto Benesch classed with the De Gheyns in the Albertina. I could not, in

my mind, quite account for the differences in style. In this case I omitted the drawing although I knew that others might hold a different view.

Another obstructive difficulty presented itself continually when approximate dates had to be determined for various drawings, even for some of the best examples. After the support provided by Van Mander and the dated engravings for almost the entire early œuvre, we have to manage without such help for nearly all the years following 1603. Dates on individual items occur but rarely. A capital drawing at Brunswick representing *Orpheus in Hades* lacks one as well. From 1603 onwards De Gheyn's style was somewhat fixed, he was an accomplished master. He could have created the Orpheus shortly after 1603, but he might equally well have done so five, or even ten years later. In that particular instance I more or less divided the difference and reduced the risk of failure to a minimum. The same applies to the copy of an *extensive mountainous landscape* by Van Stinemolen. These examples prove that an element of considerable doubt is incorporated in certain 'pronouncements' in the sequence of the plates.

Cat. II 131, pl. 313

Cat. II 1049, pl. 199

These obvious shortcomings may be corrected in the course of time and they prove how much still remains to be done. The records of several important drawings — and paintings — prove, moreover, that even a catalogue which is so much more substantiated than previous ones can only be inconclusive and lacking in finality.

The present book calls for a better appreciation of the work of Jacques III. I have greatly augmented the few items with which I began the study of his drawings in 1936. Other scholars have occasionally added to these. Paintings have remained rare, for me as well. Each time a fresh drawing presented itself as a candidate I had to consider serious pros and cons. The bold sketches of *Birds* and *Negro Heads* seem incontestable, but what is there left of the artist when we come across extremely finicky little sheets, fully signed by him? His unstable character bars our approach. He also leant on his father, whose sketches are often hard to distinguish from those of his son. The imposing *Sketch of a Galley-Slave* has more character than we generally find in the work of Jacques III. The pattern of drawing occurring in some parts can be seen in his best work. I finally allowed the traces of the head, which do not differ from the father's idiom, to prevail, but I did so without complete conviction. The line dividing their respective output may well require revision in the future.

Cat. III 77, pl. 52; 78, pl. 51
Cat. III 45, pl. 54; 46, pl. 53

Cat. II 625, pl. 389

These examples may suffice to indicate that I often had to admit to myself that there were some decidedly weak points in the structure of my concept.

The history of this book requires a brief mention here. When I was still overburdened with university duties I could see there would be no time to complete the second volume of my *Introduction to the study of the drawings of Jacques de Gheyn* (1936), which lacked a catalogue and plates. I therefore asked Professor Reznicek of Utrecht University, who had just published his excellent book on the *Drawings of Hendrick Goltzius,* to come to my aid. First of all he kindly said yes, but soon he was equally overwhelmed with other work and could not keep his promise. I would so much have liked him to help, but I fully understood his difficulties. In the meantime I was released from the heaviest part of my own commitments and the Netherlands Organization for the Advancement of Pure Research (Z.W.O.) opened up the prospect of having a secretary and making the necessary journeys. Z.W.O. continued its support almost until the completion of the task, which developed into the writing of an entirely new book. It is therefore my pleasure first of all to express my gratitude to this institution which enabled me to set up a kind of new studio. Of the two secretaries who helped me, Mrs. H.M. Hülsmann started the work and, after a long interruption which benefited her children, completed it, whilst Mrs. C. Müller-van der Leuv took over during the inter-

vening period. They both helped me in an exemplary manner and should be warmly thanked for their accurate and intelligent support. It was a real pleasure to work with both of them. I have also to thank Mrs. M. Charles who undertook the task of translating my text, which she did with great competence. But I needed more help from very varied quarters. I was received with the greatest kindness everywhere, and experienced once again how the world of art-historians is distinguished from others by its outstanding ethos. I say this to all those I am unable to mention more specifically, although they assisted me so well. But there are some exceptions I must make.

I am thinking of people who are no longer alive, but who gave me information over the years, the late Mr. P. de Boer, Dr. Vitale Bloch, Dr. M. Flohil, Dr. J. van Kuyk and Dr. A. Staring. Of those who lent support to the 1936 book only Dr., subsequently Professor J.G. van Gelder is still with us. He and his wife sent me notes with admirable assiduity, often on publications I might have overlooked, and shared as friends in my ups and downs. Mr. P.H. Bogaard kindly provided information on his family's genealogy and Jonkheer P. Beelaerts van Blokland corrected the genealogical tree of the Stalpaerts in my 1936 book soon after its publication. I had very useful talks with my friend Dr. J. den Tex on the historical background, with Professor H. de la Fontaine Verwey on the literary aspects and with several archivists on the genealogical problems. Among the latter I should mention in particular Miss Dr. I.H. van Eeghen and Mr. S.A.C. Dudok van Heel of Amsterdam, Mr. G.W. van der Meyden, Mr. J. Fox and Dr. H.M. Mensonides of The Hague, Dr. M.P. van Buytenen and Dr. J.E.A.L. Struick of Utrecht, Dr. J.S. Hoek of Middelburg and Dr. J. van Roey and Dr. J. van Nieuwenhuizen of Antwerp.

I owe gratitude to Miss J.B.E. Stokhuyzen, who met so kindly my endless requests for photographs from the Amsterdam Printroom.

I was accorded special treatment at the Cabinet des Estampes of the Bibliothèque Nationale in Paris by M. Jean Adhémar, at the Institut Néerlandais thanks to the late Frits Lugt and Carlos van Hasselt, at the Albertina, Vienna, by the late Dr. O. Benesch and Dr. E. Knab, at the Printroom of the British Museum by Mr. J. Rowlands and at the Berlin Printroom by Dr. M. Winner. The Royal Library and the Rijksbureau voor Kunsthistorische Documentatie at The Hague were always helpful.

I shall have to mention the names occurring in another anthology of memories, and the list is still too short: G.S. Abrams, B. Albach, Dr. F. Anzelewski, Prof. I. Bergström, O.H. Busch, R.E.O. Ekkart, Dr. H. Geissler, Prof. H. Gerson, Dr. C.H. von Heusinger, Miss E. Joosten, Dr. J. Kuznetzow, Prof. R. Judson, A.W.F.M. Meij, Chr. Norris, Prof. E.K.J. Reznicek, Prof. R.W. Scheller, Prof. Th.H. Lunsingh Scheurleer, J. Byam Shaw, P. Ward Jackson and Miss Dr. A. Zwollo. The mention of such a host of helpful spirits may demonstrate how deeply I am convinced that I did not write this book entirely by myself.

My first book on Jacques de Gheyn was published by Messrs. Swets & Zeitlinger, and for many years I worked on the assumption that the same firm would also be able to deal with the larger opus. However, I was informed in 1978 that this would not be possible. Shortly afterwards Sijthoff & Noordhoff International Publishers made a fresh start and the work of publishing the book was directed by Mr. A. Visser with the capable help of Mr. J. van de Woestijne for the layout. And here I should like to mention the special care devoted to the publication by Dr. E. Goldschmidt who, at the publishers' request, agreed to coordinate the many different parts which make up the present book. Laden with papers, he was one of our most frequent visitors during the past few years. I thank him for his patience, as well as for his precise and pleasant cooperation. Finally, I should like to express my thanks to all those who participated in the production of the book.

There is one factor certainly not to be overlooked: the daily support I received from my wife, to whom I dedicate the book without imposing on her the arduous obligation to read it in its entirety. I dare say she now knows it from beginning to end since our life has been so greatly affected by the difficulties facing us.

Amsterdam, April 1979                                    I.Q. van Regteren Altena

Unfortunately, it is necessary to add a brief sequel to the Preface. After a long period of illness, I.Q. van Regteren Altena died on 18th October 1980. It is sad that he did not live to see the publication of this book, his life's work. He did, however, have the certainty that his manuscript would be published.

When the author's strength began to fail in the final years of his life, we, his wife and son, became involved in the work, at first assisting him, and later on completing the publication. It would have been better for all concerned, as well as for the actual work, if the author had been able to finalize the text himself years sooner. He would then have been in a position to enjoy his achievement to the full, and the book would have benefited from the 'finishing touches' that only the author can add. The publisher, coordinator and printer would have needed less time to produce the book and we would have been spared a fundamentally impossible task.

Now that things have turned out differently owing to the circumstances mentioned in the Preface, we must give a brief summary of the items that were included in the book without the author's knowledge. A few small sections have been added: Mrs. H.M. Hülsmann was responsible for the *Addenda* to the catalogues; the publisher added the *Index of persons* in Volume I; and one of us — J.F.v.R.A. — compiled the *Chronological tables of dated paintings and drawings*. We also completed the *Explanatory notes* to the three volumes as well as the *List of publications* and the *List of exhibitions referred to in abbreviated form*. Numerous items of information provided by Mr. A.W.F.M. Meij were included in the catalogues.

The inaccuracies of fact that were found in the text have been corrected. They frequently consisted of incorrect catalogue and illustration numbers in references that had been left unamended in the final classification in catalogues and series of plates. Undoubtedly, some further inaccuracies of fact would have been found if the text had been thoroughly checked, but this proved impossible in the time available to us. In the descriptions of the individual works listed in the catalogues an attempt was made to follow the author's method of organising information where this had not yet been done. How difficult this was became evident whenever further inconsistencies were discovered in the course of correcting fresh proofs.

The original intention was to include a series of illustrations for comparative purposes at the end of Volume I. After discussing the matter with the author, Dr. Goldschmidt subsequently placed the illustrations relating directly to the text of Volume I alongside the relevant passages. Illustrations relating to passages in the catalogues were recently selected from the body of unused material and added to Volume II in a similar manner. Three works that have been linked with Jacques de Gheyn II have also been reproduced in Volume II (cat. IIP43, II1036, II1051). These illustrations are not in Volume III because the author had not included them in the plates for that volume; cat. IIP43 and II1051 were in fact to be found among the illustrations for purposes of comparison.

Besides the close attention Dr. Goldschmidt continued to bestow upon the work, the help given to us by Mrs. Hülsmann has been invaluable. Since Mrs. Hülsmann had been involved in the earlier stages of preparing the book, she was in a position to act as our guide to the material on which it

was based and also to advise us on the author's intentions. We also wish to add the names of C.P. van Eeghen, Dr. K. Freemantle, P.W.L. Russell and the late H.J. Witkam to the long list of those whose help is gratefully acknowledged in the Preface. Finally, we would like to express our appreciation to Martinus Nijhoff Publishers BV, who, after taking over Sijthoff & Noordhoff's activities in 1981, coordinated the final stages of publishing this work.

When *Jacques de Gheyn - Three Generations* duly appears, I.Q. van Regteren Altena's aspiration will have been realised at last.

Amsterdam, May, December 1982

<div align="right">A.L.W. van Regteren Altena-van Royen / J.F. van Regteren Altena</div>

# CHAPTER I

## *Jacques I and the Haarlem years of Jacques II*

In the world of Dutch art, the name of Jacques de Gheyn shines like a triple star. The monumental church windows painted by Jacques I have all been lost and a few political prints and three drawings, the scant and fortuitous remains of an artist's entire output, are all that remain to give us a brief glimpse of his talent. On the other hand, his brilliant and versatile son, Jacques II, left a comprehensive collection of engravings and drawings — some achieving true perfection — and a small number of paintings executed with equal care. All of them are worthy of study and admiration. His son, Jacques III, also produced drawings and etchings. Although the style of these is his own, it undoubtedly stems from the overwhelming example set by his father — a man of genius.

It is true that the phenomenon of the De Gheyns does not play a great part in the general development of Dutch art and it should be seen, perhaps, as an extra — but lasting — adornment. A kind of isolation seems to have surrounded the De Gheyns, preventing too great an involvement with the upsurge of talent that was forcing evolution to take a new course at the beginning of the seventeenth century. The De Gheyns appear only to have followed at a distance, keeping their peculiar identity intact, and thus compelling us to acknowledge their stubborn determination to remain themselves.

Having decided to make a study of Jacques de Gheyn's art, one is almost obliged to include the work of his father and son, particularly because the latter's output has repeatedly been confused with that of the more famous artist. When analysing De Gheyn's drawings in my earlier *Introduction* of 1936, I decided to study them under the headings *Themes, Style,* and *Chronology,* and their identification may well be due to such a method. I trust this preparatory work is an adequate reason for now giving a detailed description of the entire tripartite phenomenon of Jacques de Gheyn within a simple chronological framework.

There is one circumstance for which we cannot be too thankful. When Carel van Mander wrote his *Schilder-Boeck* in the first years of the new century — it was published in 1604 — Jacques de Gheyn II was in his late thirties. He had already produced a considerable amount of work, achieving a degree of mastery, particularly in his more recent creations, that fully justified the inclusion of a detailed *Vita*[1]. The two artists had certainly known each other for nearly twenty years. As early as 1588, De Gheyn had started making engravings from designs by Van Mander, and quite a number of these were to come off his press over a long period of time. In fact, their friendship must have been quite close, and Van Mander's description of De Gheyn may be regarded as a true portrait based entirely on first-hand knowledge. This chapter is our main source of information despite the fact that it does not extend beyond approximately 1603 and was not brought up to date for the second, posthumous edition of 1618.

For the period in between these dates there is a deplorable lack of personal records. It is only for the years from about 1616 onwards that there is another, most valuable source of information:

Constantijn Huyghens, a much younger man, and well known as a poet and mathematician and as secretary to Prince Frederick Henry. On March 29th, 1629, he was at De Gheyn's death-bed; shortly afterwards, on the 11th May of the same year, he started writing his *Autobiography*. He described his origins, youth and adult life up to May 1631, and then put the work aside, so that it was neither completed nor published in his own lifetime. The manuscript was found among his papers by Dr. J.A. Worp and was first published in its original Latin version in 1897[2]. Huyghens included several reminiscences of artists he had met and admired, and foremost amongst them were Jacques de Gheyn and his son. This even suggests that De Gheyn's death may have contributed towards Huyghens' decision to write an autobiography.

All knowledge of Jacques de Gheyn Junior would have been lost if Huyghens, his contemporary, had not included an account of him in the same section, greatly praising the achievements of the then highly promising young artist.

We cannot, therefore, complain of a lack of contemporary reactions to the work of the two younger artists, even if we are without any substantial record for the productive years between 1604 and about 1618. It is all the more regrettable that there is no such literary silhouette of the first Jacques de Gheyn and that all his important works have been lost. The only facts which cannot be refuted are the continuation of an older workshop for a further two generations and a tradition of craftmanship that was passed on by the first Jacques. This tradition narrowly escaped complete interruption when the boy Jacques II was bereaved of his father at the early age of seventeen. The latter can only have had time to teach his son the very rudiments of the art of design, although apprenticeships started early in those days. This fact allows us to give full credit to Van Mander's statement that the young Jacques de Gheyn began to complete his father's unfinished works when this heavy burden of responsibility fell upon his youthful shoulders.

Our assumptions regarding his early training may be checked by comparing his case with that of Hendrick Goltzius, about whom we are better informed. Goltzius is supposed to have attended school from his fourth to his eighth year, and then to have started his apprenticeship as a glass-painter in his father's workshop. He had already made engravings and drawings of his own invention[3] before the age of sixteen, when Coornhert took him to Haarlem. What exactly Jacques de Gheyn produced in his youth eludes us. Van Mander says that for some time he continued to produce stained-glass work and miniatures. We are equally ill-informed about the following years when he was working, and doubtlessly still learning, in Antwerp. In any case, he must have developed into an independent artist at an unusually early age.

According to Van Mander, Jacques de Gheyn Senior was born while his mother was crossing the Zuyder Zee from Harlingen to Amsterdam. In my *Introduction*[4], I was unable to state when precisely this event occurred, but I recently came across a document in the Antwerp Public Records from which the year may be deduced[5]. On May 16th, 1564, two glass-painters and burghers of Antwerp, Henri Stralen and Jacques de Gheyn, made an *attestatio vitae* concerning Christofre de Bray and four of his children, whose names are also given. It states that Jacques was then twenty-six years old, so the year of his birth was either 1537 or 1538. Van Mander says that 'his parents were from the city of Utrecht and were descended from a distinguished family of high rank'. This sounds as if they had certain ancestors in common. In his will, Jacques III referred to Wttenbogaert as his 'cousin'[6], and I therefore suggested in 1936 that the first Jacques might have been the grandson of Claes Jansz van de Gheyn who was married to Maria Bogaert, the Bogaerts and Wttenbogaerts originally being the same family[7]. But Mr. P.H. Bogaard, the present expert on the family genealogy, kindly informed me in 1971 that this marriage was erroneously reported in the sources then available to me, and that Claes Jansz was only a brother-in-law of Maria Bogaert. It there-

fore seems much more likely that either the mother or, better still, the wife of Jacques I was a Bogaert. This would also solve the problem why Jacques III should so generously remember Johan Wttenbogaert, in that case a much closer relative, in his will. However, all we actually know about the wife of Jacques I, the glass-painter, is that she was referred to as Cornelia when their son Isaac was born at Antwerp on September 25th, 1567[8].

Jacques II, the main subject of our study and the couple's eldest son, had preceded Isaac in 1565[9], and Anna is more likely to have been born in 1568[10] than in between Jacques and Isaac. The birth of Steven, the youngest son, must have followed only a few years later[11]. There is no proof at all for the assumption[12] that Catharina de Gheyn, who married the painter Jan Pietersz van de Venne, the elder brother of the better known Adriaen van de Venne, was the couple's fifth child. It may be so, but the entry of her birth has been lost and we do not know where she came from. If she were Jacques' and Cornelia's child, she may have been born before Steven rather than after him. With the exception of Isaac, who may have died young, we shall come across all the children again as adults.

In 1558[13], the father was admitted to the Antwerp Guild as a glass-painter. The *Liggeren* again refer to him as a glass-painter, when, in 1570, he took on a pupil, Philip Peeters, who is otherwise unknown[14]. De Gheyn may have been the same *Jacques de Glaesmaecker* who is mentioned in a catalogue of print-sellers — some of whom also made engravings — which was compiled at Antwerp sometime between 1577 and 1580[15]. In this case he would also have been a print-dealer. According to Carel van Mander, however, Jacques Senior was a glass-painter of considerable repute. He was known to have executed windows for the church of the Minorites in Antwerp 'for the Italians', as well as others for the Borgh-Church, and both sets were highly praised by connoisseurs[16]. The latter was demolished at the time of the Revolution, and of the Church of St. Francis only the walls of the nave are left, the Antwerp Academy of Fine Arts having been installed in its completely remodelled and extended remains. Not one of the many guides to the Antwerp churches published in the eighteenth century mentions these windows, let alone their subject matter. Carel van Mander finally refers to a window in the West Front of the Old Church in Amsterdam, once again omitting to say what it represented. If he meant the wall on one side of the West Tower of this church, there is no document at all which may even help to determine its original position, but in that case it must have been the smaller, three-light window at the northern end of the West Front. However, we do know[17] there was a considerably larger, four-light window representing the *Conversion of St. Paul* in the first chapel on the North side, which was known as the Hamburg Chapel. The window was removed and destroyed in 1621, and Van der Boom has suggested that it may have been the one by De Gheyn[18]. If that were so, he thinks De Gheyn may have seen the window in Antwerp Cathedral depicting the same subject, and that he was, perhaps, inspired by it[19]. The Antwerp work dates from 1536, and at least shows us what a window representing this subject looked like.

We are therefore completely ignorant of the appearance of De Gheyn Senior's large-scale religious designs. One clue to his style as a designer may have been found, however, when a pendrawing signed *J. de Gheyn* was bought for the Amsterdam Printroom (this drawing and those following it are reproduced before his son's at the beginning of vol. III). This drawing represents the *Seat of Mercy* surrounded by mourning angels bearing the instruments of the Passion, shown as the *Arma Christi*. This grave and serious scene is executed in a style which is definitely earlier than that of his son's well-known drawings. It is treated with admirable care and leaves unimpaired a theme of great solemnity, more familiar in the older Flemish tradition of the Master of Flémalle and Hugo van der Goes. I have described the drawing in a separate article[20].

Cat. 1 2

3

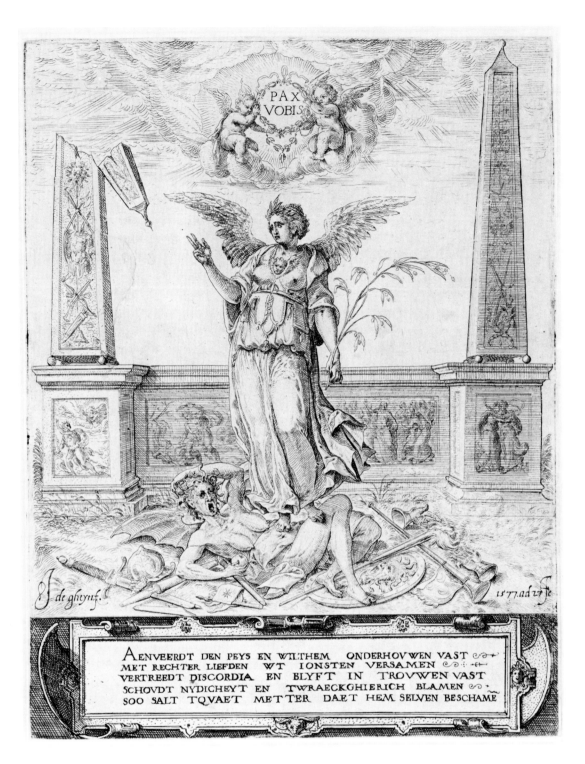

1. Jacques de Gheyn I (II?).
*Pax vobis.* Peace trampling the Fury of Discord underfoot.
Allegory on the Perpetual Edict *(Eeuwig Edict)*
proclaimed in Antwerp on February 27th, 1577.
Etching. Rijksprentenkabinet, Amsterdam

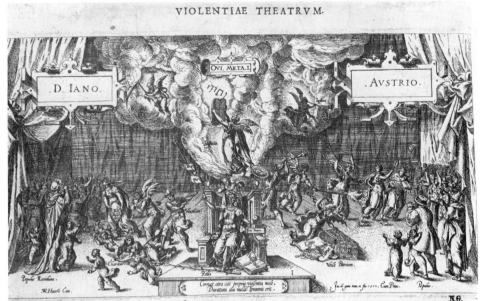

2. Jacques de Gheyn I (II?).
*Theatre of Violence
(Violentiae theatrum)*.
Allegory on the out-
burst of violence in the
Southern Netherlands in
1577. Iron etching.
Rijksprentenkabinet,
Amsterdam

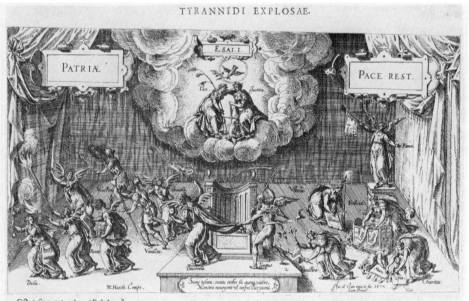

3. Jacques de Gheyn I (II?).
*Tyranny expelled
(Tyrannidi explosae)*.
Allegory on the restora-
tion of peace in 1577.
Iron etching.
Rijksprentenkabinet,
Amsterdam

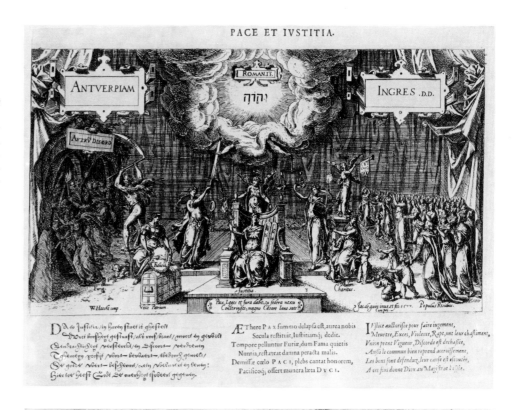

4. Jacques de Gheyn I (II?).
*Peace and Justice
(Pace et iustitia).*
Allegory on the restoration of peace in Antwerp, 1577. Iron etching.
Rijksprentenkabinet, Amsterdam

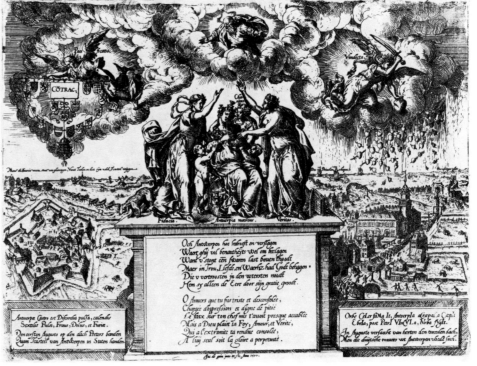

5. Jacques de Gheyn I (II?).
*Distressed Antwerp
consoled by Faith, Love
and Truth.* Allegory on the situation in Antwerp, August 1st and 2nd, 1577.
Iron etching.
Rijksprentenkabinet, Amsterdam

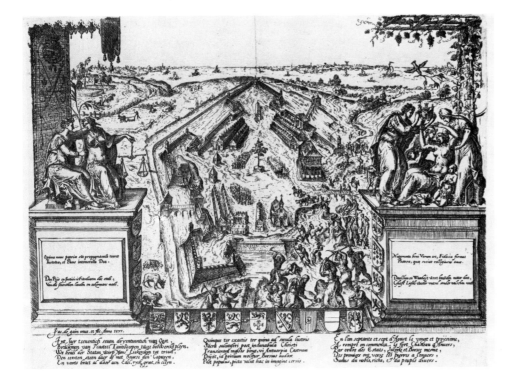

6. Jacques de Gheyn I (II?).
*The demolition of the
Castle of Antwerp,
August 23rd, 1577.*
Allegory. Iron etching.
Rijksprentenkabinet,
Amsterdam

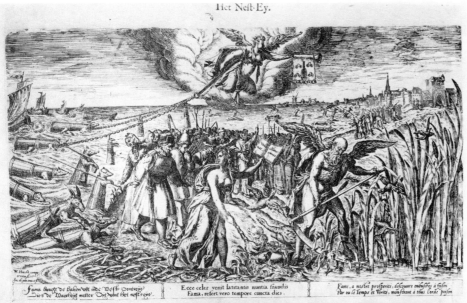

7. Jacques de Gheyn I (II?).
*The nest egg
(Het Nest-Ey).*
Allegory on the situation
in Antwerp in 1577.
Etching, with a text dated
October 29th, 1577.
Graphische Sammlung
Albertina, Vienna

Once it had been established that this first design was his work, other examples in the same style seemed bound to follow, but so far I have only succeeded in making a few rather questionable attributions. However, it has been known for many years that the signature of Jacques de Gheyn Senior appears on a series of several etchings probably executed on iron plates, a cursory technique occasionally used in the sixteenth century for less costly prints[21]. These are political protests against abuses that occurred when Antwerp was suffering under Spanish occupation. They are drawn with facility and successfully evoke the dramatic situations. The prints recently led H. Mielke to attribute a drawing in Berlin to De Gheyn I[22]. Whereas the etchings refer more to events or situations which occurred during the occupation of Antwerp, the Berlin drawing sums up the prevailing threats in two allegorical scenes illustrating the assault on Peace and Liberty by every imaginable fiendish power. In the centre sits the Maid of Antwerp (?) who, assailed from every quarter and folding her hands in supplication, can rely only on her faith to fend off the superior force of the menacing figures. In the frieze above, all the evil spirits form one long, pitiful procession of violence and war behind the Wheel of Fortune which is turned by an Angel. The complete scene is enclosed in a commemorative tablet with the coat of arms in the centre confirming the identity of the seventeenth province. [The author added to catalogue I a third drawing: a *sketch design for a painted four-light window*. Its inclusion is based on a comparison with the Berlin drawing. For a consideration by the author the reader is referred to the entry in catalogue I.]

Four more prints by the same hand were discovered in 1978, three of them previously unknown. The fourth one is an additional copy of *Violentiae Theatrum* which was already represented in the Amsterdam Printroom[22a]. All four were bought for this institution. Two of the prints seem to form part of the same sequence as the one mentioned above, to which are added *Justitia* enthroned in the middle of the same stage, and *Pax and Justitia* in which *Tempus* pursues *Discordia Tyrannidi* and the *Vices* are seen to flee. The signatures of W. van Haecht and J. de Gheyn as well as the date 1577 are the same as on the prints that were known previously. There is also an upright print, in which *Peace* tramples on Discordia and menaces her with her sword. This print is dated 27 February 1577 and is therefore the earliest of them all. It shows a flowing, thin etching line and clearly demonstrates the eldest De Gheyn's style. In the five-line poem etched below the scene, he warns against discord and envy:

> *Aenveerdt den peys en wilthem onderhouwen vast*
> *Met rechter liefden wt ionsten versamen*
> *Vertreedt discordia en blyft in trouwen vast*
> *Schoudt nydigheyt en twraeckghierich blamen.*
> *Soo salt tquaet metter daet hem selven beschamē.*

> (Accept the peace and steadfastly preserve it securely,
> [Being] — through favour — united in genuine love
> Stamp out discord and remain firm of faith,
> Avoid envy and revengeful slander.
> So shall evil truly be confounded.)

It cannot be denied that the prints and cat. I 3 display a greater affinity of spirit and form. In view of this similarity, Mielke believes that the *Seat of Mercy* should be re-examined, because the draughtmanship is so very different. It seems that we cannot entirely rule out the possibility that this may be a work by the youthful Jacques II. We should await the discovery of related material before expressing a final opinion on the matter.

H. 1, 3, 4, 2, ill. 2, 5-7

Cat. I 3

Cat. I 2

Ill. 2

Ill. 4
Ill. 3

Ill. 1

Added to what we have learned from the surviving drawings, the prints corroborate the image of an artist working in the style of Frans Floris and his follower Crispijn van den Broecke (Paludanus), although in an individual manner. We may assume that De Gheyn Senior was bound by ties of friendship to the latter artist, a native of Malines. This is borne out by the fact that his son later acquired several of Van den Broecke's drawings and made engravings from them. But the earliest source of Jacques Senior's 'penmanship' is to be found in the late manner of Maerten van Heemskerck. Only in Heemskerck's Bible illustrations — the largest collection of which is now in the Copenhagen Printroom[23] — and perhaps in Pieter Bruegel's designs for his moralising prints, do we find a similar method of rendering figures and draperies with short strokes of the pen. This suggests that the older Jacques' style may well have been formed when he was still living in Utrecht. There may have been a closer relationship since we know Heemskerck had once embarked on an ambitious project for a large window, for which he provided at least a cartoon[24].

It is not surprising that Jacques de Gheyn Senior left Utrecht at an early age to settle in Antwerp, as that city had become one of the major art centres in Europe. At the height of the city's commercial prosperity it must have provided more opportunities for a glass-painter who worked not only for the Church but also for private patrons. Utrecht could hardly compete with Antwerp's everincreasing wealth. Whilst the young family was living there, however, the situation changed radically owing to the political vicissitudes that were soon to be followed by a gradual decline.

In 1576 an uprising against the Spanish garrison was avenged when the invasion of a disorderly army led to what is known as the *Spanish Fury*. In three days of gruesome plunder and murder, six or seven thousand citizens perished. The prints of 1577 refer to subsequent events when Antwerp Castle was razed to the ground and the frightened citizens discovered how Don Juan of Austria was trying to influence public opinion[25]. They waited anxiously to see if the Prince of Orange would prevail and establish the freedom of religion he had always championed. Their fears must have been aroused on all sides — they were soon challenged about siding with Anjou, suspected of sympathising with either the new faith or the old, and accused of forsaking their allegiance to the King. The obligation to house foreign soldiers must have weighed heavily on them. All in all, these were not the right conditions for spending money on the arts, and times were doubtless hard for the eldest Jacques de Gheyn!

It seems that this inference may also be drawn from a letter which Abraham Ortelius wrote to Jacob Cole[26], his son-in-law in London, on July 17th, 1581. He said in it that, *Jacques de glaesmaecker die gestorven is, en hebbe nyt gemaent, noch oock de weduwe. Met meer gemacks can ick de 70 £ derven, dan die selfde maenen. Wat met maenen gecregen moet worden, daer en sal Ortelius geen gelt af crijgen. Ick en estimeer het volck nyt weerdich dat ickse aanspreken souden (ick laet maenen staan) die van sulcke natuere sijn. Ick laete een ander syn meyninge daer in volgen, maer ick bender te hooveerdich toe.* In translation this reads: 'I have not demanded payment from Jacques the glass-maker who has died, nor from his widow. It is easier for me to suffer the loss of the 70 pounds than to demand payment of the same. Ortelius will obtain no money by dunning. I do not consider the folk worthy that I should claim payment from — let alone dun — persons of such a disposition. Anyone else can follow his own judgement, but I am too proud for it'.

If this comment refers to De Gheyn Senior, and I shall show that there is good reason for making this assumption, then De Gheyn was burdened with at least one, and perhaps several debts when he died. However this may be, it is also possible to infer from the letter that he presumably died in the first half of 1581. We know Jacques II told Van Mander that he was born in 1565 and also that he was 17 years old when his father died. If this were true, his birth would have taken place one year earlier, or else he was still 16 at the time of his father's death, which is too small a discrepancy for

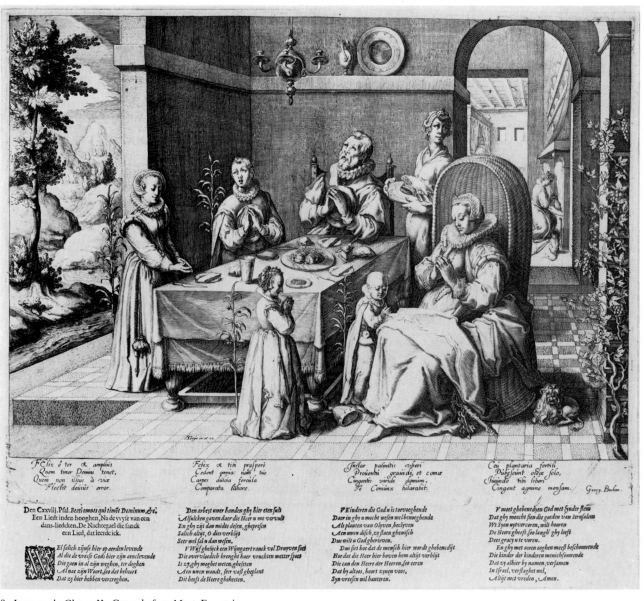

8. Jacques de Gheyn II. *Grace before Meat*. Engraving.
Rijksprentenkabinet, Amsterdam

those days not to believe in the identification of *Jacques de glaesmaecker* as the father of Jacques II. Does not Van Mander also state that the father died when he was 'about 50 years old', whereas he had, perhaps, not yet reached the age of 44? Now that we have found out more about the financial situation it seems reasonable to infer that when De Gheyn found his business was failing to improve after the Spanish Fury, he started dealing in prints as well as carrying on his trade as a glass-painter. This would have provided his son with an early opportunity to become familiar with the older examples of this art form.

The eldest Jacques' artistic career had indeed been short. We know even less about his wife. All we can deduce from the available sources is that she was no longer alive in 1593[27]. By 1581 they were probably the parents of four or five children aged seventeen and under, which reminds one of a print

10

by Jacques de Gheyn representing *The Pious Family* (or Grace before Meat). A family is gathered round a table with the father, his hands folded and eyes raised, at its head. The mother is seated in an arch-backed, wicker chair, with her youngest child standing at her knee and a pet dog lying at her feet. The older children stand in prayer round the table, with the eldest boy to the right of his father. A tender plant springs up beside each child and a vine grows up against the wall nearest the mother, while outside there is a tree. The text appears to have been taken from George Buchanan's then famous Latin translation of the Psalms. The 128th Psalm describes the house where the Lord is feared, the man is likened to a strong tree, the woman to a fruitful vine, and the children to olive branches gathered round the table. We do not think a better picture could be found of Jacques' parental home than in this recollection of it, even if it is not an exact representation of either the house or the children, as there are only two boys among them. But one might read into it the circumstance that Isaac had died young and that Catharina was, after all, one of the children, and was born before Steven.

Cat. II 198, pl. 15, ill. 8

The general composition is equally worthy of our attention. The background is formed by a wall of a simple architectural design. It is pierced on the right by a door allowing us to look into the kitchen, and there is mountain scenery on the left. The entire setting betrays an undeniable lack of skill in rendering space, and the landscape is treated with some timidity. But so true a portrayal of a family at table was a novelty at the time, for it must be placed among his drawings of the nineties at the latest and was produced quite a time before he perfected his intimate family scenes. Nevertheless, old Jacques' household must have been split up by then, and his son is just as likely to have been inspired by other families such as Carel van Mander's as by memories of his own.

Reviewing what is now known about Jacques Senior, we are conscious of the fact that his artistic personality still eludes us almost entirely. Although none of his large windows has survived the ages, the seven prints and three drawings do prove he had a sense of dignity and a dexterous and skillful hand. However, there is no way of visualising the appearance of his windows when all we have to go by is Van Mander's description of the Amsterdam example. Van Mander wrote that Jacques 'knew how to handle these baked colours or glass-pieces very skilfully, whether they were light or dark, so as to make things stand out in accordance with the principle that things appear to be darker on one side or lighter on the other. He also had a clear manner for painting miniature portraits from life, and towards the end of his life he started to paint in oils, so that ultimately he painted, on large canvases in oil colours, the compositions which, previously, he had enlarged in colours on paper'.

Van Mander reports that Jacques' son, faced with the prospect of an independent career at such an early age, at first continued to work as a *glasschrijver* and miniaturist. This reference seems to point to the traditional Dutch craft of working on monochrome or near-monochrome panels or roundels for insertion in the window panes of private houses, rather than to the creation of stained glass windows only. The former are best compared with washed pen-drawings. Dirck Crabeth had started his career in the same way and only by gradual steps did he increase the scale of his work to larger, and finally immense proportions[28]. Roundels of this kind were hardly ever signed or initialled, and the chances of finding one by De Gheyn are remote. Furthermore, Van Mander's text leaves no doubt that De Gheyn succeeded in completing all the glass paintings left unfinished by his father. Nothing of this nature has been preserved, nor have any miniature portraits been found so far. To trace his earliest work, the best we can do is look for engravings and drawings. One isolated piece is suggested because of its date: a small *portrait of Hadrianus Damman* of Ghent. It is dated 1578 and was published by J. de Bosscher[29] who, following on Goltzius, became the second publisher so far known to have issued prints by Jacques de Gheyn. If the engraving were by the

Cat. II 659, ill. 9

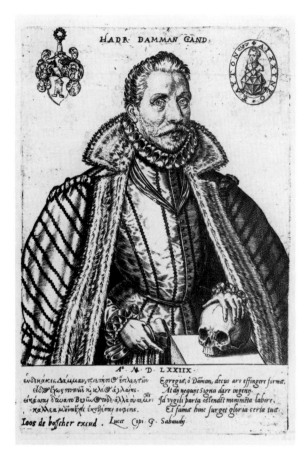

9. Jacques de Gheyn II. Traditional attribution.
*Portrait of Hadrianus Damman*. Engraving. Dated MDLXXIIX.
Rijksprentenkabinet, Amsterdam

10. Related to young Jacques de Gheyn II.
*Portrait of a Young Woman*. Drawing.
Formerly in the Tobias Christ Collection, Basle

father, it would, rather surprisingly, be his only portrait of this type and in this technique. Its timid approach to the art of miniature portraiture is, moreover, incompatible with the monumental scale he must have mastered. All we may venture to suggest is that his son started to practise engraving and that this was the first work produced by a youth aged about thirteen. Its style is obviously derived from that of either Philips Galle or Hieronymus Wiericx, the Antwerp engravers who preferred to work on a miniature scale. The year 1578 suggests it was executed at Antwerp, whence artist, sitter and publisher alike were to emigrate to the North. It is therefore not impossible that young De Gheyn started working as a pupil of one of these two Antwerp engravers and that some form of apprenticeship was interrupted by the political troubles. It should be noted, however, that this attri-

Ill. 10   bution is based on very thin evidence and I would prefer to delete the engraving from the list of his works. The same applies to the *portrait of a young woman,* a drawing at one time in the possession of Dr. Tobias Christ at Basle. Here, the sketchy execution is reminiscent of the work of artists like Sadeler and Crispijn van de Passe, but the head is finished in what may have been De Gheyn's earliest style.

In the eldest boy in the print of *The pious family,* De Gheyn may have recaptured his own youthful appearance, the most characteristic feature being the lock of hair falling over his forehead.

Cat. II 665,   There  is a portrait drawing, later signed and inscribed *I D Gheyn out 18 Jaer* that also shows  this
pl. 296   lock[30]. The left hand holding the pen proves it was based on a mirrored reflection. This portrait raises one of the insoluble problems that sometimes occur. The head itself, drawn with great care

12

and with the fine detail of an engraving, would not wholly contradict the certainly precocious date of 1583. But the arm, the hand holding the pen, and also the goat's head on the reverse, are drawn Cat. II 665, pl. 297
so freely that we can only think of them as having been created at a much later date. Nor is it a self-portrait of Jacques Junior. The question really amounts to whether it was a serious early attempt at a self-portrait in a mirror, or whether he copied, at a much later date, another artist's portrait head of himself as a boy, or even one by himself, and added the hand holding the pen. In view of the irre-futable written evidence we cannot, however, dismiss the possibility of possessing a likeness of Jacques II as a boy of eighteen.

It has always been assumed — and in 1936 I thought so too — that Jacques I left Antwerp shortly after issuing the political prints which, fully signed as they were, may in fact have endangered his safety there. He was supposed subsequently to have settled at Utrecht. He may have plied his craft there for a few more years before his early death which, as we know almost for certain, occurred in the first half of 1581. During these last few years of his life, he may have been commissioned to design the large window for the Oude Kerk in Amsterdam, its hypothetical subject, the *Conversion of St. Paul,* being quite in keeping with the recent installation of a Protestant city administration. It is possible he was replacing subject matter that was no longer suitable, or a window broken during the iconoclastic riots. From an economic point of view, however, a date before his departure for the South, when all was still quiet in the city, seems a more likely moment for the commission than one shortly after the banning of Catholicism in Amsterdam in 1578. But there is more to invalidate the hypothesis that De Gheyn returned to the North, and if we examine the relevant documents, it is obvious how shallow the evidence is. In 1806, V. van der Puyl included him in his list of painters from Utrecht when referring to the windows of Amsterdam's Old Church, and he also mentioned the year 1580. But S. Muller, the Utrecht City Archivist in 1880, found no such reference in the city's Public Records[31]. Muller had already proved how little value should be attached to Van der Puyl's superficial statements. His main evidence is based on Van Mander, and all that remains unexplained is where he found the date 1580. And so, without entirely eliminating the possibility of Jacques and his family having returned to Utrecht around 1579, we should allow for the alterna-tive, that the family came to Holland shortly after the father's death, or even much later. This is all the more likely as Van Mander does not record the move, and De Gheyn would surely have told him about it. All we know for certain is that Jacques came to Haarlem much later on, that Anna was married in Amsterdam in 1593 and that Steven lived in Leyden years afterwards. If Van der Puyl did see a document dated 1580, which is now lost, the move may have been for a short time only, after which De Gheyn returned to Antwerp.

Although Utrecht was an old and prosperous town with a wealth of churches full of art treasures, it was not a port, and lacked Antwerp's cosmopolitan character. If Humanism and the Reforma-tion had found a fertile soil in the open-minded Southern metropolis they had not penetrated so easily in a Cathedral town traditionally dominated by clerical institutions and at this time disturbed by political and religious strife. At the time when the De Gheyns may have re-settled temporarily in Utrecht, Anthonie van Blocklandt was the city's major painter. In 1579 he had been commissioned to produce paintings for the High Altar either of St. Mary's (the church where the youngest Jacques was to end his days as a Reformed canon in 1641), or, as is more likely, of the Buurkerk at Utrecht[32]. This triptych's huge central panel features the *Ascension* painted in a style that owes much to the Mannerism of Northern Italy. It is alive with colour and fluttering draperies and mani-fests a grandiloquence as yet unimpaired by the over-emphasized tricks of Bartholomeus Spranger. In 1580 this would have made a great impression on the now fifteen-year-old boy. It should not be forgotten, however, that such pomposity was not to the son's taste, even if it had appealed to his

13

father. Although he did, in later years, search for a means of working to a larger scale, he never really aspired to, or achieved, true monumentality. In fact, he is essentially to be classed with engravers or with men of minutiae, like Wiericx and Galle, from whom Blocklandt was accustomed to commission engravings after his own designs. At that time, Antwerp was still the traditional centre for world-wide distribution. But in 1582 Goltzius arrived on the scene and started engraving for Blocklandt[33]. If the De Gheyns did emigrate to Utrecht for a short time, this would help to explain why young Jacques sought employment with Goltzius in Haarlem some years later. There, the latter's fame as an engraver was rising rapidly. Soon Antwerp had to yield part of its dominant position in the print trade to Holland, while Frankfurt was also expanding its market in this field. Evidence of this change can be seen in the Antwerp Jesuits' vain attempt to commission a series of engravings from Goltzius in 1586[34]. They had received a request to this effect from Rome, and may have made a similar, and equally unsuccessful attempt to commission Jacques de Gheyn in 1591[35]. This meant they were finally compelled to be content with Antwerp engravers — double proof of the superiority of artists then working either in Haarlem or Amsterdam. It is likely, however, that De Gheyn was still in Antwerp before he joined Goltzius, and he may already have been in touch with Carel van Mander during this period. The latter arrived in Haarlem in 1583 and became close friends with the master engraver. In any case, whether or not he was aided by Blocklandt or Van Mander, Jacques was admitted to the workshop of the famous Goltzius around 1585. The precise nature of their relationship, however, cannot be established by any existing document. After a son had left school, parents were accustomed to pay for board and tuition when entrusting him to an artist who would teach him his craft, even after the pupil had become adept in helping his master in the execution of his work. A better-known example of a promising youth may be quoted for purposes of comparison. In September 1603, when he was younger than Jacques, Jan van Bronckhorst was sent by his father, Professor Everard Bronckhorst of Leyden, to learn drawing and, afterwards, engraving from Jacob Matham in Haarlem. Three months later Matham declared that Jan had already learned as much as others had in the course of a year. In spite of this, the father continued his remittances right up to 1608, and also sent payments to Cornelis Cornelisz, for painting lessons in 1607 and 1608. However, in 1606 it was agreed that Jan, although working with Matham on weekdays, would be allowed to work for himself on Sundays, and also by candlelight during the winter months[36]. This seems to provide an example of an apprentice's gradual emancipation and progress towards the status of master. When De Gheyn started his final apprenticeship he was far more competent and independent than Bronckhorst, and may have reached the Sunday and candlelight phase by 1587 at the latest. However, the first we hear of his being admitted to a Guild was in the late nineties, and this was at The Hague. The record of an earlier acceptance elsewhere may have been lost.

Initially, Goltzius must have employed him on the less important parts of his prints, or on reproducing other masters' designs for sale in his shop. Gradually, however, he handed over entire designs to the rapidly progressing pupil, who was also confident enough to engrave miniature portraits of his own. In the course of a few years he developed into such a craftsman that he was in some respects the equal of his master, although he had yet to match Goltzius' inventiveness and facility in arranging his compositions. The fact that small portraits constituted an essential and outstanding part of his engraved work proves that working strictly from nature was long to remain De Gheyn's foremost claim to success. No relevant facts are reported about the years he spent at Haarlem, and the work that can be attributed to the period[37] is limited to the above categories. We must now analyse these in more detail.

From 1585 onwards Goltzius had been engaged in engraving a series of full-length portraits of

11. Jacques de Gheyn II.
*An Ensign*. Engraving.
First state. This engraving
shows the minute
technique De Gheyn had
learned from Goltzius.
Rijksprentenkabinet,
Amsterdam

12. Jacques de Gheyn II.
*A Lieutenant*.
Engraving. Dated 1589.
Rijksprentenkabinet,
Amsterdam

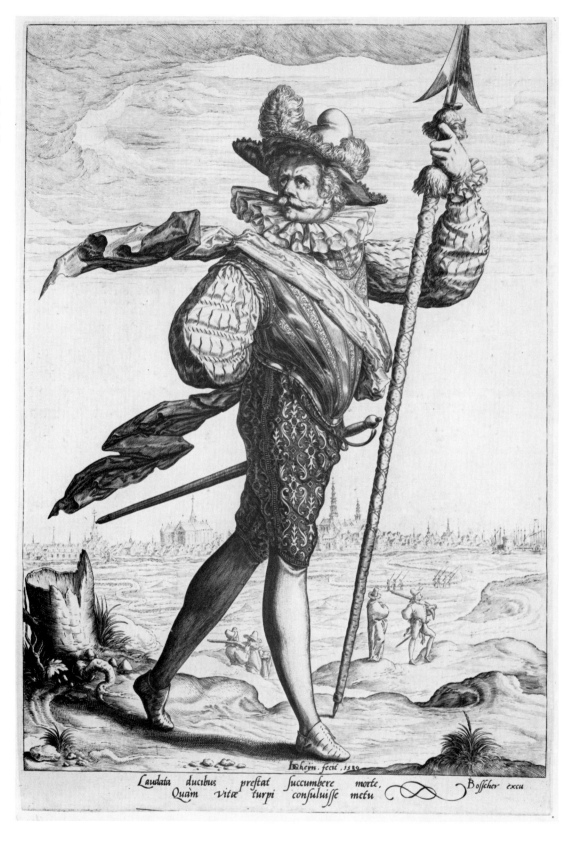

Laudatu ducibus preftat fuccumbere morte,
Quàm Vitæ turpi confuluiffe metu        Boffcher excu

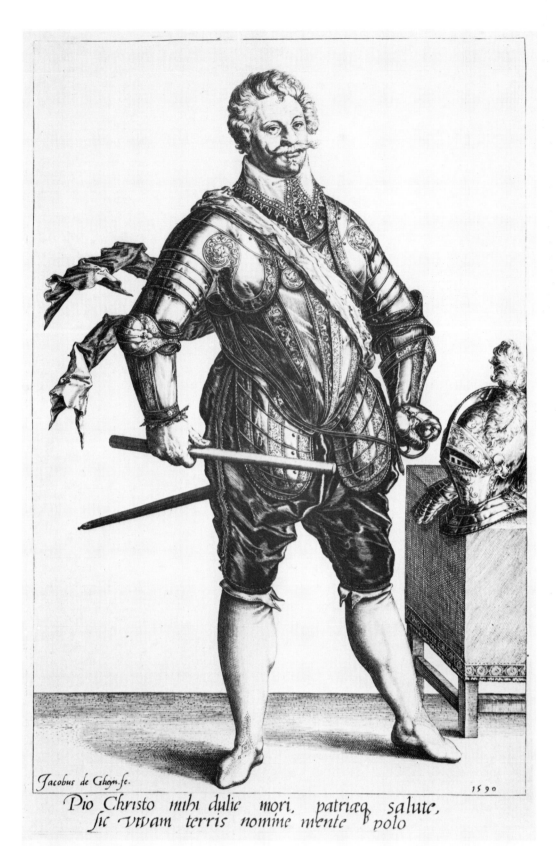

Jacobus de Gheyn fe.    1590

Pio Christo mihi dulce mori, patriæ̃ salute,
sic vivam terris nomine mente polo

13. Jacques de Gheyn II.
*An Army Commander,*
Portrait of Philipp, Count
of Hohenlohe-Langen-
*burg.*
Engraving. Dated 1590.
Rijksprentenkabinet,
Amsterdam

17

military gentlemen in landscape settings. These included foreign officers who had come from Eastern Europe to serve in Holland, Dutch ensigns, and others[38]. His sure hand and insistence on rendering every detail whilst also emphasizing the characteristics of the costumes' rich materials, made it unlikely that another engraver would ever be able to rival him in that respect. He then instructed De Gheyn to engrave another series of 12 militia men of varied rank and position after his own designs[39]. All the sitters belonged to the Haarlem militia and some of their names have come down to us; they obviously took great pride in showing off their luxurious equipment. Their classification differs entirely from the scheme followed in De Gheyn's later manual on the *Exercise of Arms*, but in a sense we may regard the series as a preliminary to the later, more ambitious enterprise. This does not, however, apply to the attitudes of the soldiers who, in the early work, pose in the contorted and ballet-like stances dictated by the rules of late Mannerism. It is hardly possible to distinguish the work of De Gheyn, the engraver, from Goltzius' early creations; at the most, all one can detect is when the easy flow of Goltzius' style of engraving has been partly replaced by a less rigid and gentler use of the burin. If one compares the lines and dots in these prints, it is apparent that whereas Goltzius used a set of tools varying from broadly to sharply whetted burins, the sharpest burins producing the most delicate lines were those guided by De Gheyn. In 1589 De Gheyn added some variations of his own design to the series, which he concluded by engraving an *Army Commander* in 1590. In rendering some of the details such as the helmet in this final design, or the decorative patterns in the dark velvets worn by the *Ensign* and the *Lieutenant,* De Gheyn's hand and design had now become as sure as his master's. If virtuosity can be learned, that is what had happened here.

Cat. 681, ill. 13
Cat. 643, 644,
ill. 11, 12

The Army Commander is likely to have been one of those under the supreme command of Prince Maurice. His identity can now be established, for he is so much like Philipp, Count of Hohenlohe-Langenburg, who was the senior Lieutenant General in the Dutch army under Prince Maurice at the time, that we may be certain that it is indeed his portrait. His sumptuous apparel strongly supports the identification. This is the first sign of De Gheyn being in touch with Goltzius' high-ranking connections and of his early contacts with the guiding spirits of the war of resistance and subsequent liberation. The sitters' desire to be portrayed cannot be the only reason for the prints being commissioned. They are accompanied by Latin distichs likely to increase the popularity of the militia companies that were only in exceptional circumstances deployed in the front line of a war fought mainly by foreign mercenaries. But they depicted the army structure and were symbolic of the valiant men who operated at home as well as in the field.

H. 433, ill. 14

A print of singular delicacy engraved by De Gheyn in 1587 shows us something of his skill at that early date. It is the reproduction of a design by the sculptor W. Tetrode for the decoration of a plaque or the inside of a bowl. Neptune is in the centre, encircled by the sea gods round the side. This print has a further value, as until quite recently we had been vainly seeking the kind of work for which the once famous sculptor was responsible. We know of the high altar in the New Church at Delft, on which he had lavished the best alabaster and rare stone available, and which must have been a masterpiece of refined architecture and sculpture. This, however, was demolished soon afterwards as a result of the change of religion. Until a short while ago, De Gheyn's print was considered the only design to show one of Tetrode's most elegant compositions with a large number of figures. However, just before completing these pages I had the good fortune to discover an actual

Ill. 15

piece of workmanship so akin to the pattern of this print that it may, without a doubt, be attributed to Willem Tetrode[40]. It is a circular bronze plaque showing an embossed *rilievo* of similar content, in which the French elegance of the human forms betrays the influence of the school of Raphael and of the school of Fontainebleau. Tetrode was indeed an artist. One can well imagine De Gheyn

18

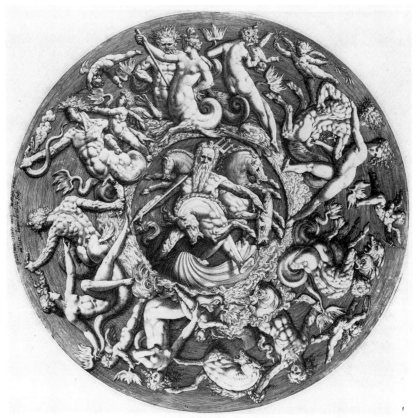

14. Jacques de Gheyn II.
*Sea Gods*. Engraving.
Signed and dated 1587.
After a bronze plaque
by Willem Tetrode.
Rijksprentenkabinet,
Amsterdam

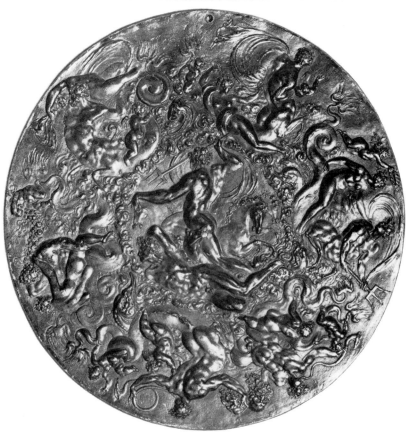

15. Willem Tetrode.
Author's attribution.
*Plaque with Sea Gods*.
Bronze.
Art market, Amsterdam

19

wishing to test his skill by reproducing a work of art as polished as the similar roundel which is now lost.

The technique employed in the engraving confirms my remarks about the minute size of the lines produced by his finely pointed burin, the only kind used here. Because of its date, this engraving is the only evidence to show that he was now well past the apprenticeship stage, however much he may still have been bound by an arrangement of this kind. It also suggests a considerable amount of prior practice, and evidence of this can be found in the engravings executed from designs by Carel van Mander and Crispijn van den Broecke, none of which, however, bears a date earlier than 1588. The fact that De Gheyn received quite a number of commissions to engrave prints from designs by Carel van Mander is an indication of the close relationship then existing between them. Goltzius never engraved after Van Mander, and it is therefore evident that the latter acted as a patron to his younger fellow immigrant and provided him with work that would more or less systematically develop his talents. This aim was indeed achieved.

De Gheyn learned the engraver's craft from Goltzius, but engraving copper plates from the designs of other artists with styles of their own compelled him to gain a wide knowledge of the treatment of very varied subject matter. He had to learn how to group and pose characters, how to arrange lighting and shading and, in general, how to handle various techniques. In doing so, he also learned how to become an inventor himself. Until some drawings come to light that are older than this practice period, nothing can be said about an earlier style. However, copying first from one and then from another master saved him from becoming a slave to the idiosyncrasies of a single artist. In the case of a lesser talent, such varied influences might have combined to bring forth a commonplace style, but for De Gheyn they led the way to the discovery and perfection of his own particular aptitude. Making friends with Carel van Mander must have stimulated him in many ways besides enabling him to make use of the latter's designs. Much of the contents of the *Schilder-Boeck,* and especially its didactic poem addressed to young artists, would have been familiar to Van Mander's circle, 'avant la lettre' as it were. We know from his *Life* of De Gheyn that they were intimate, and it is therefore obvious what the mainspring of De Gheyn's knowledge, imagination and orientation must have been during his Haarlem period. Nothing, on the other hand, is known about his sharing in the activities — whatever they were — of the mysterious 'academy' founded by Goltzius, Van Mander and Cornelis Cornelisz, and mentioned only by Van Mander's posthumous biographer. We do not know when it was founded, or if all it meant was that its members started drawing from the nude. All we know about De Gheyn's efforts in that field points to a later date. There is no proof, or indication even, that he first learned to understand and portray the human body by any method other than engraving the drawings of fellow artists and eagerly studying older works of art. There is only one example of a female, standing nude — hypothetically attributed to him — which was probably drawn before 1600. However, he must have started to draw portraits at a much earlier date. All we can say is that the only Haarlem masters whose work he engraved, happened to be the three artists who founded an academy as Van Mander's biographer tells us.

Cat. II 802, pl. 6

Curiously enough, the fashionable style of the period was further stimulated by glimpses of the luxurious court of the Vienna Hapsburgs. Its voluptuous pageantry and sophistication were captured in a few splendid designs by Bartholomeus Spranger which were sent to Haarlem's print-makers for publication[41]. When De Gheyn entered Goltzius' studio it was approaching the 'apogee of Mannerism' as it was called in the catalogue to the Vassar exhibition of 1970. He was a youth aspiring to perfect his miniature portraits and full of respect for conscientious portraiture, when suddenly he found himself face to face with the hyperbolic portrayal of the alien world of mythology and ancient man. The works he produced as a result were 'translations' performed with the aid of a

20

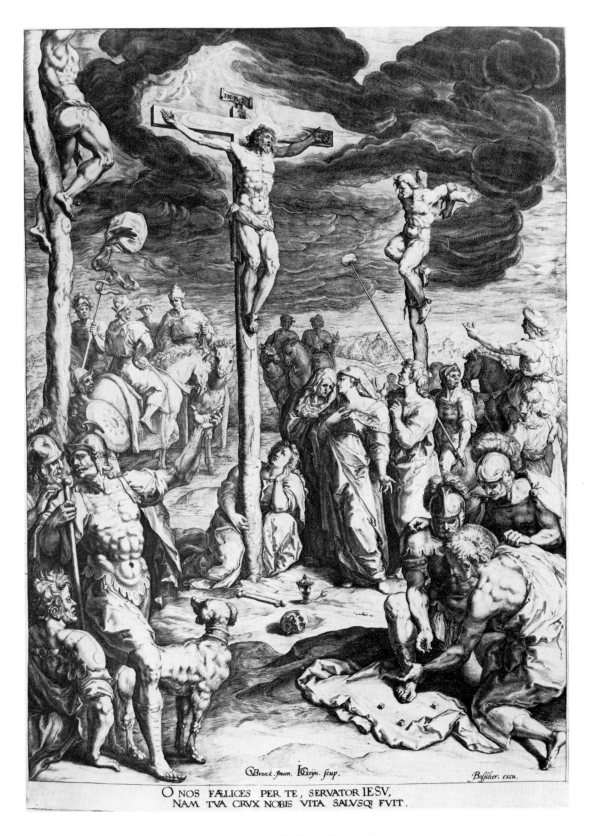

O NOS FÆLICES PER TE, SERVATOR IESV,
NAM TVA CRVX NOBIS VITA SALVSQ; FVIT.

16. Jacques de Gheyn II. *Mount Calvary*. Engraving.
After a design by Chr. van den Broecke (Paludanus).
Graphische Sammlung Albertina, Vienna

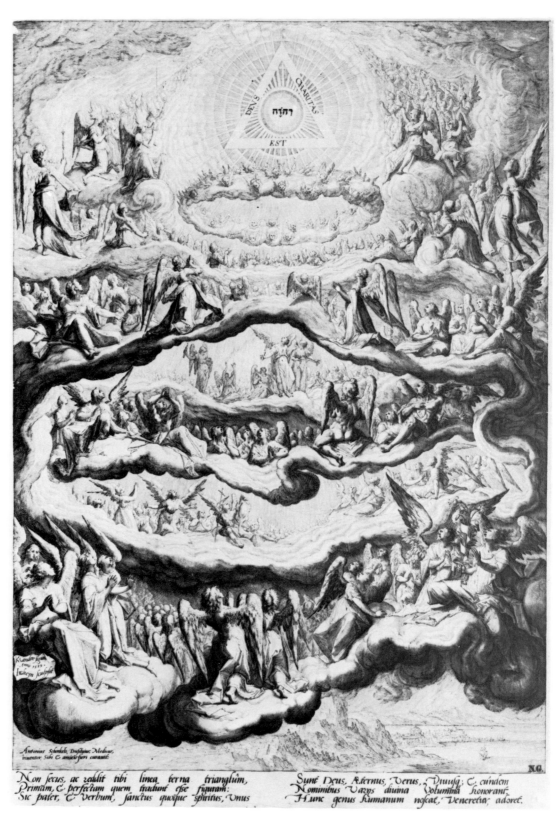

Non secus, ac reddit tibi linea terna trianglum,
Primam, & perfectam quem tradunt esse figuram:
Sic pater, & Verbum, sanctus quoque spiritus, Unus

Sunt Deus, Æternus, Verus, Diuusq; & eundem
Nominibus Varijs diuina Volumina honorant:
Hunc genus humanum noscat, Veneretur, adoret.

17. Jacques de Gheyn II. *The Adoration of the Trinity*.
Engraving. Dated 1589. After a design by Carel van Mander.
Rijksprentenkabinet, Amsterdam

visual dictionary he still had to learn to use. Among the subjects De Gheyn engraved at Haarlem, mythological scenes were very much in the minority. A large print of *Acis and Galatea* after Cornelis Cornelisz shows him battling with the portrayal of a female nude whose horror at the advances of the male seems to show up far more wrinkles in her knee than Nature could have permitted. Swirling draperies express the required excitement. The print is undated, but must have been produced before De Gheyn left Haarlem. In a *Banquet of the Gods* interrupted by Eris throwing the apple — after Van den Broecke — a sense of the ridiculous does not conceal the shortcomings in the interpretation of several faces and, here and there, a most curious lack of understanding of the human muscular system. It was not until he began to produce his own drawings that De Gheyn gained mastery in this field. This particular print dates from 1589. It is worth while comparing it with the truly monumental *Mount Calvary* that De Gheyn was to engrave after Van den Broeck at a later date. The latter work is clearly a personal re-creation of a drawing submitted to him, whereas in the *Banquet of the Gods* he remained totally dependent on his model and was unsuccessful when he had to make up for the lack of clarity in another man's drawing. In the *Mount Calvary* after the same artist it is very apparent that the figures show more of De Gheyn's own stylistic idiom and that the dramatic effect of the dark clouds is entirely due to his own creative imagination. This undated print should be listed with work of later years.

Among the moralising and religious subjects dating from the Haarlem period are the two paradigms of *Good* and *Bad Government,* dating from 1588, after Van Mander, useful subjects for teaching the engraver how to handle the perspective of the open halls forming the setting. Another example is the *Adoration of the Trinity* of 1589, which is staged along ascending, shallow tiers of clouds at the foot of the upper Heaven where the Trinity is represented — a dantesque vision, ethereal, but without sufficient solidity to be altogether convincing. But it is here that De Gheyn may have learned his fluent handling of organically connected whirls of cloud, so striking in his later work and so useful for dramatising landscape. Four medallions of *Evangelists* after Goltzius and a powerful *Rest on the Flight into Egypt* after Cornelis Cornelisz also belong to this period (1588 and 1589 respectively). Like so many works by the two Haarlem artists, these prints show a taut concentration of design despite the flurry of movement filling them. Several other prints lack any indication of their date, but they may be attributed in part to the Haarlem period. They were published by Joos de Bosscher and therefore cannot be later than the beginning of the Amsterdam period, because we now know that De Bosscher died in 1591 at the latest. He had championed De Gheyn from 1588 onwards by publishing his youthful work[42], whereas Goltzius had done so one year earlier in 1587[43]. De Gheyn's last engraving to reproduce one of Goltzius' drawings was overlooked in Hollstein's catalogue. It shows the Virgin Mary tenderly pressing her cheek against the forehead of the Child which is swaddled like a mummy. She is seated in a niche shaded by means of extremely fine concentric lines that gradually fade away at the side where the light strikes it. This very delicate print was published by De Bosscher in 1590[44], which may also have been the year when De Gheyn engraved a print of *Saint Elizabeth* after Spranger. She is standing in a similar niche and offers a loaf to a beggar who is seated on the ground. Her gown hangs in many sharply pleated folds. Spranger had obviously sent Goltzius a drawing he had used when working on one of the four paintings of saints which were moved recently from the Strahov monastery to the Prague National Gallery[45]. It is more difficult to tell when De Gheyn engraved his first portraits. The doubtful attribution of the small *portrait of Hadrianus Damman* of 1578 has already been mentioned. If this work is by De Gheyn, it remains a unique, if not very brilliant, early work and poses the question why it was not followed by others of the same kind for such a long time. The earliest date to be found is 1586, which appears on both versions of the small *portrait of Tycho Brahe*[46]. This is

H. 347

H. 336

H. 335, ill. 16

H. 427, 428

H. 380, ill. 17

H. 349-352
H. 348

Ill. 19

H. 430, ill. 18

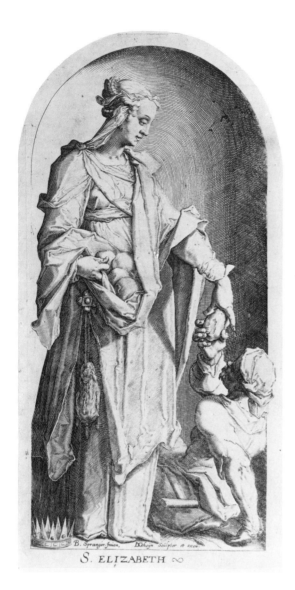

S. ELIZABETH ∽

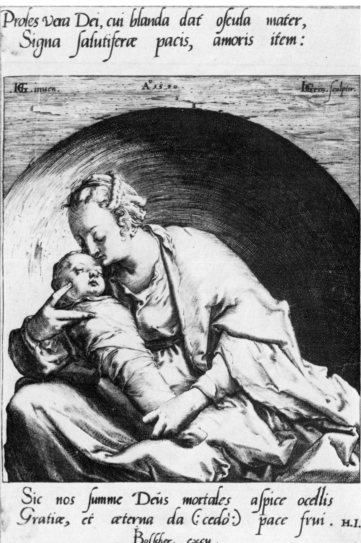

Proles vera Dei, cui blanda dat oscula mater,
Signa salutiferæ pacis, amoris item:

Sic nos summe Deús mortales aspice ocellis
Gratiæ, et æterna da (:cedo:) pace frui. H.I.
Bosscher. excu.

18. Jacques de Gheyn II. *St. Elizabeth of Hungary*.
Engraving. After B. Spranger.
The treatment of the drapery is the same
as in ill. 24 and the niche is similar to
the one in ill. 19
Museum Boymans-van Beuningen, Rotterdam

19. Jacques de Gheyn II. *Madonna and Child*.
Engraving. Dated 1590. After H. Goltzius.
Printroom, British Museum, London

20. Jacques de Gheyn II. *Portrait of an Unknown Man*.
Engraving. Dated MDLXXXIX.
Rijksprentenkabinet, Amsterdam

equally puzzling, because *1586 compl* seems to refer to a portrait dating from 1586, whereas the print is supposed to have been produced some ten years later. So the first properly dated portrait engraving is the one of the anonymous sitter with the laurel branch and this is the only example that can be proved to date from the Haarlem period. It would appear simple to identify a man who was 25 in 1589 and who was moreover accompanied by this emblem, a motto translated into Latin and a coat of arms with a crowned column with a twisted tendril on either side. This, however, is not so. There was a French schoolmaster called Jacob Claesz, a native of Barsingerhorn, who in 1598 was teaching at the 'Laurel', a school which was transferred from Antwerp, where it was called the 'Laurel-Tree', to Haarlem. He used the motto *Bemint en hoopt* which is not, however, translated in the Latin text. Still, he may well have been the sitter, particularly as he also wrote a sonnet in praise of Van Mander's *Schilder-Boeck*[47]. But the laurel-branch in his hand seems more likely to point to a doctor of medicine. This beautifully engraved miniature portrait proves De Gheyn's mastery in this field. As for an earlier example, there is much to be said for suggesting an even earlier date for a portrait supposed to represent Jan van Drenckwaert. The massive forms of the body and hand, the relatively small head, the use of the extremely fine graver creating the effect of a silverpoint drawing, and the treatment of the richly patterned surcoat, so similar to those of the soldiers of 1588, all appear to suggest a similar date, whereas Drenckwaert's age would not be incompatible with a still earlier one. This then seems to be one of the earliest works of art known to have been produced entirely by our artist.

Cat. II 724, ill. 20

Cat. II 660

Not one of the many hundreds of drawings by De Gheyn that have been preserved can be attributed with certainty to his years of apprenticeship, although there are a number of possible examples. It is difficult to express any definite opinion as there is no documentary evidence relating

21. Jacques de Gheyn II. *St. Luke the Evangelist.*
Engraving. First state.
Rijksprentenkabinet, Amsterdam

22. Jacques de Gheyn II. *St. Luke the Evangelist.*
Engraving. Second state with changed head.
Rijksprentenkabinet, Amsterdam

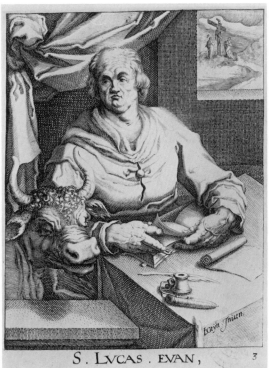

Cat. II 205, pl. 1 to them. A pen-drawing in Amsterdam represents a child seated on a skull and looking at a rose that is reflected in a small mirror held in his hand. He is surrounded by objects symbolising life's transience. The monogram *I D G f* was inscribed later. The drawing was engraved in reverse by an unknown artist, A.I., at a much later date, as indicated by the address of H. Hondius. De Gheyn may have entrusted the engraving of an early drawing to him. It is rendered entirely in the manner of H. Goltzius, but shows an affinity to De Gheyn in the conception of the plants and the smoke curling up from the vase. This weak drawing was either a relic of De Gheyn's years of apprenticeship, or else the monogram is not genuine.

Cat. II 37, pl. 14 Executed in the unusual medium of red chalk, the fully signed *Holy Family with singing angels* at Leyden is of quite a different order, although this drawing again features plants and roses. Obviously inspired by Dürer's Madonnas, it also includes an angel borrowed from Van Mander's Ill. 17 *Adoration of the Trinity* as engraved by De Gheyn in 1589. The trees, however, are derived from the repertoire of Cornelis Cornelisz. The work is clearly an early attempt at producing an all-round religious picture and it is likely to have been inspired by a strong ambition to compete with the drawings of early Northern masters such as Dürer and Lucas van Leyden. The latter were soon to inspire Goltzius himself in two of his 'master engravings'. The Leyden example seems to be one of De Gheyn's earliest drawings of which the authenticity is well established.

We may conclude this chapter by wondering when De Gheyn started to engrave his own designs, the ultimate aim of his education as an engraver. Apart from the portraits, his series of *The Four* Cat. II 91-94 *Evangelists* seems to show the greatest affinity to the Mannerist style Goltzius was to abandon completely after his journey to Rome. It is open to doubt whether these crude prints were actually engraved by De Gheyn, but the inspiration was certainly his. The articulation of the Evangelists' hands can vie with Goltzius' well-known example of virtuosity, the 1588[48] pen-drawing of a hand. St. Mark is reminiscent of Dürer's *St. Jerome in his study*. The bespectacled head of the sinister Ill. 21 St. Luke, even more alarming because of its contrast with the grinning ox, was replaced in later Ill. 22 years by one closely resembling Jan Govertz[49], and lacking the halo that originally crowned all four heads. As Goltzius had also portrayed Govertz as St. Luke[50], this must have been a somewhat tardy joke on the part of the later engraver. It would be some time before the crudeness found in these works, and at times still apparent in those of the Amsterdam period, was to disappear entirely from his oeuvre. The complete set of four may originally have included elements of stylistic exaggeration heralding a growing aversion to an environment where he had been taught to work in a manner so alien to his own aspirations as to violate his awakening conscience as an artist.

26

# CHAPTER II

## *Jacques II in Amsterdam until his marriage*

Hendrick Goltzius was in Italy from November 1590 until the end of 1591. By then, De Gheyn — who must have told Van Mander that he had been Goltzius' pupil for two years — is likely to have had his own independent shop or workshop in Haarlem for some time. He kept it on after his departure for, and even from, Amsterdam[1]. Some of the other pupils benefited from Goltzius' impressions and the new course he began to pursue, purified, as it were, by a clearer perception of the aesthetic ideals revealed to him in classical Roman sculpture. Unlike them, De Gheyn continued to work in the style he had learned from a master still steeped in Mannerism. During the next few years in Amsterdam, he was therefore temporarily to lag behind the great advances that were being made at Haarlem. This alone makes it difficult to distinguish between De Gheyn's work produced before and after his move to Amsterdam.

When precisely he arrived in Amsterdam is unknown. An entry in the diary of the Utrecht humanist Arnoldus Buchelius[2] proves he was living there by April 4th, 1591. On that day, Antonius Boonhof[3], the goldsmith, introduced Buchelius to De Gheyn. The latter then visited Jacob Razet[4], a notary and patron of the arts, with Buchelius, whereupon the three men spent several days in each other's company.

They dined at the 'Gouden Valk', where they worshipped lavishly at the shrine of Bacchus and the innkeeper's wife enjoyed their attentions; they visited the two *Doelens* — shooting-ranges — to admire the group portraits of militiamen by old Amsterdam masters, then watched a moral farce at the theatre and, in spite of all this, went to have a look at a bawdy-house. De Gheyn was later to confide to Van Mander that, as a bachelor, 'he had been sadly affected by young, alluring company' which later caused him to deplore the time he had wasted. In these years he is unlikely to have bent his head unremittingly over his copper plates.

A portrait medallion of Vincent Jacobsz Coster dated 1591 shows that the 'Gouden Valk' was not the only inn where De Gheyn felt at home at this time. Vincent or *Cente Peilder* as he was nicknamed, a scion of a well-known Amsterdam family, was a wine merchant and a publican and, as the inventory of *de Witte Calckoen* shows, an art-lover[5] as well. He was the first innkeeper to have a *Doolhof* (a maze), a pleasure garden where people went to enjoy a drink. His art collection was later found to include a portrait bust of himself by Hendrick de Keyzer, now at the Rijksmuseum, and paintings such as a *Danae,* which may well have been by Goltzius, and a *Monk with a Beguine,* possibly by Cornelis Cornelisz. It is quite likely that De Gheyn settled an account more than adequately by the friendly gift of a portrait.

We also hear of the Jesuits in Rome wishing to publish a series of engravings, and consulting their Antwerp brethren on the subject in 1591. The latter reported, *que l'on a commencé à y mettre la main, étant averty qu'en la ville d'Amsterdam se trouve un J. de Gheyn... qui se mettrait volon-*

Cat. II 686

*tiers en debvoir de les achever.* The Roman brothers then inquired whether in Antwerp *on savoit ou entendoit cestui sculpteur catholique et de l'ancienne religion,* whereupon Melandt replied, *qu'il ne croyait pas De Gheyn hérétique, que cependant s'il en était ainsi, il espérait avec la grace de Dieu le convertir, pendant qu'il travaillerait au collège.* De Gheyn's passport to travel to Antwerp was granted by apostil dated September 11th, 1591[6].

We do not know whether De Gheyn actually used it, because the prints were not produced then, but it is quite likely that he was anxious to find out what had become of his family or any possessions or interests which had been left behind, and Melandt may even have helped by providing a pretext for the purpose. The situation was certainly quite different from what it had been in 1586 when Goltzius was approached for the same purpose, and had made it a condition that he would be allowed a stay in Rome. Goltzius had originally submitted one small print as a test piece, but later on, indignant about his clients chicanery, he expressly disassociated himself from the project[7]. How De Gheyn reacted is unknown. However, as he was to marry a girl belonging to a Catholic family some years later, we may assume he was less ill-disposed towards a Roman Catholic order than Goltzius, who is thought at a later date to have entertained relations with the Rosicrucians, an 'order' fiercely opposed by the Jesuits elsewhere[8]. This does not alter the fact that later on De Gheyn was to prove he was committed heart and soul to the cause of freedom and opposition to Spain, and that he, no less than Goltzius, was absorbed in the humanist ideas which must have been wholly familiar to the latter since his early contacts with Coornhert[9].

If De Gheyn actually went to Antwerp, it is tempting to think he travelled there by way of Middelburg. One of the largest colonies of emigrant citizens of Antwerp was living there at the time, and they must have included old friends and acquaintances of the De Gheyns. Again and again we hear of the émigrés seeking out and helping each other. It was only natural: they spoke the same dialect.

If this is what happened, De Gheyn may have met Daniel Heinsius at Flushing on this occasion, although the latter was then not much more than a highly promising schoolboy, deeply versed in classical literature from a very early age[10]. Such a meeting would explain the date 1591 on the study for the first print in the series of *Virtuous Women* which was not published until 1606; this picture was combined with a text by Heinsius, one of his few works not written in Latin[11]. Some of the prints in the series look decidedly later than this first picture with its early date. Nor does its theme — the siege of Weinsberg, with the women carrying their menfolk away on their backs after the city's capture — fit in well with the other subjects, all taken from classical writers.

The first sources to tell us more about De Gheyn's family date from 1592 and 1593. On February 11th 1592, Jacques acted as a witness and *gecoren voogt* — chosen guardian — to his sister Anna when granting power of attorney to a Utrecht notary[12]. He did so again on December 4th, 1593 when her marriage to Meester Adriaen van der Burgh, a surgeon, was registered. Anna was then 25 years old[13]. As the certificate contains no reference to her mother, Cornelia, it is certain that the latter was no longer alive, otherwise her consent would have been required. In the circumstances only a man, in this case the eldest brother Jacques, could give the required consent. In view of the first notarial instrument, it is also possible that Cornelia had died (either in Antwerp or in Utrecht) around 1591. Meester Adriaen van der Burgh had moved from Brussels, where he had called himself Van der Borch, to Amsterdam prior to 1590, and must have practised as a surgeon there, although he was not registered with the Amsterdam surgeons' guild. He had been married and had two daughters, one of whom afterwards married in Amsterdam. The latitude prevailing in those days with regard to the spelling of proper names has so far concealed the fact that Adriaen van der Burgh was none other than Adriaen Verburgh, referred to by Orlers as 'an expert surgeon and art

Cat. II 275, pl. 4

28

lover' who was David Bailly's second teacher[14]. So he appears to have practised the art of painting, or in any case drawing, as well as his own authentic profession. This unexpectedly confirms Orlers' story that David Bailly had walked into De Gheyn's shop, was taken on as a pupil, and stayed for a year before moving on to Adriaen Verburgh in 1601. Apparently, De Gheyn referred the Leyden boy to his brother-in-law in Amsterdam shortly after he had taken him on as an apprentice. When Verburgh died in 1602, Bailly was apprenticed to Van der Voort. None of Adriaen van der Burgh's works has been preserved. A document unknown to me in 1936 was discovered by S.A.C. Dudok van Heel and proves that Van der Burgh, who had two children by his former marriage, had, in 1592, bought a house in De Lange Niezel from Meester Erik Dimmer and Meester Cornelis Duyn, the latter representing his niece Elizabeth Duyn who was under age. The house must have formed part of property long owned by the Duyns or De Vlamings, both old-established Amsterdam families. The vendors kept a share in the mortgage which facilitated the sale to Van der Burgh; the mortgage was, in fact, not repaid to the four persons concerned — or their heirs — until 1611 and 1612, a considerable time after Van der Burgh's early death in 1602[15].

I have dealt at such length with this transaction because Cornelis Duyn was to become De Gheyn's brother-in-law a few years later: his wife was a Stalpaert van der Wiele, the sister of Eva, whom De Gheyn was to marry in 1595. In 1612 De Gheyn drew Cornelis' portrait for a print by Willem Swanenburgh, in which Duyn is referred to as *Patricius Aemsteldamus*. De Gheyn is therefore likely to have met his Eva in Amsterdam through Cornelis Duyn.

Cat. II 662, ill. 88

Anna's marriage was blessed with two children, Jacob and Anna, but she was to lose her husband in 1602. The plague raged in Amsterdam that year and he probably succumbed to it, exposed as he was through being a surgeon[16]. We shall see how Anna, who subsequently moved to Leyden, later married Govert Basson, and bore him children as well. In April 1594 Anna de Gheyn received the sum of 108 florins from A. Fock of The Hague[17]. I relate this item to the payment of board and lodging for one of her brother Jacques' apprentices, of whom there is mention in another extremely important document, the letter in Berlin which De Gheyn sent to Isebrant Willemsen, an unidentified friend, on March 3rd, 1592[18].

Cat. II 685, pl. 8

Its importance is due partly to its contents and partly to the portrait drawing, above the writing, of the apprentice who was to deliver the letter. The portrait shows the boy hat in hand as he would have been when politely greeting the recipient. It is drawn with a pen, entirely in the style of an engraving, with the head very finely detailed, and the costume broadly rendered. The letter gives us an opportunity to become acquainted with Jacques' handwriting[19] and proves that De Gheyn was a carefully reared intellectual who enjoyed writing stylishly and with some humour. He is sending, so he says, his deaf-mute apprentice to invite the recipient to pay him a visit, as he himself cannot leave home, busy as he is with the Apostles, who occupy all his time. The latter are faced with the prospect of a journey, probably as far as Frankfurt, which 'fortunately will take place in summer, as they have no shoes on their feet'. Their departure will be accompanied by an honest banquet which is to be paid for by *heerschap* Spruyt. 'If my deaf-mute apprentice can do anything for you, he will not object, because through an oversight he hasn't a tongue in his head, etc'. Below the signature we find the motto De Gheyn apparently used as a rhetorician: *wat ick vermach* — 'as I can'.

It is easier to explain this letter now than it was at the time I wrote my *Introduction*. It was apparent then that 'the Apostles' referred to the series of fourteen large engravings of designs by Van Mander representing Christ, the twelve Disciples and the Apostle Paul full-length in landscape settings; the series was probably destined to be sold at Frankfurt[20]. Buchelius admired them in late May the following year when he visited De Gheyn, who also showed him the two *Sibyls* engraved by Goltzius[21]. However, at the time I was unaware of the identity of the deaf-mute apprentice. Since

Ill. 23

23. Jacques de Gheyn II. *The Apostle St. James the Elder.* Engraving. From a series dated 1592. After a design by Carel van Mander. Rijksprentenkabinet, Amsterdam

DECENDIT AD INFERNA TERTIA DIE RESVERREXIT A MORTVIS

30

then I have discovered that his age tallied with that of Matheus Jansz Hyc, who later worked at Leyden as a deaf-mute painter. Thanks to a substantial file in the Records of the 'Orphans' Chamber' at Leyden[22], we know that Meester Jan Symonsz Hyc, the well-to-do Leyden city surgeon, made the necessary arrangements for the future maintenance and tutelage of this handicapped child, who was to become a painter, and of whom it is known that he painted a *fruytagie*, a still life of fruit. The doctor's third wife, who was widowed in 1605, was married to Jacob Aertsz Spruyt, himself the widower of Marye Dircksdr, on May 24th, 1608. Later on, Jacob Spruyt was to arrange for regular payments to be made to the handicapped artist from the capital managed for him by the 'Orphans' Chamber'.

It has not been possible to establish the identity of the *heerschap* Spruyt who, according to the 1592 letter, was to pay for the farewell banquet for the *Apostles* on the eve of their departure for Frankfurt. One must assume he was a patron of the arts and he may therefore have been the father, or an older relative, of Govert Spruyt, who was to marry the elder Jacques Savery's widow Trijntje Kokelen after her first husband had died during the plague of 1602[23]. The large family lived, later on at least, in the Breestraat near the Rembrandthuis, where a house called 'In het stadhuys van Kortrijk' still recalled the origins of the Savery family. There is no evidence of a direct link with Jacob Spruyt of Leyden, although it may have existed.

Jacques de Gheyn's connections with the Hyc family were not to be confined to the unfortunate son whom the Leyden doctor had entrusted to him as an apprentice. On May 16th, 1603, De Gheyn's youngest brother, Steven, married the deaf-mute artist's sister Grietgen Jansdr at Leyden; he had several children by her.

Matheus Hyc was not the most prominent of De Gheyn's apprentices. When Van Mander made inquiries about them for his *Vita*, De Gheyn apparently failed to mention all those he had trained over the years. David Bailly's name does not occur either, but in 1604 he could hardly be called fully trained. However, Van Mander does mention the following — in 1603 —: 'Firstly the excellent and famous Jan Saenredam who now lives at Assendelft. Also a Zacharias Dolendo who began very well, as can be seen from several things engraved by him, for example a small Passion drawn by me, (*i.e.* Van Mander), and other things. He was greatly inspired towards Art but died very young, having through leaping and dancing, or immoderate drinking, internally injured his lungs, so that he began to spit much blood from his mouth, and in the end could not be succoured. And also a Robert of Amsterdam, and a Cornelis who is now in France'. Robert refers to the engraver Robert de Baudous, and Cornelis, so it has been thought, to Cornelis Drebbel, who became better known as an engineer and an inventor than as an engraver. The latter's identity remains uncertain. It is not easy to decide whether Van Mander lists the four in the chronological order of their arrival at De Gheyn's workshop, but an attempt may be made to establish the dates of their apprenticeships more closely.

Jan Saenredam and Cornelis Drebbel are known to have lived at Haarlem, not Amsterdam. Saenredam was the elder of the two and almost certainly De Gheyn's first apprentice. They were the same age and their relationship is an indication of De Gheyn's early mastery in contrast to Saenredam's late apprenticeship. After his departure for Amsterdam, De Gheyn may have entrusted his Haarlem interests to Saenredam. The first date to occur on the latter's work is 1593, which appears on prints of drawings which Goltzius had made in Rome, partly from works by Polidoro and partly following his own designs. From that time onwards he worked mainly from designs by Goltzius. Nothing is known of a similar association with De Gheyn, whose teaching must therefore have been of a technical nature, and whom he must have assisted in a subordinate capacity. We may assume that his apprenticeship coincided with Goltzius' journey to Italy, and that after his return, Saenre-

24. Zacharias Dolendo. *St. Cecilia playing the Organ with Angels singing.*
In the doorway her Marriage. Engraving. After Jacques de Gheyn II.
Rijksprentenkabinet, Amsterdam

dam came completely under the spell of the great Haarlemmer. De Gheyn had certainly taught him to produce true, and often very delicate engravings. Reznicek's hypothesis that Saenredam travelled abroad (Italy?) is not based on any known sources. Jan Saenredam was undoubtedly the most gifted of De Gheyn's pupils. A comment by Schrevelius[24] reveals that his character was unmarred by the thirst for honours of which De Gheyn could not be exonerated altogether.

The likelihood of Drebbel (1572-1633) having been the apprentice Cornelis remains a hypothesis, particularly in view of the fact that his connections with Goltzius have been firmly established. For a while he lodged at the latter's house, and in 1595 he married Sophia Goltzius, a younger sister of the engraver. They also shared a liking for chemical experiments[25]. At a much later date, De Gheyn was also to take an interest in one, or perhaps several, of his inventions. A few prints signed by Drebbel are known[26], the most important being a *Plan of Alkmaar*. This was produced in the same year as De Gheyn's *Plan of Schiedam* and bears comparison with it. The remaining prints were produced at about the same time; it is therefore possible that De Gheyn initiated Drebbel in the art of print-making around 1596-97 and not, as in the case of Saenredam, during Goltzius' absence from

Cat. II 159

32

Haarlem. However, I do not at all rule out the possibility of Van Mander's 'Cornelis' not referring to Cornelis Drebbel; Van Mander would, after all, have known his surname, for some of his own drawings were engraved by Drebbel.

On the other hand, both Zacharias Dolendo and Robert de Baudous must have been trained at the workshop in Amsterdam. During his brief life, most likely to have been cut short so tragically before the turn of the century, Zacharias Dolendo worked almost exclusively as a reproductive engraver. Carel van Mander provided him with many designs, and a number of engravings after De Gheyn are also known. These include *St. Cecilia playing the Organ* which, according to P.M. Fischer, was designed and engraved for the Leyden organist and composer Cornelis Schuyt to celebrate his marriage to Cecilia Pietersdochter of Uitgeest. By then, the engraver had fully mastered his craft and his workmanship was as fine as that of De Gheyn and Jan Saenredam. At a later date he also engraved the design for a folio-sized *Calvary*. Here De Gheyn independently created a robust variation of the drawing by Van den Broecke that he himself had engraved previously. On this occasion Dolendo failed to achieve the same delicacy, but the drawing is likely to have differed from Van den Broecke's in this respect as well. He did, however, clearly bring out the essential contrast between light and shade. De Gheyn must have trained Zacharias to do full justice to the designers' intentions. In 1596-97 he also employed him to engrave the large series of *Vicissitudes* and the same can be said of this work. A comparison with the original designs still in existence reveals that hardly any of the dramatic force of the principal characters had been lost. Zacharias was not the kind of engraver who was able to inject something of his own personality into his prints, but his technical skill is beyond question. Perhaps he lacked sufficient time to develop a greater independence.

Cat. II 97, ill. 24

Cat. II 54, ill. 25; cf. ill. 16

Cat. II 177-185, pl. 25-32, ill. 42

To a certain extent one might say the same of his elder brother, Bartholomeus Dolendo, who was two years older and may have been trained by Goltzius, but who was certainly not included in Van Mander's list of De Gheyn's apprentices. In fact, he was also a gold and silversmith[27]. Nevertheless, he is known primarily to have been a reproductive engraver, who came nowhere near to equalling his brother's delicate technique. He was rather a stiff and clumsy, if not a coarse engraver.

Robert de Baudous was born in Brussels and therefore had a natural claim to be taken on as an apprentice by De Gheyn, perhaps on the recommendation of his brother-in-law, also a native of Brussels. De Baudous was born in 1575 and must have been taken on in the workshop as an apprentice, though at a far more youthful age than the Dolendos. His style of engraving displays far less schooling in the elegant technique which the Mannerists demanded, and which did not fail to produce its effect in Dolendo's print of *St. Cecilia*. De Baudous remained a useful assistant for a considerable time, and it is not at all unlikely that he produced most of the prints for the *Exercise of Arms* for De Gheyn, whose most important commission it was. After this he continued to collaborate closely with De Gheyn. Following in his master's footsteps he did, however, manage to develop into an independent designer, producing, amongst other items, the war reports and political prints for which there was such a great demand. In his own version of the *Pious family at table* his dependence on De Gheyn's design for the same theme may well be unmistakable, but in other prints he appears to disassociate himself from De Gheyn. To a greater extent than the other engravers mentioned previously, he had a preference for unembellished scenes of real life, and managed to do full justice to them.

After the publication of Van Mander's book, De Gheyn continued to make frequent use of engravers. Whether or not he trained them in this technique himself is, however, unknown.

In 1592 De Gheyn first produced a print of a drawing by Abraham Bloemaert. Bloemaert, a Utrecht painter, had purchased Amsterdam citizenship on October 31st, 1591, in order to marry

25. Zacharias Dolendo.
*Mount Calvary*.
Engraving. After
Jacques de Gheyn II.
Rijksprentenkabinet,
Amsterdam

Judith Schonenberg there on May 2nd, 1592. He was about the same age as De Gheyn and so productive a draughtsman that he was obliged to call upon a large number of engravers to help him distribute his 'inventions' by way of the press. His association with De Gheyn came to an end when the latter left Amsterdam after his marriage. Bloemaert, who did not form part of the same artistic environment as Goltzius, had also been unable at this time to rid himself entirely of Mannerist excesses, but he was in the process of styling his compositions and forms in accordance with an aesthetic ideal that French and Italian models must have revealed to him. To some extent he was more successful in this than Hendrick Goltzius, for whom contact with reality was to become of increasingly dominant importance. Bloemaert, however, was finally to arrive at a compromise where classical harmony and perfection in portrayal were victorious over a fortuitous fidelity to nature which appealed so much to the non-conforming. The 'beau faire', the deliberately and gracefully balanced subject treatment so uncharacteristic of the Northern Netherlander, was to remain with him permanently. During the years of Bloemaert's association with De Gheyn, his art was at a stage of development similar to that of the late-flourishing Francesco Vanni and Ventura Salimbeni of Siena. De Gheyn was consequently faced with something that was to exert great influence, not so much on his overall concepts, but rather on his technical skill and, we suspect, particularly on his treatment of washed pen-drawings.

Of the designs by A. Bloemaert that were engraved, the folio one for *Christ instructing the Jews* of 1592, the still extremely Manneristic *Miracle of the five Loaves* of 1592 (engraved in 1595), and the brilliant *Annunciation* of 1593 (engraved in 1599), may also be mentioned. The last two prints were put into circulation through the intermediary of Jacques Razet.

<div style="text-align: right">H. 331<br>H. 332<br>H. 329</div>

While in Amsterdam, perhaps shortly after the death of Dirck Barendsz in 1592, De Gheyn also engraved the former's older works *Daniel in the Lions' Den*[28] and *Diana and Actaeon*[29] which express a more complex concept of landscape and picturesque reality. This contact in particular must have compelled him to learn to overcome the automatisms of the engraving technique when working from pen-drawings; he would then be able to interpret with greater sensitivity the subtle shades of the watercolours and tonal washes on the drawings submitted to him.

<div style="text-align: right">H. 327, ill. 26;<br>H. 328</div>

At the same time, De Gheyn must have commissioned copper engravings of drawings of his own, such as the series of seven allegorical figures of women set in *tondi,* whose highly Manneristic concept I regard as typical of his Amsterdam period. Whoever translated the drawings into prints must have been one of his earliest apprentice engravers. The draughtsman appears to have delighted in exaggerated counterpoise, turns of the head, sausage-shaped hands with inorganically moving fingers, and particularly the uncoordinated movements of lappets, veils and folds without keeping within the limits of a disciplined style. Some of the distortions must be blamed on the anonymous apprentice who executed the prints. A comparison with drawings of a slightly later date indicates that the designs must have been considerably better than the result of their transfer to copper plates.

<div style="text-align: right">Cat. II 186-<br>192</div>

In 1593 De Gheyn got his first commission to immortalize one of Prince Maurice's feats of arms. The commission was given by the City and Board of Admiralty of Amsterdam[30], presumably because the subject was an exploit which took place partly on the water. The portrayal of land and sea battles could already be regarded as an ancient custom which had originated in several different environments. It was a sign of the times that in 1594 a commission of this kind in its grandest form, that is for a series of tapestries, was not given by a monarch, but by the city of Middelburg. When the Prince captured Groningen in the same year, the siege was barely commemorated in works of art because the city did not trouble to do so. It was therefore largely due to the civil authorities that hardly an event occurred at this time without a visual report ensuring that people at home could picture what was happening on the frontiers. Moreover, this kind of propaganda for his military

Bis fut obiectus (res mira) Leoinbus, Idem
Seruatus DANIEL tot fuit et vicibus

Corpora bina licet danata darentur ad escam
Quotidie et tot oues Turba pepercit q.   IHR   Bofcher. excu

26. Jacques de Gheyn II.
*Daniel in the Lion's Den.* Engraving. After Dirk Barendtsz.
Rijksprentenkabinet, Amsterdam

operations is unlikely to have displeased the Prince. In the long run it must have become increasingly clear to him and to the Government that pictures which were originally intended to serve merely as incidental reports would, in due course, make it possible to provide a complete illustrated record of historical events.

Cat. II 147     In accuracy and comprehensive detail, the *Siege of Geertruidenberg*, engraved by De Gheyn on two connecting copper plates, is superior to all previous work in this field. The city defences, approaches, and the two armies are shown on a map of the terrain re-measured by Baptista Beazio and seen from one side, which adds to its clarity. To give greater prominence to the city it was, quite unobtrusively, fitted into the map on a somewhat larger scale. There are a few captions, for example, inside the blockaded port, next to the unmanned ship which managed to achieve its purpose of letting the enemy waste ammunition on it. The river is represented with far greater subtlety than it was on older maps: the open water is indicated by small waves and the river Donge by a very fine layer of dots. De Gheyn had by then also become a competent designer of cartouches, coats of arms and letters.

36

In producing these works he was, as far as we know, entering a new field. However, one need only place his father's political prints of 1577 beside this large map to recognise the relationship. The figures and coats of arms included in the cartouche, as well as the view of the city and armies, were prefigured in those etchings. Later on, Jacques was also to practise birdseye perspective, but here the scene was viewed from one side and placed on a completely horizontal map. This must have involved a considerable amount of measuring and calculating, which appears to have been carried out most scrupulously. The print is consequently very good of its kind. Thanks to his precise nature, De Gheyn had in one stroke managed to acquire a new speciality. The records referring to this commission provide the first example we have of official remuneration on a scale that was far from inconsiderable. The Board of Admiralty of Amsterdam, which commissioned the work, rewarded the artist with 200 guilders for the copy they had received and for the one they were to present to Prince Maurice. The States General set aside 120 guilders and the Council of State 80 guilders as a remuneration for the dedications to them occurring on the prints. The Utrecht City Fathers presented De Gheyn with twelve pounds and his fellow artist Cornelis Ketel arranged for the city of Gouda to add another 54 guilders to this[31]. I mention these facts to show how highly valued such competent engraving was. The strenuous work involved certainly warranted it. At a later date, this may have resulted in the gradual substitution of the less laborious skill of etching, which, however, caused a sharp fall in prices! In this particular instance, the preparations had also required a carefully planned approach.

It seems likely that on this occasion De Gheyn was presented to the Count of Hohenlohe, if he had not already met him when engraving his first portrait. The Count was soon to become Prince Maurice's brother-in-law, and had played an important part in the siege. But it was not until after his marriage in 1595 that De Gheyn drew the extremely fine silverpoint drawing of the Count that I was able to identify at the Louvre, for it must have been accompanied originally by the portrait of his wife, as is stated on its verso.

Ill. 13

Cat. II 682, pl. 19

Shortly afterwards De Gheyn also came face to face with Prince Maurice himself. The Prince captured Groningen in the summer of 1594. On his return, a triumphal reception awaited him in Amsterdam. In lieu of the roses which had adorned the intradoses of the triumphal arches on the occasion of Leicester's departure in 1588, and which were now said to have wilted, gold stars set in a blue firmament made their appearance. There was an orange tree, and a stage, 60 feet wide, was erected on the Dam for the performance of a play or show about David. The 76-year-old Frans Volckertsz Coornhert, the brother of the poet, took the part of King Saul, and the 29-year-old Jacques de Gheyn that of David triumphing over Goliath. Was it actually a play, perhaps the one by Carel van Mander that is now lost, or an older folk-play? One might well imagine how, before taking part in an official performance by the Flemish Chamber, De Gheyn had already earned his spurs as a rhetorician under the direction of Van Mander. But the much later reports about the triumphal entry are too short to enable us to draw any such conclusion from them[32], and its oldest witness, J. Pontanus, even says that it was only a dumb-show — *stomspel*[33]. It was, however, customary during the seventeenth century to alternate plays with pantomimes. We do know that, in a quatrain, the poet H.L. Spieghel likened Maurice to Claudius Civilis, the first time this national hero and the biblical David were to find themselves cast together as the great forerunners in the good fight. Amsterdam was not to abandon the theme for another hundred years.

The portrait of the unknown man with a comet and a monogram in the margin, which the artist engraved in 1594, has not been satisfactorily explained so far; there is but little reason to suppose that George Clifford was in Holland at the time and posed for it[34]. I would rather identify him as Adriaan Metius, who had finished his study of astronomy with the Leyden professors and was now

Cat. II 697, ill. 27

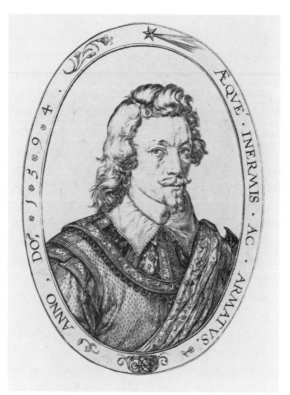

27. Jacques de Gheyn II.
*Portrait, probably of A. Metius.*
Engraving. Dated 1594.
Rijksprentenkabinet, Amsterdam

to travel to Denmark to work with the famous Tycho Brahe on Hven. Metius may have shown the latter his recent portrait and urged him to acquire one of himself from the skilful engraver. It may have been one of the last works De Gheyn produced in Amsterdam, or even his first in Leyden, for shortly afterwards he was to leave the former city, moving not to The Hague, as was deduced at one time from an incorrect reference to the entry of his admission to the Guild of St. Luke there[35], but first to Leyden. It may well be that he had reason to expect more work from the Government. Soon this was also to bring him into contact with the circles connected with Leyden University and the School of Engineering which, through the efforts of Maurice, was becoming increasingly involved in Government work. Or was De Gheyn already courting Eva Stalpaert van der Wiele, the Hague girl he was to marry the following year? The notice of his intended marriage to the aristocratic young lady shows that in 1595 he was living in the Molensteech in Amsterdam, but his fixed abode was at Haarlem. The contract was drawn up in Amsterdam on March 31st and at The Hague on April 1st[36]. It is possible that the young couple did not settle at Leyden straight away; De Gheyn was certainly living there by 1597.

There are not enough works that were definitely executed by De Gheyn during his Amsterdam years to enable us to make a precise assessment of his development prior to 1595. The dividing line between his Haarlem and Amsterdam periods is concealed from our view. It is evident, however, that he had gained great mastery in translating the designs of other artists into copper engravings. He was to carry on with this occupation for a few more years before gradually abandoning it altogether.

While in Amsterdam, De Gheyn had already lost his leanings towards the somewhat daring mythological fantasies so popular with the school of Goltzius. Biblical subjects continued to absorb him, but the predilection for allegorical scenes, the truly characteristic phenomenon of the age, was also gaining a hold on him. Since the days of Coornhert, the Rhetoricians' Guilds had certainly

stimulated the interest in allegory, to which Heemskerck had already devoted so much effort. Scarcely a print appeared without a moralizing title, preferably worded in Latin prose or verse. De Gheyn himself once wrote eight lines of Latin verse beneath a print, the large *Calvary,* as appears from the signature: *Pictor,* the draughtsman. Most poets practised some profession in addition to writing poetry, and the dividing line between professionals and dilettanti was but vaguely defined. Painters, on the other hand, liked to raise their status by mixing with the multilingual elite. De Gheyn was destined to be absorbed by it. The map of the *Siege of Geertruidenberg,* in a sense a *volte-face* to a totally different field, dictated by an existing situation, did not at all signify that he was seeking a purely craftsmanlike existence, however much he might excel at his work. His ambition to extend his endeavours to a wider and more contemporary terrain was to become abundantly clear in the years to come.

Ill. 25

At some time in the course of these years the example of Dirck Barendsz, who kept alive Titian's concept of landscape, is likely to have provided him with a stimulus for tackling this subject as well. Such a conclusion might, in any case, be drawn from the large drawing at Veste Coburg representing *the Temptation of Christ* in a spectacular, rocky landscape. There is, however, no evidence of a Titianesque concept here. As far as the trees are concerned, De Gheyn was still dependent on the last works executed by Goltzius before he set off on his travels[37]; he is likely to have found the rocks in the drawing by Dirck Barendsz, *Daniel in the Lions' Den,* or in Van Mander's *Apostles,* all engraved by himself, while the archipelago glimpsed through a break in the mountains was inspired by prints such as those based on works by Hendrick van Cleve, or distant views such as those by Hans Bol, whom he may have met in Amsterdam during the final years of the latter's life. Out of these three elements, De Gheyn, who had obviously never seen a mountain himself, independently built up a grandiose scene. The result could hardly be other than a highly unnatural fantasy. Against the horizontals of the bay with its many creeks and inlets, the rocky mountains present an absolute contrast of verticals. A middle distance of gently undulating hills is lacking. The rocks suggest the shapes of a high mountain range.

Cat. II 47, pl. 16

Ill. 26; ill. 23

Nevertheless, the ghostly, ever-receding peaks are highly arresting. The scene furthermore provides us with a valuable yardstick for measuring the artist's attempts at an increasingly faithful portrayal of the world around him during the following decades. His landscapes were to undergo a metamorphosis from eery hallucination to the countryside beyond the sand-dunes of South Holland, but he still had a very long way to go!

Even so, this particular sheet does show more than an independent skill in composing a fantastic landscape. The two masses forming the setting enclose a prospect firmly supported on the flat expanses of water. They are riveted together so cunningly, and the forms of the shadows are outlined so harshly in the foreground and so airily in the receding distance, that we are left without a shadow of doubt that the entire scene might conceivably be true. In entering this new phase in his life, De Gheyn was obviously equipped with a mastery of his material that was, in future, to enable him to convey to a spectator the full vigour of his extensive and fertile imagination.

# CHAPTER III

## *The Leyden years, the army and Hugo Grotius*

De Gheyn's young wife belonged to a large and prominent South Holland family whose members had held high office and contracted advantageous marriages ever since the fifteenth century[1]. Her grandmother, after whom Eva was named, was the daughter of Vincent van Mierop, nicknamed 'Big Vincent', the wealthy Treasurer of the Netherlands under Charles V, and also a great landowner; after his death, she occupied a house in the Lange Voorhout. Eva's parents, Jan Stalpaert van der Wiele and Elizabeth van Lambroeck, moved away from there in 1585 or 1586. Her father, however, remained an alderman at The Hague until 1588; he had been Burgomaster from 1584-85. As a Catholic he would have been unable to hold public office after that date, and he may well have settled in the country. At one time he lived in the Spuistraat next-door to Mr. Lenaert de Voocht, Pensionary of Delft, who, as we shall see, once drew up a deed for him. De Gheyn's marriage linked him to the aristocracy of South Holland and made him independent financially, if he was not so already. Ultimately, he had also to manage estates inherited by his wife. For himself this independence certainly meant happiness, as he could devote himself in future to the kind of work best suited to him. The reverse applies to his only son who, at an early age, appears to have expressed a desire to follow in his father's footsteps. There was no need for him to earn a living and his energies were gradually weakened until, with no obstacles to overcome, his talents finally faded or, in any case, failed to reach full maturity. This, at least, is the impression one gains from reading Constantijn Huyghens' account of him.

Cat. II 670, pl. 22

Cat. II 671, pl. 207

Cat. II 666, pl. 21

Two portraits may be assumed to represent Eva Stalpaert: one of them, a seated, full-length likeness, shows her modishly dressed and holding a flower that clearly points to her forthcoming marriage; in the other, a bust in an oval frame, she is wearing the same lace butterfly cap, except that here it does not cover the curly hair on her forehead; her head is framed in the same millstone ruff. It may have been drawn about 1602. De Gheyn is likely to have reciprocated by presenting his wife with a handsome likeness of himself and this is to be found in the Vienna portrait of a middle-aged man apparently observed in a convex mirror, and also wearing his best clothes, as we can see from the wide, elegantly folded ruff. The bride is an attractive young woman, but the look in the eye of the man expresses a determination and intensity that leaves us in no doubt as to his powers of imagination, his self-assurance and his pertinacity in pursuing any purpose on which he had set his mind. There was no reason for Eva Stalpaert to feel ashamed of her lover's appearance or of his qualities as a draughtsman.

Their only son, also called Jacques, was probably born in 1596. In his commentary on Van Mander's *Schilder-Boeck,* Jacobus de Jongh mentions being told that Jacques III was born at Haarlem[2]. There is no reference to this in the Haarlem Public Records, which is natural enough in view of the mother's Roman Catholicism; it was therefore assumed[3] that the event took place at

40

28. Jacques de Gheyn II. *Lottery Print* for the building of the Leyden Plague Hospital next to
the General Hospital and the Madhouse. Engraving. 1596. After I.N.van Swanenburgh.
Cabinet des Estampes, Bibliothèque Royale Albert I, Brussels

Leyden. I do not consider this altogether certain as De Gheyn's entry in the marriage register refers
to Haarlem as his fixed abode. In any case, the young couple was soon to settle at Leyden.

In 1595 it was decided to organise a lottery for rebuilding the hospital at Leyden. On October 1st,
Barth. Dolendo was paid 39 Guilders to do an engraving on two copper plates, showing the silver
prizes to be won. There do not appear to be any extant copies of this print. De Gheyn must have
been commissioned at the same time to engrave a view of the building on two copper plates; the   Ill. 28
Madhouse is shown on the left, and the building of the Pesthouse on the right; in between the two
we have a view into the main ward of the hospital which leads into the chapel, an arrangement that
can still be seen at Beaune. We should not, however, expect to find the actual buildings: the print is
more likely to be a fantasy to explain their function. The original drawings were by Isaac Nicolai
van Swanenburgh. The print was intended as a fundraiser, although apparently it was not complet-
ed until some time later. R.E.O.Ekkart found a unique copy at Brussels, and the relevant entry in
the Leyden accounts for 1596[4]. Swanenburgh was also Burgomaster of Leyden, where De Gheyn
may have gained a foothold through his wife's influence rather than through Dolendo, whom he
may well have introduced instead. We shall see how one of the burgomaster's sons was soon to
follow in De Gheyn's footsteps. At the same time, De Gheyn's relations with the Municipality
brought him into contact with the Town Clerk, the well-known author Jan van Hout, whose   Cat. II 684, ill. 29
portrait he also engraved in 1596[5].

Cat. II 112,
pl. 289
There exists a curious drawing of a gathering of people surrounding two boys seated on the ground in a landscape with dunes in the background, while one of the boys looks at an object partly buried in the sand. One of these people seems to be dressed in an old-fashioned habit. The explanations suggested hitherto, such as Job surrounded by his friends, do not fit, because Job was not a child when they commiserated with him. We should rather look in a different direction. There is a legend of an early martyr and saint Jeroen or Iero, whose body had been exhumed and brought solemnly to the Abbey of Egmond, but whose skull was missing. A long time afterwards the skull Ill. 117 was found and reunited with the body. In another drawing[6], we see the boy sitting in the same attitude and contemplating a skull which he holds in his hands. This almost seemed proof that I had caught the meaning of the drawing, for the lower jaw-bone of the skull is missing, and that was all that had been found previously along with the remains of the body. The event, moreover, took place at Noordwijk, where the Stalpaert family owned land later to become the property of Jacques III[7], and where the famous Janus Dousa was the local squire. De Gheyn may have been interested in the legend, and it is possible that at some time or other he was commissioned to illustrate part of the story for one of the Noordwijk buildings. It is difficult to give an approximate date for it. In general, his themes were not to be found in the past history of the Catholic faith.

There is a considerable amount of evidence referring to De Gheyn's relations with Leyden in the course of the following years, but the most spectacular occurrence was the fact that Hugo de Groot's first texts to appear in print consisted of verses written for engravings by De Gheyn[8]. Hugo de Groot, the child prodigy, had arrived in Leyden from Delft in 1594 and was lodging with Professor Franciscus Junius, the theologian. He had enrolled as a student at the university, and must have been well prepared after the early education given to him by his father, Johan de Groot. The latter, one of the university's first students, had been burgomaster of Delft for many years until 1595; in 1594 he was appointed to be one of the Governors of Leyden University, where his brother

29. Jacques de Gheyn II.
*Portrait of Jan van Hout.*
Engraving.
Teyler's Museum, Haarlem

42

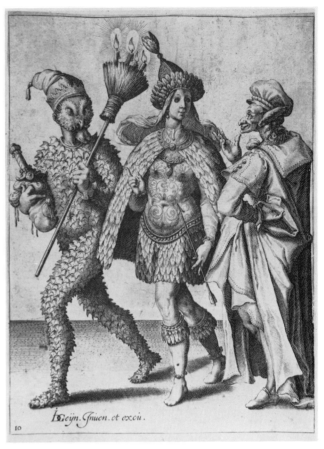

30. Jacques de Gheyn II. *Series of Mummers.*
Engraving. Second leaf.
Prentenkabinet, Leyden University

31. Jacques de Gheyn II. *Series of Mummers.*
Engraving. Tenth leaf.
Prentenkabinet, Leyden University

Cornelis, the jurist, was Rector when Hugo enrolled as a student. A small, oval silverpoint drawing by De Gheyn probably represents Johan de Groot. He was a man of science, a mathematician by profession, and was in touch with Ludolf van Collen and Simon Stevin, whose paths De Gheyn was also to cross shortly. De Gheyn probably met the young Hugo through Johan de Groot, or, with greater likelihood, through Wttenbogaert, then a minister at The Hague. The latter was a distant relative of De Gheyn and at one time was like a second father to young Hugo.

Cat. II 678, pl. 42

Young Grotius provided De Gheyn with Latin legends on four occasions before reaching his thirteenth birthday on April 10th, 1596; he signed them: *H. Grotius aet. 12.* One example referred to De Gheyn's work in publishing a series of designs by Carel van Mander which were engraved either by De Gheyn himself or by Zacharias Dolendo[9]. The *Conversion of St. Paul,* for which De Groot wrote eight lines of verse, was certainly engraved by De Gheyn, but again after a drawing by Van Mander. But the *Allegory of Vanity,* represented by a young woman gazing in a mirror, wearing a rustling dress, and accompanied by a lapdog and an impudent monkey, was De Gheyn's own invention. So was the series of *'Mummers'* for which his twelve-year-old friend wrote his intelligent verses. Perhaps the artist and young De Groot had been to some Leyden festivity where a number of students dressed up in grotesque clothes and masks and put on some kind of a show, an early example of the masquerades so popular at a later date[10]. Any connection with the festivities of the meeting of the Dutch chambers of rhetoric must be excluded because De Groot had just reached his thirteenth year when this pageant was held in Leyden. For it is only the signature to the texts, *i.e.*

H. 395

Cat. II 209

Cat. II 605-614, ill. 30-31

43

*Hug. Grotius Aetat.XII* that enables us to date these prints so accurately. Although the series of mummers still suggests a later Mannerist artist, this is due to the subject-matter, droll costumes and dancing movements, rather than to the style in which they were executed. I think they must accurately represent the costumes and movements, if they were not, in fact, costume designs. De Gheyn dedicated this series to Cornelis van Bleyenburgh, a member of the prominent Dordrecht family and a distant cousin of Eva Stalpaert, who was also his patron on other occasions.

From now onwards, De Gheyn's collaboration with Hugo de Groot remained on a permanent basis. The latter was constantly writing quatrains or short texts in pungent Latin which add an explanation or a moral to a scene, or accompany a portrait. We can even tell how the legends were incorporated: the artist passed on his drawing to De Groot, who filled in the texts. There is proof of this in the folio-size design of 1599, now in London, for an allegory, in many parts, on the transience of all things. Here the legends that were to accompany the engraved prints are written in De Groot's familiar handwriting. Ultimately, De Groot was also to make use of De Gheyn's burin for his own writings. When, at the age of fifteen, he returned from Van Oldenbarnevelt's mission to Henry IV of France, he had his own portrait drawn and added it to that of the young Prince of Condé in the prelims for his edition of Martianus Capella's *Satyricon*, published in 1599. The drawings for these two prints have also been preserved. What strikes us in the portrait of the youth holding up the small pendant on a chain given to him by Henry IV[11], is how closely the entire concept approaches that of Goltzius in his small silverpoint portraits[12]. De Gheyn must have been given a copy by Jozef Texera of a French miniature portrait of the Prince of Condé when working on his likeness. I found the original from which Texera worked, at Chantilly.

(margin) Cat. II 204, pl. 78

(margin) Cat. II 677, pl. 61
Cat. II 658, pl. 60

(margin) Ill. 32

32. Anonymous French miniaturist.
*Portrait of Henry II, Prince of Condé.* Miniature.
A copy of this miniature was to provide
De Gheyn with a model.
Musée Condé, Chantilly

33. Jacques de Gheyn II. *The Four Seasons.*
Engraving. One of the illustrations
for *Syntagma Arateorum* by H. Grotius,
published in 1600

44

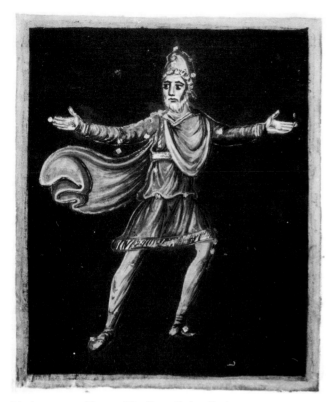

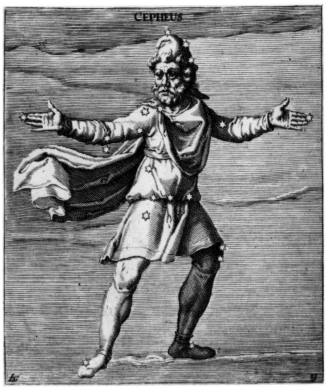

34. Anonymous Master. *The Constellation Cepheus.*
Miniature in ms. Voss. lat. 9.79., fol. 26 v°.
Universiteits-Bibliotheek, Leyden

35. Jacques de Gheyn II. *The Constellation Cepheus.*
Copied from the miniature (ill. 34) for the *Syntagma Arateorum*
published by Grotius in 1600

Hugo de Groot did not leave it at this. For his edition, with critical comments, of the *Syntagma* <span style="float:right">Ill. 33-35</span>
*Arateorum* he asked De Gheyn to produce engravings of the constellations as they appeared in the <span style="float:right">Cat. II 231-274,</span>
brightly coloured illuminations of the late-Carolingian manuscript, now at Leyden. It was only <span style="float:right">pl. 84</span>
natural that in translating these fairly primitive, highly coloured IXth century derivations of
ancient models into black and white, De Gheyn should embellish them to suit his own taste, but, in
doing so, his main purpose seems to have been to clarify them for the benefit of the reader and De
Groot is sure to have been pleased. De Gheyn and Grotius' final joint enterprise, the *Land-yacht,*
will be discussed later.

Through his contacts with Grotius, De Gheyn was drawn into a privileged circle differing from
that of the Rhetoricians. It was an ambitious one where Latin, if not actually spoken, was usually
written in a profusion of adaptations to the modern world, and wittingly at that, while its aims were
the pursuit of all kinds of human knowledge. De Gheyn was probably taught Latin at school and,
as we have seen, he himself once wrote the Latin text for one of his prints[13]. At this time, people
sometimes learned Latin later in life; this happened in the case of Cornelis Drebbel, who taught
himself[14].

De Gheyn's dealings with young De Groot were not his sole contacts with the University. His
first activities in connection with the anatomy lectures may have been due to Professor Pauw, for
whom he made pictures of abortions that had taken place in 1596-98. These drawings were long dis- <span style="float:right">Cat. II 811</span>
played for scientific purposes in the theatrum anatomicum, but they are now lost. It was not until a
much later date that he was to immortalise an anatomical demonstration by Professor Pauw. In <span style="float:right">Cat. II 154</span>
1596, De Gheyn also came into contact with the mathematician Ludolf van Collen, who partly

Cat. II 657, pl. 44 owed his fame to his accurate calculation of π. He drew the latter's portrait with appropriate accessories to illustrate one of his treatises. The drawing has been preserved.

The precision with which these early commissions were executed was certainly suited to the requirements of his patrons and their specific branches of science. It was, in fact, only one facet of De Gheyn's talents; if a task required more imagination, he could provide that as well, and in some instances to such an extent that, ultimately, there was no one to rival him. But his powers of imagination were only to develop as a result of his increasing facility in exploring reality with a sure and versatile hand.

De Gheyn must also have kept in touch with the rhetoricians at Leyden. In the festival year 1596 Cat. II 229 he engraved, for their chamber, the emblem and legend 'Love is the Foundation' which was intended to be printed above the rules and regulations. The escutcheon shows the copper snake upright in between columbines; the ornamental frame is crowned by the seated figure of the Lady Rhetorica. Cat. II 230, ill. 35a Another small emblem has *nosce te ipsum* above the World in a fool's cap.

De Gheyn is bound to have met his compatriot Jonkheer Jacob Duym who in 1590 had founded the Flemish chamber *d'Oraigne Lelie* of which he became 'Emperor' in 1591. Duym, an acquaintance of Carel van Mander, was also on friendly terms with a number of the young university's Cat. II 661 coryphaei. Later, in 1600, De Gheyn engraved the portrait of this writer who had recovered but slowly from his imprisonment at Antwerp, as one can tell by the lines on his face: it is the appealing countenance of one who has suffered deeply. It may have been in 1596 that De Gheyn asked him Cat. II 219, ill. 36 for two short poems to print below the picture of two fools performing in the Chamber, each one with his bauble. The poems are definitely initialled *I.D.* A bill for work executed for the Chamber *Liefde ist Fondament* shows that the commissions were carried out in that year, when the various chambers were to assemble at Leyden[15]. When we see Van Mander treating the same subject in a Ill. 37 totally different manner a year later—in a drawing at Leyden showing two putti, each with his 'bauble', seated beside the fool's cap and including a legend dated 1597 and written by Van Mander himself—we can understand how the themes sometimes followed each other as in a conversation with questions and answers. As in so many letters between humanists, these sequences of statement and counter-statement held an element of play; a feature to which Erasmus had certainly given lasting publicity in our country, but which, to whatever circle it is limited, is in fact closely related to the essence of every civilization. It took the form of a "Challenge and Response" which Professor T.S. Kuhn has analysed as having so frequently been fruitful for the advancement of knowledge, and which also appears to have featured prominently in the development of art.

35a. Jacques de Gheyn II. *The World in a Fool's Cap.* Engraving. Produced for the Leyden rhetoricians on the occasion of a meeting of rhetoricians from various towns, which was held in Leyden in 1596. Municipal Archives, Leyden

36. (After) Jacques
de Gheyn II. *Two Fools,*
one of them avid for money,
the other for love.
Engraving. 1596.
Issued for that year's
Leyden pageant.
Printroom, British Museum,
London

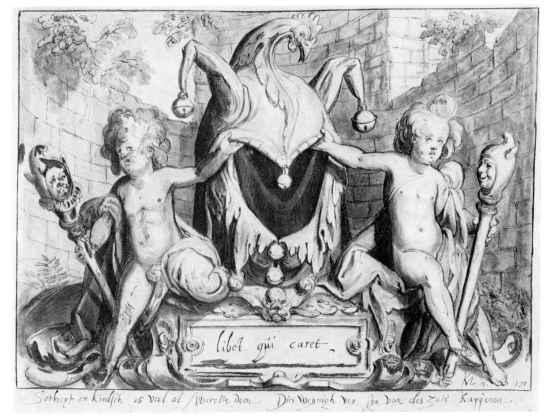

37. Carel van Mander.
*Cartouche with a Fool's Cap
held by two Putti.*
Drawing. 1597.
Prentenkabinet,
Leyden University

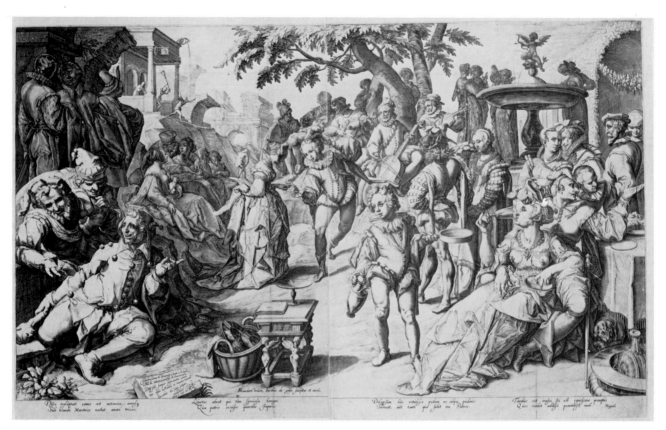

38. Jacques de Gheyn II. *The Prodigal Son*. Engraving. 1596. Large print dedicated to the Count of Solms.
After Carel van Mander. Rijksprentenkabinet, Amsterdam

It is more than apparent that once established in Leyden, De Gheyn was overwhelmed with commissions of an extremely varied nature. In his work as a reproductive engraver, he continued to assist Carel van Mander for the greatest length of time. One may see in this the proof that the ties linking him with his compatriot had always been based on an affinity of character and interests greater than those with his actual teacher, Goltzius, whom he had always striven to surpass, the natural attitude of a pupil towards his master. Goltzius had undoubtedly stimulated De Gheyn's ambition and sense of responsibility and had taught him the perfect craftmanship that was to benefit him all his life. In Van Mander, with his talent for improvisation, De Gheyn is likely to have found an older friend with whom frank discussion was easier and whose erudition never took the form of pedantry, but simply inspired him ever to explore new fields. In 1596 Van Mander passed him a

H. 410, ill. 38

folio-size drawing to engrave: it shows the *Prodigal Son* squandering his goods at a feast, a lively scene which at a later date may have led to the painting of outdoor revelries by Haarlem artists. There is only Hogerbeets' legend to warn the viewer that spendthrifts and sinners come to a bad end. De Gheyn dedicated the print to the Count of Solms, Lord of Müntzenbergh and Sonnewalt, not to be confused with Frederick Henry's father-in-law who was a Count of Solms-Braunfels.

If we read this print correctly, its message was intended not so much to dissuade the young from merry-making, as to install in them the concept of 'moderation in all things', and to point out to anyone ensnared by the whiles of a seductive meretrix, the great compassion shown by the Father to the repentant sinner. Are we not dealing with the period when Hendrick Laurensz Spieghel was writing his *Lof van Danssen* (In praise of Dancing)[16]? The seeming ambivalence apparent in so many themes of this era cannot, in my opinion, be explained in any other way. Merry-making was

48

inevitable in a victorious country where a *Wirtschaftswunder* was taking place. Nor was it necessary to shun it. But where painters invited the senses to take pleasure in human intercourse and in Nature, a word of warning frequently continued to accompany the appeal, either overtly or couched in symbolic language. In feasting one might well see humanity prior to the Flood, or the Prodigal Son[17]; the flower might point to its future fading, but final salvation was still conditioned by the attitude towards the transient that one adopted. Coornhert had also argued thus, albeit in more stringent terms. A next phase in Dutch art was to leave the moral lesson entirely to the man in the pulpit and to confine itself to the portrayal of the visible world. But to return to our starting-point, did not the *fêtes champêtres* that artists such as Buytewech, Frans and Dirck Hals made so popular at Haarlem, spring from this prototype by Van Mander and De Gheyn, even though the latter might still point to a distinct moral?

Thanks to Goltzius, a new phenomenon and fresh exchanges within the trio Goltzius-Van Mander-De Gheyn were to occur at this same time. In 1593 and 1594, the great Haarlem engraver had amazed the world with his folio-size imitations of old Masters, Dürer and Lucas van Leyden in particular. His *Circumcision* in the style of Dürer had, so Van Mander tells us[18], led a number of connoisseurs to believe they had discovered a hitherto unknown print by the German master.

Particularly amongst graphic artists, an intensified desire to emulate the Old Masters followed, and to this we owe the engraving of two 'small Passions' similar to those once produced by Dürer and Lucas. The one by Dürer had been outstanding because of its impeccable technical competence; the one by Lucas was notable for its realistic characterization and the delicacy of the burin. At the request of De Gheyn, who was to publish it, Van Mander started drawing his series in 1596. Hugo de Groot himself wrote the texts on the design for the title-page[19]. Nine of the designs were engraved by Zacharias Dolendo, the title and remaining three illustrations by De Gheyn. Goltzius started the same year, but finished later, producing both the drawings and engravings; at least, he signed the latter with his monogram[20]. The final verdict must, I think, favour Goltzius. Lucas van Leyden's example, already recalled by Van Mander, did not prevent him from presenting a new and dramatic rendering of the Passion in clearly arranged scenes and with a wealth of striking detail. In Van Mander's version, clarity is frequently lost in over-complex scenes and fussy architecture. There, however, the engravers' burins were ground to an even finer point than Goltzius', presumably so as to equal those of Lucas and the Wiericx brothers. To appreciate the results of this technique fully, it is essential to examine early prints, as later impressions have lost all their forcefulness. The near-simultaneous publication of the two series is symptomatic of the period when it occurred: these years were characterized by a general revival of interest in the northern masters of the past era, who were diligently copied, leaving their mark on the drawings and engravings of the period.

Around this time De Gheyn may also have drawn a deceptive copy of Lucas' small print of *St. Christopher*. It is particularly remarkable in that Jacques, though working from a print, came very close to Lucas' technique of drawing. We must conclude therefore that De Gheyn was as familiar with Lucas van Leyden's pen-drawings as he was with his prints, unless he worked from Lucas' original drawing. It is possible that he put on the market a small print of his own drawing[21], but I prefer to consider that to be by another hand. On more than one future occasion he made pen-copies of works by Dürer, Lucas van Leyden and others, in an attempt to gain an even greater mastery of the secrets of their art. The *Passions* by Goltzius and Van Mander also cast a clear light on the element of competition that dominated the development of art. It was certainly not alien to De Gheyn. Schrevelius was to write the following character sketch[22]: 'Jacob de Ghein raised his head amongst the Disciples of Goltzius, a young man of *generous temperament* and industrious spirit

H. 390, ill. 40

Ill. 39

Cat. II 1044, pl. 37

Cat. II 1034-1043, pl. 33-36, 374

*who could ill tolerate anyone outshining him.* He made many things of his own invention, well in advance of his years, and published the same, *so that there was always emulation between pupil and master,* but the one to have been more moral was Johan van Saenredam!' (our *italics*) In the course of this narrative, we shall repeatedly come across instances of De Gheyn's 'generous temperament', but also of his fierce ambition.

Cat. II 177-185, pl. 25-32

His most ambitious scheme in the highly productive[23] year 1596 consisted of the independent designs for a series of allegorical figures whose purport was presumably based on an idea by De Groot. The texts, in any case, are from his pen, and express a concept of world history that De Gheyn would scarcely have been capable of devising. I suspect they suggested themselves to De Groot as a result of his reading Petrarch's *Trionfi*. The concept, at least, lends itself to a comparison with the once famous poem. It is conceivable that the eight plates entitled *Omnium rerum vicissitudo est (Transience)* series owe their origins to an awareness that the country was doing extremely well and that Hollanders could afford to indulge in luxury. It would have been natural to conclude in the spirit of Coornhert: 'Keep to the path of Virtue lest you fare otherwise'. On the contrary, however, a kind of fatalism seems to prevail in this series, suggesting that throughout history, times of prosperity and peace have alternated more or less regularly with periods of war and

39. H. Goltzius. *The Road to Calvary.*
Engraving, after his own design. Not later than 1598.
Rijksprentenkabinet, Amsterdam

40. Jacques de Gheyn II. *The Road to Calvary.*
Engraving, after C. van Mander. Probably 1596.
Rijksprentenkabinet, Amsterdam

50

41. Jacques Laudun I. *'Terra', the Rabbit Shooter.*
After a print by Jacques de Gheyn II. Enamel plaque (cf. cat. II 175).
Musée des Beaux-Arts, Orléans (inv. n. 6343)

42. Zacharias Dolendo. *Fortuna.*
Engraving. After Jacques de Gheyn II.
Rijksprentenkabinet, Amsterdam

misery, so that the conclusion to be drawn is one of a recurrent cycle of events. Fortune results in Prosperity, Prosperity brings forth Pride, Pride arouses Envy, Envy is followed by War. War leads to Poverty, Poverty to Faith and Faith to Peace. This rounds off the cycle, for Peace, in turn, produces Fortune. In similar style, Petrarch had let Man be conquered by Amor, Amor by Virtue, Virtue by Death, Death by Fame, Fame by Time and Time by God's Eternity.

Ill. 42

The cycle may vary, but the system whereby one situation is conditional upon another is similar, and the prints cannot, therefore, be understood outside the context in which they appear. De Gheyn was following a literary and philosophical concept that De Groot may have adopted at a very early age.

In the course of the same year, De Gheyn also drew a series of *The four Temperaments* (or, alternatively *Elements*) and had these engraved as well. Only one drawing for this series is known, but I have been able to trace all but one of the preliminary studies for the *Transience* series. It is, therefore, now possible to form an accurate idea of the style of drawing prevailing in 1596.

Cat. II 193-196, pl. 46

Personifications of concepts are not usually shown as figures standing at ease. It is true that in the early Middle Ages Virtues and Vices had been inspired by the warring figures in Prudentius' poem, but in the Renaissance they had been converted into female types recognisable only by their attributes.

The remarkable thing about De Gheyn's representations is that he wholly identified the figure personifying the concept with the role allotted to it. *Pride* does not merely hold up the traditional

Cat. II 179, pl. 27

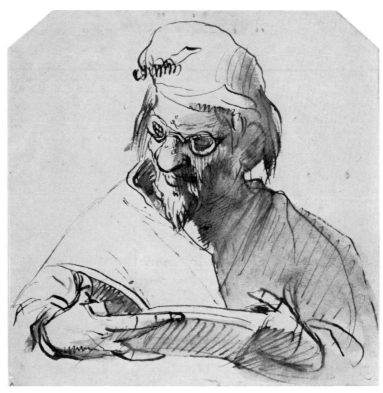

43. C. van Mander. *A couple Conversing*. Drawing. Stichting P. en N. de Boer, Amsterdam

44. C. van Mander. *A Fool Reading*. Drawing. This rapid sketch shows Van Mander's skill in grasping the essentials of a subject. Hessisches Landesmuseum, Darmstadt

Cat. II 181, pl. 29

Cat. II 180, pl. 28

looking-glass, she also moves like a lady in elegant apparel, lifting her overskirt to show off her sumptuously decorated petticoat, whilst glancing contemptuously over her shoulder. *War* is an ardent warrior with raised shield, drawn sword and swirling cloak, reminding us of the Haarlem officers. The artist, however, achieved the ultimate in expressiveness in *Jealousy,* who is portrayed as a running, half-naked megaera devouring a heart, her head wreathed in snakes instead of in hair, and holding a writhing snake in her left hand[24]. Here, for the first time, De Gheyn developed the dramatic force so prominent in his master-drawings of a later date. By setting off the violently illuminated figure against the dark smoke in the background, and by including a few distant, small-scale groups of quarrelling people to make her form appear inordinately large, he created a character whose horrific behaviour overwhelms us.

Ill. 43, 44

Following Van Mander's example, De Gheyn used pen and brush to produce this kind of drawing, but in the rendering of sculptural form he now surpassed Van Mander. Placing their drawings side by side, one is struck less by the difference in generation, than by the disparity in their powers of portrayal. De Gheyn did not rest until he had gained such a thorough understanding of the human form and its apparel that their structure had no further secrets for him. From being an interpreter of reality as seen by others, he had become a perfect translator of reality itself. The slight nonchalance characteristic of Van Mander's drawings was totally alien to him. His undeniable mastership dates from 1596.

In 1597, the authorities again showed interest in his work, the fortunes of war and increasing prosperity making it easier for them to employ artists and pay them a proper fee. Maurice had gained a Victory at Turnhout which, like the Siege of Geertruidenberg, was to be immortalised by De

Cat. II 148

Gheyn. This time, however, he did not follow prevailing custom by projecting the scene on to a map of the country; instead, he placed the moving troops in an elongated, hilly landscape that was divided into two parts and was seen from a high, imaginary viewpoint. Each time he received a commission, he endeavoured to achieve a more vivid portrayal of an actual situation. He managed, nevertheless, to depict the troops individually, clearly following an accurate account by the army command. Grotius was not slow in writing a commemorative poem, a chronostichon, which was printed in its entirety on the engraving. De Gheyn was rewarded by the States General, to which the work was dedicated, the States of West Frisia, and the city of Leyden, but the initiative may have been due to the Count of Hohenlohe, who had played such an important part in the victory. His copy of the print remained in the possession of the Hohenlohe family until 1933, when it was sold at Leipzig[25]. Perhaps it was on this occasion that De Gheyn drew Hohenlohe's carefully executed silverpoint drawing now in the Louvre, one of the most spirited of his existing portraits. It cannot antedate 1595, the year of his marriage to Maria van Buren, daughter of William the Silent, because originally it must have been accompanied by her portrait, which has since been lost.

Cat. II 682, pl. 19

The print of the *Battle of Turnhout,* where the Spanish troops were surprised and put to flight, appears to have been highly successful: in 1598 it was still on view at the *Binnenhof* in the Hague along with the thirty-seven standards captured from the Spanish during this adventure. Buchelius saw them displayed there when he visited the town with his kinsman Vorstius[26], and he expressed his admiration for De Gheyn, who had depicted 'the battle, or rather the rout of the enemy' *verissime* on the copper plate. The year before, in December 1597, the presence of the captured standards was reported, in primitive Latin, in the diary of Philip von Hainhofer[27], a traveller from Augsburg, who had been fortunate enough to see the Prince in person, *vidi suam Excellentiam, sc. comitem Mauritium egredere equorum stabulo, in more nam habet singulis matutinis horis videre equos, et astare quando domantur et id usque ad 11 horam. illo egrediente sequebatur plurima turba ex equitibus, comitibus, baronibus et nobilibus. Homo est iusta statura, sub rubra barba, hilaris vultus, occreatus* (sic) *incessabat, calcaribus deauratis. Ex adverso pallatij sed transitus per pall. Ibi pendent signa adversarij, quae com. Maur: illi in bello desumpsit et abripuit.* (I saw His Excellency, viz. Prince Maurice, leaving the riding-school, for he is wont to inspect his horses for several hours in the morning and to remain there while they are being trained and this goes on until 11 o'clock. When he came out he was followed by a host of cavaliers, counts, barons and nobles. He is a man of fair stature, with a cheerful expression on his face which is covered with a red beard, and he strode along in top-boots with gilt spurs. From the side opposite the palace he passed through the palace courtyard. There hang the standards of his adversary, which Prince Maurice won and snatched from him.) Von Hainhofer then continues, this time in his native language, *Den 20 Augusti* [1598], *am Donnerstag haben wir gesehen alles fues volckh ins feldt ziehen mit fliegenden fähnlein in der schlacht ordnung, ist ihr excellenz, mit graff wilhelm (so gubernator in frieszlandt ist) und mit graf johan, (der in deutschlandt wohnt) auch rausz khomen da haben sie sich auf allerley weiz mussen uben, sich kehren und wenden, von und zu einander lauffen, schiessen und stechen, als wan sie den feindt vor ihn hatten, gar lustig und schon zu sehen gwest, hats dan der Capitein nit recht gemacht oder gewisen, so hat ihms ihr excellenz under sagt, und anderst zeigt... Ihr Excellenz und alle mit einander am hoff reden vast nur frannzosz...* (On August 20th [1598] on Thursday, we saw all the foot-soldiers march into the field with colours flying, in battle array, His Excellency, Count Wilhelm (who is the Governor of Friesland) and Count Johan (who lives in Germany) came as well. They then had to drill in all kinds of ways, turning and about-turning, marching towards and away from each other, shooting and handling pikes, as if they were facing the enemy, all very delightful and fine to see; when the Captain did anything wrong or gave the wrong

order, His Excellency interrupted him and showed him how to do better... His Excellency and all those at Court speak French almost without exception.)

On another occasion he says that His Excellency's pleasure garden, his *viridarium,* is well worth a visit.

After visiting Scheveningen on some other day Hainhofer mentioned that he had seen, in the church, a waggon three times as long as an ordinary one, 'into which His Excellency ascends with gentlemen who are his guests when there is a strong wind. It has huge wheels and a pinewood mast as tall as a house on to which to hoist the sail, and it is steered like a ship. Its speed is twice that of a horse. It usually stands dismantled in the church and whenever His Excellency so wishes it is assembled and driven to the sea-shore. At The Hague there is another waggon for the same purpose, but that one can be occupied by three people only'.

Not only is this the first mention we have of Simon Stevin's famous land-yacht, which must have been built some years previously, but when reading Hainhofer's other comments one is inevitably reminded of De Gheyn's various works for Count (later Prince) Maurice. Soon the two men were, in a sense, to be driven towards each other in all the fields to which Hainhofer himself was so greatly attracted.

For it was not long before the army command came to regard De Gheyn as an engraver after its own heart. In 1598, Count John II of Nassau, cousin to Prince Maurice, spent some time in the Netherlands where he had lengthy discussions with his brother William Louis and Maurice about military science in general, siege methods, and improvements in drill. In their youth the three cousins had been educated together at Dillenburg and Heidelberg, Count John being the one who was most interested in the theoretical aspects of the subject, on which he was compiling extensive documentation[28]. It was he who conceived the idea of publishing a book devoted to the cavalry and infantry of the States' army, and Jacques de Gheyn was commissioned to produce it. The cavalry series was published in an oblong format in 1599, and was particularly notable for its survey of the arms in use at the time. The portrayal of the three corps of foot-soldiers, consisting of musketeers, marksmen armed with hand-guns, and lansquenets, had a further purpose. All positions and manual holds used in drilling were to be shown in separate illustrations, in order to provide a complete drill manual. To judge partly by the style of the drawings, the book was completed shortly after the cavalry series, that is to say, the illustrations were drawn by De Gheyn, and engraved either by himself or by one or more of the engravers employed in his workshop. Prince Maurice and Count William Louis delayed its publication for years so as to prevent the enemy taking advantage of the information it contained[29]. The first edition appeared in 1607/1608 with texts in French, German, English and Danish as well as in Dutch, and was followed by other new but less handsome editions. The book became De Gheyn's most popular work and we find reminders of it in Delft tiles and wherever it was thought necessary to depict soldiers in action, right down to the most recent picture-books used in school history lessons. It must have provided him with a considerable income for many years.

A large number of the original designs for the two series have been traced. The commission was essentially factual and laborious, but not for one instant did De Gheyn lose patience or become untrue to his artistic nature.

Drawing horsemen was hardly an insuperable task for him; nevertheless, he is likely to have looked around for useful models. He probably found the majority in prints, particularly amongst the works of Dürer and his German contemporaries and imitators — for example Burgkmair — or amongst those of Jacob Cornelisz and Jan Swart. It is impossible to determine whether he was already familiar with the works of Tempesta at this time, but I do not consider it likely. He would,

Cat. II 300-321, pl. 63-70

Cat. II 342-464, pl. 85-155

of course, have had an opportunity to study the cavalry's actual equipment at The Hague. I think it is probable that the four extremely meritorious busts of trumpeters were derived from his cavalry portraits. There may have been five of them originally. Similar trumpeters wearing soft hats, and with rectangular banners suspended from their instruments, made their appearance in the final print of the cavalry series. However, the separate studies are rendered far more freely, as if they were the result of much preliminary work. In the decorative washes of the shadowed sections De Gheyn finally achieved an astounding directness and virtuosity, closely emulating Van Mander's more rapid sketches.

Cat. II
646-650,
pl. 72-75

For the *Exercise of Arms,* the drill manual, he must have used a manuscript which remained in Holland and is now in the Koninklijke Bibliotheek. Some rather primitive pictures have been added and apparently served as prototypes for his far more carefully executed figures[30]. But Huyghens tells us that Captain Pierre du Moulin, the same officer who was shortly to instruct him and his brother in gymnastics, posed for De Gheyn to show him the various movements and positions.

Ill. 45, 46

Another drawing may belong to the years when the cavalry series was being produced: M. Curtius on horseback sacrificing his life by jumping into the pit in the Forum Romanum to save Rome from the pestilent vapours which issued from it and for a long time mortally infected the population. An oracle had proclaimed that the plague would be stopped by the sacrifice of a single person. After M. Curtius had disappeared it did in fact cease instantly. The style of this highly inspired drawing, paraphrased still more wildly on its verso with a broad pen, is decidedly flamboyant. This flash of recklessness is best explained if we consider that it was De Gheyn's spell of concentration on the movements of a horse which allowed him to render, with such obvious ease, the ultimate of its energy in the final leap.

Cat. II 141,
pl. 55, 56

We have seen how, over the years, De Gheyn changed his attitude towards his occupation as an engraver. He had been trained as an engraver and had set up in business as one. Apart from the small portraits which he had successfully engraved from his own precise drawings, he worked mainly from designs by other artists. The first prints based on his own drawings aroused few expectations; as a designer he was still awkward and lacking in originality, but copying the works of other artists eventually increased his own powers of imagination. As commissions became more frequent, he trained assistants to do the work of engraving and made increasing use of them, while he confined himself more to design work. Once in a position to finance the expanding business from his own resources, he continued publishing series of prints engraved in his workshop and drawn by himself, and also entire books, like the military series and among them, as already said, the cavalry series[31]. He could hardly have managed otherwise: for the *Exercise of Arms* he had to produce well over a hundred finished drawings, which must have entailed at least a year's patient and somewhat monotonous work. It is easy to understand that ultimately he would only handle the burin himself in exceptional circumstances.

In addition to this, the difference between the technique of engraving and the possibilities inherent in the art of drawing became increasingly apparent. It is true that when using a silverpoint or a pen, a trained engraver never quite rids himself of the technical effects resulting from long years of working with the burin. Goltzius, for example, retained the engraving line in his pen-drawings, but usually managed to rid himself of it when using other techniques, although there are exceptions to this rule. De Gheyn's case is somewhat similar, although he succeeded in guiding his pen with increasing freedom and adapting it to the situation to be portrayed. Another graphic technique, etching, was beginning to gain ground, and appeared more appropriate to some commissions than the use of the burin. De Gheyn employed it but rarely, although his efforts received special praise from Huyghens[32]. In 1598 he produced his first signed etching of a drawing by Pieter Bruegel

45. Anonymous Draughtsman.
*A Soldier with a Lance.*
From a manuscript in the
Koninklijke Bibliotheek,
The Hague

56

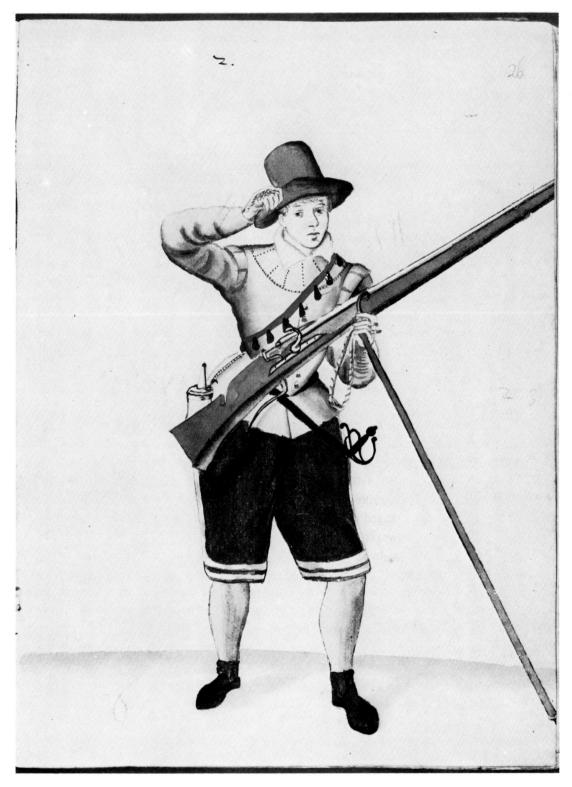

46. Anonymous Draughtsman.
*A Musqueteer.*
From a manuscript in the
Koninklijke Bibliotheek,
The Hague

dating from 1561 and now in Berlin[33]. The etching showing the Pilgrims to Emmaus which, according to Huyghens, opened Claes Jansz Visscher's eyes to this technique, has not, as yet, been traced[34]. However, the engraving technique itself did allow a number of variations. It is impossible to tell whether some prints of this period are in fact engravings or etchings. The folio-size *Plan of The Hague,* completed in 1598, so much resembles an etching that we might believe it to be one, were it not that De Gheyn had been commissioned to 'cut' it[35].

This plan was preceded in 1597 by the one of Schiedam. Wishing to present a graphic picture of the town as well as information about the street layout, De Gheyn decided to produce a bird's-eye view of the plan and a side-view of the town on one plate, and this was added, as a folding illustration, to a description of the Netherlands by Jean François le Petit. He could limit the town plan to what lay within its moats and ramparts, but in the streets each house is registered and clearly visible. The view of the town is enlivened by ships sailing on the Maas in the foreground, and by the mills, meadows and further surroundings with the houses, tall church and ships' pennants standing out against them.

In the case of the *Plan of The Hague,* De Gheyn provided a masterly solution to the problem of how to combine full information with maximum clarity. The commission must have been discussed in 1597, as the armorial bearings are those of the burgomasters in office that year; it was finally given to De Gheyn on January 7th, 1598, and he received 200 guilders for it the same year[36]. This print was also intended to serve as an illustration to a chronicle, but it was never used and in fact it was never completed as the cartouches were not filled in. But Hugo de Groot wrote a 12-line Latin poem for it: 'I, The Hague, now live immortalised by the hand of De Gheyn, and can henceforth withstand the vicissitudes of Fate'.

The Hague had never been fortified, but merged somewhat haphazardly into the countryside. There was therefore no question of any clear-cut demarcation such as had been possible in the case of the Schiedam map, where the city was enclosed by its walls. The bird's-eye view had to be cut off by the frame of the plate, which in itself furthered the suggestion of reality. Extending around Binnenhof, Buitenhof and the Jacobskerk, the comparatively few streets, showing each house as seen from the South, gradually changed into country roads, with canals running between meadows and farmsteads. At this point, however, De Gheyn resorted to an artifice. On a rise in the foreground, he placed a number of passers-by, some of them acting out a lawsuit, a gentleman on horseback and several dogs, all in very natural attitudes. They were, however, seen from one side instead of from a bird's-eye viewpoint, and were thus outlined against the plan which is, as it were, pushed into the distance as a result. This highly efficient device had already been employed by Joris Hoefnagel, but it was dramatised by De Gheyn. The elegant young couple sauntering in the foreground probably represent De Gheyn and his wife. These small-scale figures clearly introduce a new phase: they are contemporaries and no longer characters taken from books. The last traces of Haarlem Mannerism, still perceptible in the 'Transience' series, had been completely eliminated by 1598. Together with the *Exercise of Arms* which had restricted the artist to the portrayal of real attitudes, the plan of The Hague introduced a new era. It also became one of the prototypes for the famous town maps in the *Toonneel der Steden* by Joan Blaeu. The engraving technique is characterised by great sobriety: it lacks the swelling and emphasis of the customary engraved line and owes some of its successful effect to the stippling with small strokes which approaches a tone-creating *pointillé.*

These changes in technique naturally had a deeper cause. Their aim was to evoke reality with ever-increasing competence. One step further would mean the transition from drawing to painting, and De Gheyn was soon to take it, almost at the same time as Goltzius did. But we shall deal with this later.

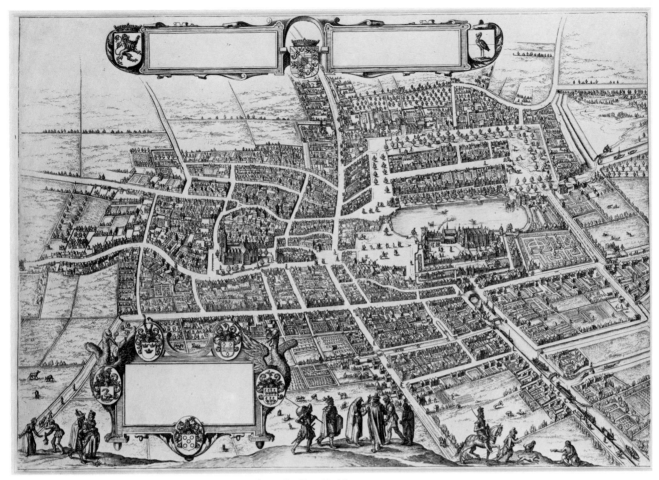

47. Jacques de Gheyn II. *Plan of The Hague as seen from the East.* Etching.
Rijksprentenkabinet, Amsterdam

It is impossible to state with any certainty where De Gheyn produced the work discussed in the previous paragraphs. He must have enjoyed a certain amount of mobility in these years, as we can tell by the subject matter of his plans, the portraits produced in this period, and his contacts with patrons, engravers and draughtsmen. He is bound to have stayed at Schiedam and Delft, and probably visited Van Mander at Haarlem. References to his home in the years 1596-98 only mention Leyden, where he dwelt 'in the Steenschuyr near the Tanners' Hall'[37]. On this occasion his son Jacques was mentioned for the first time. In 1601 he still testified before a Leyden Notary Public[38].

The first documentary evidence of his living at The Hague dates from 1603; he was then occupying a house in the Voorhout backing onto the Dennenweg[39], and clearly recognisable on the *Map of The Hague* produced a few years previously. He was to remain there until 1623. It was close to the house formerly owned by Eva's grandmother, if it was not, in fact, the same one[40]. The house had a peculiarity which is known to us from the deed by which De Gheyn sold it on May 2nd, 1623, for the exceptionally large sum of 6600 pounds. Excluded from the sale were 'the two stone figures by Michiel Angelo at present lying in the courtyard, which they shall be allowed to remove in their own time and at their own convenience'.

Even if they were not 'from the chisel' of Michelangelo, two cumbersome, reclining figures by an Italian sculptor would have been an impressive and unusual possession at The Hague in 1623. If the figures were, in fact, recumbent, one might form an approximate idea of them by thinking of the

river gods designed by Michelangelo for the Medici chapel, although never actually placed there[41]. Perhaps the mighty Van Mierop had once received them from Italy. What happened to these probably important works of art cannot be traced. To judge by the building accounts, they do not appear to have found their way to one of Frederick Henry's gardens. The courtyard where they once reclined is shown on De Gheyn's *Plan of The Hague* as containing an enclosed flower garden with statues at each of the four corners. It is possible, however, that the word 'lay' which occurs in the deed may have been used in the sense of 'were stored'. In that case, one might think of smaller statuettes such as the *Crouching Boy* in Leningrad[42]. The portrait of De Gheyn, dated 1610, shows the statue of a seated boy.

Before De Gheyn left Leyden, his style of drawing had taken the decisive turn already referred to briefly; it would ultimately distinguish his 16th century œuvre from all his later works. Only the first signs of this will be discussed in the present chapter.

Cat. II 877, pl. 82 Something of the sparkle his draughtsmanship would ultimately display is apparent in a *sheet of studies* of storks that we may relate to the coat of arms on the *Plan of The Hague.* Storks used to be less timid than they are nowadays. In my youth they still wandered about peacefully in the Fish Market at The Hague, and De Gheyn would have been able to study them without any difficulty. He made good use of the opportunity to learn about the structure of their plumage and delicate legs. At a later date, he was frequently to examine dead birds.

Cat. II 965, pl. 52 De Gheyn was now also beginning to be active in the field of pure landscape. For many years he would still continue to let his imagination run riot, but gradually he started checking his vision against Nature itself. An undated drawing at Orleans that I have attributed to him, still displays a conventional approach. It represents a rocky coast with buildings and islands, and with galleys and other vessels sailing along it in the light of a sun just visible above the horizon. The land now merges more gradually into the water than it did in the *Temptation in the Desert,* his earliest known attempt at an imaginary landscape. The influence of other artists is very evident: one is reminded of Paulus Bril. The shadow effects are created by grey washes; the actual pen-drawing is in brown ink. The line has become much freer and displays some deliberate tremors here and there, which

Cat. II 973, pl. 156 increases its liveliness. The concept in *Ancient ruins in a mountainous landscape* is similar, although this work is more in the style of Jan Brueghel. The earliest date to appear on his land-

Cat. II 963, pl. 57 scape drawings is 1598. *A river crossing a mountainous landscape* in the Louvre dates from that year, and may be compared with the landscape style Hendrick Goltzius had been developing over the past years[43]. In his sketch of a *Rocky landscape*[44], Goltzius completely abandoned his engraving style to arrive at a concept of mountains containing something of the violence of their creation. De Gheyn continued to use the sea or a lake to provide a firm horizontal, but arched his pen to follow the mountain contours and, in the manner of Pieter Bruegel, placed a grey sky above the

Cat. II 979, pl. 59 light crests in the distance. In a landscape with a castle to the left the trees with their clusters of leaves already play an important part, but the architecture and the bridge with its oval arch are still reminiscent of the Danube School. Nevertheless, it is this drawing that shows the greatest affinity to Goltzius, particularly to his woodcut of a *Water-mill by a Mountain Stream*[45], if one imagines the design in reverse. Both compositions are constructed according to a similar scheme, which features an overhanging tree high in the centre. Of the two draughtsmen, Goltzius is likely to have been the originator, if he did, in fact, provide the design for the woodcut. This puts his series at a date no later than the beginning of 1598; Hirschmann was hesitant about this, and suggested 1598-

Cat. II 499, pl. 216
Cat. II 941, pl. 62 1600. Evidence of De Gheyn's familiarity with the series is to be found in some direct derivations in a *sheet of sketches.* De Gheyn's composition, however, places greater emphasis on the diagonal and on the effect of depth. On the other hand, his *Canal with sailing-boats,* also dating from 1598, is

60

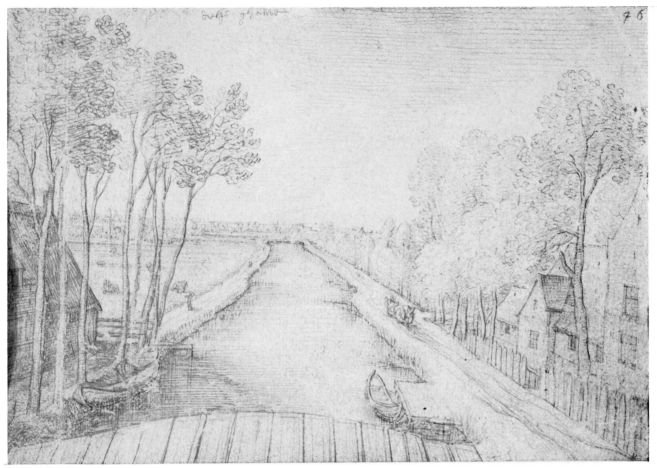

48. Hans Bol. *View from a bridge at 'delfts ghouw'*. Silverpoint drawing. To be compared with cat. II 941.
Printroom, British Museum, London

totally different. Keeping to strict rules of perspective, it leads the eye along the diagonals of the picture plane to a bridge in the centre. The sky appears to take over the upward movement along the crossed diagonals. The compositional scheme was started by Bruegel the Elder, but is here derived from Hans Bol; it was still to be used frequently by Jan Brueghel. De Gheyn, however, exploited the movement of the clouds to give greater depth. The link with Hans Bol goes further, because it was he who, at an earlier date, wrote above a drawing of a similar view: *delfs ghouw*. De Gheyn's view shows a similar location, recalling the 'Vliet' when one looks towards Leyden[46]. It is notable that De Gheyn drew the westering sun in the extreme top corner like a fire directing its rays over the countryside from a light-coloured disc.

Ill. 48

It was a complete revelation to me when, in 1975, Dr. E. Knab sent me the photograph of a large drawing inscribed *J. Gheyn f.*, which he had found in the Albertina and which, until then, had remained concealed even from Benesch and himself. It represents a castle, seen from the rear, its tower, if there was one, hidden by a large tree in the centre, with adjoining buildings, more or less as if drawn by Bloemaert around 1620. Closer examination showed the trees were not drawn in De Gheyn's late style, but resembled those in the *Cavalry battle* of 1599, or in the Orleans *Bay and its rocky coastline* of about 1596. The castle might correspond to Rozenburch near Voorschoten, and Rozenburch is likely to have been the home of Eva's eldest uncle, Jacob Stalpaert, at the time. Everything seemed to point to a much earlier drawing which may even date from the first years of

Cat. II 948,
pl. 50

Cat. II 321,
pl. 70
Cat. II 965,
pl. 52

61

49. Joachim Patinier. *Landscape with the Story of St. Mary Magdalen.* Painting. At the base of cat. II 1045. Kunsthaus, Zürich

Jacques' and Eva's marriage. Only the fact that the work is an exact representation of a given situation can explain the stylistically advanced impression that it makes. And it forces us to conclude

Cat. II 950, pl. 249

that the other landscapes of the same period, the farm of 1603 included, are to be regarded as designed in a much more artificial manner, as if the artist were practising a form of calligraphic art far removed from his everyday personal script. It was, therefore, with an arguable chance of being right that we were able to insert this item among De Gheyn's early landscape drawings.

Cat. II 977, pl. 77

The wide *Mountainous landscape* in the Albertina dates from 1599 and is an imaginary view sketched with even greater facility and freedom. It is drawn entirely in pen and ink, and the artist distinguished the undulating, receding planes from each other by grading the thickness of the ink from the foreground to the remote distance. The transparency of the shadows creates an all-embracing, daytime atmosphere in this exceptionally well-balanced composition.

Cat. II 1045, pl. 159

Ill. 49

An even larger, and far more carefully finished drawing in London is dated 1600 and represents steep rocks bordering a bay with a galley sailing across it. As Popham once noted, De Gheyn's main source of inspiration on this occasion was a painting by Joachim Patinier, a fact which provides further evidence of his interest in old masters. Despite adding many new elements to Patinier's invention, he also undoubtedly endeavoured to enter into the old way of thinking, which was akin to Bruegel's as well. One might even think in terms of a deliberate attempt to emulate Bruegel's

large landscape drawings in technique as well as in their descriptiveness and penetration of the theme. The affinity of the distant view on the right to Bruegel's drawings of his journey to Italy is so marked that one might think it was immediately inspired by a lost Bruegel drawing[47]. In spite of this, one is still reminded of the static character of Patinier's rocks, but De Gheyn may not have known they were meant to evoke the exact appearance of *La Sainte Beaume* in southern France, whence St. Mary Magdalen was said to have been raised to Heaven by angels[48].

So complex and deliberate an adaptation of heterogeneous examples also increased his own facility in inventing other landscape themes, a good example being the *Watch-fire in a landscape,* now lost, which also dates from the first year of the new century. On this occasion he placed the dark silhouette of three figures, an officer and two sentries, in the foreground of grandiose river scenery. The pen that scratched in all this so effortlessly, moved with increasing speed, its direction occasionally modelling the structure of the rocks, in the manner of Tobias Verhaecht. One also notes that the direction and tonal value of the clouds play a part increasingly equivalent to that of the landscape itself, a factor eventually exploited to dramatize the landscape as a whole. It is clear that in the few years at Leyden when he began concentrating on landscape, this type of work became firmly established, and played an essential part in developing a new and highly personal style. Provided no topographical documentation was required, landscape was, of course, the kind of work upon which an artist might most effectively impress the stamp of his own personality.

Cat. II 960, pl. 160

An examination of all the landscapes De Gheyn may have drawn prior to 1600 is beyond the scope of this book, nor would it prove very illuminating. The problems he solved varied from case to case. By confining ourselves to the dated examples it has been possible to demonstrate clearly which years were crucial to his development and growing awareness in this field.

In his portraits De Gheyn had so far confined himself to precise and truthful likenesses, always using a miniature, and preferably an oval format. A number of examples date from the years 1596-1599, and these were sometimes executed in silverpoint either on a mustard-yellow, prepared ground or on a grey one. It was probably in 1596 that he produced two copper plates showing the *portrait of Tycho Brahe,* the famous astronomer, whose observatory was on Hven in the Sont. By showing him his portrait, fresh from the needle, in 1594, Metius may have induced Brahe to ask the Leyden artist for one of himself. With the aid of the scholar's diary, it is possible to argue convincingly that an original portrait of Brahe by the Danish artist T. Gemperlin of 1586 — the year on the actual prints — was copied on May 4th, 1596, so that Willem Jansz Blaeu, who had taken part in Brahe's researches, could take this copy for De Gheyn with him on the 24th of the same month. The first engraving produced by the latter, either then or as early as 1594, was unsatisfactory because of several inaccuracies concerning the ancestors represented by their armorial bearings; he thereupon engraved a new version which was incorporated in a book published in 1596. The scholar is shown in state-robes beneath an arch, his 16 quarterings displayed along the voussoirs. The pen-drawing for the definitive print is in Copenhagen. The execution of a small *portrait of Marnix van Sint Aldegonde* is finer; this served as a design for the small print published later, after Marnix' death. Here again the pen appears to function with so much assurance that the slight nervousness of the line in no way detracts from its quality, and, in fact, adds a final touch of life to it. This is more obvious in a sheet of sketches with several figures drawn to a larger scale; De Gheyn's complete mastery when working from nature is again evident. The preliminary studies for the portraits of Carolus Clusius and Abraham Gorlaeus have been lost, unfortunately, but the engraved portraits themselves provide an opportunity to devote some thought to these two men.

Cat. II 651, pl. 41; 677, pl. 61; 678, pl. 42; 687, pl. 38; 711, pl. 40; 719, pl. 23 Cat. II 653, 654, pl. 45

Cat. II 694, pl. 20

Cat. II 493, pl. 267

Cat. II 656, ill. 53; 676

The great victory in the battle which Maurice reluctantly fought at Nieuwpoort in Flanders was not only to be recorded in an engraving, but the States also decided to have a commemo-

63

Cat. II 150; 149
pl. 157, ill. 50
rative medal struck[49]. The task of designing it was entrusted to De Gheyn. He embellished the reverse with a plan of the recently captured redoubt of St. Andries, but for the obverse he chose a type of representation that had not been in vogue since the days of Maximilian, thus producing an innovation, as Van Kuyk has demonstrated: the General is seen in side-view, with raised sword, dressed in full armour and mounted on a walking horse. He is the 'Victor' in person, with the battle itself in the background and the sign of God in the sky above. It is quite possible that the monumental medals by Pisanello which, on so much larger a scale, also contained horsemen, were not foreign to De Gheyn's ideas. This is all the more likely as we know he was famil-

Cat. II 1029-1033,
pl. 197, 198
iar with a large number of Pisanello's medals and even used them, somewhat clumsily altered, for engravings produced either by himself or his assistants. He added hands which, from the 15th century point of view, entirely destroys their character[50]. He may have become familiar with these medals through Gorlaeus. At the mint in Dordrecht, where the Nieuwpoort medal was struck in 1601, he must have resumed contact with the Bleijenburghs, its hereditary assayers. Through his wife's youngest sister, De Gheyn was also connected with the Master of the Mint of West Frisia, Caspar Wijntghen or Wijntges, who, in turn, was related by marriage to the van Bleijenburghs. The

Cat. II 676
pen-drawing for the obverse of the medal is in London. The finely engraved portrait of Gorlaeus dates from the same year. Counsellor to the Dowager Countess van Nieuwenaar, he was above all a numismatist, and the portrait was to embellish his *Dactyliotheca*. Hugo de Groot, more genuinely a native of Delft, was not to be outdone, and in addition to the letterpress for the print, he also wrote a long poem in which a ring 'worthy of a Prince' is addressed in every other line as *Annule*. Gorlaeus' book deals with ancient coins and gems, but when Buchelius saw his collection in 1597 he thought there were hardly any authentic pieces in it and suggested that Gorlaeus and the goldsmith Arnoldus had produced most of the items themselves. The collection included a great many portraits of Roman Emperors[51]. It was from Gorlaeus that De Gheyn may well have acquired the *quantité de copies de plomb de très belles médailles antiques* of which J. Brosterhuisen tried to

50. Jacques de Gheyn II. *The Battle of Nieuwpoort*. Commemorative Medal. Silver.
Stolen in 1979 from a private collection, Amsterdam

51. Jacques de Gheyn II.
*Julius Caesar*. Engraving.
From a series of Roman Emperors.
Graphische Sammlung Albertina, Vienna

64

52. Joachim Beuckelaer. *A Peasant's Larder*. 1567. To be compared with cat. II 837.
Museo di Capodimonte, Naples

obtain plaster casts in 1630, shortly after the former's death, by managing to borrow them from Jacques III through Huyghens[52].

In this context, one may also mention a series of medal engravings published by De Gheyn and featuring the busts of the first twelve Caesars: those described by Suetonius and designed to illustrate Fenacolius' edition of his *Lives*. De Gheyn may have copied them from a series of sixteenth century northern Italian plaquettes in Gorlaeus' collection, but one might also think of the description of 'forms of the twelve Roman emperors, round, by W. Tetterode', included in a list of objects pawned to Aper van der Houve by Thomas Cruse, a silversmith in Delft in 1624[53]. Other drawings also show evidence of De Gheyn's endeavours in connection with coins, medals and gems.

De Gheyn's desire to stop working solely in black and white, and to include colour in his means of expression, must also have arisen in the course of these years. It is remarkable that both he and Goltzius should, only then, have arrived at this stage in their development. It is true that they were both originally engravers, or, at the most, glass-painters. The actual process, however, was different for each of the two artists. Goltzius learned the advantages of red chalk before De Gheyn did, although, generally speaking, he did not use it until his visit to Italy. Like Zuccaro, he combined its use with black chalk[54]. Goltzius also used pastel crayons to colour the large portrait drawings he

Ill. 51

Cat. II 1012-1023

Cat. II 695, pl. 415; 1010, 1011, pl. 396, 397; 1024-1026, pl. 324, 472, 473

produced during his Italian journey. According to Van Mander, it was not until 1600 that he actually started painting.

Cat. II 837, pl. 83 Ill. 52

De Gheyn did not attempt such almost life-size portrait drawings, but gradually began to add finishing touches of water-colour to a few small drawings, on which he apparently wished to lavish special care. The earliest dated example is the drawing of a *Skinned Calfshead* such as occurs in paintings by Pieter Aertzen and Joachim Beuckelaer [55], although it is impossible to determine whether one of these was copied by De Gheyn, or whether he worked from life. Its technique, in any case, is already perfect, and its theme may be considered another innovation in the history of the art of drawing. Around 1600 it must have created a sensation comparable to the furore caused, in their days, by Rembrandt's slaughtered ox or Soutine's carcass of a cow. Suddenly his interest in the small wonders of Nature, a theme accepted since Dürer and Hoefnagel, was also aroused; several miniature sheets of drawings at Frankfurt bear witness to this. We may assume that, a short time previously, he had seen some work by Joris Hoefnagel, whose miniatures had also featured small creatures, and who had portrayed them in colour. This may have been in The Hague, at the home of Christiaen Huyghens, Prins Maurice's Secretary, who was married to Joris' sister, but in that case it was before Hoefnagel's estate was divided; the artist died in 1600 and Huyghens' wife received her share in 1601 at the earliest [56].

Cat. II 895, pl. 194

Cat. II 898-900, pl. 479-481 Cat. II 673, pl. 208

Cat. II 909-930, pl. 172-193

In these first attempts, which may include the scale drawings of small *flies,* the artist had already fully mastered his task [57]. We also find he added some light touches of colour to a small picture of a rosy-cheeked little boy, perhaps a youthful portrait of his son. This shows that when a commission was particularly near to his heart, he tried to achieve the ultimate in fidelity to nature. In 1600 he also started working on a parchment flower-book which was to assure him a permanent place in the development of scientific illustration. Its creation arose out of his association with Carolus Clusius, the botanist to whom Leyden owes its famous Hortus. This contact may well be regarded as the keystone to De Gheyn's life in the shadow of the university. Together with the complementary school of natural science it had involved him in the study of classical antiquity, astronomy, medicine, mathematics, military science and humanistic thought. Now his interest in biology was to be developed. When Robert de Baudous failed to capture the likeness of the famous botanist in 1599, and Clusius was preparing to have his *Rariorum Plantarum Historia* published, De Gheyn was asked to produce his portrait surrounded by a pompous framework, which could then be added to the book along with an allegorical title-page. All this appears greatly to have stimulated De Gheyn's imagination, and the framework around the relatively small oval portrait indicates the point of development at which the current style of decoration had arrived. The framework was developed out of a cartouche: in front of a suspended curtain, a convex table with rounded corners is incorporated in the frame and bears the caption; on either side is a candelabrum supported by a winged female herm and consisting of piled-up gourds surmounted by an ornamental vase containing tulips on the left, and lilies and snake's heads on the right. Fruit in all manner of shapes litters the foreground. What De Gheyn managed to cram into this baroque elevation was a small foretaste of the baroque fountain for Prince Maurice's garden which he designed twenty years later. His study and lifelike portrayal of natural things were evidently no obstacle when he allowed his imagination to run riot. I consider it likely that, like all his portraits, this illustration was still engraved by De Gheyn himself: the sparkling quality of the still life in the foreground is an indication of this. The unmonogrammed *title-page* is somewhat coarser in execution and appears to have been engraved by someone else following his design. The figures as well as the plants play a leading part here: Theophrastus and Dioscurides are seated in the foreground, and Adam and Solomon stand on either side of the frontispiece, with Adam covering himself with leaves and Solomon, as the author

Cat. II 656, 465, ill. 53, 54

Cat. II 161-163, pl. 438-441

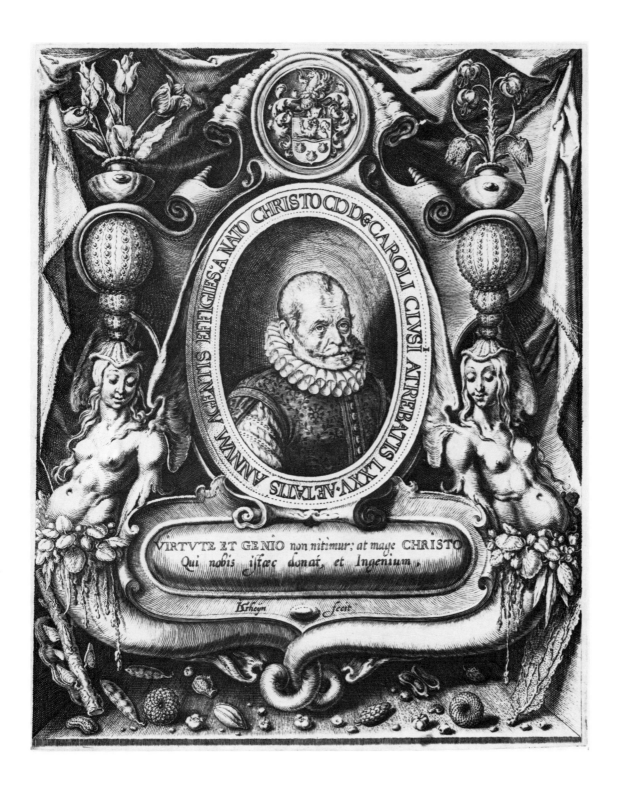

CHRISTO CIƆ IƆᴄ CAROLI CLVSI ATREBATIS LXXV AETATIS ANNVM AGENTIS SILENEAE EFFIGIES A NATO

VIRTVTE ET GENIO *non nitimur; at mage* CHRISTO
*Qui nobis istaec donat, et Ingenium.*

IᴅɢHeyn                      *fecit*

53. Jacques de Gheyn II. *Carolus Clusius,* in an emblematical frame.
Engraving, 1601.
Rijksprentenkabinet, Amsterdam

54. Anonymous Engraver. Title-page of *Rariorum Plantarum Historia* by Clusius, 1601. After Jacques de Gheyn II. Universiteits-Bibliotheek, Amsterdam

55. Jacques de Gheyn II.
*Plan of the Hortus
Botanicus of the Leyden
University.* Engraving.
Rijksprentenkabinet,
Amsterdam

of the *Song of Songs,* expressing his delight in the budding flowers (II: 12). The book was printed and published in Antwerp by Plantin.

De Gheyn's association with Clusius also led to the engraving of a *Plan of the Leyden Hortus* for insertion in a record, now rare, of the existing plants, which was published by Professor Pauw in 1601. It is a factually recorded plan, to which the small figures in side-view add a piquant note. Pieter Pauw, professor of medicine and also a herbalist, is explaining something to students, while Clusius stands talking to a Governor, and, on the left, a 'hortulanus' appears to be welcoming De Gheyn with a deep bow. De Gheyn's sense of humour is fully evident in such details. No scholar engrossed in his reading and followed at a respectful distance by a young alumnus had ever been drawn so wittily as the one on the lowest path leading past the flower beds. The Leyden citizen Johan van 't Woudt, or Woudanus, was later employed to complete the records by engraving the other special features of the university.

We know from the catalogue of the Ottley Collection that in 1598 De Gheyn did a drawing of 'a flower-piece with insects on vellum', but this, his earliest recorded still life has unfortunately been lost. We can form some idea of it from the far more important work he was to complete between 1600 and 1604: a complete booklet consisting of twenty-two sheets of parchment featuring

Cat. II 165,
ill. 55

Cat. II 932

69

Cat. II 909-
930,
pl. 172-193
mainly flowers, but also small creatures, in clear watercolour. De Gheyn had barely ventured upon this new technique before producing a unique achievement of unprecedented quality. His drawings of flowers — a lily, a columbine, a tulip, cornflowers or pansies or whatever they might be — were generally arranged two or three to a page, and, in clearly defined form and colour, excelled anything so far produced in this field, while they themselves were not really surpassed in the seventeenth century, however frequently they were repeated. In certain respects the book was a link in the long chain of herbaria produced over the centuries, but, as Mrs Hopper-Boom has proved, it contains several illustrations of specimens which were very rare at the time, all kinds of roses in particular. The production was therefore not the direct result of systematic studies in the *Hortus*. Moreover, it also contained very refined representations of small creatures. However, the artist's enthusiasm for the subject must have been aroused by the opportunity to admire the beauty of pure cultivation. Van Mander relates how a similar booklet was sold instantly to the Emperor Rudolf II, which, in view of the latest date appearing in it, 1604, identifies it as the item in the Custodia Foundation in Paris. In purchasing it for the Foundation, Frits Lugt provided clear proof of his sharp eye and sense of quality by immediately spotting its unique character. How De Gheyn's contact with the Emperor came about is a matter of guesswork. I think it is unlikely that Clusius had a hand in it by calling upon his old acquaintances at the Imperial Court. It was not, after all, an isolated incident, for the Emperor had frequently made purchases in the Netherlands through the intermediary of agents, including one occasion when Frans Badens may have acted as such for Hendrick Goltzius. That De Gheyn knew Frans Badens is apparent from a small copy he made of one of

Cat. II 1050,
pl. 466
F. Badens sr's compositions. It is, however, just as likely that another of the Emperor's agents, Jacob Hoefnagel for instance, negotiated with De Gheyn.

It is most fortunate that the little book was never taken apart entirely, and that so many of its leaves have come down to us fairly intact, so that we can still see what he managed to achieve in this first outstanding effort. The layout, that is to say the arrangement on the page, and the choice of subject matter were undoubtedly influenced by existing works of art: the position of the flowers, placed upright on the page, either singly or in groups of several specimens, occurs in older printed herbaria. The insects, which include, for example, a stag-beetle, form part of a tradition reaching back at least as far as Dürer. However, I believe De Gheyn was also inspired by the example of Joris Hoefnagel rather than by that of Jan Brueghel. The first statement needs no further argument, the second one does.

Before undertaking his journey to Italy in 1590, Jan Brueghel was unknown as a painter of small creatures or flowers. When he was in Italy he applied himself to drawing and painting landscapes for six years. As Van Gelder noted, his earliest dated *flower painting* dates from 1609[58]. Bergström added that one may go back as far as 1606, if one relies on the description of a lost flower

Cat. II 910,
pl. 173
painting[59]. As far as the still life with a flower pot in the booklet is concerned, I would not go beyond agreeing that De Gheyn may have depended on the example of other artists.

In 1596 Jan Brueghel travelled from Rome to Milan to work for Cardinal Federigo Borromeo. The results of this stay, including a number of impressive landscapes, are still in the Ambrosiana. It

Ill. 56
may have been overlooked, however, that the same library also houses a small painting representing a mouse and a rose sprig with a butterfly and a caterpillar on it, and this may also have formed part of the works supplied in 1596 (inv. 72)[60]. On October 10th, 1596, Brueghel reported to the Cardinal that he had returned to Antwerp four weeks previously after travelling home by way of Holland[61]. This small work is in complete thematic agreement with the repertoire of De Gheyn's booklet, which also features a *crab* and a *mouse* as the sole somewhat larger creatures. This makes it possible that on his journey through Holland, where he may have displayed and sold his work

70

56. Jan Brueghel. *A Mouse, two Roses, a Caterpillar and a Butterfly.*
There is only a remote possibility that Brueghel executed this painting before leaving Milan
and therefore preceded Jacques de Gheyn in depicting this genre. It is much more likely
to have been one of the later works he sent to Cardinal Borromeo from Antwerp.
Biblioteca Ambrosiana, Milan

before facing considerable financial commitments in Antwerp, Brueghel also showed them to De Gheyn, and that this was how the latter learned about his Italian landscapes and about his oldest still life paintings, if they already existed. There is a later portrait drawing of Jan Brueghel by his hand, and it is known that De Gheyn purchased a painting by Brueghel for the Stadtholder considerably later on. I therefore think we should not altogether rule out the possibility of Brueghel having influenced the flower-book, and of also having stimulated De Gheyn in the matter of landscape painting, but it is much more likely that on this occasion it was De Gheyn who opened Brueghel's eyes more widely to the small wonders of Nature. <span>Cat. II 655, pl. 378</span>

It was in 1601 that De Gheyn at a single stroke reached another peak in his development by executing an unusual form of miniature following the death of a lady of high rank. She appears to have been Walburgis van Nieuwenaar, the widow firstly of the Count of Horn, who was beheaded, and secondly of the Governor of Utrecht, Adolf Count of Nieuwenaar and Meurs. She died without issue in 1600 and, as a widow, left Meurs to Prince Maurice, her possessions in Cologne and Westphalia to the Count of Bentheim, but the county of Horn and its appendages to George Eberhard, Count of Solms, whom she made her 'universal' heir. We have already come across the latter when De Gheyn dedicated a print after Van Mander to him: he is standing in solemn mourning near her bedside. He points to the peaceful, recumbent figure of the woman in her splendid bedstead, its green curtains caught back on either side, with, beside it, a bench supporting her prayer-book and a burning candle in a candlestick. The portrait of the dead woman is based on an <span>Cat. II 699, pl. 162</span>

Cat. II 698, pl. 161impressively penetrating pen-drawing, where she is seen at rest, her honest face framed by her cap and ruff, and reposing on the large pillow, one delicate hand placed across the other upon the sweeping folds of the blanket. Only a rare artist could turn a deathbed into such a solemn and harmonious scene[62]. A further significant and creative phenomenon was involved in the transposition of this impressive sketch into the final composition. We know De Gheyn had already been engaged in the art of limning, which had certainly been practised in this country since the beginning of the sixteenth century, perhaps since Holbein or perhaps even earlier, as in Flanders, but only by a few specialist artists. De Gheyn may well have been familiar with works by Hoefnagel, but it is uncertain whether the Englishmen involved were known in Holland. For this particular form of art had been brought to unprecedented perfection by Hilliard and his followers in Elizabethan England. A number of more ambitious works by Hilliard are known, including a portrait in a landscape, and they were not limited to the traditional oval portrait. De Gheyn's invention, however, whereby two figures were combined in one picture, was to remain unique. It was not without reason that he signed them in gold lettering. Van Mander refers to limning as one of De Gheyn's main occupations, and Huyghens pays high tribute to these portraits, comparing them to those by Hoefnagel and Isaac Oliver. The former was Huyghens' uncle, and he was to become familiar with the latter's work on his first journey to England. As long as nothing is known about Jacques II visiting England, it will be impossible to tell whether he was familiar with the English versions of this form of art, or whether he met his contemporary Isaac Oliver.

No further argument is needed to prove that De Gheyn had found his true vocation in his last few years at Leyden. With his insatiable curiosity and thirst for knowledge, he had continued to explore a large number of new fields, and, in doing so, had changed his attitude towards mankind from that of a docile craftsman carrying out miscellaneous commissions, to the viewpoint of a true humanist with an eye wide open to the visible aspects of the world and to whatever an inquisitive and inventive generation was making of them. Circumstances enabled him to do so: the state of material well-being brought about by his marriage had given him an opportunity to widen the scope of his business and ultimately to include the art of painting in it. This will be discussed in a later chapter. But he would not have gone so far if his own nature and perseverance had not led him deliberately to change course whilst carrying out his numerous commissions.

# CHAPTER IV

## *As a painter at The Hague since about 1600*

De Gheyn was admitted to the *St. Lucasgilde* at The Hague by 1598 at the latest. He was described as a 'painter' and 'engraver', but in 1615 the word 'engraver' was omitted. This is important in view of the date. The first entry at least implies that it was the artist's intention to concentrate on painting, even if he could point merely to the miniature portraits which he must have been painting ever since his Antwerp days, although, strictly speaking, only one of them has survived. However, one would prefer to assume that he had already completed the first true painting on Van Mander's list, which was undoubtedly based on information supplied by De Gheyn himself. This was a *cleen bloempotken naar het Leven,* (a small pot of flowers from Life), which was purchased by the Amsterdam collector Heyndrick van Os. There may be a link with *a flower-piece with insects* painted in watercolour on parchment in 1598; it was mentioned in the early nineteenth century collection of W. Young Ottley, but is now lost. The watercolour cannot possibly be the same as the flowerpainting De Gheyn described to Van Mander as being his first work in oils, but the combination of facts does point to a date around 1598 for the latter work[1]. It also proves that De Gheyn's oeuvre as a painter began with small flower-pieces and developed out of the art of limning, even before Hendrick Goltzius started producing larger-scale paintings in 1600. In this respect, De Gheyn was ahead of his former master. However, the still life of 1600 on one of the pages of the booklet, is the best existing paradigm for the first 'flower pot'. Here, the vase, which holds a few flowers, almost hesitantly drawn, is surrounded by a considerable amount of space and placed on a plinth large enough to allow ample room for a number of small creatures.

De Gheyn had also told Van Mander how, in order to learn the art of painting without too much trouble, he had divided a panel into about a hundred squares and painted light and dark shades of many colours on it. He gave each of these a number which referred to notes in a booklet where he appears to have written down the substance and mixture required for each shade. This unusual expedient, so characteristic of his liking for systematic method, had, so Van Mander tells us, been of great assistance to him in learning to prepare the right colours as and when required. For a first attempt, the *blompot* belonging to Heyndrick van Os was, in Van Mander's words, *verwonderlijck,* admirable. Although his mind was already set on figure painting, his second attempt was another flowerpiece in which he endeavoured to correct the shortcomings of the earlier work. He sold it to the Emperor along with the small book mentioned above. The only dates to occur on his known flower-paintings are between 1612 and 1615, and it is not easy to determine to what extent his first works had already assumed the style of the later examples. Yet we can almost prove that there was a considerable lapse of time between De Gheyn's earliest flower paintings and those dated after 1612: one early painting, unrecognised hitherto, came to light recently.

Mrs. F. Hopper-Boom undertook the study of the book of flowers and insects from a bio-

Cat. II 699, pl. 162

Cat. II P 29
Cat. II 932

Cat. II 910, pl. 173

Cat. II P 30

Cat. II P 31, pl. 1

logical point of view and scientifically determined the various species, the flowers frequently proving to be very rare kinds. One of her findings was that many of them were copied in a sumptuous manuscript, the *Prayer-Book of Maximilian I,* Duke of Bavaria, in Munich[2]. She observed that among other illustrations of the same type in the prayer-book there were quite a number which looked as if they had been copied from similar models. So if one asks the pregnant question whether the Paris volume is still complete in itself, or whether it forms the principal part of what was originally a larger book, it is the latter alternative which appears to require a positive answer. There are other circumstances which prove that from the moment it arrived in Prague, De Gheyn's book aroused widespread interest among artists. It may be said with emphasis that it was there that Conrad Flegel first started taking his highly captivating look at the world of small inanimate objects and small creatures. We should not forget, however, that the ground for the attention paid in Vienna and Prague to the small wonders of Nature had been prepared by Joris Hoefnagel. De Gheyn intervened in a development which had its centres in Frankfurt and Prague rather than in Holland. But the artists concerned with it were mainly from the western part of Europe, Antwerp in particular.

Cat. II P 31, pl. 1 As I have said already, one early flower-piece repeats several of the flowers represented in De Gheyn's album. I have never seen the painting but know a reproduction of it from Bergström's article on radial composition in early flower still lifes[3]. This fact appears to date the work with some precision: it could hardly have been invented before the completion of the album, whereas it would have been uncommonly difficult for the painter to design it after the models for the various flowers had been sent to Vienna. The date of the picture, if genuine, therefore seems to be about 1603 or 1604. One peculiar characteristic provides a direct link between this De Gheyn still life and Hoefnagel: De Gheyn placed the butterfly on the bowl in exactly the same position as J. Hoefnagel did in an earlier miniature now belonging to the Ashmolean Museum at Oxford[4]. This circumstance can hardly be considered fortuitous.

When this early still life is compared with those of Jacques' later years, it becomes evident how much De Gheyn's flowers had gained in brilliance over the years and how the remaining traces of the decorative formality of Hoefnagel's art had completely disappeared from them.

It is evident that De Gheyn had not taken to painting and the use of colour in the way Hendrick Goltzius had. In a sense, both were late-comers compared with true painters like Cornelis Cornelisz, Carel van Mander and Abraham Bloemaert, but their drawings were superior to those of the painters.

Goltzius had acquired his preference for red chalk, which he sometimes combined with black and white, in Italy, where he had also used pastel crayons on the life-size portrait heads he produced there. We may assume that from 1600, when he started concentrating on figure painting, his work was always on a larger scale than De Gheyn's. De Gheyn began with small, even minute paintings, but his third commission suddenly confronted him with the task of working to a monumental scale.

Cat. II P 15, pl. 2 The result has come down to us, albeit in rather poor condition, in the life-size painting of a horse, dated 1603, now in the Rijksmuseum in Amsterdam.

The story has often been told how Louis Gunther of Nassau gave his cousin Maurice the magnificent white stallion on which he had taken the Almirante of Aragon, Francesco a Mendoza, prisoner in the Battle of Nieuwpoort. The Prince subsequently commissioned De Gheyn to do a painting of the horse. For De Gheyn, now living close to the Court, this was a multiple challenge, and he met it successfully. Maurice is likely to have known that Giulio Romano had immortalised Federigo Gonzaga's most beautiful horses in life-size frescoes in one of the rooms of the Palazzo del Té[5]. They were portrayed above eye-level, standing unsaddled in front of an imaginary window from

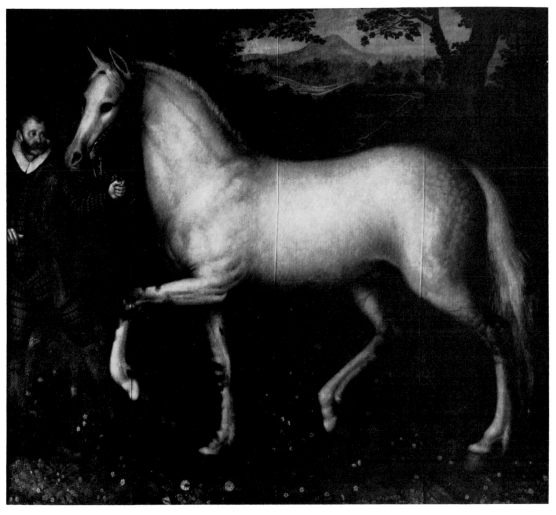

57. Anonymous Master. *A Grey Stallion*
said to have been ridden by Queen Elizabeth,
led by a servant of Sir Robert Cecil. 1594.
Hatfield House, Herts.

58. Florentine Master. Second half of
the 16th century. *Trotting Horse.*
Bronze statuette. See also cat. II 848.
Kunsthistorisches Museum, Vienna

where there was a view of the countryside. De Gheyn, however, had never seen this potential model and can only have known the series of octavo prints engraved from drawings by J. Stradanus and representing the stud belonging to Don Juan of Austria. Each of these prints portrays a single example of one particular strain in movement against a landscape background. But the nearest con-

Ill. 57

temporary model is the life-size portrait, now at Hatfield House, of a horse said to have belonged to Queen Elizabeth, which is led by an elderly equerry in a landscape setting and is dated 1594. It has been catalogued as probably of Flemish origin and painted for Sir Robert Cecil[6]. De Gheyn must have been in touch with the latter, as we know the splendid copy of his *Exercise of arms*, which was Robert Cecil's presentation copy. It does not seem likely that De Gheyn was aware of the existence of Cecil's portrait of a horse, but Prince Maurice may have known about it and wished to possess a similar portrait of the horse he was so proud of. De Gheyn shows a groom leading the grey at walking pace past a dark wall pierced only by two small, rectangular windows. The painting's appeal must have been due to the horse's gleaming coat and long, waving mane and tail. After the most recent, unfortunate restoration it is only possible to surmise this. The finely modelled head and the figure of the groom have fared better. The work of a beginner is revealed in two ways: firstly, by the introduction of the harshly outlined window apertures in a background which would have looked better if left uniformly dark in colour, and, secondly, by the over-elongated left fore-leg which suggests that the horse is turning to the left, whereas its hind-quarters move parallel to the wall. Perhaps this was also the reason why the artist himself was dissatisfied with the result, as Van Mander has related, although the lithe thoroughbred's light colouring and muscular structure come across despite these failings.

Hugo de Groot wrote two distichs for this painting, which attracted considerable attention on account of its size and unusual theme. De Gheyn may have found a suitable model for the horse's position among the numerous smaller Italian bronzes which are all derived more or less directly

Ill. 58

from the classical horse of Marcus Aurelius' equestrian statue[7]. However, before commencing his large panel, he also made a thorough study of the grey, and of its head and movements, in a number of freely executed pen-drawings, one of which also includes the groom[8]. What strikes us most in these sketches is their almost rough spontaneity, indicating that on this occasion De Gheyn was not interested in producing a fine finish, but was attempting to record rapidly changing positions. We can see how working to a large scale gave his draughtmanship a liberating impulse. Now, for the first time in his career, he was showing boldness and daring. For how long had the thirty-seven-year-old artist not been encapsulated, scarcely allowing himself any freedom!

Cat. II 854, pl. 371

The supreme example of these drawings is the one in Berlin showing several heads of a horse in varying positions on a single sheet of paper. Once he even made the horse lie down to capture its head in a different position. The modelling is surprisingly strong and the mane graceful. The drawing is worthy of a place alongside those by Leonardo and Pisanello, whose drawings of animals are the greatest of all times, but it also stands comparison with Delacroix' work.

Cat. II 152, ill. 59-62

Another exacting commission carried out by De Gheyn in these same productive years was the one for the *Land-yacht*. It consisted of a drawing, to be reproduced in a print from three copper plates, and the artist had to concentrate on minutiae to a far greater extent than had been required for the monumental horse. The object was to illustrate, in a large, oblong drawing, the start of a journey from Scheveningen to Petten in two land-yachts constructed in accordance with an invention by Simon Stevin. Stevin, a native of Bruges, had fled his own country and was now connected with the Engineering School at Leyden. In addition to being a brilliant economist, one of the founders of modern bookkeeping, and mathematical adviser to Prince Maurice, he was also an engineer. The idea of using wind propulsion for land vehicles seems to have originated in China.

But one may doubt if this was known to Stevin. He so constructed his land-yacht that on the famous trip, when the wind was favourable, the vehicle — for it was only the large one which actually sailed to Petten — reached a speed which neither the sailing vessels on the sea nor the horses on the beach could maintain, and which was probably not exceeded by any vehicle prior to the nineteenth century. Conditions, however, had to be so good that they occurred but rarely, which is probably the reason why the idea never progressed beyond a few experiments. The date of the special trip is unknown, but it probably took place in September or October 1600. We also know that the Count of Hohenlohe took the land-yacht out again on January 25th, 1602[9].

De Gheyn showed the two yachts with the sea in the background, as seen from the sand-dunes. Prince Maurice and his brother Frederick Henry are seated in the small coach preceding the yacht, and their important guests, including Mendoza, Prince Ulrich of Denmark, the French Ambassador de Buzenval, young Hugo de Groot and presumably De Gheyn himself are among the twenty-two persons in the large one behind it. They are all portraits. It may also be possible to identify Count John II of Nassau and Johan van Oldenbarnevelt. Galloping horsemen accompany the vehicles along the sands, and boats have put out to sea to follow the trip along the coast. The ladies who were left behind, and a few gentlemen, children and Scheveningen fishermen are shown in the foreground. De Gheyn's wife and small son are among them. The engraving was printed on three sheets; De Gheyn's original complete design has been lost. The remarkable thing about the print is that it gives a credible, overall view of the beach without the artist having made any great effort to show perspective foreshortening. The concept of the 'frieze' is linked with that of the city profile and some of the sea-scapes by Hendrick Vroom. This is also true of the figures in the foreground, although De Gheyn included a greater number of close-ups. The artist's achievement is, in fact, a most excellent historical documentary.

A woodcut by Chr. van Sichem was added in the centre of the lower border, showing Simon Stevin and his three builders next to a horizontal section through the vehicle, with an explanatory text above it. The borders along the sides and the remainder of the lower edge are completely taken up by the twenty-two Latin epigrams Hugo Grotius had dedicated to the enterprise. These include a breath-taking account — Iter, a title borrowed from one of Caesar's writings — of the trip, high-flown praise of the hero Maurice, some baroque reflections pronounced by the vehicle, and a tribute to Simon Stevin and De Gheyn's splendid picture. Under the heading Ichnographia, the last two lines assure the spectator that, unlike Icarus, he need not be afraid of flying as, in this vehicle, he may consider himself as safe as Daedalus...

It is possible to trace several stages in the preparations for this unique creation. De Gheyn took a trip to Scheveningen to draw the sea and groups of seamen. He also did some careful preliminary drawings of the vehicles' occupants, not on the day of the trip itself, but at his drawing-table. However, the Warsaw Museum possesses two sketches of figures on the beach, and these appear to be so much more spontaneous that one is inclined to believe they were sketched on the spot while De Gheyn was waiting for the departure of the coach, and were therefore true snapshots. They include one of the countesses living at Prince Maurice's Court, who also appears in the print with her young page. She may also have been Margaret of Malines. The Land-yacht print must have been distributed as a gift in court circles as well as through the trade, and De Groot took care to ensure that his poems were read by the cultural élite of Holland and France. He called in Heinsius and even Scaliger to help with their distribution. As a means of propaganda, the print proved wholly successful, keeping alive the memory of Simon Stevin's sensational invention, which would otherwise have passed into mere legend.

One other person may have accompanied De Gheyn when the land-yacht set sail, and this was

Cat. II 940, pl. 204, 205
Cat. II 507, pl. 214; 514, pl. 219
Cat. II 556, 557, pl. 212, 213

59. Willem van Swanenburgh. *The Land-Yacht*.
Engraving. First state. After Jacques de Gheyn II.
Rijksprentenkabinet, Amsterdam.

60. Willem van Swanenburgh.
*The Land-Yacht*. Detail including
Eva de Gheyn and her son.
Engraving. First state.
After Jacques de Gheyn II

61. Willem van Swanenburgh.
*The Land-Yacht*. Detail.
Engraving. First state.
After Jacques de Gheyn II

62. Christiaan van Sichem. *The
Construction of the Land-Yacht.*
Woodcut.
Rijksprentenkabinet,
Amsterdam

80

63. Hendrick Goudt. *Distinguished People Conversing.*
Pen drawing. From the 'Elsheimer Volume'.
Städelsches Kunstinstitut, Frankfurt

64. Hendrick Goudt. *Two Mounted Guards.*
Pen drawing.
Ecole des Beaux-Arts, Paris

young Hendrick Goudt. I found a drawing by him showing the same group consisting of two <span style="float:right">Ill. 63</span>
fashionable ladies accompanied by a gentleman wearing a plumed hat, in a style inspired by De
Gheyn's[10]. He also sketched the same two horsemen at walking pace, one of them wearing a <span style="float:right">Ill. 64</span>
plumed hat, whom De Gheyn had shown cantering along the beach[11]. These two drawings confirm
my supposition that Hendrick Goudt served some form of apprenticeship with De Gheyn from
1602 onwards. The young man on the extreme right of the print, who is doffing his cap to the
elevated company, may even be a portrait of him. We shall return to Goudt in the final chapter.

Now we have seen how intently De Gheyn had concentrated on depicting his environment during
these years, we must consider whether his numerous drawings include any other important signs of
such application. However, as the volume of his drawings expands, it becomes increasingly diffi-
cult to arrange them in chronological order. His idiom had by now more or less assumed a definite
form, although it continued to vary from instance to instance within the same period. We can only
rely on minor indications to suggest a number of hypothetical dates.

One of these refers to the incomparable portrait of a young mother with her small son looking at <span style="float:right">Cat. II 672,<br>pl. 164 and</span>
a picture-book by candle-light. The pen-drawing is sketched with great ease, but the artist gave it <span style="float:right">frontispiece vol. III</span>

81

special emphasis and a sense of profound intimacy by isolating the closely knit group by means of a dark background applied with a brush. This clair-obscure treatment was totally distinct from Caravaggism, which had not yet penetrated as far as Holland, and it was based entirely on an observed situation. It is an immediate forerunner of Rembrandt's intimate evocations, and constitutes a warning to us not to explain the latter's works as due entirely to Caravaggio's example! It would be natural to think of a domestic scene with Eva de Gheyn spending the evening showing young Jacques a book of animal and tree sketches by her husband. The child's age would point to a date

Cat. II 620, pl. 327; 618, 619, pl. 433, 432

around 1602. A drawing illustrating a similar theme, with a man writing up his cash-book, perhaps features another of De Gheyn's relatives, and other examples like this may have been produced at a later date.

Cat. II 783-785, pl. 254-256; 795, pl. 250; 30-32, pl. 245-247

One model at least is known to have posed for De Gheyn, and that was Prince Maurice's groom. Studies of his head are easily recognisable and appear to have been executed in black chalk, an argument in favour of studies of his body being in the same material. I also think he posed for De Gheyn a little later on, wearing a somewhat different set of clothes. This was when De Gheyn was planning to paint an *Adoration of the Shepherds*, for each of whom the model had to adopt a

Ill. 117

different pose. There is a sheet of sketches at Rennes, signed *Goudt,* which shows a number of figures copied from designs by De Gheyn: two of the standing figures, somewhat sketchily drawn, appear in the grouping for which they were ultimately intended. One of them, however, is also

Cat. II 950, pl. 249

included in the landscape with a farmhouse which is dated 1603 and therefore provides the latest possible date for the entire group.

It must have been in the same period that De Gheyn started drawing from the nude. This led to a veritable campaign in which he not only made a thorough study of the true appearance of the female form, but also produced a number of drawings of superb quality. Most of them appear to feature the same model, and the possibility of his wife having posed for him cannot be ruled out, strange as this may seem bearing in mind the decorum observed in high circles. Although this obviously has nothing to do with the aesthetic value of the drawings, it is interesting in that it breaks with existing convention for the sake of penetrating the appearance of nature. Here again a comparison with Rembrandt comes to mind.

Cat. II 802, pl. 6

It is possible that in the course of his apprenticeship to Goltzius, De Gheyn had on one occasion also done a pen-drawing of a standing female nude. This work at least belongs entirely to Mannerism. The long veil fluttering from the figure's shoulders reminds one forcibly of the shape of the banners in the military prints. In this study in the Amsterdam Printroom, the clear delineation of the hands and feet is also reminiscent of De Gheyn in a later phase, but there is no definite proof he drew it. However, around 1603 he was drawing his nude figures, now clearly from life, in chalk on tinted paper, sometimes partly completing them with a pen. Parker once attributed to De Gheyn a

Ill. 65

silverpoint drawing (London, British Museum) of two standing female nudes, previously thought to be by Dürer. Since then, Rowlands has suggested the name of Lucas van Leyden[12]. If he is right, De Gheyn may well have known this drawing by Lucas, which would not have been an isolated instance. The standing woman holding her shift up to her may then have been his first reaction to it.

Cat. II 803, pl. 276

The curves of the body are rendered by means of parallel, lightly undulating hatchings in fine chalk, as if the artist had been copying Lucas' technique. Afterwards, he added his own powerful shading and strengthened the drawing of the shift with more forceful pen-strokes. The concept of the 'Model

Cat. II 804, pl. 275; 800, pl. 278; 808, pl. 274; 807, pl. 277

seated on the ground' in Berlin is similar. De Gheyn's complete mastery of the nude figure is also evident in the drawing with four studies of a seated woman doing her hair, and two drawings showing a reclining nude. Particularly cat. 807, shown beneath a looped bed-curtain, and drawn in black and white chalk only on chamois-coloured paper, comes close to the suppleness of Rubens' nudes.

65. Attributed to Lucas van Leyden.
*Two Female Nudes.* Silverpoint.
Attributed to Jacques de Gheyn
by Sir K.T. Parker.
Printroom, British Museum,
London

Cat. II P 7

Bearing in mind this drawing, it is easy to understand that the fifth and last of De Gheyn's paintings mentioned by Van Mander as having been painted in 1604, was a *Venus asleep.* She was accompanied by a sleeping Cupid, and two satyrs approached her feet, one of whom *al schroemende,* hesitantly, was trying to lift the thin drapery from her body. It is possible that the Venus was based on one of the drawings referred to above. Van Mander praised this painting lavishly on account of its composition, poses and proportions, as well as for its fluid brush-work. Unfortunately, the work has not been found, but if the opportunity arises it may be identified positively by the elongated proportions of De Gheyn's model as compared with those of the stocky figure Goltzius used. The description, however, shows how De Gheyn's life studies also helped him when painting subjects Van Mander refers to as *uyt den gheest,* from imagination.

In painting a life-size recumbent nude, Goltzius was a year ahead of De Gheyn: his *Danae* dates from 1603[13]. De Gheyn must have seen the painting at the Leyden home of Barth. Ferreris immediately after its completion. It does not seem to be a mere coincidence that De Gheyn produced his own large nude a year later. Rival artists were still producing sequences of related themes, like ques-

Cat. II 807

tions and answers, or as a challenge and response, thus creating an opportunity to draw comparisons. The indication of the cushions and looped curtain in De Gheyn's drawing may have been inspired by Goltzius' painting. But his *Venus* is just as likely to have followed cat. 808. It may be assumed that most of the studies of female nudes were produced shortly before the painting of 1604.

Cat. II P 11,
pl. 3

Cat. II 204,
pl. 78

The penultimate, or fourth painting mentioned by Van Mander was a *dootscop*, a skull, which was to be seen at the home of Reynier Anthonissen in Amsterdam. Van Mander gives as a date 1604, but it was actually painted in 1603. The painting was discovered by I. Bergström and published by him in considerable detail[14]. It was not merely a skull, but a detailed and profound allegory of mortality. De Gheyn had already taken infinite pains when working on this theme in 1599. It was then that he drew an allegory for a folio-size print to which Hugo de Groot added texts. Van Mander had his own scene engraved by J. Matham in the same year[15]: it features a double window, loaded with three pairs of tablets, a tall vase of flowers in the centre of the plinth, and beside this a putto and Death, all seen against a distant landscape. It is no longer possible to decide which of the two versions was the challenge and which the response. But it is significant that Van Mander gave the vase such a prominent position just at a time when De Gheyn was also taking an interest in flower arrangements[16]. It is also noteworthy that allegory was displaying a tendency to establish itself in still life. This process was completed by 1603 and was to have consequences lasting far into the century. De Gheyn retained the flower vase and smoking urn from his design of 1599, but for the old theme of the Dance of Death — king and peasant, symbols, after the manner of Holbein, of the futility of social position in the face of Death — he substituted Democritus and Heraclitus, symbols of the vanity of every human reaction, and placed them above the niche containing a skull and a glass ball, and, on the plinth, the equally useless money. The glass ball — and herein lies great subtlety — reflects the many disasters man cannot avoid in life, but which are nevertheless of his own making. A heart transfixed by an arrow is seen on the shining surface of the ball, as if the light on it reveals that the ultimate cause of all sorrow, as well as the final remedy for it, can only be found in love, in the wounded heart. There is no actual reference to Christian love, but this can be read into it by anyone wishing to do so. The allegory's climate remained pessimistic or fatalistic, but could still be taken as an admonition. Anyone wishing to make a further study of the symbolism is advised to read Bergström's detailed discussion in *Oud Holland*.

Cat. II 206,
pl. 163

Undoubtedly De Gheyn had come face to face with death on more than one occasion over the past years. He lost his brother-in-law in 1602, a year in which there had been a serious outbreak of the plague. In 1600 he had been called upon to draw Walburgis van Nieuwenaar on her death-bed. The variety of his reactions is remarkable however. In 1600 he had already produced one of his most moving drawings: a woman surprised in her sleep by Death, who summarily thrusts a knife into her head. Judged by her clothes, she may well have been a relative or in any case a contemporary, and only Holbein had managed to portray the work of Death so directly, and with so much bitterness. The still life of 1603, on the other hand, reveals a more philosophical concept of the theme. Not the relentless blows of Nature, but their significance for our contemplative minds were symbolized there.

Cat. II 136,
pl. 264

Before including Democritus and Heraclitus in the above still life, De Gheyn had also shown them in a drawing, where they are sitting beside a globe, and this reminds us that Cornelis Ketel had recently popularized these characters by portraying them on the front of his house[17]. Ketel, along with Van Mander the most erudite of the Mannerist painters, showed the two philosophers bending over a globe, and flanked by a symbol of Time, which can only be conquered by Art. Responding to this aspect, De Gheyn transferred the theme to the realm of still life, and showed the seated phi-

84

losophers as statues in grisaille against a rear wall. The still life gained in concentration as a result of this device, since a separate scene was no longer required for the philosophers to put the rhetorical question 'Is it better to laugh at the world or weep for it ?'. Instead, such reactions were subordinated to a more deeply analytical and subtly descriptive manifesto that penetrated to the dramatic roots of *la condition humaine.* De Gheyn had fully mastered the art of expressing himself in symbolic images.

The painting also has its chromatic peculiarities. Colours stand out sparingly in a predominantly tonal arrangement. Significantly, the brilliant red tulip is placed below Democritus as an 'active' flame, contrasting with the deathly pall below Heraclitus. This tendency to let ochres predominate and to avoid gaudy colours is occasionally apparent in De Gheyn's later paintings, although it was to disappear entirely from his still life work. The sober colouring of the 1604 still life is surely due in part to the sombre subject-matter. This effective symbolic use of his resources is one of the reasons why the still life with the expressive skull marks one of the peaks in the development of his art.

We may assume that, *mutatis mutandis,* this was also true of the large flower still life commissioned by the States in 1606 for presentation to Maria de Medici. The painting is no longer known, and we can only form some idea of it because of its possible analogy to an impressively large flower-piece painted in 1615. This is distinguished by the bright colours of the many varieties of flowers, which are rendered with great care, but in a stiff, symmetrical arrangement. <span>Cat. II P 38</span> <span>Cat. II P 41, pl. 10</span>

In his drawings meanwhile, De Gheyn's imagination was becoming active in the haunting territory of ghosts and underworld, themes which owed their especial rise to Hieronymus Bosch. His earliest work of this kind known to us is a *Christ in Limbo* drawn with pen and brush in one of the last years of the sixteenth century. A host of fiendish spirits vainly endeavours to prevent Christ from opening the gates and freeing the first human couple from Limbo. On the right are the gaping jaws of a gigantic fish, with an owl sitting quietly inside them. In the background, cities burn, and devils, witches and other beings rush through the smoke-laden sky. <span>Cat. II 59 pl. 51</span>

The attitude of De Gheyn's old friend Hugo de Groot demonstrates that this particular theme had become unpopular in the North. It was the sole article of faith De Groot omitted from the Creed in the Catechism he wrote for his daughter when he was in prison[18]. For centuries the Church had thought it beneficial to include the theme in the mirror it held up to mankind, but it had been discarded in the change of religion, whereas painters in Antwerp continued to illustrate it. It is hard to imagine to what extent such a subject had anything to do with the religious convictions of De Gheyn, who was to use a far more abstract mode of expression in his allegories on mortality. We may assume it amused him to let his imagination run riot. Nor did Van Mander read anything more profound into the works of Hieronymus Bosch which, currently, appear to inspire far more circumstantial comment than that of being merely *koddig om t'aanschouwen,* droll to observe.

The memory of Hieronymus Bosch is clearly seen to live on in an ice-scene dating from the same period, in which a tree-person is carrying a dish of frogs plus decomposing victims of the gallows towards a monster looking up out of a hole in the ice. This drawing simultaneously conceals and reveals a state of the artist's subconscious mind; twisted by the course of his life into the allegorical form of an ancient tree with two roots[19], man is ordered by a devil holding two swords to carry the offerings laboriously across the slippery ice to the waiting, all-devouring monster. None of the soul's burden of memories and experience can be obliterated, and it has to put up with the young couple frolicking with a jester just below its top, and tolerate the eagle which, high above everything else, has brought home its quarry to its young. Thus fate propels man along amidst his environment. <span>Cat. II 510, pl. 271</span>

It is precisely here, in this evocation of the soul's bondage, that we observe in De Gheyn not

merely a draughtsman, but also a visionary, a poet. His many representations of witches confirm this notion. A physician such as Paracelsus may well have based his findings on experience, on observation[20], but sixteenth century scholarship as a whole still reckoned with mysterious, immaterial and spiritual forces at work in nature, forces which the mind cannot explain, which go beyond reason and can only be comprehended by intuition. The circle of philosophers and pansophists which the Emperor Rudolf had gathered around him was still busily engaged in attempting to locate them by means of occultism, alchemy and magic, in order to define and ultimately subjugate them[21].

The Church, however, had in a similar reservoir discovered the forces whereby it was threatened and which it had to resist as if they were the blasphemous work of the Devil, the Antichrist: witches were in his power and had to be exterminated. In this way the thriving white magic, which sought the lapis philosophorum and embraced the *chymische Hochzeit* in its programmes[22], and black magic, which was supposed to celebrate orgies on the nights of the witches' sabbaths, touched each other.

In the sixteenth and seventeenth centuries thousands and thousands of unfortunates perished at the stake in France, Spain and Germany after merciless mock-trials[23]. After the publication in 1564 of Johan Weyer's *Pseudo monarchia Daemonum* the number of trials decreased, particularly in the Netherlands[24], although, in the South at least, they did not cease altogether. After 1620 Germany was once again to be plagued seriously by them. Weyer regarded the unfortunate women's manifestations as psychic disturbances or diseases. Heurnius and Pauw, both of them acquaintances of De Gheyn, were among the Leyden professors who reported to the States in 1594 on the trial by water resorted to in the case of witches, the apparent reliability of which they refuted on natural grounds. Simon Stevin thought along the same lines, and, as a lawyer, Jacob Cats managed to procure a woman's acquittal on one occasion. In England, Reginald Scot's *The discovery of Witchcraft* contributed most towards debunking the belief in the existence of witches, but James I relapsed into the old superstition, whereupon the laws were tightened up in 1603 and all copies of the *Discovery* were ordered to be burnt. Thomas Basson had received a copy in 1602 and subsequently worked on a translation which was published in 1609[25]. Van Dorsten suggests that Petrus Scriverius urged him to publish it; he certainly wrote a sonnet commending it. The University Governors granted the printer 30 guilders. One is reminded that Govert, Thomas' son and collaborator, was to marry Anna de Gheyn in 1608. Consequently, De Gheyn must have been familiar with the *Discovery* by 1609, and probably long before then. It is therefore abundantly clear which side he favoured. I think it is valid to draw the conclusion that De Gheyn's aim was not only to display his virtuosity, but also to undermine the belief in the existence of the so-called work of the Devil by means of drastically overcharged representations, and by appropriating the entire theme for the benefit of the artist's creative imagination, as well as for his own entertainment and that of his viewers. He was therefore of the company of Shakespeare, who was also inspired by the *Discovery*, in *Macbeth* as well as in *A Midsummer Night's Dream*. The paraphernalia and requisites for the abominated rituals of the Devil, mostly age-old relics of forgotten heathen rites, were well known to De Gheyn, and he exploited them with spine-chilling competence. He may well have derived them partly from the extensive incriminating writings still used by the judiciary. The best-known of these was the *Malleus Maleficarum*, written in about 1490 by the Inquisitor General of Germany, Jac. Sprenger O.P. The Church itself had mythicized the rites of the witches' sabbath and tortured the unfortunate incriminated creatures into confessing they had taken part in the imaginary cult[26]. In some places this cult was identified with the Reformation, but originally it was the target of all heresy hunters and it was also manipulated by Protestant tribunals. Hieronymus Bosch, who cannot have

been unaware of the *Malleus,* laid the rich foundations for illustrating demonology, but the witches' theme is derived rather from the same Germanic reservoir Goethe too was to draw on for his *Walpurgisnacht,* or else from the works of Hans Baldung Grien and Dürer, sources that were certainly tapped by De Gheyn. From them he acquired sufficient imagery to develop a thematic repertoire that was not superseded until the days of Goya, who raised it to a level with greater appeal to modern man.

The first document that can be dated is the series of sketches on the reverse of a page with some studies for the *Land-yacht,* and therefore attributable to 1602. It includes the magnificent watercolour drawing of a lobster, perhaps supplied by Scheveningen as being something out of the ordinary. There are also two scenes: the first one features a down-and-out signing a contract with a group of proboscidiferous devils, one of whom holds a shield with a transfixed victim above his bottle-shaped head, and the second an elderly procuress and a naked woman leading off a victim, himself now promoted to devil. As an introduction to De Gheyn's occult representations these two sketches indicate that there is an erotic element at the root of most of his scenes of infatuation and witchcraft[27]. A small, wildly sketched fantasy which is to be found at Rennes is dated 1603 and provides a synopsis of the ghost-industry: an old witch is seated, amidst the remains of victims, in a vault beneath the stairs, and staring at the small image of a man, a *homunculus.* On the stairs, another witch leads a goat away from an archway, through which the skeleton of a horse is gazing. A goat ridden by a man canters across the sky. Linked with this drawing is an even wilder representation of four naked beings in a goat-cart with, on a dish, the offerings transfixed by a cross, and a bat flying through the smoke from the fire. In yet another drawing, witches are boiling a pot of human remains, while a cat looks quietly on. A somewhat similar scene appears in the folio drawing at Christ Church, Oxford, where a naked human couple are seated on a monster that could hardly have been invented without some notion of giant prehistoric animals. This may well have been one of De Gheyn's first efforts in this field. The sketch in Dresden, on the other hand, is closer to the one at Rennes, but in the former the pot-boiling scene is transferred to the first floor of a complicated ruin which also harbours an elephant as a proboscidean, and seated witches in the vaults. Amidst winged devils, a multitude of other witches on broomsticks fly through the smoke-laden airspace.

The two drawings with the most complete pictorial composition are the examples in Oxford and Berlin. The Oxford drawing shows a vast vaulted cellar where witches are engaged in their gruesome manipulations. A ripped-up corpse is lying on the floor next to the pot in which they are preparing their magic potion. It looks as if De Gheyn had already attended an anatomical demonstration at Leyden, one indication being the horse's skull which is taking part in the occult act and is shown in the same position as it occupied on the complete skeleton displayed in the Anatomy Theatre. There is another skull, still adorned with tangled hair, a frog's body, and an abundance of unguent jars, cats, mice, and bats. The great *trouvaille,* however, is the vastly magnified shadow which is cast by the stooping woman on to the lighted vault, and there follows the direction of the vaulting. Here De Gheyn devised an artifice of a kind employed again and again by Rembrandt[28] as well as in the subsequent history of painting. It is highly effective. In view of its style, this drawing cannot be later than 1604. The new element in the repertoire which appears in the Berlin drawing, where the date 1604 is not entirely legible (1608?), is the procession entering the overcrowded kitchen. Preceded by a stately woman wearing a bishop's mitre and holding a candle, a naked Salome enters, bearing a head in a dish. Above the vaulting, where rats sniff at a corpse, the cooking scene is taking place, while a witch is just flying into the fireplace on her broomstick. Another room contains the sleeping figure of a woman. There are a number of variations of this scene, all

Cat. II 514 recto, pl. 218

Cat. II 521, pl. 261

Cat. II 517, pl. 434

Cat. II 524, pl. 342

Cat. II 518, pl. 336

Cat. II 520, pl. 260

Cat. II 523, pl. 273

Cat. II 522, pl. 272

based on the theme of the witches' sabbath. If one insists on assuming that De Gheyn was deliberately pronouncing a moral judgement in these drawings — both he and De Groot moralized about their times — then it is possible, although not verifiable at present, that it held a veiled warning to young men or students, as the case may be, who were in danger of being ensnared by drug addiction or by the wild parties certainly indulged in by the worldly circles of the Court at The Hague and elsewhere at this time.

Cat. II 519, pl. 337-339; ill. 67

The campaign was to culminate in the somewhat damaged, large-folio design in Stuttgart for the engraved *Witches' Sabbath*, one of the mightiest products of graphic art, which, presumably because of its rarity, has not yet received the appreciation it deserves. We are still somewhat in the dark as to when it was produced since neither the drawing nor the print bears a date, but as Nicolaes de Clerck of Delft was the publisher, it is presumably later than the works discussed so far[29]. De Gheyn was apparently endeavouring to make his interest in witchcraft universally known, and he was certainly successful in this; its influence is particularly evident in the graphic work produced in France, and probably also in *The Temptation of St. Anthony*[30], one of the best-known engravings by J. Callot who may have been familiar with the print.

Not all the details can be described here, but it is worth noting that in De Gheyn's folio print, the preparations in the cauldron take place in a landscape setting. Amor, seated on the Leviathan from the Christ Church drawing and holding an arrow, is introduced as the *primum movens* of the aberration. One is surprised to discern, beneath the explosion that causes the entire atmosphere to vibrate, the view of a pleasant mountain lake bathed in late afternoon sunshine. The composition was constructed with a great deal of forethought: it is as if one looks out on to that peaceful light from beneath swirling vaults of smoke and tears.

Cat. II 892, pl. 386

De Gheyn drew several *studies of frogs, rats and mice*, finally arranging their dead bodies in various cramped positions[31]. From these he also distilled the freakish monsters that crawl around in these haunted scenes. In one of the studies an open book of spells — as demonstrated by the picture of a hand in a circle — is lying on top of a skull. This entire still life really also belongs to his world of phantoms. Something had changed since books and a skull were quietly engraved on the window-sill of Dürer's *Hieronymus im Gehäuse*.

Cat. II 131, pl. 313

The year 1605 also saw the creation of another ambitious work dealing with a kindred theme. In this large drawing the scene is set in the Greek underworld. Orpheus is playing his lyre — which has become a harp — for Pluto and Proserpina who are seated, somewhat entwined, on a throne beneath a baldachin. On the right, Cerberus is protesting by an archway, but, above him, Euridice is already descending. Pluto's palace resembles a Roman ruin rising up out of the water, with scenes of battle and torture taking place in and above it, and witches mingling with demons. The vast stage consists of the monumental ruin, its promontory on the right, and a landscape bounded by a high mountain range. With inexhaustible imagination, the artist permeated and garlanded all these elements with a pall of smoke which rises from the left, bifurcates beneath an arch in the vaulting, and spirals up towards the right in revolving strands of cloud, with ghosts flitting through them. This drawing is distinguished by its delicate technique reminiscent of the elder Bruegel, and totally different from the one used in the scenes of witchcraft described earlier on. Here again, despite the complicated build-up, the artist never lost sight of the overall composition.

In Leyden, De Gheyn was on friendly terms with the family of Burgomaster Isaac Nicolai Swanenburgh. The latter was a painter himself and also a draughtsman, as we have seen; he must have trained three sons in the same crafts. Willem, the youngest, devoted himself to engraving and was deeply mourned after his early death in 1612; it was probably Scriverius himself who, using the monogram *P.S.*, wrote a verse calling upon De Gheyn and Goltzius to extol, better than he could

do himself, the virtues of the deceased[32]. Perhaps he read out the rather pathetic poem to the mourners.

Willem's elder brother Jacob was in Italy from at least 1592 until 1615; he married a Neapolitan, and in 1608 was summoned to appear before a tribunal of the Inquisition on account of a painting of a witches' sabbath[33]. This story shows how paintings like De Gheyn's spectral scenes and witches' kitchens were still unacceptable to the Roman Catholic Church under the rules for artists drawn up after the Council of Trent[34]. One suddenly realises what it meant that there was no danger in publishing such scenes in Holland; in Naples, Jacob Swanenburgh only just managed to extricate himself from the Inquisition's clutches, and from then onwards he probably confined himself to painting his city views, including several where the cardinals are shown riding in full fig across St. Peter's Square. This artist must somehow have been an early acquaintance of De Gheyn, even if he was not actually a pupil as I assumed in my *Introduction*[35], because he is now known to have left for Italy before Jacques arrived in Leyden. But Van Swanenburgh must have known drawings like De Gheyn's *Christ in Limbo,* and he borrowed from De Gheyn the flabby jaws of Hell appearing in several of them[36], the construction of the underworld[37], and the dead bodies and skeletons in action[38]. He links up with De Gheyn's earliest works of this kind, as he usually painted scenes of Hell and is unlikely to have used De Gheyn's later folio print of a *witches' sabbath,* since he was abroad when it was published. However, the ghost-ship flying through the air with its sails in shreds[39] appears to have been his own invention, although a similar craft also appears, albeit on a turbulent sea, in a *Jonah cast overboard* which was painted by Maarten de Vos in 1589[40].

Another theme introduced by De Gheyn and popular as late as Teniers, was that of *gipsies*, or 'heathen', as they were called. He may have started drawing them at about the same time as the earliest scenes of witches, and the later folio print shows an old, bare oak tree similar to the one in the print of the *Fortune-teller*; in any case the themes are not wholly distinct from each other, in view of the witch-like appearance of some of the gipsies.

The first gipsies crossed our eastern borders around 1420, and in the course of the next two centuries they were followed regularly by small groups who continued to roam about the countryside. Towards 1500 edicts were issued to expel these unwelcome foreigners who, apart from tinkering, lived at the expense of the native population, and in the days of De Gheyn they were banned from all the provinces and frequently mentioned in the same breath as beggars and vagrants[41]. But many folk crossed their hands with silver to have their fortunes told, and it was this kind of happening that De Gheyn drew for engraving. In Leyden, on the other hand, this remarkable people aroused scientific interest, and the two oldest vocabularies of their language came from the Netherlands. One of them was compiled in the vicinity of Aachen, and Scaliger passed it on to Professor Bonaventura Vulcanius, Marnix' learned protector, whose *De Literis et lingua Getarum sive Gothorum, etc.*, published in 1597, already included this glossary. Gipsies were therefore also a subject for study, and De Gheyn supplied a number of doubtlessly faithful illustrations for the purpose. An elegant young lady, accompanied by her maid and a dog, has her fortune told beneath an ancient oak-tree, and holds up a coin in her hand. Another couple and a child are seated by the tree.

The subject is drawn and engraved with great sureness of hand, but the engraving lacks the charm resulting from the interplay of greys and browns in the drawing. More gipsy-women in sack dresses appear on other pages of studies; one is spinning, and another one is even holding a snake. The artist was particularly interested in types with dishevelled hair resembling the haggard old witches and their improvised clothes. He also featured itinerant gipsies in one of his six small engraved landscapes, and these may well have inspired artists such as D. Vinckeboons and H. Avercamp to include them in their landscapes, while the Pseudo-van de Venne made a speciality of them.

Cat. II 59

Ill. 66

Ill. 67

Ill. 68

Cat. II 534,
pl. 301

Cat. II 535-537,
pl. 298-300; 538,
539, pl. 421, 422

Cat. II 969,
ill. 75

89

66. Jacob Isaacsz van
Swanenburgh.
*The Torments of Hell.*
Stedelijk Museum
'De Lakenhal', Leyden

67. Jacques de Gheyn II.
The large-sized
*Witches' Sabbath.*
Engraving.
Rijksprentenkabinet,
Amsterdam

90

68. Jacques de Gheyn II.
*The Fortune-teller*.
Engraving.
Graphische Sammlung
Albertina, Vienna

91

The large tree with fissured bark and heavy roots featuring in each of the prints was the result of sketching expeditions at times when De Gheyn was taking a special interest in old trees. There is a whole series of them, not all belonging to the same period, and again without a single date that might shed some light on the question of when De Gheyn's two final master engravings were produced. This must have been prior to 1615 when he no longer referred to himself as an engraver in the Guild Register. One cannot go beyond surmising that the youngster appearing in one of them, as well as in a view of the fields near Voorschoten, was young Jacques, who accompanied his father on these sketching expeditions, and that, to judge by his apparent age, the date of these drawings and the prints mentioned above was about 1610 but no later. By then we have arrived at the most mature period of De Gheyn's artistic career, and it is certain that several of the other tree studies are earlier. Similar studies by Abraham Bloemaert are also known, but there the emphasis is on grace and elegance. De Gheyn's work is executed with greater *bravura* and is distinguished by the understanding he displayed for the substance of the bark, the bare, stripped trunk, the leafy roots at its foot and the indication of the direction of the branches' growth[42]. In fact, he dramatized his

Cat. II 998 recto,
pl. 304

Cat. II 945,
pl. 363

*Inter alia*
Cat. II 986,
pl. 265

69. J.Matham. *Faith, Hope and Charity*. Engraving. 1590. After H.Goltzius. This print shows how Goltzius was amongst the first artists to draw views of mighty trees with exposed roots. Rijksprentenkabinet, Amsterdam

subjects, and one is conscious of the vestiges of a mannerist tendency to use landscape for the purpose of portraying budding life. Goltzius had been the first to present this kind of monumental tree, full of movement, in his design *Faith, Hope and Charity* for a print by Jacob Matham, which bears the early date 1590[43], but later on he insisted on their purely pictorial aspect.

H. 255, ill. 69

A number of masterpieces among De Gheyn's later landscape drawings may be mentioned here. In 1603 he included a goat-ride through the clouds in a biblical theme, this time referring to the consequences of *accidia,* sloth, which, although it had become a favourite subject for sixteenth century painters, had so far usually been illustrated in some scene other than that of the *Devil sowing seeds*[44]. A countryman, stretched out beside his horse, is sleeping off the effects of a plentiful repast, while the Devil travels across the land and the apparitions in the eddying whisps of cloud harbinger nothing but ill. As in the witches scenes, there is great dramatic tension in this illustration. When, at a later date, he isolated the sleeping man in a purely Dutch landscape with a central group of trees, one of the earliest examples of a composition still popular in Ruysdael's day, that well-tried dramatic power greatly benefited the landscape itself. This drawing proves that De Gheyn, a late-comer in the genre of true landscape, ultimately came to be far ahead of his time. There is much less dramatic power in the earlier landscape with a barking dog despite the lugubrious wheel with a corpse on it, past which, in the second plane, a cart is being driven to an army encampment; here the trees clearly follow the older style. Each of these drawings was a complete creation in itself, and this is a clear indication of how the importance of drawings had increased, so that, as an art form, they were now fully equal to paintings. What had been achieved by Dürer had, in a way, become equally valid for the Dutch.

Cat. II 50, pl. 236

Cat. II 957, pl. 428

Cat. II 958, pl. 81

To De Gheyn, adding one or more figures to a landscape no longer simply meant 'furnishing' it in the sense of completing it with secondary matter; the figure was one of the essential elements and was involved right from the first, although mainly after he started drawing from nature. A larger-scale figure has already been mentioned, and must have been used for an *Adoration of the Shepherds,* but it was also inserted in the view of a farmhouse dated 1603. This drawing already includes all the thematic elements of a genre that, repeated endlessly in the first half of the seventeenth century and as late as the etchings by Rembrandt and Ostade, gained much in clarity through concentrated arrangement and lighting. De Gheyn overloaded the foreground with willows, a tree trunk, fencing, a broken wheel and the peasant couple standing by the cow that is being milked, all drawn more aggressively than in Lucas' engraving of a milkmaid. The farmhouse is in the second plane with dovecotes and small, active figures, while a distant view forms the third plane, with the dunes showing up light against the horizon. The drawing may suffer from over-emphatic descriptiveness, but it presents a highly animated synopsis of farm life. As yet, the function is nowhere subordinated to an aesthetic fantasy of the truth.

Cat. II 30, pl. 245
Cat. II 950, pl. 249

There is an etching of this drawing in reverse, which Ludwig Burchard attributed to Jacques de Gheyn and described as one of the first masterpieces of the new Dutch art of etching. Since then a second etching by the same hand has been discovered, which features a huntsman and a timber house by a pool surrounded by willows and which seems a less obvious example of De Gheyn's work. The only specimens of the two etchings are printed on heavy paper that might be eighteenth century, and so the alternative possibility of their being much later cannot be dismissed. This is all the more probable as the etched line only suggests spontaneity, whereas in fact it closely follows the impetuous drawing, in the way a copyist or even a falsifier might do. I therefore consider it less likely that a contemporary such as Simon Frisius or Esaias van de Velde made etchings of two drawings, perhaps by different artists of the period.

Ill. 70

Ill. 71

An example of De Gheyn's later development in the direction of a somewhat more poetic mood

70. Anonymous.
*A Farmhouse*.
Etching after
a drawing by
Jacques de Gheyn II
(Cat. II 950).
Kupferstichkabinett,
Berlin

71. Anonymous.
*A Farmhouse by a Brook*.
Etching. Perhaps
late 18th century and by
the same hand as ill. 70.
Kupferstichkabinett,
Berlin

is to be found in the view of fields with a village church in the hazy distance, presumably drawn on the spot in the vicinity of Voorschoten; a seated boy resting his head on his hand is seen in the foreground. It is spring, the willow-trees are coming into leaf, and the more distant shades are softened and refined. The quiet figure enhances the stillness of the surroundings and bestows upon the drawing the character of a landscape of mood in the same way a lyric poem might do. In evoking such a mood De Gheyn was again far ahead of his times.

Cat. II 945, pl. 363

One becomes more and more convinced that a small number of these works were drawn immediately from nature. Without precise exemplars, the artist could not have produced such true impressions, however much he relied on experience and the habit of inventing his own landscapes. This was apparent in the study of old tree-trunks, but also applies to the slender stems of a group of trees stirred by the wind as well as to the still freer treatment of weathered oak-trees on the edge of a forest. It is worth noting that this last subject, in my opinion an impression sketched on the spot, was certainly created long before Willem Buytewech and Hercules Seghers produced their interpretations of closely related themes[45].

Cat. II 986, pl. 265
Cat. II 985, pl. 76

It is still extremely difficult to place many of these undated drawings in any kind of chronological order. Fortunately, there are four dated landscapes belonging to the first decade of the seventeenth century and dated 1602, 1603 and 1609 respectively.

The year 1602 saw the creation of a view of a tall bridge surmounted by a lantern, with two men standing on a jetty in the foreground paying the ferryman for his services. The appearance of the bridge and houses suggests superficially that they were based on the impressions of an artist who had looked round Prague, Venice or some other city. But the idiom, effect and even the form of two graceful bridges reflected in the calm water are certainly Dutch, and Jacques de Gheyn's own reaction to what he observed. Moreover, the originality of the composition is undeniable.

Cat. II 942, pl. 222

The castle on the rocks overhanging a stretch of water with a fortified bridgehead is dated 1603. There is even a Dutch bridge-tower. It is a type of drawing of which there are other examples in De Gheyn's oeuvre: the movement of nature is contrasted with the static verticality of buildings which, together with the horizontal provided by the water, give the eye the support required to regain a sense of balance that has been thoroughly upset by the extravagance of the rocks. Such a bold juxtaposition of mannerism and realism in a single composition really amounts to something like mannerism squared; however, this type of phenomenon was confined to the final phase of the movement that arose in Haarlem around 1585. The drawing of the farm and its workings described above also dates from 1603.

Cat. II 966, pl. 235

Finally, the date 1609 appears on a wide *mountainous landscape* with a distant view of the coast; bandits have robbed a man, and a guard-post on a hill in the foreground is darkly silhouetted against a light line of hills. Even here, the artist, who so much enjoyed contemplating nature, did not hesitate to mould it to his own purpose. All the elements in this highly dramatic scene, the mountain massifs, heavy cloud formations and arched shape of the earth's surface in the foreground and distance appear to form one cohesive fluid movement, against which the guard-post, church tower, castle and ships offer a minimum of vertical support to the eye, which experiences these contrasts with a certain amount of tension. The drawing proves once again that De Gheyn's development did not proceed simply from mannerism to realism, but that he kept the two tendencies permanently at his disposal. This was confirmed when later still he was to design a fountain for Prince Maurice which may be considered a final pinnacle in the history of Mannerism.

Cat. II 961, pl. 364

He seems to have taken a retrograde step in drawing his most detailed landscape which gives rise to a whole series of problems[46]. I refer to the drawing acquired by the Pierpont Morgan Library in 1967 for the highest price which, at that time, had ever been paid for a De Gheyn. There is a second

Cat. II 1049, pl. 199

72. Jan van Stinemolen. *View of Riardo, Monte Maggiore and the Valley of Capua.* Drawing.
National Museum, Stockholm.

Ill. 72 version of the same subject in Stockholm, where the name of De Gheyn, though an ancient addition, is misleading. Contrary to the opinion of others, I consider the latter work to be the exemplar on which De Gheyn based his drawing. The Pierpont Morgan drawing is therefore a copy by De Gheyn, which follows the model in almost every respect, but in which the trees in particular appear to have been executed by an artist familiar with Mannerist usage. On the one hand, this resulted in some of the impulse of the original creation being lost, whereas on the other hand, a link, admittedly a somewhat artificial one, was forged between the various parts of this impressive prospect. In my opinion the Malines draughtsman Jan van Stinemolen was the artist who drew the Stockholm landscape, and I believe Jacques de Gheyn copied the luminous view down to its finest detail[47]. Van Stinemolen must have used a map to construct, at his drawing-board, a general memento of the small mountain city of Riardo, Monte Maggiore and the valley of Capua. Copying and interpreting his work must have been a lesson in landscape treatment which benefited De Gheyn's own creations later on. In 1594 Hendrick Goltzius had sketched an equally ambitious landscape[48], but I consider De Gheyn's still more elaborate work to be of a later date, without being able to decide precisely how much later.

Cat. II 967-972, pl. 270, ill. 73-76     Finally, mention must be made here of the *six small landscapes* published as a series of prints. Only one of the original drawings is known. It is evident that the mountain scenery had benefited

96

*Quid prodest vitasse homines, loca sola secutum    Si capiat Christum est ausus qui tendere contra. 1.*

73. Jacques de Gheyn II. *The Temptation of Christ* (cf. cat. II 967).
The first small landscape.
Rijksprentenkabinet, Amsterdam

*Quicunq Icario defigis lumina Casu    Discito Dedaleis mage post hunc credere verbis. 2.*

74. Jacques de Gheyn II. *The Fall of Icarus* (cf. cat. II 968).
The second small landscape.
Rijksprentenkabinet, Amsterdam

*Nigra fames et rara fides, nisi euro, vel inter Non cultos mage, nos terris agit omnibus orbos.3.*

75. Jacques de Gheyn II. *Gipsies* (cf. cat. II 969).
The third small landscape.
Rijksprentenkabinet, Amsterdam

*Frigus iners qui dixit, enim se fallere discat; Hosce agiles spectans glaciali tempore lusus.5.*

76. Jacques de Gheyn II. *Skaters and golfers* (cf. cat. II 971).
The fifth small landscape.
Rijksprentenkabinet, Amsterdam

98

from knowledge extracted from the above drawing by Van Stinemolen which, by then, may have been in De Gheyn's possession for a long time. The free engraving technique also points in the direction of etchings. The artist seems to have been demonstrating that he was at home in all kinds of landscape: fantastic mountain scenery, a forest with a stag, a Dutch winter scene, or popular way-side stopping-places, with gipsies or pilgrims supplying anecdotal detail. The series also includes one biblical and one mythological theme. This is in contrast with most similar series, which tend to show variations on one theme, or views in one locality.

Halfway between figure-drawing and landscape there is the scene of *the archer aiming at the spectator* and in the company of the same coquettish peasant maiden with whom he is disporting himself among the cows in the meadow in the distance. There he is wearing his own plumed hat, which in the main scene is worn by the girl. The legends in Latin and Dutch show that the print contains a moral: 'Beware of him who aims in all directions lest his bow unmasks you'. The girl helps the archer to take more precise aim at 'that which is inflated'[49]. Panofsky stresses the 'vanity, pride and pompousness' which are combated in this way. I would prefer to read an allusion to Cupid into the archer 'aiming in all directions' and consider the erotic undertone to be the principal motif. Here again we are in uncertainty as to the date of origin, particularly because this definite study for the print may be regarded technically as a work perfecting the drawings of soldiers, whereas a second drawing featuring a variant of the figures only, is an improvisation which exemplifies De Gheyn's greatest virtuosity and breadth of style. Rosenberg believed the preliminary study for the print to be an early work done under the influence of Goltzius, and the broader variant to date from around 1610. I agree with him as far as the sequence is concerned, but would prefer to place both of them later. This is because the complete preliminary drawing makes use of a number of studies of cows[50] drawn in a masterly, sweeping style, and because the reverse of the improvisation illustrates a theoretical tenet which De Gheyn may have learned from a book by Marolais published in 1614[51]. As with Dürer, we are aware that the mode of expression did not depend merely on the date, but also on the purpose underlying a particular commission, in this instance whether or not the drawing was intended to be an accurate preparatory study for the print.

It is plain from his lively sketches that cows intrigued De Gheyn: he regarded them as monuments ornamented by their horns and the angular ridges of their backbones, and weighed down by their immense mass. He was, however, equally fascinated by the smallest of creatures. To illustrate this, one need only mention two sheets of drawings, each featuring four small mice scampering around and portrayed with great application and a sparing use of colour[52]. Further examples are the dead *stilt,* and, on yet another occasion, a brightly coloured *frog* drawn several times in various positions on one sheet of paper. Later drawings of animals include a page with three vigorous sketches of a donkey, first in black chalk, and then more accurately finished in pen and ink.

In these sketches, we are struck by the presence of more than one motif on each page. This is generally characteristic of the earliest sketchbooks that originally served as source-books. During the Renaissance, the single page filled with heterogeneous subjects developed into a genre of its own as a result of an increasing awareness of the aesthetic possibilities inherent in grouping sundry, often extremely diverse subjects and even techniques on one page. Nevertheless, however deliberately composed, the sketchbook page retained an element of chance that continued to surprise. De Gheyn, and also Bloemaert, made a special feature of such sketches, and we would know more about them were it not that incisions show that many examples by De Gheyn were cut up in later days. However, there are several model pages still in existence which amply demonstrate the artist's versatility and virtuosity.

One example is a sheet of drawings, dated 1604 and consisting of nine heads of boys, for which

<div align="right">

Cat. II 217,
pl. 373, ill. 77

Cat. II 216 recto,
pl. 328

Cat. II 834-836,
pl. 409-411

Cat. II 865, 866,
pl. 341, 340

Cat. II 878,
pl. 442
Cat. II 888,
pl. 334
Cat. II 856,
pl. 286

Cat. II 773,
pl. 282a

</div>

*Tiro tuos tensis sic arcus dirige nervis;*     *Wacht, u Oogr sem, die alsins mickt.*     *Quia manibus, cubitos infulas fulcis, dicas*
*De medio ferias cogite quod tumuit.*       *Dat synen boogh, u niet verblieckt.*     *Tortius ut lineas, Et bene Virgo docet.*

77. Jacques de Gheyn II. *The archer aiming at the spectator*.
The large-size engraving.
Graphische Sammlung Albertina, Vienna

he used two different models. The most striking feature here is De Gheyn's ability to portray the way in which, viewed from all angles, the curly hair grew away from the crown. Such pages also formed part of the source-book Bloemaert was compiling for future draughtsmen[53]. In the case of the single page with six heads of boys, the emphasis is mostly on the modelling, which De Gheyn appears to have studied from a sculptural point of view. A third sheet of drawings in an even bolder manner combines a bust and a head with two separate studies of folded or crossed hands. When Rembrandt came to produce this kind of grouping, his closest links were, again, with De Gheyn.

Cat. II 774, pl. 227

Cat. II 778, pl. 302

The largest sheet of scattered, heterogeneous drawings is in Amsterdam. This too contains numerous sketches of boys, including three of the same one, who is first shown reading and then leaning on a corner of the table with his book beside him. Each of these studies is a minor genre piece in itself, and one can understand why a later generation was so inclined to cut out these marvellous snapshots and present them as separate works of art. There are, however, many more things to be seen on this page: studies of hands, a standing negress with a baby in her arms, and a group of half-length figures engaged in some kind of Judgment of Paris. It is likely that the boys and hands were drawn from life, but the additional scenes were imaginary. The combination again provides a sample of the artist's untrammelled virtuosity. Apart from the studies drawn in 1602 in preparation of the *Land-yacht*, the reverse sides of which are covered with other themes, we have only one other dated sheet of studies, the one formerly in Gotha which goes back to 1600. Here one is struck by a number of half-length figures which, although presumably unrelated, are squeezed close together. Arrangements like this also occur in the works of earlier Italian artists. The sheet of paper itself is also very small. Probably this was a very early experiment, soon to be followed by sketchbook pages where the studies were more widely spaced. It is also possible, however, that the page is a fragment of a larger one.

Cat. II 493, pl. 267

Cat. II 495, pl. 166

Whereas the study of a small boy formed the point of departure for the two examples already mentioned, the sheet of drawings in Berlin consists of comparatively free copies of the small landscapes which Hendrick Goltzius published as coloured woodcuts. Other small sketches are scattered among the fragments. The balanced composition is particularly attractive here. Another highly decorative example is the sheet of drawings where a melon and vines are sketched in chalk and brushwork, and combined with the portrait of an elderly, seated woman. De Gheyn continued jotting down casual notes like this until his old age, ultimately returning to smaller pages. One can, as it were, see him thinking aloud in visual terms. The great number of heads and figures of boys and youths may include several of his son Jacques, young Hugo de Groot or Daniel Heinsius, but I would not venture to identify any of them in view of the difficulty of establishing a likeness.

Cat. II 499, pl. 216

Cat. II 504, pl. 229

In any case, by the time he wrote his texts for the land-yacht, Hugo de Groot was a grown man of eighteen with a literary *oeuvre* to his name. The *Land-yacht* was the last but one of De Gheyn's works in which De Groot participated. It is assumed, at least, that De Groot was the prime mover in the scheme to write the history of Prince Maurice's conquests, and that De Gheyn was involved in work on the illustrations for this book, which was finally published in Leyden by J. J. Orlers and H. van Haestens in 1610. *De Geslachtsboom van de Nassausche Helden* (The Genealogical Tree of the Nassau Heroes) had appeared as early as 1601, again through the efforts of Grotius, and also contained verses by him; a letter by Grotius to J. A. de Thou (Thuanus) dated July 31st, 1601, shows he sent the latter a copy for presentation to the King of France. Pictures of the battles, so the letter tells us, had been included in the binding, thus making it a unique copy, which has not been traced so far[54]. I suspect this may well refer to a bundle of illustrated pamphlets and expedition reports, but also including other material in the form in which it was ultimately used in 1610, when the definitive *Nassausche Laurencrans* (Nassau Laurel-Wreath) was compiled. In my opinion, De

Cat. II 289, ill. 78;
290, ill. 79; 291-
294, ill. 80

Cat. II 275-282,
pl. 3, 4, ill. 81-
83

Ill. 84

Gheyn drew not only the title-page for the editio princeps of 1610, but also improved designs for the illustrations, particularly by completing them with figures in the foreground. From this one may draw the provisional conclusion that an idea which had occurred to De Groot at an earlier date, did not assume its final shape until 1610.

De Gheyn also drew all the designs for two other volumes. In 1606 Daniel Heinsius published his *Spiegel van de Doorluchtige Vrouwen* — Mirror of Illustrious Women — with a frontispiece by Hondius and eight prints executed to designs by De Gheyn. As we have seen, the preliminary study for the first print dates from 1591, and I think several of the others were produced later, perhaps one at a time, as De Gheyn received a section of the text. The influence of Lucas van Leyden's *St. Joseph* series on one of them is remarkable. It remains a possibility that the illustrations were completed at Leyden and not published until later.

78. Anonymous Engraver.
Title-page of *Alle de Victorien...*
by J. J. Orlers. 1610.
After Jacques de Gheyn II.
Rijksprentenkabinet, Amsterdam

102

79. Engraver and book as ill. 78. *The Court of Holland.* After Jacques de Gheyn II (?). Rijksprentenkabinet, Amsterdam

Although they were started later than the above series, the twenty-four round emblems accompanied by texts written by Daniel Heinsius under the pseudonym 'Theocritus à Ganda' were first published around 1601, with escutcheons on the title-page left blank for the future owner to complete himself. The work of engraving this very fine title-page was certainly carried out by De Gheyn himself. The actual series was also engraved by him, without any loss of quality, following his delicate and varied drawings. Four of these were found at Brunswick recently. This was the first book of emblems to appear in Holland, seventy years after Alciatus had first introduced the genre. The booklet is extremely rare.

Cat. II 466-490, pl. 168-171

Ill. 85, 86

After settling at The Hague, De Gheyn rarely produced any more portraits, his oldest specialisation. When Hondius was compiling his book of artists' portraits, he must have asked De Gheyn to draw a self-portrait for him to have engraved. It is unfortunate that only the print, which is dated 1610, has survived, but this is adequate enough to give us a clear picture of the mentality of the artist, now in his forty-fifth year, famous, and showered with commissions. He managed to indicate the variety and nature of his work in a number of subtle, but unambiguous allusions. The métier is illustrated by means of a portrait miniature he is holding, by a burin, quill, brushes for oil paints and watercolours, a small bottle, a flower vase, a painting with a mythological subject, sculpture, and, in the background, a small figure of himself, dressed in a smock, and painting a

Cat. II 667; vol. I, frontispiece

nude female model. He had aged greatly since he drew his self-portrait for his fiancée in 1595. One hand points to the miniature, undoubtedly a portrait of his wife, which he is holding in his other hand, as if it were the ring on his finger. By placing a winged hour-glass in the circle on the side of the cube on which his arm is resting, he added a more human touch: *ruit hora,* one might think. The wings are those of a bird and a bat, day and night, when the work that leads to fame is accomplished: only the artist's work survives the artist. The portrait therefore testifies both to his all-round achievements and to the effort required to gain them, as well as to the notion of what we called *la condition humaine.* The somewhat melancholy expression on the arresting face is in complete agreement with the analysis of the symbols. The artist presents himself to us as a well-groomed and smartly dressed citizen, and yet he manages to give us some insight into his innermost convictions. The gesture which occupies such a dominant position, also suggests that he really owed a large part of his status to his marriage.

Cat. II 703, pl. 314    The portrait, lovingly drawn, of an elderly, grey-haired man reading a book represents, I believe, a scholar whose features are familiar from several portrait paintings and who was, in fact, no less a person than the renowned philologist Joseph Justus Scaliger. It must have been sketched shortly before his death in 1609. This drawing explains, with greater clarity even than the paintings, why Heinsius wrote of Scaliger, *Forma eximia fuit nisi quod collapsa tempora ac cava saepe materiem*

80. Engraver and book as ill. 78. *The Expedition to Nova Zembla.*
After Jacques de Gheyn II (?). Rijksprentenkabinet, Amsterdam

81. Jacques de Gheyn II. *The Woman of Lacedemon.*
Engraving. From *Spieghel van de Doorluchtige Vrouwen.*
Rijksprentenkabinet, Amsterdam

82. Jacques de Gheyn II. *The Daughter who suckled her Mother in jail.* Engraving.
From *Spieghel van de Doorluchtige Vrouwen.*
Rijksprentenkabinet, Amsterdam

83. Jacques de Gheyn II. *The Fisherman's Wife.*
Engraving. From *Spieghel van de Doorluchtige Vrouwen.*
Rijksprentenkabinet, Amsterdam

84. Lucas van Leyden. *Joseph in Prison.* Engraving.
Rijksprentenkabinet, Amsterdam

*iocandi illi darent*[55]. The high forehead, angular, raised eyebrows, long, pointed nose and the shape of the long beard closely resemble the features in the full-face portrait[56]. This is how Scaliger must have looked on a day when his hair was particularly luxuriant. There are two other portraits of the same old man; one where he is engrossed in a book, and one where he is studying a globe with a young pupil. It is impossible to tell for certain who this was—Heinsius, or young De Gheyn accompanying his father on a visit, or someone else, perhaps Philippus Cluverius, if one looks at the globe, or one of the figures on the table in front of them. But the likenesses are true *documents humains* in that they savour more of direct observation than do the painted, more or less official portraits.

Ill. 87

Cat. II 704, 705,
pl. 312, 315

85. Jacques de Gheyn II.
Engraving for the title-page
of Heinsius' *Emblemata
Amatoria*.
Rijksprentenkabinet,
Amsterdam

86. Jacques de Gheyn II.
*The Fatal Torments of Love.*
Engraving.
From *Emblemata Amatoria*.
Rijksprentenkabinet,
Amsterdam

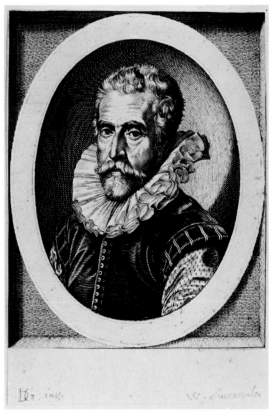

87. Anonymous master.
*Portrait of Professor Joseph Justus Scaliger.*
University, Leyden

88. Willem Swanenburgh. *Portrait of Cornelis Duyn.*
Engraving. First state. After Jacques de Gheyn II.
Cornelis Duyn was De Gheyn's brother-in-law.
Rijksprentenkabinet, Amsterdam

On the final occasion when De Gheyn drew a small portrait for an engraving, the sitter was his brother-in-law, Cornelis Duyn. He confined himself to a sober and somewhat stiff medallion portrait of the then elderly Amsterdam regent.

Cat. II 662, ill. 88

Jacques de Gheyn also recorded a death-bed scene when his close friend and kindred spirit Carel van Mander passed away in 1606. His death, barely two years after the publication of the *Schilder-Boeck*, came as a shock to the entire world of art. De Gheyn travelled to Amsterdam to join some three hundred people who had gathered to *verselscappen*—accompany—the body from the *Uytterse Steiger*, that is from his house on the Rokin, whence the barges departed for Utrecht, to the Old Church, where it was interred in the ambulatory. He did two drawings of the deceased's head on a single sheet of paper, along with the harp that had been placed on the body of the man who wrote so many pious songs in *De Gulden Harpe*. The appearance of the poet painter is rendered with great care, but the state of death is also portrayed impressively. A civilization may, as it were, be judged by a drawing like this. It is significant that it was produced at the beginning of a period in which Holland was to render Man and Nature readable and understandable in a new way.

Cat. II 693, pl. 318

We shall be brief about the many further drawings executed during De Gheyn's first ten years at The Hague. Again they bear witness to the increased diversity of the themes explored, as in, for example, the figure of an elderly, seated germanic judge dressed in a voluminous mantle and holding a staff; a farcical scene of a man and woman, one of them holding up a purse; or a representation of *The three Magi,* in which the two elderly heads, so full of character, are in striking contrast

Cat. II 615, pl. 331; 600, pl. 356; 33, pl. 248

with that of the negro. In this last drawing one notices that in later years there was occasionally great similarity again between De Gheyn's style of drawing and that of Goltzius[57]. They must have seen each other's work on many occasions. In general, the greatest variety occurs in the many sketches of the human face. De Gheyn seems to have felt an increasing need to draw the heads of old and young people in every imaginable position and costume.

cf. p. 82

Cat. II 103, pl. 266

Cat. II 784, pl. 254

From time to time one has the impression that certain drawings were studies for paintings since lost. This was mentioned in the discussion on the studies for an *Adoration of the Shepherds,* and I suggest that the masterly sketch of *St. Sebastian* was also a preliminary study for a painting. Both scenes must have been produced after 1604, otherwise they would have been mentioned by Van Mander. They must also have been painted in rapid succession, since the head of St. Sebastian is based on one of the three chalk studies of a boy's head, the technique and style of which appear to be related to the studies of models for the shepherds. In the drawing of St. Sebastian, extremely powerful pen-work is superimposed on the delicate modelling of the body in black chalk. In view of the summarily sketched tree against which St. Sebastian is standing, this drawing should not be dated earlier than the studies of old oak-trees.

Cat. II 164

Cat. II 625, pl. 389

In De Gheyn's *self-portrait* we found what was presumably an allusion to his work in the field of sculpture. To conclude this chapter, a commission connected with sculpture is worth mentioning. In 1607, the Hague magistrates instructed De Gheyn to produce a design for a frontispiece to be placed in the archway leading to the new Madhouse. It was carved by the then famous sculptor Gregorius Cool of Gouda, better known for the monumental staircase he built and had carved for the townhall there. Although the archway was preserved until the nineteenth century, when it was demolished, no valid reproduction of the frontispiece is known and the only other information we have is that it represented the inside of a hospital ward. It is possible that this work led to De Gheyn drawing one of the dangerous lunatics at a later date, if he is not a galley slave as old sale catalogues seem to call him.

It is conceivable that this contact with a sculptor first made De Gheyn aware of the opportunities awaiting him in the field of sculpture. This would have been in 1607, whereas the self-portrait of 1610 provides clear evidence of the presence of sculptures in his workshop. It has proved impossible to establish whether he himself was their creator, or whether they were originals by other artists, as I believed at one time. However, the very fact that, at a later date, he was to execute a large fountain in relief, justifies the assumption that he was once again embarking on a course which led him further in his quest for universality, one of the most ambitious ideals of Renaissance man.

# CHAPTER V

## *Settled at The Hague and the first works by Jacques III*

Van Mander completed his text in 1603. To discover paintings by De Gheyn produced after that date, we have to rely on signatures on existing works and on conjecture. An *Adoration of the Shepherds* (see p. 82) has already been mentioned. Several drawings dating from the beginning of the century seem to point to such a painting and also to a later *St. Sebastian* (see p. 100), for which the drawing in Weimar was possibly intended. But these are no more than hypotheses. The *flower-painting* commissioned by the States General in 1606 (see p. 85) for presentation to Maria de Medici has also disappeared without trace. It must have been large. In any case De Gheyn received the princely sum of 1000 pounds for it[1].

In the *Seated Venus with Cupid,* possibly painted for Prince Maurice and now in the Rijksmuseum[2], the artist took up a theme that had been popular with the Mannerists, Spranger in particular. Bending his bow, the winged Cupid aims an arrow at the goddess' midriff, an allusion, perhaps, to the role Homer allotted to that part of the body. Next to Cupid two doves are mating. In view of the principal character's pose, De Gheyn was probably familiar with the *Crouching Venus* from the Belvedere. Goltzius is bound to have drawn it, and prints of it were already in circulation. However, the painting owes its charm mainly to the well-balanced arrangement of the various contours within the confined space that is completely filled by them. The effect is all the more suggestive because of the gaze directed at us by the delectable girl who, embracing Amor with one arm, holds up a burning heart in her other hand, her fingers expressing the movement of leaping flames. The flowing brushwork on the nude makes us forget how much effort would be required for a model actually to adopt such a pose with its several contrasting movements. In view of its contrived composition, the painting should be dated before 1610, and this also applies to the *Neptune, Amphitrite and Cupid* in the Wallraf-Richartz-Museum at Cologne.

Cat. II P 6, pl. 4

Cat. II P 5, pl. 5

The foreground of the latter painting is occupied entirely by a still life of exotic shells, cutting off the figures from the spectator. The characters, moreover, do not look at us. With one arm around Neptune's neck, Amphitrite, Tethys, or whichever one of his amours she may be, shrinks from the importunate Neptune with his soaking wet beard, but turns her head towards him; here for the first time the painter was trying to express the understanding between two characters by means of the look they exchange. In the linear play of the flowing strands of hair and the sensual allusions in which the shells play a part, this painting still has certain features in common with Haarlem Mannerism. Shells, of course, were to provide a final ornamental motif before the transition to the lobular style with which Mannerism passed into the Baroque.

I suggested previously that the Neptune may have been painted for Cornelis van Bleijenburgh, the Hague magistrate and one of the *schelpisten* (shell collectors) who also included Jan Govertsen, a man portrayed by Goltzius on several occasions. It was to Van Bleijenburgh that Philibert van Borse-

len dedicated his fine didactic poem *Strande* (Beaches) (Amsterdam 1614) which describes the sea and all it casts upon the beach. The painting evokes the opening lines addressing Neptune, and the shells may have been show-pieces from the Van Bleijenburgh Collection. De Gheyn himself, however, was probably also a *schelpist,* and was said to have owned some remarkable specimens[3]. Perhaps it was Van Borselen who was inspired by De Gheyn rather than the reverse. De Gheyn had been in contact with the aquatic world since working on the *Land-yacht.* Later on he drew another *Neptune,* and we shall see how on one further occasion he was to become totally absorbed in the latter's realm, when Maurice commissioned him to design a monumental fountain.

Cat. II 121, pl. 350

Cat. II P 13, pl. 6

Another painting that may have been commissioned by Maurice is *Caesar on horseback,* half inside and half in front of his army tent, dictating reports to several scribes at once. The theme was highly appropriate as a paradigm of the successful general: a well-known *topos* going back to Plutarch and recommended by Van Mander as suitable for illustration[4]. Maurice may have given the painting to Sir Thomas Vavasour, who had held a command in the States' Army in 1600; it is still at Ham House, which Vavasour built in 1610. If only we had Maurice's household accounts, which might confirm this hypothesis!

The composition can hardly be described as successful. Caesar, riding the Nieuwpoort stallion, is placed in a rather isolated position in front of the busy group of scribes in the tent, and he also seems too tall. Despite the red cloak worn by the scribe on the left, the colouring is far from brilliant. But the artist brought to life Caesar's face which is based on a medallion he had copied at some time. The eyes meet those of the principal clerk along the line of a diagonal which cuts across the symmetry of the background and so ties together the entire composition in a somewhat unusual manner. Again De Gheyn was searching for a 'vector' to express a human relationship.

Cat. II P 4, pl. 7

This latter element became a central feature in *The Empress Helena kneeling before Christ bearing the Cross,* a monumental altarpiece dated 1611 which came into the possession of the episcopal seminary at Bruges from the Dominicans, providing evidence of De Gheyn's contacts with southern Catholicism in that period. So it should not come as a surprise to us if at some time it were established that, as a result of his marriage, he had not entirely severed his ties with the old faith. Later on he was to illustrate a number of other typically Catholic themes.

The culminating point of the scene is the emotional contact experienced by the kneeling Helena when her eyes meet those of Christ who is coming towards her. Here for the first time the artist was successful in freeing the figures entirely from a dominant decorative pattern and placing them, now clearly corporeal, in front of a darkened landscape, with the sun breaking through the clouds. And, in a period when Rubens was producing his large-scale triumphs in Antwerp, we find for the first time in De Gheyn's work, a dramatic power that heralded the end of the 'erudite' Haarlem Mannerism. A derivation from Scorel's *St. Mary Magdalen* makes one suspect that the study of older paintings had some bearing on this new awakening. But the control of the two life-size characters in the highly effective 'stage' setting and lighting can only have been inspired by the artist seeing recent southern, perhaps Flemish, works of art. We have observed a similar tendency towards dramatisation in his landscape drawings of the same period. A turning-point had apparently been reached, but it was to apply only in part to Jacques de Gheyn.

Ill. 89

The flower-pieces he had started painting as soon as he began handling the palette were totally unrelated to 'historical' painting, and constituted a genre in themselves. The silent contemplation of a number of flowers blooming in different seasons led to the composition of an ornamental flower arrangement on a panel. De Gheyn had probably never seen them all together in the form of a bouquet. Apart from a few notable exceptions, this was to remain the character of Dutch flower-pieces for two centuries. The sole Baroque element in the painting that, according to Van Mander,

89. Jan van Scorel.
*St. Mary Magdalen*. Painting.
Rijksmuseum, Amsterdam

was sold by De Gheyn to the Emperor Rudolph II in 1604 along with his recueil of flowers, consisted of the lines of verse dedicated to it by Hugo de Groot (*Poemata,* 1639, p. 280, not previously related to De Gheyn). It must surely have been a show-piece of its kind. 'To Mars thou owest, Caesar, that the armies of the Barbarians tremble before thee; to Zephyr's spouse [Flora], the spring that he commanded the Dutch Apelles to make the fields flower eternally as a gift to thee. Each year the ornamental gardens of Alcinous and Adonis wither, and the roses of Pharos end their flowering. Even where Pomona leads Semiramis, winter always buries her work. Why should not thy honour be lasting? When joined together these flowers serve to make thy imperial dignity triumph even in infertile times'. The poem is not wholly devoid of irony. Rudolph was experiencing great difficulty in repelling the Turks. His alliances were instable. He was averse to his imperial duties, and his treasures were the only sanctuary to which he could withdraw. Now he was having his own crown made and Hans von Achen portrayed him with a laurel wreath encircling his brow. Hugo de Groot must have been aware of all this, and he must also have seen Sadeler's print of Von Achen's portrait (1603). De Gheyn's bouquet formed part of the only world that afforded the Emperor any consolation: a consolation to the eye.

Bergström has opened our eyes to the symbolic significance of flowers, insects and butterflies. We do not know to what extent De Gheyn took account of this, and in any case one is always left with the mortality or resurrection motif. L. J. Bol has in fact quite definitely asserted that the opposite applies to the Bosschaert type of flower still life[5]. By contrasting painted flowers with natural ones Grotius showed how symbolism could be manipulated. In the minds of the humanists, it was the permanence of art that constituted the sole imaginable victory over mortal nature. The poem therefore also provides an additional pointer towards the explanation of the symbol on Jacques' self-portrait: Only Art is victorious over Time. As for the reminder of mortality, both L. J. Bol and J. R. Judson place far more emphasis on De Gheyn's botanical interest than on a significance of that kind. It may therefore be assumed to play no more than a minor part, and to do so mainly when the nature of a creature such as a mourning-cloak butterfly, burying beetle, or death's head moth provides a direct clue to such an interpretation.

The question whether there was an extraneous reason for the upsurge in the popularity of the flower still life around 1600 — the import of art from the Far East perhaps — must be given a negative answer for the time being. Similar suggestions have been voiced with regard to landscapes[6], but no direct proof has been supplied. Although porcelain, including floral ware, was beginning to pour into the country, China itself was still a closed book. The flower-piece surrounded by insects and butterflies does occur in Chinese art, but so far we have not found any examples prior to the year 1600. For the present therefore, the scientific studies encouraged as a result of the founding of the Leyden *Hortus* by C. Clusius, the import of seeds and bulbs, and the greatly improved methods of cultivation must be considered the principal reasons for the spectacular success of the painted flower arrangement. Early examples include work by Hoefnagel, who may have introduced the genre in Frankfurt and was closely followed in Holland by Nicolaes Elias (seen by Buchelius in 1598, but none is now known), Lodewijk Jansz van den Bosch (according to Van Mander, before 1604; now lost), Carel van Mander (in 1606; including a painting mentioned as being in the house where he died), Roelant Savery (*vase of flowers* in a private collection, dated 1603[7], and another at Utrecht, dated 1604 and painted immediately before his departure for Prague), Jan Brueghel (oldest reference 1606), Ambrosius Bosschaert de Oude (earliest known date 1607), and Jacques de Gheyn, (oldest recorded date 1598). Van Mander wrote of his earliest work in oils, which was sold to Heyndrick van Os: 'This was treated very neatly and admirably for a first attempt'. It was followed by the painting of 1604 for the Emperor, the one for which Grotius must have written his poem. If one disregards Joris Hoefnagel, whose work differs somewhat from these new paintings with their single bouquet, it is impossible at the moment to think in terms of any one of these artists being the first to produce this particular genre. De Gheyn is certainly a possible candidate. A *vase of flowers*,

<span style="float:left">Cat. II P 31, pl. 1</span> anonymous until a short time ago, is also known to us. This painting was in the possession of Mr. B.L. Koetser, London. It includes several flowers which we find also in De Gheyn's series on parchment. At all events the type appears to have been fully developed in 1604. De Gheyn's interest in flowers and perfect specimens was undoubtedly stimulated by the Leyden *Hortus* which he himself immortalized. At The Hague he may well have had a flower garden at the back of his house in the

<span style="float:left">Ill. 47</span> Voorhout: his *Plan of The Hague* shows a courtyard there. For preference he painted tulips, particularly striped varieties[8], narcissi, roses, carnations, columbines, lilies, lilies of the valley and anemones, all of them flowers he could well have grown himself. Only the snakeshead is unknown here as a cultivated flower. The painter populated his flower arrangements and the ground with insects, butterflies, a frog or a lizard.

<span style="float:left">Cat. II P 39, pl. 8</span> The *Bouquet* at The Hague, dating from 1612 and a work of art of the very first order, has a vertical composition. The narrow neck of the ribbed bottle could not possibly hold the stems of all the tulips, roses and other flowers that are crammed into it; the artist did not really arrange the flowers in water, but placed them on his panel so that every flower remained visible. One flower is not hidden by another, as happened occasionally in Savery's work. There is nothing fortuitous about it: each flower is a perfect, carefully selected specimen, in its Sunday best. The execution is dazzling: the colours are of the very best materials in all the required shades. De Gheyn must also have studied mounted specimens of butterflies. The painting has the beneficent preciousness of the fifteenth century painter's craft.

<span style="float:left">Cat. II P 40, pl. 9</span> The *Flower glass with roses and tulips* dated 1613 in the De Villeneuve Collection is distinguished by a somewhat greater naturalness. The flowers at the back merge gradually into the shadow, while those in front, in the light, demonstrate opening, flowering and fading. The painter understood

<span style="float:left">Cat. II P 41, pl. 10</span> them as living organisms, changing from day to day. The tulip petals shoot upwards like flames.

The large *Flower-piece* dates from 1615, and consists of an overcrowded, rigidly symmetrical

112

bouquet topped by a white lily and placed in a niche with a looped curtain on either side. The even, time-consuming finish to every part makes it more than a decorative show-piece; the execution must have required months of patient work and makes us appreciate the artist's controlled temperament. This painting is also distinguished by the sparkling lilies of the valley and other small flowers interspersed among the larger varieties.

Early this century another, equally large flower painting was auctioned at Fred. Muller's with the Hoogendijk Collection; it is now in a Dutch private collection. It is more appropriate to discuss it later on, because it proves to have been painted after 1620. It is likely that the painting of 1615 remained in the possession of Jacques III, for it is described in his will. Its value was enhanced by its ebony frame fitted with an outer casing for protection.

Cat. II P 42, pl. 20-22

Unfortunately, I did not see several other flower-pieces which passed through the trade under the name of J. de Gheyn in more recent years and may well be genuine. Two of them belong to the same smaller type featuring mainly roses and tulips and allowing a considerable amount of space for butterflies, insects, and on one occasion even a frog. I have had to omit them from the catalogue as it is too risky to judge them by photographs only.

Among De Gheyn's younger contemporaries, the Middelburg Bosschaerts in particular continued to elaborate on his theme and ideas. With them, flower painting developed almost into a regular — though high-quality — industry. They have been competently described by L.J. Bol. In Delft, Jacob Vosmaer also closely followed De Gheyn's concepts. Roelant Savery, who had already produced flower still life paintings of similar quality at Utrecht in 1603 and 1604, was again to challenge De Gheyn once he had returned from Prague. Concentrating on equally ambitious schemes with monumental flower vases, also in niches and accompanied by various creatures, he added a mixture of wild flowers, contrasting them with the colourful, cultivated varieties. His bouquets therefore acquired something of the romantic flavour prevailing in his mountain scenes, and this was further enhanced when a cockatoo was included among the creatures in the foreground[9]. The sober De Gheyn did not allow himself to be tempted into such extreme diversions. On the whole it is fair to say that the smaller flower paintings by De Gheyn and Savery are superior to the very large one which I described. In the latter, the symmetrical arrangement in a static pattern is out of keeping with the fluid character of the individual flowers. It is a composition based on the flat surface itself, and not on a bouquet of flowers arranged naturally in a vase. *Too much ordered,* one might say, as did George Gage when writing to Sir Dudley Carleton from Péronne on November 1st, 1617: *And howsoever you esteeme there your Jacques de Gheyn, yet we preferre by much Brugel, because his thinges have neatness and force, and a morbidezza, which the other hath not, but is cutting and sharp (to use painters phrases) and his thinges are too much ordered*[10]. It cannot be denied that the numerous flowerpieces painted by Jan Brueghel at the time were executed with such facility, and were so full of life, that most of the works from the North are distinguished by some emphasis on the stillness of still life. It was a distinction resulting from different environments. The large examples in particular should therefore be seen as survivals of a tradition which did not acquire significance again until the days of Van Huysum, when the decorative function of a painting on a wall came to predominate. The small flower-pieces, on the other hand, are totally consistent with the pioneering spirit of the awakening Golden Age, which in every field managed to bring to life aspects of reality, each in a genre of its own.

Evidence of De Gheyn's continued preoccupation with the study of flowers may be found in the *Twig of Roses,* painstakingly modelled with a fine pen as late as 1620.

Cat. II 934, pl. 417

The intensity with which De Gheyn devoted himself to painting flower-pieces in the years between 1612 and 1615 makes it clear that there was no particular emphasis on 'history' painting at

Cat. II P 4,
pl. 7
that time, although one example, *Christ and Helena,* was executed in 1611. In his work as a painter there was undoubtedly a field of tension, with one pole constituting a conventional approach, although the emphasis ultimately came to rest on the other pole, a better understanding of the secrets of Nature. Something of what was passing through his mind may be gleaned from two apparently contradictory subjects, the drawing of *Empedocles* of 1613, and the *Anatomical demonstration by Professor Pauw* which dates from 1615.

Cat. II 132,
pl. 381
In the drawing at the Victoria and Albert Museum dated 1613, a naked Empedocles, spectacles in hand, is sitting among his books contemplating the smoke which rises from a wooded mountain range, perhaps intended to represent a volcano. A bat is flying up into the smoke and the philosopher can see heads and limbs floating about in it, a vision evidently inspired by some of Empedocles' traditional sayings. In one of these there is an allusion to a kind of *generatio spontanea,* brought about by the coming together in mid-air of drifting parts of the body which, formerly divided by hatred, are then united by love to form new human beings. This somewhat cryptical pronouncement was apparently passed on to De Gheyn by one of his philological friends, who may have introduced him to the work of Diogenes Laertius. Perhaps it was his son's classics tutor, or perhaps a famous classical scholar such as Heinsius. In any case the introduction of these new themes into the visual arts stemmed from the world of classical philology at Leyden.

Cat. II 133,
pl. 381a
From a technical point of view it is important that the drawing was preceded by an inspired rough sketch providing further evidence of the co-existence of very different styles of drawing. Thematic details such as the spectacles are also arresting and appear to be an allusion to the heterogeneous, individual views so characteristic of the oldest Greek philosophers 'The two eyes produce one view only', is one of Empedocles' sayings. 'But one person's opinions may still differ from another's', the spectacles on top of the books in De Gheyn's illustration appear to add. It is also worthy of note that in the preliminary drawing the philosopher is gazing only at the tangled growth on the rocks. Had the draughtsman seen more in the natural formation than merely its substance? Something of the haunted worlds he had conjured up still echoes in these fantastic themes. In

Cat. II 1004,
pl. 444
other, undated, but certainly later sketches he returned to the motif of mountain views with dense vegetation, in which human heads do in fact appear. An explanation whereby hatred and love are held to be the ultimate causes of existence must have appealed to his inquiring mind and stimulated his imagination. After all, it was he who gave form to this ancient interpretation.

Further evidence of De Gheyn's preoccupation with the world of early Greek thought, albeit by way of legendary tradition, appears in the theme of Hippocrates' visit to Democritus of Abdera, who is slaughtering his herd like a savage for the sake of acquiring anatomical information. This tradition is really more advanced since it is concerned with first reports of an extremely primitive form of scientific research. No earlier illustration of the theme is known, and De Gheyn may even

Cat. II 134,
pl. 354
have chosen it from his own reading. Contrary to later tradition, Hippocrates is shown as a young man; he sits watching the wild 'medicine' man move around the slaughter-yard with a butcher's knife. A ray of light from behind a mountain is cast upon him. The entire scene is recorded with harsh penstrokes and the composition framed by some rapid outlines. More or less as occurred in

Cat. II 135,
pl. 355
the case of the *Empedocles,* there is a second, 'finished' drawing showing the model for Hippocrates, once in a similar attitude with an expression of surprise on his face, and a second time in a more frontal position. There he represents Democritus giving a demonstration about milk by means of gestures. Perhaps De Gheyn did a painting of the theme. The sole ground for such an assumption is the description of a painting, perhaps inspired by it, among the effects left by Lambert Jacobsz[11]. Here again there is a reference to a ray of light appearing from behind a mountain, and it would be very strange if there were no connection between the two works[12].

114

The ancient Hellenic themes appear to have been deliberately chosen as very early examples of the study of physical nature. At the new University, medical science had now found a centre for far more advanced research, so that Professor Pauw was able to claim that Leyden could be mentioned alongside the celebrated schools of Padua and Louvain. Anatomical studies to increase the knowledge of the human body were encouraged by university dissections which, at Leyden, were open to the public and also attracted foreign physicians.

An *Anatomical demonstration* of this kind carried out by Professor Pieter Pauw at Leyden was recorded by De Gheyn in a drawing engraved by Andries Stock in 1615[13] at the professor's expense and accompanied by an elaborate Latin poem by Petrus Scriverius in the margin. The drawing is lost, the print rare, and the marginal writings are known from still rarer examples such as the copy in the Leyden University Museum, where it remained unrecognized even by W. Heckscher[14]. Scriverius reminds us of human mortality and argues that the gory spectacles which so delighted the peoples of antiquity had been replaced here by a demonstration which contributes towards the well-being of mankind. The distinguished scholar elaborates on this theme in flowery Latin, apparently in order to dispose in advance of any criticism of these public demonstrations.

Cat. II 154

Ill. 90, 91

University coryphaei long since dead may be observed among the spectators in the front rows. They include Scaliger, the elder Dousa and even the renegade Lipsius who left Leyden for the Catholic university of Louvain. Aristotle and Galenus themselves are seated in the front row of the auditorium, and Hugo de Groot is unlikely to have been absent. According to Scriverius, Professor Pauw admitted anyone wishing to attend, and students, 'eagles or screech-owls' mingled with physicians from places as far away as Hungary and Poland. It is perhaps possible to identify the artist himself, accompanied by his only son, high up on the left side.

For Jacques, the youngest of the three generations, had been growing up. In drawings by his father, we saw him as a child, looking at pictures with his mother, sketching, or doing nothing in particular. He must have been carefully educated, and it was perhaps taken more or less as a matter of course that he would follow in his father's footsteps. Whether he had any difficulty in choosing his vocation is impossible to tell. Presumably he learned more in his youth than his father had done: in 1616 he was competently using the Greek alphabet and not merely the Latin one. He must have been acquainted with the neighbouring boys in the Voorhout, and he was, later on in any case, a close friend of his contemporaries Constantijn and Maurits Huyghens, particularly the latter. Jacques may have had the same kind of education by private tutors as the Huyghens boys. It is not impossible that, like his cousin Jacob van der Burch, he enrolled as a student at Leyden[15]; his classical scholarship appears to be an argument in favour of this. But he must have been destined for an artist's career at an early age.

The first date to occur on work by Jacques III is 1614. I think we may regard one drawing as a youthful work: a seated, elderly *Father Time* surrounded by symbols of mortality — his father had apparently impressed upon him at an early age the need to use his time to the full — signed with his monogram I D G, the same as his father's, but with an additional I for Junior drawn through it. He is likely to have drawn his inspiration from older examples and not from his father's more recent work. But he was already a reasonably competent draughtsman. The ruled lines for the architecture and table are worth noting, since in the work of Jacques II these occur, at the most, as erasures. At a later date Jacques III appears to have used a ruler most effectively in his prints as an essential aid to indicate, by means of fine, close parallel lines and cross-hatchings, every required gradation of even shadow cast on a flat surface.

Cat. III 25, pl. 1

In 1614 Jacques III, then probably 18 years old, collaborated with Cornelis Boel, perhaps a son of the Hans Bol who at one time was on friendly terms with Jacques' father in Amsterdam, on the

90. A. Stock. *The Anatomy of Professor Pauw.* 1615.
Engraving. After Jacques de Gheyn II.
Academisch Historisch Museum, Leyden

91. A. Stock. *The Anatomy of Professor Pauw.* 1615.
Engraving. After Jacques de Gheyn II. With a poem by P. Scriverius.
Academisch Historisch Museum, Leyden

# THEATRI ANATOMICI
## Academiæ Lugduno-Batavæ
# DELINEATIO.

### SPECTATORI S. D.

Exhibetur tibi hac Tabulâ, Candide Lector, non tam locus, quam actus ipse Anatomicus. Solent autem eo tempore quo actus ille institui-
tur, gradus omnes Theatri ornamentis ordinarijs orbari, sceletis inquam humanis, belluinis, picturis, alijsque istiusmodi parergis, ut oc-
cupari locus vacuus à spectatoribus queat. Hæc causa est, cur non eam nunc videas rerum faciem, quæ aliàs vacuo theatro conspici solet. Id volui,
nescius ne esses. VALE.

In Theatrum Anatomicum,

quod est Lugduni in Batavis,

secante & perorante

V. C. PETRO PAVIO MED.

Botanico & Anatomico præstan-
tissimo.

Quo tam densâ cohors Apollinaris
Hinc vulgò cubitis & inde trudens,
Quo frequentia tanta, quo virorum,
Quo manus juvenum, Viator hæres,
Mirarisque suum perire nomen
Lugdunensibus (insolens) plateis,
Calcem calce premente. Quid futurum,
Ad Vesta (siquidem huc vocantur omnes)
Speras, mirio? Non tumore tanto,
Non tanto agmine pulvis eruditus,
Aut Arithmetica triumphus artis,
Ipsi denique non libri petuntur.
Turbam Bibliotheca quum recuset,
Si Mathematicus procul repellat,
Credis forsitan hos adire ludos,
Aggretasque sequi crumeninulgos.
Fugit te ratio, nihil jocorum est.
Non Anglus sale pruriente tinctus,
Non Philistio, non gelasianus
Lacessit Sybariticos cachinnos:
Non mollis cytharædus, aut choraulus:
Projectis neque sannio pudoris:
Non hic gesticulator, histriove
Laudari cupit à loquente dextra:
Non mechanicus exstit petauro.
Non fracta vocat hos magister artes,
Non minax gladiator, aut lanista.
Extentis neque funis ambulator
Tantos denique concitat tumultus.
Quo sutor modo subula relicta,
Quo læsti dominus pediculosi,
Quo vicinia tota, quoque tressis
Textor consuit hinc & inde sullo.
Non hæc sordida turba, sanque vulgi
Ad Pavi stomachum faciunt, nec illas
Tam stultos populus rudesque quærit,
Illustat quibus anseratque mentes.
Cordatos amat, expetitque tersos
Aureis, non modo barbaras avorum
Aut nostrorum hominum ferociorum.
Docta Pavius arbiter coronæ.

Quem pleno (puto) cernis in theatro
Tot cheirurgica vulnerariorum.
Ferramenta manu levi rotantem,
Siphoneis, cyathosque, turbinata
Specilla, & dupyrena, forcipesque,
Volsellasque, spathasque, singulasque,
Dum spectas sceletos, novasque larvas
Mira arte ingenioque copulatas,
Aptis articulisque vertebrisque,
Et symphyses mobilis artis,
Quid pedem retrahit, quid extimescis
Ceu Manes videas, domumque Ditis?
Hæc respublica, sed pusilla, Paul.
Hic regnat Batavi decus Lycei,
Regnandi vetus, & vetus docendi,
In cujus Charitæ sedent labellis:
Dexter cheironomus, volante cultro
Quo nam aptius exta dissecaret
Aut scissor Latiaris, aut Pelasgus.
Hic hic disce movi Viator, & te
Nosse ante omnia, disce. disce, quid sis.
Quam res lubrica trita tota nostra est!
Te cæco lavitasse ventris antro
Novem mensibus, abditum inter alvi
Urinas sordesque faculentas?
Ut ut riseris & tue parenti
Ilithya favoni, deique Nixi,
Uter substulerit Levana teneris,
Admoruisse faventibus papillis,
Flebis quanta eris, missile stebis.
Fletus auspicium, tenerque vitat.
Fletus finis erit, gravisque summus.
I nunc tolle animus, manubiisque
Plenus stribus in ambitu sequêris.

Fasceis, prædia, regna concupisce,
Ipsis regibus invide curuleis:
Postquam hæc omnia fueris, relinqun
Fasceis, prædia, regna, nilque præter
Urnam & marmora pauca te sequêtur.
Quod si dissimulas, agis quo minuum.
Si tinctis senium tegis capillis,
Atque a pyxide capsulaque pendes,
Ne te fallere posse crede mortem,
Per mendacia mille, perque fraudeis
Hæc te profugiet, tuoque demet
Personam capiti, nihilque fies
Qui comptis modo crinibus nitebas.
Hei! quam gaudia vana, quam cadaca!
Hei! quam solstitialis herba vita est!
Quid multis moror? afside Viator.
Prisca & plurima doctus ille Varro
Magmus Scaliger hic sedendo dixit;
Discit Dousadesque, Lessusque.
Quos hic ad podium vides. Sed illis
Conjunctos alijs vides Viator:
Heröes puta gentium minorum.
Permixtos populis, nec exprobratur,
Aut res invidia est calumniave,
Si fors hic aquilasque noctuasque
Jungat, linea, namque disputare
De loco, aut trepidare, insulsum est.
Nempe hic delicijs ineptisque
Se vila anima in scholis fatigant.
Pavi (credite posteri) theatrum
Æqualeis fecit accepitve cunctos.
Tu quem perculit ista vox Theatri,
Et frontem caperas, trahisque vultum,
An me prisca loqui theatra censes?
Non hæc cura tuum coquit poetam.
Non in supplicijs mihi voluptas.
Non in sanguine cædibusque vivo.
O Urbs grata, mihi, amata multum,
Et septemgemino superba colle,
Non istam tibi noxiam remitto.
Nec laudem pietatis hinc sirreis
Vos, o Iuniada, quod edidistis
Primi munera civibus Latinis:
Et quamquam inferias patri dedistis,
Detestor scelus exsecroque tantum.
Quid Bruto Styeia palude mersa,
Et pallentibus addito catervis
Prodest hæc lamina funeralis?
Quæ solatia manibus sepultis
Fuso e sanguine, quæ pudor nupleptaa?
Annum lugeat. Urbs suam parentem,
In pulla sedeat, toga senatus,
Matronæ, puellæque casta
Lessis pectora mæmsque rumpant.
Virent omnia lætis, publicoque
Vatent inilitio: forum perenneum.
Ne curet populus: fotis superque est.
Quid sicas gladiosque ventilatis?
Vestrum hoc, Iuniada, probare factum
Vix Scytha poterunt, vagique Moschi.
Ne me hæc munera cruda, ne cruenta
Arena, caveæque sævientis,
Ne diras sue missione pugnas,
Ne Threces proprio cruore mersos.
Aut spectacula bustuariorum.
Saturno puta sacra, sacra Marti,
Vncu & ignibus expianda matris,
(Quæ Cæsar vetuit, bonusque censor
Cum damno pietatis esse dixit)
Hic laudare puto. Silete matre,
Non spectacula funestiora
Promisse populo dederit quisquam.
Non Neptunus in his Venusve sacris
Quicquam vindicat, Herculesve: nullas
Summano locus est. Hygeia præsto
Hæc uni sibi tota consecravit.
Quid theatrica, Roma, vis viseri?
Albus gratia nulla nunc lacrymis,
Nativo puta flore destitutis:
Vestreis sanguine Roma decoloris,
Et rubentia munerariorum,
(Saturno licet invidente) pone
Pone pallia: coccinata non suni.
Non e murice latiore fulgent.
Pone lurida, pone barbararum,
Certa hæc symbola visferationum.
Illa illa edita pluribus ticiatris
Sunt spectacula mortu, hæc salutis.

Scribebam P. SCRIVERIVS,
Anno cIↃ IↃ cxv.

### MEMORIÆ S.

### AMPLISSIMIS, PRVDENTISSIMIS, FORTISSIMIS VIRIS,
### D. D. CONSVLIBVS, PRÆTORI, IVDICIBVS SE-
### LECTIS INCLYTÆ VRBIS

# LVGDVNO-BATAVÆ;

ARTIVM, LITTERARVM, ET DISCIPLINARVM HVMANARVM
HOSPITIBVS AC MAECENATIBVS, HANCCE THEATRI
ANATOMICI DELINEATIONEM M. ET G. A.
MONVMENTVM CONSECRABAT

PETRVS PAAW Amsteldamensis.

92. Jacques de Gheyn III. *The Alliance of Charles V and France against the Turks*.
Detail showing the rich technique of young De Gheyn. Etching. After A. Tempesta.
Rijksprentenkabinet, Amsterdam

Ill. 92

Cat. III 49-51,
pl. 2-4

Cat. III 80,
81, pl. 55, 56

series of eight prints illustrating the *Main events in the life of the Emperor Charles V* and copied
from the original drawings by A. Tempesta. They each produced half, Jacques being responsible
for nos. 1, 4, 5 and 6[16]. The large prints, partly engraved and partly etched, conscientiously follow
the firmly drawn models. In some areas, like the modelling of the rearing horse's neck in pl. 6, he
already employed the stippling technique that was to remain characteristic of him. In his next work
the young artist was partly to drop the use of the burin, only retaining it for the heavier parts, or for
decorative inscriptions.

The visit Jacques and his father paid to the Anatomical Theatre in 1615 at the latest, must have
been of greater significance than is apparent at first sight. Artists no longer merely learned the anat-
omy of the human body from their Vesalius. There are a number of drawings of an *arm* and a *leg*
taken from a dissected body which appear to have been executed by Jacques III rather than by his
father. Such limbs may also be plaster casts taken from a living body or from classical sculpture,
and they are found in several artist's inventories of this period, including those of Cornelis
Cornelisz[17] and Rembrandt[18]. In the case of De Gheyn's drawings, however, there are clear indica-
tions that they were made after a dissection, which would naturally have been performed at
Leyden. I therefore assume that this took place prior to 1615. At a later date Jacques III must also
have made two folio drawings of different views of the *carapace of a tortoise*. This object was to

118

be found in the *Hortus* at Leyden, as can be seen in a print by W. Swanenburgh who included it in the lower border.

As Judson has shown[19], the elder De Gheyn had also been concerned with other kinds of dissections: the frogs he drew are sometimes shown in the position in which they were normally dissected or placed in spirits. There is further evidence of the elder De Gheyn's interest in biology in a drawing showing the front and side view of a *blow-fish* and accompanied by a neatly written caption. Going through the drawings, one has the impression of being in a *cabinet* of natural curiosities of the kind frequently added to a collection of art or curios. We learn from Jacques III's will[20] that he possessed a valuable collection of shells and minerals, possibly inherited from his father who was himself probably a *schelpist,* and this signifies that to them such objects were a matter of biological as well as artistic interest. Other Dutch artists followed their lead, among them Jan Goedaert, who was later to make an entomological discovery[21].

Cat. II 896, pl. 370

By 1616 Jacques III had fully mastered the skills of engraving and etching, and it was then that he published the work which established his reputation: a series, including a title-page, of *Seven Wise Men* of ancient Greece, each with an individual character suggested by an episode taken from his biography. 'These images of the seven wise men of Greece were designed and engraved in cop-

Ill. 93, 94

Cat. III 13-20

93. Jacques de Gheyn III. Title-page for
*Septem Sapientes Graeciae Icones.* 1616. Etching.
Rijksprentenkabinet, Amsterdam

94. Jacques de Gheyn III.
*Chilo.* 1616. Etching.
Amsterdams Historisch Museum, Amsterdam

per single-handed by Jacques de Gheyn, the son, and dedicated as first fruits 'to the excellent Mr. Jacques de Gheyn, his father, on account of the excellent instruction in this art given by him', the Latin title tells us. Jacques de Gheyn had therefore personally trained his son in the art, whereas we also know that in 1610 he had refused Christiaen Huyghens' request to give drawing lessons to the latter's son Constantijn, referring him to Hendrik Hondius[22] instead. Hondius, therefore, may originally have been his pupil.

It needs emphasizing that, in these prints, young Jacques disassociated himself from his father from the outset. He appears to have been fully familiar with the latter's conviction that an artist should exert himself day and night since life is so short, and this is reflected in the hour-glass adorned with the wings of a bat and an eagle which he placed in the hands of his Pittacus. His considerable technical skill must have been due entirely to his father's counsel. At a later date their styles of drawing were, from time to time, to show an even greater affinity, so that there are instances where it is difficult to distinguish between them. This cannot be accounted for by the mere fact that he received his initial drawing lessons from his father at an early age, but it was also because his father remained almost his sole example at The Hague and was forever finding new solutions in the field of drawing. In a way, the instruction he received may have been too perfect, the obligation to respond to it too onerous. Maybe this situation was at the root of an inner conflict which was to reveal itself at a later date.

Jacques III took his material for the *Seven Wise Men* from Ausonius and quoted a heptastich from the latter's work below each illustration. For this, he is likely to have used one of the editions of Scaliger, who had died in 1609[23]. The venerable figures are shown seated, enveloped in heavy cloaks, and reading their books, with other folio volumes or instruments on the ground beside them. Six of them stand out in a clear light against a severe architectural background or a curtain, one of these in a handsome floral pattern. The artist did his best to provide the oldest wise men with an abundant growth of hair and beard, and to show them engrossed in their reading. All attributes such as books, compasses, sextant and astrolabe, a steel gauntlet, a quill, scissors, a corn sieve, a classical tripod or altar are drawn with great understanding of their material properties. Finally, the young dare-devil upset the conventional architectural type of title-page by allowing the border to cut off the objects in the background as it would a landscape — and by placing a text escutcheon ending in a lobular scroll in front of them, an innovation that makes a somewhat programmatic impression, but is certainly effective. From beginning to end, the young artist's application was such that his intentions, even the bizarrerie of some of his figures, come across perfectly. This work provided so much insight into his personal style that it proved possible to reconstruct his drawing oeuvre from the series[24].

Cat. III 31, pl. 13; 32, pl. 15; 29, pl. 16; 30, pl. 12; 1, pl. 10; 7, pl. 11; 35, pl. 23; 22, pl. 14; 33, pl. 20

The following drawings may undoubtedly be attributed to the hand which etched the *Seven Wise Men*: a seated, bespectacled old man reading and a seated old man with his arms crossed, both at the Ecole des Beaux-Arts, Paris; a seated old man enveloped in a cloak, Dresden; an old man with outstretched hands, Van Regteren Altena Collection, Amsterdam; Moses, Gdansk; seated lawgiver, with head and body completely concealed in a cloak, Hamburg; head of an old man, Montpellier; seated M. Manlius with goose, metalpoint, Düsseldorf, and a seated old man in a glaring light, Windsor. I have enumerated them all so as to demonstrate that the motif of an imposing old man seen in profile, whose heavy cloak first catches the eye, was one of Jacques' main preoccupations in these years. One example, the rigid, full-length figure in Hamburg, is a complete work-out including the background, where the parallel hatchings are more regular even than in the prints. This drawing, moreover, is signed. Along with the old man at Windsor, probably a somewhat later drawing where the kind of clair-obscure treatment intended is most apparent, the type constitutes

120

95. Hendrick Terbrugghen. *David playing the Harp amidst the Angels.* Detail.
The position of the angel to the left is the same as in the *Seated Biblical Figure* (cat. II 95, pl. 366).
Wadsworth Atheneum, Hartford (Conn.)

the starting-point for a number of youthful works by Jan Lievens and Rembrandt[25]. We shall
return to this later on.

In a letter Constantijn Huyghens wrote to Cesare Calandrini in the summer of 1617[26], he asked
the scholar, for the benefit of *un certo amico nostro, chiamato de Gheyn, pintore eccelentissimo,*
by whom he may have meant his contemporary Jacques III rather than the latter's father, to send a
suitable text for a painting showing *King David* amongst his books, 'seated as if in meditation,
thinking about some psalm or other, whilst the Holy Ghost descends upon him'; the text, more-
over, was to be clearly written in Hebrew with the appropriate points and accents. Calandrini sent it
to him in September[27]. The description is reminiscent of the etchings, but also of a drawing by
Jacques II in which a seated figure, inspired by two angels, is writing in a book. The coins be-
neath his feet, symbol of the contempt of riches, and the owl in the niche render the figure even
more mysterious. Who was this legendary character: David, St. Matthew or Erasmus? Stylist-
ically, moreover, the angel standing before him is remarkably similar to certain angels in paintings
by Hendrick Terbrugghen who had returned home to Utrecht in 1614. This opens our eyes to a new
link with Jan Pynas, Pieter Lastman and Terbrugghen, who brought back elements of recent
Roman art to the Netherlands at this time, but who may also have benefited from the achievements
of the older De Gheyn. This is certainly true of Hendrick Goudt, who had returned to Utrecht in
1611 and was dependent on De Gheyn's style of drawing even before his departure.

Cat. II 95,
pl. 366

Ill. 95

121

96. Abraham Janssens. *Ecce homo.*
To be compared with cat. III 3.
Muzeum Narodowe, Warsaw

97. Jacques de Gheyn III. *St. Matthew the Evangelist.*
Etching. The only known copy. De Gheyn employed a stipple
technique to express the ethereal substance of the Angel.
Rijksprentenkabinet, Amsterdam

Cat. III P 1
Cat. III 2

Cat. III 3,
pl. 7

Ill. 96

The painting of *King David seated* by De Gheyn's son is lost, and so is a *King David writing* which was reported in 1649 as having come from the collection of Charles I. This was a pen-drawing probably taken to England by Jacques III in 1618 and sold there, but certainly an important achievement. It brings us to another kind of work, one example of which, dating from 1616, still remains: the large 'pen-painting', over a metre wide, in the Albertina, which shows the *Ecce homo*. This happily supplements our knowledge of the debut of Jacques III. Using a pen even finer than his etching-needle, he formed four half-lengths and one figure in the background into a group: the High Priest in floral cloak and turban, holding his staff of office and with his thin face framed in a luxuriant beard; Christ, his crowned head drooping to one side over a glowing young body, and the executioners with their vicious faces. It is not easy to say where the young draughtsman found his inspiration; before painting his *Crowning with thorns* of 1620 in Copenhagen[28], which is comparable to some extent, Terbrugghen may also have produced a piece with half-length figures that De Gheyn had seen. Without any knowledge of such a painting, Jacques' remarkable piece of work is left somewhat in the air. Particularly the figure of Christ, with its reminiscences of Italy, seems completely isolated in its period. But even if it is impossible to imagine the soldier in armour in the right foreground as being independent of the Terbrugghen brand of Caravaggism, we should not close our eyes to what had been happening in Antwerp recently. Rubens had established his empire there, and the lesser talents were gradually being carried along in his wake. The *Ecce Homo* by A. Janssens, now in Warsaw[29] and dating from about 1612-13, shows the

122

process well under way and, if reversed, could very well have served as a model for Jacques. The high priest, seen full-face to one side of the main group, as well as his dress and the position of the soldier's arm, could hardly have been worked out independently in two places at once.

One fully signed drawing, dated 1617, shows a completely different side of the third Jacques de Gheyn's talent. Executed with a sharp pen, it shows a classical hero wearing armour and a plumed helmet and using a long stick to write an undecipherable, lengthy text in the sand on which he is standing, the entire scene set in a hilly landscape. In the right background a woman with uncovered breasts descends a road leading to the foreground; it seems that the text is intended for her. But the meaning of the scene remains enigmatic. It could not be found in any passage of a classical author, or in Tasso or a more contemporary French or English writer. This very minute drawing still awaits its iconographic explanation.

Cat. III 21, pl. 32

Before leaving for England in 1618, Jacques had four etchings, again featuring seated figures, published by Nic. de Clerck of Delft, who had also issued his father's most recent prints. The figures represent *St. Peter, St. Paul, St. Matthew* and a *Sleeping Mars*. The first two link up with the *Seven Wise Men*. The drawing for St. Paul in Budapest shows that the designs were executed in black chalk. In the etching of St. Matthew, only one copy of which is known, the angel is executed entirely in stipple technique so as to indicate its ethereal character. This was neither more nor less than a first experiment in suggesting the appearance of supernatural light within a strongly contrasting and realistic clair-obscure: an attempt that was to be perfected by Rembrandt. The *Sleeping Mars* is probably somewhat later, and the weapons, which include the iron gauntlet featured in the *Solon*, again testify to the artist's interest in the sculptural representation of such objects. According to the distich, the theme was apparently meant as a tribute to the Truce which was still being observed and was proving altogether beneficial.

Cat. III 4-6, 8
Cat. III 5, pl. 17
Cat. III 6, ill. 97

Cat. III 8

Cat. III 15

The word-puzzles appearing in this print as well as in the following examples, must not be shirked. The monogram *Hh* behind Nic. de Clerck's *exc.* suggests Hendrik Hondius, probably as the keeper of the copper plates at The Hague. After 1621 the latter appears to have been in the possession of all the copper plates and to have replaced De Clerck as the publisher. The plates which have Hondius' address only may therefore have been executed after 1621. The problem of the letters *O H* (?) used to sign the couplet has not yet been solved. As far as links with the De Gheyns are concerned, it is possible that Otto Heurnius — who belonged to a prominent Utrecht family and was a Leyden anatomist — wrote the distich as well as the lines below *St. Peter* and *St. Paul*, although this seems less likely in view of his medical profession. After the publication of the *Seven Wise Men* De Gheyn Junior always surrounded his own monogram with the symbol *I S* or *S I* in cursive letters, placing them above, below and on either side of the monogram, thus forming a cross. One wonders whether this had any significance, and if so, what it may have been. The question whether the Societas Jesu was involved is less surprising than might appear at first sight, since sons frequently adopted their mother's faith, and his distant cousin, the poet J. Stalpaert, who had been archpriest at Delft and protonotarius apostolicus since 1613, was striving tirelessly to return the 'lost sheep' to the ancient fold. That the latter was also active at The Hague is proved by his support for the son of Diederik van Schagen[30], for whom Jacques de Gheyn II was to paint a large *triptych* in 1618. Another explanation would be that *I S* stands for J. Stalpaert, in which case we should perhaps think in terms of one of the older Stalpaerts, to whom he owed a great deal. Finally, *I S* could also refer to collaboration with an engraver such as Jan Saenredam, but this seems most unlikely. The mystery, however, remains unsolved as well.

The etching entitled *Vertu mesure du bonheur* was produced in 1617. Here we see a kneeling Fortuna shaking out a horn of plenty before Hercules, who is leaning on his club — again a most orig-

Cat. III 10, pl. 8

inal invention. The design, executed in red chalk, has also survived. The artist's rendering of the heavy, naked form of Hercules is highly successful; his study of human anatomy had not been in vain. At the most he contravened the laws of proportion by placing the knee rather too low. The work owes nothing to the *Farnese Hercules*. The graceful goddess with her fluttering veil, and the bunches of grapes she is pouring out with a caduceus, Mercury's symbol of prosperity, are also rendered skilfully. The chilly old men may well have looked as if they were doing a stretch of solitary confinement, but here the myth is enacted in the open air. The best explanation for the obvious increase in facility would be some knowledge of the art of Rubens or Jordaens. It is impossible to say what the origin of the theme was, or whether it was wholly imaginary, but a literary source should not be ruled out. At the end of 1617 a large painting by Rubens representing a fox and wolf hunt arrived at the house of Sir Dudley Carleton, the British envoy at The Hague, in advance of a number of paintings and tapestries Carleton was accepting in exchange for his collection of classical sculpture. *The Hunt of wolves and foxes* may have been one of the first paintings by the Ant-

Cat. II 769, pl. 322

werp master seen by the elder De Gheyn, and there is one piece of evidence, a tiny study of the head of a trumpeter, which seems to prove he studied it carefully. Furthermore, the majestic rearing

Cat. II 849, pl. 253

horse in the centre may have impressed old Jacques so much, that he drew a similar horse in a position which had not suggested itself to him before.

The debut made by De Gheyn's talented son was therefore full of promise. As mentioned earlier,

Cat. II P 3, pl. 11-15

the father himself was commissioned in 1618 to paint a large triptych for Diederik van Schagen, the second son of the premier nobleman of Holland. The work was probably destined for the chapel of his house at The Hague, and by inheritance has finally found its way to Xhoz Castle (Province of Liège). The central panel shows the Virgin Mary and St. John in rather pathetic attitudes at the foot of the Cross; St. John wipes away his tears, and Mary, her hands folded, is looking up at Christ who, his head drooping to one side, is hanging on the Cross. Dark clouds loom ominously over Jerusalem, which can be seen behind the Cross. Something of the spirit of Antwerp Baroque had been transmitted to Jacques de Gheyn. However, this is not apparent in the side-panels which are smaller in scale and follow the older tradition of portraying the kneeling founders and their patron saints. On the right, Margaretha van der Noot, the wife who had died in 1608, is shown inside a church with flowers strewn in front of her and Saint Margaret standing behind her. On the left, Diederik van Schagen and his son Willem are dressed in armour, with their gauntlets, reminiscent of those in the prints by Jacques III, lying in front of them. St. Thierry of Rheims and St. William of Aquitaine accompany them. Inspiration for the triptych presumably came to the artist in the course of a stay at Bruges; he must have seen the figure of William of Aquitaine in Hans Memlinc's *Moreel triptych*. It is primarily due to its arrangement that the painting fails to make a convincing impression despite its competent workmanship. The side and centre panels are conceived quite separately from each other, and the total lack of any spatial relationship between them is most unsatisfactory. If De Gheyn had already seen Rubens' triptychs they had failed to have any effect on him.

When the panels are closed, a scene in two zones is seen to be painted across them: above the large cartouche with an elaborate inscription and the Arma Christi over Christ's tomb, the four Evangelists, figures comparable to the seated old men portrayed by Jacques III, are seated in a semi-circle. This part of the triptych is painted as a grisaille in alternating shades of grey and yellow

Cat. II 55, pl. 413; 740, pl. 401

ochre. I have found preliminary studies for the group of figures in the *Crucifixion* and for the head of Mary[31].

De Gheyn may well have regarded this triptych as a stimulating commission, but to us it lacks all the qualities that make his drawings so attractive. More in keeping with the latter is the *Madonna*

*and Child* supported by three winged heads of cherubs in the Bardini Museum in Florence. It must date from the last ten years of his life. The motif is only in part of Renaissance origin: the Virgin's finger pointing to the Child's heart does not belong to the original codified gestures; the three heads of cherubs are a contemporary phenomenon which originated in Italy and was, for example, also included in Abraham Bloemaert's altarpiece for St. John's Cathedral at 's-Hertogenbosch. The painstaking workmanship apparent both in the drawing and in the bright colour, suggests an obvious attempt to emulate Quinten Matsys' Madonnas.

Cat. II P 2, pl. 16

In 1618 Hendrick Goltzius was no longer alive. During the last years of his life he seems to have been in touch with the Rosicrucians[32] and Libertines, who were regarded with a certain amount of suspicion in Holland, as will be seen later in connection with Johannes Torrentius. They frequently belonged to the intellectual élite and probably had protectors among members of the House of Orange. But Goltzius must have had enemies in Haarlem as well. In any case, when he died there was no question of the kind of general mourning there had been for Van Mander. This is probably the reason why Balthasar Gerbier wrote an elaborate poem in which he made the artists of the day pay tribute to the deceased. Seven *gheesten* (spirits) present themselves to help the orphaned Muse of Drawing reap glory again in the future: they are Jacob Matham, De Gheyn Senior and Junior, Jan Muller, Pieter Serwouters, Hendrick Goudt and Crispijn van de Passe. De Gheyn, the 'Nymph's' eldest nurseling, is accompanied by his son who, 'soaring like an eagle', will one day surpass his father. Of the father it is said that *Flora, ondanks Hyems' cracht, zijn liefelijk penceel doet blosen als corael* (Flora, despite Hyems' power, makes his gentle paintbrush blush like coral) the same topos Grotius had used in praise of the bouquet he had painted for the Emperor. The poem was not printed until 1620 and appears to have been distributed amongst a very small circle only[33]. It provides a clear indication that the youngest De Gheyn was compared favourably with his father at this time. However, it could also prove he had almost reached the culminating point of his development.

Our information about the journeys abroad made by De Gheyn and his son is far from complete. I assumed De Gheyn travelled to Flanders shortly before 1610 and gained new impressions of contemporary and earlier painting there. The assumption was a natural one, since the frontier was re-opened in 1609 when the Truce came into operation. Perhaps some of his father's friends were still living there, or he may even have had business interests in Antwerp. The journey would explain the commission for the large panel representing *Christ and the Empress Helena,* now at Bruges. But it is undocumented.

Cat. II P 4, pl. 7

However, we are told about young Jacques' visit to London in 1618 in letters written home by Constantijn Huyghens, who was in London during the same summer. In 1622 the latter also wrote a poem commemorating the trip the two of them had made to Oxford[34]. The purpose of Huyghens' long-planned journey was primarily to gain proficiency in English and to take a closer look at the workings of state, but it yielded far more than he had dared to hope: King James received him most graciously and he came to know an impressive number of town and country houses as well as their occupants. Young De Gheyn's stay was also meant to provide him with a 'finishing touch', but the art collections were to be his main interest. A week after his arrival Huyghens wrote that De Gheyn had made the sensible arrangement of having his meals with an English family in London — a common custom among foreigners — so that he was rapidly learning to speak English. Without a doubt he owed much to the Republic's Ambassador in London, Sir Noël Caron, to whom he was to dedicate his *Laocoon* print in gratitude a year later. On July 3rd Huyghens took De Gheyn with him to visit the collection of paintings on view in the Palace of Whitehall, for which he had been given an introduction. The paintings had belonged to Henry, Prince of Wales, who had died in 1612, and

98. Daniel Mijtens. *The Earl of Arundel
and his Gallery of Antique Sculptures
in London.* Painting.
Arundel Castle, Sussex

were later to pass to Charles I. Prior to this visit, De Gheyn had been at the house of the Earl of Arundel, where he in turn had taken his friend. *Hier je menay de Gheyn veoir la galerie de pein-tures du feu prince par l'adresse de certains gentilshommes anglais qui m'ont grandement obligé. Celle du conte d'Arundel avec les antiquitez etc. de Gheyn m'avoit fait veoir par cy devant. Au reste nous voicy au païs le plus gentil du monde ou journellement nous voyons des palais et païsages om op clavecingeldexels te schilderen... wij spreken samen niets dan Engelsch* (Yesterday I took De Gheyn to see the picture gallery of the late Prince through the assistance of certain English gentlemen who have deeply obliged me. De Gheyn had earlier taken me to see the one belonging to the Earl of Arundel. So here we are in the pleasantest country in the world where every day we see palaces and landscapes to paint on the lids of clavichords... we only speak English to each other). If Huyghens' interests were centred on the Court and the King, who received him, it was the Arundel Collection that appealed most to De Gheyn. He must have heard about it when Arundel visited The Hague in 1613 on his return from Rome, where he had been buying classical sculptures[35]. These were now displayed in a wing of Arundel House in the Strand, and Daniel Mijtens was engaged in painting the life-size portraits of the Earl and the Countess, with the gallery containing the Earl's antiquities in the background[36]. Jacques was very much impressed by the classical sculpture, although the examples he saw were mainly late or badly restored. This aspect of his trip to London was comparable to the journey to Rome undertaken by so many other artists. He knew he would be able to become familiar with the largest collection of classical sculpture available to him so far away from Rome. He and his father may have had their first view of ancient marbles at Carleton's house at The Hague. A number of complete sculptures, including 16 busts of Roman emperors pur-chased in 1616, as well as the busts of Seneca, Cicero and Chrysippus and many others were dis-

Ill. 98

126

played there. However, just before his departure, Carleton had disposed of them to Rubens in a vast deal whereby they were exchanged for paintings by the Flemish artist and for Flemish tapestries. So Holland soon lost its first collection of classical sculpture. *I am now saying to my antiquities 'Veteres migrate coloni'*, Carleton wrote to Caron on May 23rd, *having past a contract with Rubens the famous painter of Antwerp for a sute of tapistrie and a certaine number of his pictures, which is a goode bargaine for us both, onely I am blamed by the painters of this country who made ydols of these heads and statuas, but all others commend the change...*[37]. Throughout the century, painters interested in antiquities were to see their opportunities for studying ancient sculpture in the Netherlands come and go. In the end very little remained of all that had passed through the country. The painters' protests were understandable: on the one hand they lost their only chances of seeing classical art, whilst on the other hand, the revelation of the genius of Rubens, whom none of them could rival, was equally annoying. On the whole they continued to resist his influence.

In the meantime, De Gheyn II had managed to execute a drawing of Carleton's *Head of Seneca,* which he may have used later on when he transformed a rapid sketch for the *Death of Seneca* into a more finished work of art, now lost. It is not impossible that by then he knew of Rubens' composition for this subject in which he had utilised his knowledge of a life-size ancient marble[38]. The head, in any case, features in a drawing by Jacques II and, seen from a different angle, in De Gheyn's *large still life* which will be discussed later on. Jacques II may also have drawn a *classical bust of Socrates* in the Carleton Collection.

The statues in the Arundel Gallery sketched by Jacques III in chalk or pen and ink include *the so-called Homer,* viewed from two sides and also to be seen in Mijtens' background, three so-called

Cat. II 1027, pl. 436
Cat. II 144, pl. 435
Cat. II P 14

Cat. 1009, pl. 430

Cat. III 89, 90, ill. 100

99. (After) Jacques de Gheyn III. The *Diane de Versailles,* now in the Louvre. Etching. From *Signorum veterum Icones* by J. de Bisschop. Rijksprentenkabinet, Amsterdam

100. (After) Jacques de Gheyn III. *The so-called Homer.* Etching. From *Signorum veterum Icones* by J. de Bisschop. The Greek statue, at one time in the Arundel Collection, is now severely multilated. Fawley Court, presently on loan to the Ashmolean Museum, Oxford. Rijksprentenkabinet, Amsterdam

127

Cat. III 95, 96
and 100
Cat. III 103

*Minervas,* male figures in togas, several draped female figures, and finally the attractive sculpture of a seated girl resting her head in her hand, usually referred to as the *Clio meditans* — in short, a sufficiently varied selection to open his eyes to the way in which clothes were worn in antiquity and large-scale figures were sculptured in marble. The so-called *Homer* may have been an original dating from the early third century BC[39]. It is conceivable that Jacques was meant to illustrate the entire collection — the systematic presentation points to this — but nothing came of any such scheme. He kept the drawings all his life. After his death they passed to his cousin Johan Wttenbo-

Ill. 100

gaert who lent them to Jan de Bisschop for reproduction in the latter's *Signorum Veterum Icones Semi Centuria* in 1671[40]. The etchings provide ample evidence of the purity of De Gheyn's designs which had retained the characteristic features of each item, including damage and mutilations. His approach was more painterly than that of most copyists, and pointed ahead to Dutch realism.

In a poem Huyghens wrote in 1622[41], we are told about a trip to Oxford made by De Gheyn in the company of Huyghens and Joost Brasser:

> *Iuvit et Oxonij sacros invisere colles*
> *(Metkerko duce, Brasserio suavi comite, et qui*
> *Geiniades famae obstruxit cum Laude Paternae)*
> *Et pluteos, Bodleie, tuos, et millibus istis*
> *Millia librorum generosis addita donis,*
> *Regalesque domos, quae, quot Collegia, gratis*
> *Occupat incumbens studijs bene nata Iuventus.*

Led by Eduard Meetkercke, who was living in Oxford, they visited the Bodleian Library, which filled Huyghens with awe, the Sheldonian Theatre, and many ancient colleges. Bachrach[42] gives a detailed account of the seven days the 'Comices' spent there together. Finally, they also paid a visit to Woodstock with its gardens and memories of Queen Elizabeth who had been imprisoned there by Mary Tudor.

Cat. III 104,
ill. 99

When and how De Gheyn returned is unknown. It is not inconceivable that he made his way back by way of Paris. One sculpture reproduced by De Bisschop, known now as *Diane de Versailles,* did not belong to Arundel, but to the King of France; Buchelius drew it at Fontainebleau, but Henry IV had the famous group transferred to Paris and set up in the Gallery of Antiquities of the Louvre[43]. This is where De Gheyn must have drawn the Diana.

Jacques may well have become familiar with a number of masterpieces of the Italian Renaissance in Paris, and may have seen the *Gioconda,* which, most likely, was still at Fontainebleau[44]. Presumably he did see the copy of the Laocoon cast in bronze by Primaticcio in 1540, which Buchelius had seen at Fontainebleau and which was now in the Jardin de la Reine near the Louvre[45].

It would be natural to assume that if Jacques travelled home by way of Paris, he continued his journey via Antwerp where, having seen Arundel's antiquities, he now also managed to find those belonging to Rubens. In addition to the Carleton marbles already known to him, the collection also included the antiquities Rubens had bought in Rome. There is further reason for thinking in terms of a visit to Rubens: in a postscript to a letter dated January 23rd 1619 and addressed to Pieter van Veen, the Court Advocate at The Hague, a painter in his spare time, and a brother of Otto Vaenius, his third teacher, Rubens wrote, 'I also kiss the hands of M. de Gheyn, in all affection'[46]. These greetings are likely to have followed a recent meeting, and Jacques presumably returned home before the onset of winter. At Rubens' home he may also have met Jacob Jordaens and Anthony van Dyck, whose great talents were rapidly developing at the time.

In connection with the journey to England, it is also necessary to discuss seventeen silverpoint

101. B. Breenbergh. *Fountain at Vilvoorde.*
Drawing. Cf. cat. S 17.
École des Beaux-Arts, Paris

102. Jacques de Gheyn III. *The Laocoon Group.* Etching.
Dated MDCXIX. After the bronze copy now in the Louvre.
Rijksprentenkabinet, Amsterdam

sketches [47] executed by an artist who had been in London, as well as on the waterways of Zeeland, Cat. S 1-17, pl. 1-17 in the course of his travels. These sketches are scattered over various collections. Originally the series must have been much larger, since the pages which have not been cut are numbered up to 49. As the *Batsen tower in the East Scheldt* is on page 22, and a very tall and narrow sixteenth century house that the artist must have seen in Walcheren, Antwerp or London is on page 24, we may conclude that he travelled by way of Zeeland, and subsequently executed the drawings in London. If the artist were Jacques de Gheyn III, and several circumstances favour this suggestion, he must have travelled to London by way of Zeeland. In that case it is possible to establish a rough sequence for the drawings, including the pages without numbers.

Having filled twenty-one pages and passed the Batsen Tower and another small, polygonal chapel in the East Scheldt (p. 22), he drew two small portraits of a boy, evidently a companion aboard ship (p. 23). These were followed by a row of somewhat sketchily drawn façades of houses, including a detailed rendering of one very narrow, but exceptionally tall example (p. 24 or 29). It is tempting to think that De Gheyn visited his grandfatherly home in Antwerp and drew it in detail. The Antwerp City Archives, however, provide no definite evidence as to the house's whereabouts. In London, the artist sketched details of Holbein's frescoes in the Guildhall. There are two pages of classical sculptures, heads, an urn and a cippus, and also the profile of a lady, presumably Lady Arundel. The artist must then have ridden to Hampton Court, visiting Ham House on the way, where he copied a fragment of *Julius Caesar mounted on horseback* painted by Jacques II, and also drew the stocks. He did an outline drawing of Hampton Court, and of a small monument of

books, obviously a sundial, in the same place. He also drew a harp. His interest was attracted by a bear (p. 39), either in a menagery belonging to one of the royal palaces, or in a circus where bear-fights had been a familiar feature since the days of Elizabeth, and a horse frisking about in a meadow. At the very end of the book he had occasion to draw some studies of a slaughtered horse, a macabre theme occupying several pages and showing his penetrating talents at their most striking (pp. 45-48). One of the two fountains appears to have been situated at Vilvoorde near Brussels (cf. ill. 101), so that it may have been sketched on the homeward journey between Paris and Antwerp. Page 49, the final numbered sheet, contains a still life of agricultural implements and a horse-collar drawn with a delicacy of which neither Dürer nor Menzel would have been ashamed.

It is extremely tempting simply to attribute this sketchbook to Jacques, and I believe there is enough evidence to do so. On the other hand, a connoisseur like A.E. Popham always[48] advocated an attribution to Wenceslaus Hollar, who travelled to London by way of the Zeeland waterways in 1637. The provenances of the drawings make the matter extremely complicated, however, and final judgment must await a really conclusive argument.

Cat. III 88,
pl. 18, ill. 102

No dated works produced by Jacques II in 1619 are known: 'Geiniades', the son, was indeed eclipsing his father's fame. His *Laocoon* print appeared in 1619: he dedicated it to Noël Caron in gratitude for his stay in England and the introductions he had been given there. As Reznicek first pointed out, the print, made from a drawing now in Göttingen, shows the group in the condition in which it was found, that is without Laocoon's right arm, the younger son's raised arm, the hand of the elder son, and the heads of the two snakes. The mutilated arm of the younger son did, however, belong to the original find. This clearly shows that he worked from the Renaissance bronze in Paris. He knew about the replicas since he told Buchelius later on that Goltzius' *Laocoon* had not been copied from the ancient sculpture, but from 'a cast by Bandinelli'[49]. This text may be explained in two ways: either Goltzius worked from the Laocoon that Bandinelli had cast, or else he possessed a copy cast from the one by Bandinelli. Perhaps the latter alternative is to be preferred, since it is unknown whether Bandinelli cast the Laocoon before sculpting his copy of it. According to Vasari he copied the group in wax[50]. When Goltzius was in Florence he should have been able to arrange for a plaster cast of Bandinelli's group to be made for him, and he also owned plaster casts, either of *Day* and *Night*, or of *Morning* and *Evening*[51]. But we are left wondering how so heavy a group was actually transported. The print gives an excellent idea of the unrestored original of the Laocoon. Huyghens supplied three verses for the work, as Grotius had done for the elder De Gheyn. 'What thanks do we not owe to the burin of young de Gheyn? What once belonged to our grandfathers is re-born for our grandchildren', Huyghens wrote in conclusion.

It may well be that Jacques de Gheyn's son also produced some of his other surviving works before 1620. We shall return to these in the next chapter. If we now consider the fact that prior to that year he had already completed a number of important commissions — the *Seven Wise Men,* the *Arundel marbles* and the *Laocoon* — we are confronted with the image of a younger generation pitting itself against the older one. His father's most recent work, the triptych for Diederik van Schagen, still had many features in common with the art of the sixteenth century, and as a figure-painter the artist proved to be, in the main, a conformist. Blended with the son's interest in classical antiquity there was a creative power that, by way of a certain revolutionary bizarrerie, gradually adapted its forms to classical discipline. His discussions with the universal Huyghens must surely have contributed to this, as did his knowledge of the great art of the southern countries which he studied so eagerly in London, Paris and Antwerp. His rare remaining works will reveal only in part to what extent the promise contained in all this was to be fulfilled.

# CHAPTER VI

## *The last years of Jacques II*

In the same year 1618, when Huyghens and young Jacques were in London, the conflict between the Stadtholder and Oldenbarnevelt erupted. When Huyghens arrived home, the latter had been arrested[1]. Living only a few steps away from the Kloosterkerk, where the Prince had ostentatiously attended divine service, and equally close to Oldenbarnevelt's home and the Court where the tragedy unfolded, the elder De Gheyn is bound to have been deeply affected. He must have known all the principal characters involved. Had not his old friend De Groot also been imprisoned, and was a fatal conviction so hard to imagine after his rather unsuccessful defence? And all this was taking place at the instigation of a Prince who had favoured De Gheyn with several commissions! For De Gheyn, the conflict was one between friendly powers. One cannot help wondering how friendly these were, since, as so often happens with artists, the sources fail to tell us what his thoughts were as a human being. This is true not only of this particular period, but also of his earlier and later years. After some time, the Prince was once again to call upon his services. That is why the most we can do is draw the conclusion that he was not overtly Remonstrant. It is more likely that inwardly he shared the indignation of Count van Schagen, whose brother's portrait he had just painted. But we also know how his own brother-in-law, Govert Basson, helped to keep the imprisoned De Groot unobtrusively informed of news that would be useful for his defence[2]. And how many liberal minds had not De Gheyn already encountered in the course of his life!

In a material sense, the artist must have prospered. The will he and his wife had drawn up in 1599, leaving their estate to each other, shows that even then they owned property, both 'movable and immovable, in Brabant and elsewhere'[3]. No later than on his twenty-fifth birthday, their only son was to receive *drye duyssent carolus guldens te XL grooten 't stuc* (three thousand carolus guilders at 40 groats the piece). Jacques must have had control of this sum by 1621 at the latest. The records provide us with detailed information about the property owned by the De Gheyns in South Holland.

The young family must have moved into the large house in the Voorhout by 1603, when they paid 78 guilders on it. The widely scattered estates belonging to the parents of Jan Stalpaert do not appear to have been completely divided among their children, and therefore only the income was shared out. The large house on the south side of the Voorhout which Eva's grandparents had probably occupied, was not sold until after the death of their uncle, Rutgert van Ylem, when it fetched 8000 pounds, for their joint benefit, on November 14th, 1613[4]. Elizabeth's death may have been the reason for the disclosure that a jointly owned estate, probably at Heer Ydo Ambacht, and certainly on the West Meuse, had been unlawfully sold by the female tenant for the sum of 16,800 guilders. In 1601, Jacques and his uncle Rutgert van Ylem consequently appealed to the High Court, which ruled the sale to be null and void[5]. The remainder of the estate was scattered over

Cromstrijen (Strijen), Spijkenisse, Voorschoten, Delft, Noordwijk and Soeterwoude. Further on, we shall see how De Gheyn gradually separated the older generation's shares from his own and from those of his sisters-in-law or their heirs[6], and also how he managed the estates[7], and, at a later date, how he sold parts of his own share in the inheritance[8]. He finally acted together with his son[9], who subsequently took over the running of the estates which he managed on his own after his father's death[10]. Jacques III had also inherited from his grandfather certain 'rights of gift and collation of the benefices of the vicariates and jus patronatus'[11] and was invested by the States of Holland and West Frisia with part of the Manor of Ruiven near Delft and with part of Woutersland in Noordwijk on September 16th, 1622. All this seems to have been sufficient to give the bachelor son full patrician status.

In 1627, when the 500th penny was levied in tax, his father's capital was assessed at 40000 guilders[12]. The latter therefore belonged to the small group of wealthy citizens of The Hague. In the same year he and his son were to sell the large house on the north side of the Voorhout, which had probably become too large for him, for 6600 pounds. By then he had already moved to the Lange Houtstraat, where he lived with his son next door to Constantijn Huyghens, who had become Secretary to Frederick Henry in 1625. The house belonged to Meester G.M. van Kenniphoven and De Gheyn rented it from him[13].

Cat. II 669, pl. 416

The deed of 1613 refers to De Gheyn acting on behalf of himself and others, and it would be possible to draw the conclusion that his wife, to whom the property belonged, was no longer alive. When writing my *Introduction,* I assumed this to have been the situation and believed she had died shortly after 1599 when their will was drawn up. Bearing in mind similar cases, I later began to doubt whether this conclusion was, in fact, watertight. Eva now appears to have died in 1621. The identification with De Gheyn's own family of a group portrait representing three people, an accomplished drawing from his later years, seems fairly conclusive in view of the resemblances to father, mother and son. It must have been drawn shortly before 1621. Her death would have been the reason why the two now solitary men looked for a smaller house.

Here we may also take a glance at the small family's nearest relatives. De Gheyn is likely to have stayed frequently at Leyden, not only because of his learned and literary friends, but also because his own brother and sister lived there. After the death of Adriaen van der Burgh or Verburgh, Anna had settled there with her children, Jacob and Anna. In 1608 she married Govert, the son of the English publisher Thomas Basson[14]. In 1602, Thomas became acquainted with Reginald Scot's *Discovery of Witchcraft,* a translation of which he published in 1609. De Gheyn's drawings of *Witches' Sabbaths* make it likely that he had already discussed the subject with Basson in 1602 and had seen the book then, although van Dorsten denies there was any connection between De Gheyn and Basson's publishing firm. But the Leyden world, however varied and famous its activities might be, was not very large. Perhaps it was Jacques de Gheyn who persuaded his brother-in-law to go into printing shortly after his marriage. Basson also helped De Groot during his detention.

We know a considerable amount about Jacob van der Burch, Anna's son by her first marriage[15]. He studied at Leyden University and later called himself *juris consultus.* He must have met the Huyghens brothers at the university town—he was to keep up a regular correspondence with Constantijn—and also Jan van Brosterhuisen, who is noted for his architectural studies and delicately drawn and etched landscapes. He appears with the latter in a double portrait by David Bailly[16]. Jacob also had musical and literary talents which drew him into the Muiderkring, and they are supposed to have been dearer to him than his various official appointments. As Secretary to the Dutch Delegation at the Peace of Westphalia, he also had the opportunity of being portrayed by Gerard Terborch[17]. Jacques III de Gheyn left this cousin 8000 guilders[18]. Jacob van der Burch's sis-

ter Anna married a cousin, Hendrick Woutersz van Veen, an Amsterdam broker. She had children and was a widow in 1641 when she received a similar legacy[19].

Steven de Gheyn, Jacques' younger brother, had married the daughter of a Hague doctor in 1603. She was the sister of the deaf-mute painter Matheus Hyc. In 1606 Steven was granted citizenship of Leyden, where he was already living in 1601. In 1619 he was still there. In 1607 and 1609 he was mentioned as the landlord of the *Roode Leeuw*. In 1601 Steven had travelled to France, apparently on business for Pieter van Dijck, which included effecting the sale of recently produced prints. Some of these he had taken with him, others he had received from a certain Pieter Hagel in France. The latter included scenes of the Battle of Nieuwpoort and portraits of Prince Maurice. He presented copies of Prince Maurice's genealogical tree to the King, the Duke of Bouillon[20], the Duke of La Trémouille[21], Louise de Coligny, Van Aerssen[22] and the Seigneur de Villeroy[23] respectively, and received gifts of money in return. Legal action ensued concerning expenses for which he had not been reimbursed, and the documents of the case give us some idea of the propaganda made for Maurice and his army after the victory in Flanders. In my opinion, the *geslachtsbomen en genealogie chaerten* (family trees and genealogical charts) are likely to refer to the large folio-size sheets with the engraved coats of arms of Prince Maurice's ancestors, a complete set of which I found at the Rijksprentenkabinet in Amsterdam[24]. They have been described by Fred. Muller[25]. Steven was a limner and may have coloured copies of the engravings — by Jacques or himself — but, despite my investigations in France, all traces of the copies taken there have been lost. We also hear of him in 1610, when he was said to be dealing in art with a goldsmith in Middelburg, and we finally learn that in 1623 he was living in Brussels and was 'sick and no longer capable of working'[26]. In 1622 his son Abraham was living at the house of his aunt, Anna Basson[27]. In 1641 he too was left a legacy of 8000 guilders by Jacques III[28].

No more is heard of Isaac, the second son of Jacques' parents. As already indicated, he is likely to have died young.

As mentioned earlier on, it may well be that the woman later referred to as the widow of Jan Pietersz van de Venne of Middelburg was Jacques de Gheyn's younger sister. This would explain why, in 1623, her brother-in-law Adriaen van de Venne dedicated a long poem to Jacques III in the *Zeeusche Nachtegael*[29]. It is possible that an allusion to an unrequited love for a peasant girl Jacques had met in Middelburg should be read into it, and that the trialogue *het Minne-mael van Dirck-Leendert, en Lijsje Teunis, met Joncker Maerten 'aen den Achtbaren, Constrijcken, Jacob de Gein, de Jonghe'* contains a romanticised account of the story. Jacques may have stayed with Van de Venne or with the Mint-Master of Zeeland, Melchior Wijntges, who was presumably a brother of Jacques' uncle in Hoorn, and was mentioned by Van Mander as a collector. This visit may have coincided with the short period when Anna Roemers brought the literary minds of Zeeland together at Middelburg. 'Gein, my friend, when you see how people make love beneath the lime trees in the Voorhout' — the same trees that Huyghens had celebrated[30] — 'you may well conclude that love is to be found everywhere', ends Van de Venne, 'a lover of the paint-brush'. Nevertheless, Jacques de Gheyn, the son, was never to marry.

Besides entertaining close relations with his own brother and sister(s?), Jacques II must have been on intimate terms with his brother-in-law Caspar Wijntges, Mint-Master at Hoorn. I would at least like to draw such a conclusion from the prominent place his daughter Anna, and the latter's son and daughter, occupied in Jacques III's will[31]. Regarding Eva's sisters — she had four — it is known that Catherina lost her husband, Meester Cornelis Duyn, the Amsterdam regent, either prior to or in 1613. It may well be that in 1611 either she or Jacques asked Willem van Swanenburgh to make an engraving from De Gheyn's portrait drawing of him.

Cat. II 662, ill. 88

Cat. III 11,
pl. 38

Cat. III 26;
ill. 103

Pl. 199
Cat. II 934,
pl. 417

Cat. II P 18,
pl. 19

Cat. II P 19,
pl. 17

Cat. III P 7,
pl. 2

Cat. II P 20,
pl. 18

The early works of Jacques III include a pen drawing again illustrating a theme taken from classical literature, this time Ovid's Metamorphoses: Iris appearing before the dwelling of Somnus (Sleep). Roots overhang the cave, where silence prevails and no light penetrates; in front of it there are flowering poppies; the waters of Lethe, Oblivion, well up out of the rock. Sleep, his chin sunk on his chest, lies on his bed of feathers; the ray of light cast by Iris awakens him: 'vestis fulgore reluxit sacra domus'; he rises, and in response to her plea promises to send the unhappy Alcyone the image of her drowned Ceyx in a dream[32]. The work reinforces the impression made by Jacques' previous œuvre that he never allowed his imagination to go beyond the text he was illustrating. This may have been a deliberate reaction to his father's unbridled fantasy. Inspired by the poetic description, he did, however, succeed in preserving the atmosphere of the story in a compact scene. *Sleep,* the main motif here, also featured in a print he may have produced either before or after his visit to England. Dense clouds emerge from a horn in front of the sleeping figure with his magic wand: we are still in the *soporifera aula*[33]. A French quatrain below the illustration praises Sleep for releasing us from our anxieties. Without the perfection of its workmanship, the print could almost be taken as an advertisement for narcotics; was the artist perhaps familiar with drug-taking? The fact that Huyghens was later to deplore his inertia, his *sterili illaudabilique otio indormivisse*[34], cannot allow us to rule out the possibility of Jacques being an addict. Nor can we ignore the importance of a theme that attracted visionary artists and poets such as Dante, Michelangelo, Novalis and Goya. With this mature etching, young De Gheyn added to a chain linking the theme across the ages.

In 1620 young Jacques travelled to Sweden to show King Gustavus Adolphus eight works by his father, including drawings and paintings. They were dispatched in five crates, which suggests there were four paintings, one to a chest, and four pen-drawings packed together in the fifth. The paintings are likely to have included flower-pieces and perhaps one of the schoolmasters referred to below, whereas the drawings, which must have been of the highest order, were probably landscapes such as the highly detailed cat. 1049, and also included the roses dating from 1620, just the kind of work most likely to appeal to a prospective purchaser. We know about the trip because on September 19th the States General granted exemption from customs duty on any of the works brought back into the country[35]. There is no record of who gave the painter the idea and what the outcome of the expedition was.

In the same year, the elder De Gheyn had painted a theme pointing to an orientation totally different from any we have been accustomed to find in his work so far. The painting represents a seated schoolmaster giving an explanation to two youthful pupils. The cartouche frames a late Greek motto claiming that the aim of all good education is virtue. Here again the artist was endeavouring to portray a relationship expressed simply by the attentive glances the students cast at the master. He took his models from his large store of male portrait heads both youthful and mature. The variant featuring only one youth is, perhaps, an improvement. To judge by the reproductions — the author has seen only the first, signed and dated, painting — both works are by his own hand. A second variant with three pupils is different in composition as well as in its execution, which is smoother and flatter. This work may well be by young De Gheyn, in which case it would be the earliest painting I have tentatively attributed to him. The teacher certainly resembles his type of elderly men; the children's heads are less individually modelled, and, unlike his father's models, their hair does not curl. Furthermore, the legend is not written on a heavily framed board, but on the customary pinned-up piece of crumpled paper.

It is not impossible that the *schoolmasters* were preceded by another conversation piece known to me only from a photograph. I do not know whether the work is signed. It describes two kinds of

103. Jacques de Gheyn III. *Sleep*. Etching.
Graphische Sammlung Albertina, Vienna

104. J. W. Stap. An *Old Man* reading in a studio in the
company of a boy warming his hands. Painting.
Sold at Christie's on December 12th, 1930

love, and again the figures are half-length. A young, elegantly dressed woman chooses between the
advances of a young man, partly symbolised by a bowl of sweets, and those of an elderly one hold-
ing up a coin, and with a bowl of coins placed in front of him. If the painting is indeed by De Gheyn
II, it must, in view of the costumes, date from his later years.

This type of painting with half-length genre figures arranged in a confined space is found in
Amsterdam during the same period in works by the painter Jan Woutersz Stap[36], whose elderly
men sometimes resemble De Gheyn's. The connection is superficial and may be fortuitous; perhaps
Stap was following the tradition of Pieter Aertszen's studio rather than De Gheyn's.

I consider the panel with the bust of a *Young Woman* in mourning to be an even later work by De
Gheyn II. She raises her hands, apparently in lamentation, over three dead birds lying before her on
a table: a dove, a partridge and a kingfisher. The significance of the theme is a mystery to me
— Lesbia wept only for a single sparrow — but even so, the very flowing brushwork in this
painting may be admired as an exceptionally early example of a painting technique which was to
become almost commonplace later on in the century. In his rendering of the colourful breast
and wing feathers of the birds, De Gheyn anticipated the best kind of workmanship by later
bird-painters such as Lelienberg and Vonck. In the highly individualized fingers of the young
woman, on the other hand, we can still recognize the differentiation and rustling that made some

Ill. 104

Cat. II P 16,
pl. 24

135

hands by De Gheyn seem like leaping flames. The painterly treatment of the entire work proves that, by the end of his life, De Gheyn had left the engraver's craft behind him and was one hundred per cent a painter.

The interpretation of a *large still life* which I shall try to give later on, renders it likely that this subject too was a disguised political outcry: in those years, so full of trouble for non-conforming minds, the three birds may have referred to specific persons who had recently become victims. For we know that, when prosecuted, they were sometimes indicated by names of birds. To give an example, when Paschier de Fijne, a Remonstrant preacher who was in constant danger, ventured to preach from a sledge of the ice, and then disappeared, he was nicknamed *'t ijsvogeltje,* 'the ice-bird' = the kingfisher. But so far I have been unable to identify the three persons referred to here.

Cat. II 874,
pl. 335; 882,
pl. 447; 879,
pl. 448; 883,
pl. 295

De Gheyn had also drawn *studies of birds* before. Some of these belong to his very best pen-drawings, for instance: young birds which had fallen from their nest; suspended, plucked chickens, unequalled in the way their substance is suggested; ducks; and a dead partridge and heron, sketch-

Cat. III 78,
pl. 51

ed more freely. This last drawing may have been executed shortly before the painting, whereas the duck, drawn four times before and after its death, may be compared with a large drawing by his son that appears lugubriously to evoke the same duck in its death-throes, still cackling in spite of having been plucked. Young Jacques achieved this macabre effect by suspending the dead duck by its neck and one of its feet, but omitting the cord from the drawing, so that it looks as if it is trying to raise itself up in a final convulsion. A comparison of these two drawings clearly reveals the difference between the artists' styles: the father modelled body and plumage with fluent virtuosity and clarified the bird's movements, whereas the son provided a tart caricature of the drama in a fairly monumental, if somewhat crude manner, recording it less mildly, and with less concern to fill the page elegantly, using violent contrasts of light and shade, and also off-setting black against white. Despite all that is true to nature in Jacques II's work, it is Jacques III who emerges as the real verist.

Cat. II 878,
pl. 442

An unsurpassed page of studies by Jacques II showing four views of a dead black-winged stilt, brushed with watercolour, has already been mentioned. The perfection achieved with the colourful paint, for example in the treatment of the bright red legs, makes the page a worthy successor to Albrecht Dürer's studies of animals. Superficially, the layout appears to be that of a systematic scientific illustration, but, in fact, it has a surprising, and deliberately contrived balance.

Cat. III 77,
pl. 52

There is another bird drawing by Jacques III which features a squacco heron rushing forward to attack, its beak open, foot raised, and wings flapping. Here again Jacques used the trick one would never expect to find in his father's work: either the bird was tied up in this attitude when he drew it, or else, more likely perhaps, it was stuffed. Presumably there was a support beneath the body, which consequently acquired a strange lump at the back, giving it an unreal, ghostly appearance. The lighting effects also contribute to this. The body and left wing are enveloped in deep shadow, so that the neck and legs, which are lit from close by, show up all the more clearly. The movement following the diagonal of the page does the rest.

The schoolmasters and the birds best show us how young Jacques had benefited from his father's teaching. In these works, he linked up with the latter thematically, but in his technique he

Cat. III 52-54,
pl. 24-26;
62, pl. 28; 58,
pl. 30; 59, 60
pl. 35, 36
Cat. II 859, pl. 234
Cat. III 80, 81,
pl. 55, 56

followed his own inspiration. He had been an excellent draughtsman from an early age, first copying apes, a cat and a fox by Marcus Gheeraerts from a book of fables, then sketching dogs and foxes or wolves, and finally producing two pages with studies of lions and their cubs. Here, although undoubtedly aware of a similar page full of lions by his father, he consistently used a technique of short pen-strokes and dots. The tortoise carapaces already referred to provide further evidence of his preference for a larger format than his father required.

136

When Huyghens was in England again in 1622, he met Cornelis Drebbel who, if not a pupil of De Gheyn's, must have been in touch with him when they both engraved city maps in 1598. Drebbel was a versatile engineer who had briefly also produced engravings and had succeeded in reaching a fairly high standard. However, he was now responsible for all kinds of inventions or ingenious improvements to instruments, which delighted the English of all ranks including the King. To us, his *camera obscura* and his microscope are of particular interest[37]. His *camera obscura* was based on the same principle as photography. He succeeded in projecting an image on to a movable white surface through a concave polished lens instead of through a narrow opening as had been done previously. However, he was not yet able to devise some means of turning the upside-down image through 180°[38]. The painter Johannes Torrentius[39] must have found out about this at an early date, and, with its aid, he succeeded in making the good people of Haarlem believe in magic, although, according to Huyghens, he had led the latter to believe that he was unaware of the device's existence[40]. The letters to Huyghens' family show that De Gheyn must have learned about the instrument from Huyghens, who brought it home from his stay in London in 1622[41]. De Gheyn does not appear to have used the *camera obscura* for his art, and, as will appear later, he was to come into conflict with Torrentius, who did make use of it.

Drebbel appears to have constructed a usable form of microscope, and he may have invented it, although the principle was probably known already[42]. It is based on double refraction through two convex lenses placed one behind the other. Huyghens called it the 'upright double viewer' and declared, 'Even if Drebbel had not achieved anything else in his whole life, he would undoubtedly have deserved an immortal name because of this admirable 'tube'. For he has brought the bodies, which until now were included amongst the atoms and which are entirely hidden from the sight of man, so clearly into view that when inexperienced folk are shown that which they have never seen before, they first complain that they cannot see anything, but they soon exclaim that they are observing unbelievable things with their own eyes. For this is indeed like being on a new stage of Nature, and in another world! And if De Gheyn Senior had been able to make use of his life longer, he would, I believe, have undertaken that which I had just begun urging him to do — and the man was certainly well disposed towards the idea — namely, to portray the most minute things and insects with an extremely fine brush, to gather them into a book, of which it would have been possible to engrave the copies in copper, and to give to it the title *The New World...*'[43]. This is the only time we hear explicitly of the pressure exerted on De Gheyn by a man he respected, to produce a scientific publication. Since illustrating the *Exercise of Arms* for the House of Orange and the *Aratea* for Grotius, his own searching mind had become more and more inclined towards the 'new world' which the study of Nature was to reveal. Although the dates of one small page showing several insects and three others illustrating flies are uncertain, a slightly enlarged drawing of a *phosphoricus* is dated 1620, and suggests that De Gheyn may already have worked with a magnifying glass in that year[44]. It is the oldest representation of this creature in existence, and presumably also the most accurate. The specimen must have been brought by ship from Surinam to Holland shortly beforehand. One needs to see one of these creatures to realise how accurately the substance of its legs, scales and veined wing membranes was expressed. The small creatures in his flower still lifes had already demonstrated how clearly De Gheyn could observe with his own eyes; how much more he must have seen through his lenses! The present-day viewer needs a magnifying glass to appreciate it.

Cat. II 886, pl. 196; 898-900, pl. 479-481; 905, pl. 420

This peculiar animal was repeated (in reverse) in a large still life which may have come from a descendant of the Huyghens family and is now in a Dutch private collection. The painting is uncommon in that it has a vertical shape (113 × 75 cm) which may have been due to the position it

Cat. II P 42, pl. 20-22

had to occupy, a chimney breast perhaps, or one of two matching wall panels. The arrangement too is curious, as the picture is divided lengthways. Pushed towards the left side is a glass bowl filled with a tall torchlike spray of flowers: roses, tulips, irises and a stem of white lilies at the top, all of them rendered with loving care and in a wealth of fresh colours.

The bouquet is in sharp contrast with the sombre rock next to it at right and flowers pop out casually from the dark background. This rock in turn is bordered by a reddish brown curtain which is looped up irregularly. The huge phosphoricus crawls towards the centre below the glass bowl. There is also a mouse and another flickering beetle. The painting is clearly signed in capitals. It is not dated, but we now know it was painted in or after 1620.

Contrary to what we saw happening when the earlier flower pieces followed one another, the customary symmetry in composition has been dropped altogether and a splendidly capricious baroque arrangement allows the rich colours to vie with each other. One wonders why the actual bouquet is pushed to one side. But the loving treatment of the delicate flowers gives us a feeling of warmth. One is amazed to see how De Gheyn continued to develop his art in the final phase of his career!

Between whiles De Gheyn had been engaged in designing title pages for books. In 1601 he had made one for Clusius, in 1607 three for his own *Exercise of Arms,* and in 1610 one for Orlers. At about the same time he must also have been working on an *Aesop,* for which he drew a single illustration. In 1617, when Nicolaes de Clerck, his publisher, asked him for a title for the compilation of biographies of dukes and war heroes, De Gheyn supplied a rather uninspired design which, in the same year, was totally eclipsed by that of his son's *Seven Wise Men of Greece.*

The year 1630 saw the publication of an historical work by J. Sleydanus with a title engraved by Delff from a design left by De Gheyn who had died the previous year. There was now a decidedly old-fashioned look about the design which lacked the rejuvenation so successfully attempted by Jacques Junior. The contrast with his animal drawings shows clearly to what extent the focus of his interest had shifted from allegory to living nature!

Prince Maurice was not destined to become a great Maecenas. Trained in the hard school of the soldier, he had distinguished himself as an able and successful general right up to the Truce (1609). The portrait painted by Miereveld in 1608 which, like most royal portraits, must have been re-ordered many times and is to be found in most of the prints, presents him as a general in armour (Rijksmuseum, Amsterdam). By the end of the Truce (1621), he had acquired the status of a ruling monarch, although sharing his authority with the States General. His powers were consolidated and his income was considerably increased. For the first time this would have been sufficient to allow for patronage of the arts, but Frederick Henry was really the first Stadtholder to make full use of such an opportunity. We do not know if it was Maurice who, at about the time of the Truce, commissioned the painting of a series of busts of the *Twelve first Roman Emperors,* which were later inherited by the Great Elector (Schloss Charlottenburg, Berlin)[45]. Although representing the same emperors, these paintings are entirely independent of the engravings by De Gheyn and the emperors are no longer shown in profile, but as busts of living persons. It is generally held — although there is no proof — that Frederick Henry, then still a cavalry general, commissioned them. Is it not far more likely to have been the Stadtholder himself, who had worked so hard to gain power? Rubens, as the *primus inter pares,* produced the energetic head of Caesar. Strangely enough, De Gheyn had not been involved; he probably acted as *auctor intellectualis* and as an intermediary for the painters, unless the Vitellius, wrongly attributed to Goltzius, was one of his less successful works.

Towards the end of his life, Maurice was, however, drawn by De Gheyn in 'civilian dress'. He is portrayed wearing an embroidered doublet with a cloak draped loosely over his shoulder, next to

Cat. II 465, ill. 54; 342-344; 289, ill. 78; 284, pl. 426

Cat. II 285

Cat. II 283, ill. 105

Cat. II 1012-1023, ill. 51

Cat. II 695, pl. 415

the design for a ring representing a miniature of his head only and shown above its box. It would be natural to assume that De Gheyn executed the medallion on the ring: Huyghens, after all, mentioned his miniature portraits in the manner of Isaac Oliver, and this must surely have referred to the latest examples of a genre he had practised successfully from the very first[46]. Perhaps the ring was to be a present for Jonkvrouw Margaret of Malines, mother of the Prince's three illegitimate sons. The three-quarter-length drawing also served its purpose: when Andries Stock published his engraved portrait of the Prince in 1623, it was based on De Gheyn's design. Only for the head did Stock make use of the type that had been established by Miereveld[47]. By then the Prince must have aged considerably. The anonymous portrait painting at Nantes and other versions can only be regarded as copies based on Stock's print.

At about the same time, the Prince gave De Gheyn the important commission to design a garden and pavilion or 'grotto' for the south-west side of the Stadholder's quarters. Two sources provide extensive information about this, enabling us to visualise the work which, by the eighteenth century, must have been entirely obliterated. I have given a detailed account of it in a separate article[48]. The oblong garden was surrounded and divided down the middle by *berceaux* with eight pavilions at the corners, and inside the *berceaux,* also within covered walks, there were two flower-

Ill. 106

105. W. J. Delff. Title-page of J. Sleydanus' *Des Hooch-beroemden Historie Schrijvers III Boecken...* Engraving. 1630. After Jacques de Gheyn II. Rijksprentenkabinet, Amsterdam

106. Hendrik Hondius. *Prince Maurice's Pleasure Garden,*
from his *Optica.*
The monumental fountain was behind the columns of the
Gallery on the left.
Rijksprentenkabinet, Amsterdam

107. Jacques de Gheyn III. *Triton.*
Etching.
Rijksprentenkabinet, Amsterdam

140

beds in the shape of joined circles, with a fountain set in the centre of each one. It was the ideal intimate 'pleasure garden', and Huyghens and young Jacques must have seen several examples of these on English estates. The garden itself must have been completed by 1623. Along one of the short sides, however, a gallery had been built 'in the Doric order' — or could it, after all, have been the Tuscan? — containing several aviaries; at the lower level, where it was open to the garden, a long, ornamental platform was constructed, with sculpture in low relief. It was protected by the ceiling, and so acquired the character of a 'grotto'. Work on the wall must have continued until after 1625 before it was entirely completed. It was therefore a grotto fashioned after the Italian style, but in reality no more than a huge frieze set up inside a classicistic building, open on the opposite side. The composition of this *Realm of Neptune* was based on a symmetrical pattern, and developed into a unique apotheosis of an unreal world of cliffs and water, plants and animals. Two designs for it are known: a comparatively short one, and one measuring almost two metres. The work was probably carried out in accordance with the latter drawing, at first by Jacques II himself, and later on by his son, to whom the designer also passed on the princely emoluments received from Maurice, and, after his death, from Frederick Henry. Both designs are undoubtedly by the father, and reveal the full splendour of his last style, in some ways a negation of his fully developed naturalism. There had been some earlier preparation for all this. Had he not previously painted Neptune and Amphitrite with their shells, and had he not also, in 1610, drawn a Neptune surrounded by fishes and shells? His son too had, perhaps in connection with this work, produced an etching of a Triton blowing a horn.

Cat. II 162, 163, pl. 439-441

Cat. II P 5, pl. 5
Cat. II 121, pl. 350
Cat. III 12, ill. 107

However, the rocky landscape rising from the water in the pseudo-grotto is infinitely more elaborate and varied than these relatively simple fantasies. Rocky arches and caves open up above the immense plinth of rock over which the water flowed into the bowl of the fountain. The mountain ridges and every nook and cranny are alive with sea animals, shells, water plants and coral. In the midst of all this sits Neptune, legs wide apart, and embracing two amphorae with water spilling from them; Gorgons emerge from the caves, clutching their water-plant hair; dolphins, lizards, a tortoise and bats are seen amongst the horrific beings, half man, half animal, which crawl over the rocks. The bright patches of colour emphasizing the shells and coral in the large design suggest these were imported in large quantities and placed in wet plaster of Paris, or whatever material was used, as they were in the surviving shell grottoes of a later date[49]. As for the quantities, it is known that a later order for a shell cabinet for Frederick Henry required transportation in no less than fourteen barques sailed across from Dieppe[50]. It is likely that a good many were needed on this occasion as well. For the last time, De Gheyn's rich imagination found full scope in this largest and most original scheme ever devised by him. With its origins in ornamental work, but developed into a living panopticon, the finished design may be regarded as the final great illusionistic firework display with which Dutch Mannerism celebrated its fortieth anniversary.

Contemporaries were impressed by the beautiful garden. In 1623 Hendrik Hondius published his handbook on perspective, and included a clear illustration of the garden complex in it. The Museum in Oslo has what is probably a preliminary design for one of the fountains, although it was not followed entirely. Huyghens wrote a distich *In hortulum P. Mauritii Dikuklon*[51]:

Ill. 106
Cat. II 161, pl. 438

> *Quidni Mauritius geminos calcaverit orbes?*
> *Orbis Alexandro non satis unus erat.*

The last time we hear about the garden is in the verses Jacob van der Does devoted to it in 1668[52]. He praised all the exotic trees it contained, orange trees, myrtles, cypresses, lemon and pomegranate trees, as well as the fountains which provided for their irrigation, and the grottoes decorated

with the costliest materials, mother of pearl, shells and sea-plants. One could hear birdsong issuing from a hundred throats in the aviaries. 'If Tethys had seen the grottoes, she would have been amazed to find them resembling those in her own palace or the Court of Neptune...'. When Huyghens wrote his early memoirs, he provided us with some information about these first burgeonings of Maurice's princely urge to build which his early death in 1625 brought to an untimely end. Along with Hondius' extensive text and engraving, Huyghens' writings enabled me to reconstruct the entire progress of this commission[53].

Ill. 108
Cat. II 696,
pl. 451

Cat. II 696,
pl. 452

The Prince, whose erstwhile resilience had entirely disappeared in his later years, died on April 23rd, 1625, before the fountain wall was completed. A liver complaint and the party feuds, although ending in his favour, had sapped his energies. Apparently De Gheyn was given an opportunity to draw Maurice on his death-bed, even before Adriaen van de Venne did so[54]. Either De Gheyn or his son did a small sketch with a fine silverpoint. Above a pleated ruff and wearing a nightcap, the emaciated face rests upright against the pillows: only a shadow remains of the once powerful head Miereveld had portrayed. It was either the fourth time De Gheyn was to draw the portrait of a dead person or the first his son did. On the reverse, he recorded the likenesses of three women who provided refreshments for the callers offering their condolences. There is Amalia von Solms, only recently married to Frederick Henry, her profile even more youthful than in Rembrandt's portrait of 1632[55]. The two others, one of them wearing a widow's cap, cannot be identified with certainty.

After the death of William the Silent, the entire funeral procession had been engraved and etched by Goltzius in a long frieze, one of the masterpieces of his burin. The custom was continued in 1615 after the death of Walraven van Brederode, and, when Amalia's father was interred with great pomp in 1623, the copper plates from 1615 were, for economy's sake, reused with amended inscriptions[56]. Obviously, this could not be done for Maurice's cortège. On July 5th, 1625, the States General licensed Jan van de Velde to engrave and publish it within eight years, provided he did so under the direction of Jacques de Gheyn[57]. On July 25th of the following year he was forbidden to sell the prints before the necessary corrections had been made under De Gheyn's supervision. This instruction is also mentioned in the colophon. De Gheyn obviously acted as a Court official fully informed on the actual ceremony and on those who took part in it. He may have received one-third of the expected profits, which were to be divided into three parts. We do not know who drew the designs: according to Van Gelder, it was not Van de Velde, but up to now I have been unable to suggest a better candidate. It is not altogether impossible that De Gheyn had cherished some hope

Cat. III 24,
ill. 109

of his son producing the prints. The title-page, where we can recognise the latter's hand, points to this. It is of great simplicity, consisting of a framed title with two smoking lamps below it and three skulls crowned with laurel wreaths above; a plain curtain is suspended behind the entire composition. The hand of Jacques III is clearly recognisable in the stipple technique, but the concept is more sober and therefore more classical than the title for the *Seven Wise Men*. The subject matter

Cat. III 83-85,
pl. 41, 39, 40

Cat. III 83

was certainly a reason for this. It would be possible to deduce from three drawings of *Heavy cloaks* that he was also working on the figures, perhaps with too much thoroughness so that time passed and it became necessary to find a draughtsman who worked faster. One of these studies, remarkable in itself, very evocatively suggests a figure walking away from the spectator with measured tread, and creates an effect that would not have been out of place in work by Jacques Bellange.

This is therefore the place to draw attention to a link between the De Gheyns and the art of Lorraine, particularly that of Bellange, Callot and Du Mesnil de La Tour. We can be brief about this. Jacques III had probably seen some of Bellange's prints before starting on his own. His technique, and an occasional detail such as the masculine, long thumb with the broad top phalange points to

108. A. van de Venne. *Death-bed study of Prince Maurice*. Oil on paper. Rijksprentenkabinet, Amsterdam

HÆC POMPA FVNEBRIS
SPECTATA FVIT DELPHIS
BATAVORVM DECIMO SEXTO
SEPTEMBRIS ANNO 1625.

Ante duos ductores funeris pro-
dibant cives Delphenfes armati,
fed lugubri habitu, penesque
templum ftabat Centurio
principis, cum fua cohorte;
tres item aliæ cohortes
erant, ad coercendum
hominum vulgus.

109. Jacques de Gheyn III. Attribution.
Title of the large series of prints
commemorating the funeral of
Prince Maurice. Etching. The entire
print was etched by Jan van de Velde
under the supervision
of Jacques de Gheyn II.
Rijksprentenkabinet, Amsterdam

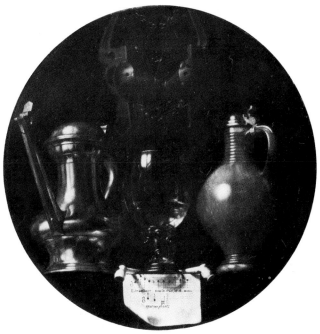

109a. J. Torrentius. *Allegorical still life*.
Rijksmuseum, Amsterdam

this[58]. But the similarities are very superficial: Bellange was one of the later mannerists, De Gheyn III a verist. The connection with Callot is the reverse. Here Jacques II was directly or indirectly on the giving side. Callot's *Temptation of St. Anthony* appears to be based on a *Vision of Hell* by Jacob Isaacsz Swanenburgh rather than on similar scenes by De Gheyn, who had influenced Swanenburgh. Finally, prints by both Jacques II and Jacques III may have had some influence on Du Mesnil de La Tour. An example of this is De La Tour's standing figure of a peasant-woman[59], which could not have been created without knowledge of a print by Jacques II, the *Virago,* although it does not reproduce her character. F. Grossmann has also pointed out other prints by Jacques II which were, he considered, sources of inspiration for De La Tour[60]. The sole factor of any real weight, however, is the attempt made by both De Gheyn III and De La Tour to emphasize volume by means of piquant, heavy lighting effects. To that extent they both belong to the same generation of moderate Caravaggists.

H. 106, cat. II 224

An excellent example of this method of expressing physical volume is to be found in two monumental pen-sketches of *Heads of negroes,* now in Darmstadt, by Jacques III. I consider them to be imaginary heads. One of them is, in fact, based on a plaster cast of a negro's head of which there are two other sketches; it is clearly recognizable by the front flaps of the cap. All three drawings are executed in very heavy pen-lines, those of the plaster cast merely being somewhat harsher, and show that he was continuing the course he adopted when drawing the dead duck and stuffed squacco heron. The drastic contrasts between light and shade prove that Jacques III was now wholly converted to Caravaggism. The *Head in profile* is recognizably an immediate forerunner of Jan Lievens. One need only place the *Three Magi* by Jacques II — the King of the Moors is based on the same plaster cast — alongside these drawings to see how much more graphic the father's rendering was, and how much more the latter was encumbered by tradition despite his playfulness. Lievens may have regarded himself as a successor to Jacques the Younger, whereas Rembrandt followed both the De Gheyns!

Cat. III 45, 46, pl. 54, 53

Cat. III 106, pl. 49

Cat. II 33, pl. 248

Where Jacques III acquired this pronounced preference for plasticity does not appear to me to be in any doubt: the youth must have admired Terbrugghen immediately after the latter's return to the Netherlands, and he must also have come into contact with the early work of Jacob Jordaens a few years later. A sketch by Jacques III shows that he had copied two heads from the latter's *Four Evangelists* (Louvre), a painting that must have been in Holland early on: it was auctioned, together with a copy, in Amsterdam on July 7th, 1632 along with the paintings belonging to Pieter Lastman (shortly before the latter's death which occurred in 1633)[61]. A painting like this may also have taught him to give his figures more volume by means of heavy shading.

Cat. III 105, pl. 22

There is a record dating from 1625 about Daniel de Kempenaer's meeting with father and son. This man, who was interested in occult sciences, and must have been on the point of going on a sea-voyage, was apparently acquainted with a great many art-loving contemporaries. The *album amicorum* was in fashion at the time, and it was customary among the intelligentsia to ask friends for a contribution, preferably written in impeccable Latin, or else in the form of a coat of arms or a drawing, for an oblong booklet of this kind. De Kempenaer's *album* contains a large number of attractive drawings giving us an inside view of artistic life at The Hague and elsewhere. Jacques III drew a *Hercules* standing on a defeated Vice, with a palm branch and a laurel-wreath as symbols of his victory. A master in the use of a very fine, sometimes stippling pen, he drew this extremely polished work at The Hague on July 9th, 1624. On another page his father evoked a small-scale but impressive storm at sea, with Christ in the little vessel, apparently to ease the recipient's mind about his voyage. Perhaps Daniel had come to ask the De Gheyns for information about travelling to England. This small drawing is a masterpiece that could be magnified an unlimited number of

Cat. III 9, pl. 57

Cat. II 49, pl. 455

144

times without losing its dramatic power; it anticipates the great sea painters of the new century.

The date 1624 on a loose page, once belonging to an album, is the latest to appear on any signed work by De Gheyn. The subject, the head of a boy in a complicated turban, shows a curious return to the engraver's manner. Cat. II 780, pl. 458

After Maurice's death, Frederick Henry must have made a final payment to Jacques de Gheyn Junior for completing the fountain in the palace garden[62]. We also hear of De Gheyn II's purchase at Middelburg, for the Prince's collection, of two landscapes by Jan Brueghel from Brueghel's son in 1627. They were: a summer scene, with figures by Hendrik van Balen, costing 500 guilders, and a Diana fishing, costing 300 guilders[63]. It may well be that De Gheyn performed more services of this kind for the Prince.

The Art Gallery at Yale possesses a large still life, but it is unknown whether it was painted by the father or the son. Originally it was signed and dated, but at the beginning of the present century the signature was changed into *Van Rijn An. 1621*. Since Rembrandt was not yet active as a painter in 1621 we assume that *J. de Gheyn* was changed into *Van Rijn,* but that the date may have formed part of the original signature. It is no longer possible to make out whether or not the monogram included the I of Jacques Junior. The subject, *Vanity,* suggests the father, and Huyghens' dictum that de Gheyn was unsurpassed in painting books and papers is the most weighty argument in favour of his having been the artist. The symmetry of the composition could be the work of either painter, but the light coming from one side and the light and shade effects are more like the son's. However, it is only natural that the father had some share in the development his son was undergoing. All in all, the impression prevails that this is a late work by Jacques II. Cat. II P 12, pl. 23

It is a *Vanity still life* with the proverb *Servare modum finemque tueri naturamque sequi* on an open page below it. The composition is strictly symmetrical. Beneath an urn there is a large pile of parchment-bound books with, in the middle, a folio-volume which may have contained drawings and which has a skull with a laurel-wreath on it. Two trumpets project above the urn: they are the trumpets of fame, and are placed at an angle beside a winged hour-glass covered with a black veil. Through a lunette, a cherub's head is visible in the sky. A shelf supports closed books and boxes on the left, and three busts on the right: one of the *'Dying Alexander',* as it was called at the time; one of *Laocoon's* youngest son, that is the son who in any case died with his father; and one of *Seneca,* who committed suicide at Nero's command. The connection with the tripartite text is obvious: *servare modum* is symbolized by the closed books and boxes; *finem tueri* by the lunette, and *naturam sequi* by the fate of the three historical characters.

The text represents Stoic philosophy. In Lucan's *Pharsalia* the words are spoken by the elder Cato[64]. This reminds us that, when speaking about the life of Torrentius, Huyghens remarks that he does not wish to pass judgment on him like a Cato, a moralist[65]. One wonders whether someone else would have done so, and whether that person was, in fact, De Gheyn. It will be remembered that De Gheyn, stung by the universal praise for Torrentius' *still lifes,* had challenged the latter to a competition, undoubtedly in the field of still life painting.[66] Could not this particular still life have been the outcome? Could it be the piece that in the last days of his life he had, in a fit of grimness, offered for comparison with those so-called 'miraculous works'? It certainly looks as if this may have been the case. De Gheyn may have wagged Cato's finger at a man who was by then a prisoner. But I consider it unlikely that the painting was originally executed as a challenge to Torrentius. To make this clear, we should look into the matter in greater depth.

Only one of the names on the books and papers is legible. It is that of Vitruvius, the classical author who had laid down the rules for architecture, the highest authority to defer to in matters of art. Therefore the common denominator of the pile of paper may be read as: the arts. The heads,

however, point to more obvious historical connections with classical antiquity. Its significant position in the centre of the composition indicates that *finem tenere* was given an emphasis which I believe to be a barely noticeable, contemporary Christian element in this mainly classical ideology. Death is not contemplated merely in general terms. Eternal salvation, omnipotent and watchful over life and death, is not for anyone striving after absolute power (Alexander), or for anyone who, for reasons of guilt not necessarily his own, is struck down by divine hand (Laocoon's son), or for the suicide, whatever the reasons or moral considerations for his action may have been (Seneca), or even for anyone living in the total innocence of ignorance — Oldenbarnevelt's *nil scire tutissima fides* — or protected by strict austerity: closed books and boxes. Shun the conflicts of power and religion, but if you do not, realise what may happen. Shun the inactivity which results in total oblivion. Of all the wisdom expressed in writing and art — pen, paper and compasses — nothing more than the reverberations of the trumpets of praise will remain. However that may be, be moderate, look to the end, follow nature[67]. Despite the moderate pessimism of Stoic thought, one should be governed by Christ's law, and bear in mind that God is then also moderate. In any case follow nature, your nature. Although no more than an interpretative accentuation, this is what De Gheyn's ultimate outlook appears to have been, in that, with greater experience, he viewed things not so much differently, as more realistically than when he designed his *Vanitas* in 1603. 'Be moderate' is an Aristotelian adage, *naturam sequi,* an indication that the classical thinkers had gained a place of their own within a context with Christian bias[68]. The need which the Humanists, and with them the artists, had felt to account for their views on life, had led to the formulation of these views in a quotation that was to remain valid and satisfying for the entire seventeenth century and long afterwards. And if one were to ask what realities had so firmly impressed the mark of the Stoa upon the artist, the answer would have to be: the events of the years leading up to 1621.

We must not forget the context in which De Gheyn's quotation originally appeared: in the *Pharsalia,* the struggle between Caesar and Pompey described in verse by Lucan. In 1621, Holland did not only have the first forty years of the war against Spain behind it, but also a civil conflict, or at least a religious and power struggle in which it took part and which would have been seen by many as threatening civil war. In 1617, shortly before the final episode in this conflict, a Dutch translation of the *Pharsalia* was published. In his dedication to the Board of Admiralty of Amsterdam, the author, Hendrick Storm, refers to the work as being *niet ondienstig in onse tijden tot mijding van quaed ende waerschouwinge van veel onheyls 't welck door particuliere passien veroorzaakt kan worden* (of some service in our times for the avoidance of evil and as a warning of the great calamity that may be caused by private passions). A number of sonnets are printed at the beginning of the book, including one by the poet Bredero. The poem by L.T. (motto: 'Suffer and Hope') tells how Storm had refrained from translating the final chapters describing the battle that was to be fatal to Pompey — *Hadt toch den ouden helt Pompeius soo ghedaen, Hij hadt soo groote schandt met vechten niet begaen* (If the old hero Pompey had done alike [*i.e.* abstained] he would not have incurred so much shame by fighting). In 1617 this must have sounded like a covert warning to Maurice or Oldenbarnevelt, which perhaps makes it understandable why the book was reprinted in 1620 when the tragedy on the Binnenhof had taken place, but peace and quiet had not yet returned. The reprint was also commended by Hooft, Vondel and several others. The protagonists in the struggle had failed to heed Storm's allusion which, three years later, must have seemed prophetic! A head had fallen, but thanks to the book-chest Hugo de Groot had managed to save his skin in May 1621. If De Gheyn had completed the quotation with: ... *Hi mores, haec duri immota Catonis / secta fuit, servare modum finemque tenere / naturamque sequi patriaeque impendere vitam / nec sibi, sed toti genitum se credere mundo,* the allusion to recent events would have been too obvious for

someone living almost next door to the Prince. For Seneca, who had ruled the Roman Empire on Nero's behalf, one would then have read Oldenbarnevelt, and not the author. Only people with a classical education would have been able to complete the text immediately. As it stood, the painter could hardly have been regarded as a political moralist, but rather as a pacifist advocating the control of passions. Even after their collaboration had finally ceased, De Gheyn therefore appears to have stood by his old friend Hugo de Groot.

As we have seen, a controversy arose between De Gheyn and the frivolous Torrentius, the painter who must have used a *camera obscura* when working on his still lifes and who boasted that because of this, the good people believed he dabbled in magic. Torrentius' sole surviving still life, painted in 1614 (Rijksmuseum, Amsterdam), proves that, with or without the aid of an instrument construct- <span style="float:right">Ill. 109a</span> ed by Drebbel, he managed to achieve the effect of a deceptive *trompe l'œil*. If he did indeed use such an instrument, this would prove it was developed prior to 1614, and therefore long before Huyghens may have seen it in London in 1622. There is no further proof of this, but I still think Van Riemsdijk's arguments[69] in favour of the theory are valid. Below the horse's bit, 'rummer', pewter jug and earthenware jar, he painted the text of a song on a sheet of music *ER +*[70] *wat bu-ten maat be-staat, int on-maats qaat ver-ghaat* (whatever ventures to exceed the measure, turns into the evil of excess). There is no evidence as to when precisely De Gheyn challenged Torrentius to a competition, but at the end of his life it must have caused him, 'the old gentleman who', according to Huyghens, 'was not devoid of ambition', an outburst of rage which we would not otherwise have been inclined to expect of him. The incident can hardly have taken place after 1627 when Torrentius' trial, which casts a somewhat shameful light on the justice of the period, was in full swing. So it seems more likely that the idea of a competition with Torrentius was suggested to someone else. De Gheyn may have seen a number of Torrentius' paintings at the home of 'a gentleman at Lisse', who was looking after them for King Charles I of England; these included the work now in the Rijksmuseum. The gentleman was probably Isaac Massa, whose portrait by Frans Hals is well known. Huyghens had not seen the competition panels himself; in any case, he wrote, diplomatic even when addressing himself, he would not have wished to express an opinion on them as he did not feel competent to do so.

Young Jacques may have continued working in his father's studio until the latter's death; at all events he went on living in the same house. Even after Jacques II's death, something of the father's concepts is still to be found in his own work. Towards the end of his life, the elder De Gheyn paint- <span style="float:right">Cat. II P 25, 26, pl. 25, 26</span> ed two cow's heads from life in wet paint. Both paintings bear his monogram on one of the horns. A date of around 1626 was established by analysis of the panels on which they were executed[71]. Frans Floris used this same *alla prima* oil technique, otherwise uncommon, for painting human heads immediately from life. Nearly all the paintings of the sixteenth century and most of those of the seventeenth were based on drawings. Frans Hals made a definite break with this tradition. De Gheyn must have seen oil studies from life in Antwerp, and appears to have adopted this technique towards the end of his life. One of the cow's heads was used by Jacques III for his *St. Luke*. <span style="float:right">Cat. III P 4, pl. 5</span> These sketches in oils strengthen my earlier attribution to De Gheyn of the front-view of a horse's head at one time in the Murray Bakker Collection in Amsterdam. Perhaps it dates from as early as <span style="float:right">Cat. II P 24, pl. 27</span> 1603, when De Gheyn painted the Prince's grey stallion, but it is much more likely to belong to this same late period. Like the cows, it may in that case have been painted at the farm of one of his tenants. I have sometimes wondered if the monogram was, perhaps, the mark branded on the horns of the cattle grazing on De Gheyn's estates[72]. However that may be, the monogram is his. The painting of the horse's head anticipates a closely allied study by Th. Géricault[73].

In one instance it has been almost impossible to determine whether the father or the son executed

Cat. II 625, pl. 389 a drawing: the work represents a *standing prisoner* or madman, called 'a slave' in the older sales catalogues. The technique led to shaping details being almost literally the same as in the son's studies of draperies, for example the ragged outlines of his cloak. However, I finally left it included with the father's work owing to the absence of more automatic hatchings, the shadows here being executed with greater inspiration. The brooding facial expression is characteristic of the elder De Gheyn, and wholly appropriate to this man, whose resistance was still smouldering and whose entire attitude betrays suspicion and imposed restraint.

We cannot tell with any certainty which drawings date from the last years of the father's life. We may, however, endeavour to identify the utmost limits to which his draughtsmanship extended. For this we shall confine ourselves to a few final examples.

The fact that a mature artist manages to express himself with greater economy of means than he was able to do in his youth has sometimes led to the idea that a summary suggestion of form and an evocative approach are typical of older artists, of their *Altersstil*. This is a dangerous generalisation. De Gheyn's large design for the grotto wall shows with how much precision he continued to work after his sixtieth birthday, although there are abbreviations in it which, because of his long experience, he could safely afford to make. With the great fluency he had gradually acquired, he was sometimes able to achieve a masterly breadth of style. But this phenomenon was also apparent at an earlier date.

Here one cannot emphasize too strongly the connection with the international stylistic developments which, as far as drawing was concerned, originated in Italy. One force to be reckoned with was the influence of Jacopo Palma Giovane, himself inspired by the genius of Parmigianino, while the greater boldness of the Caraccis and their school constituted another. Goltzius benefited in a more general way from what he himself had seen in Italy — where he had been confronted with such heterogeneous concepts as those of Federigo Zuccaro, Francesco Vanni, the Caraccis and the Venetians — than stay-at-homes such as De Gheyn could have done. Searching for examples of the freer handling of the pen, one finds, in Lisbon, the allegory by Goltzius dating from as early as 1593[74], and equalling the work of Annibale Carracci; secondly, there are his 'cosmic' Ill. 110 landscapes[75] and a head such as that of the man with the lumpy nose[76], and finally an imaginary figure[77]. In all of these there is evidence of the phenomenon which De Gheyn, relying on his own experience, was not to develop until later, but which sometimes led to very closely related results. In the case of both artists, however, this particular technique occurs in between many other styles, and it is not confined to any one period. How difficult it sometimes is to identify a particular artist's hand can be seen from the fact that, in his catalogue, Reznicek overlooked a pen-portrait represent- Ill. 111 ing Jacob Matham which, in my opinion, is a rapid sketch by Goltzius dating from around 1592[78]. It is certainly not by De Gheyn; the style is akin to that of Bolognese verism. In fact, De Gheyn borrowed only from quite different sources, although it is not easy to put one's finger on definite links with the works of other artists, unless he was actually producing a copy or a paraphrase. Still, it can be done occasionally. Young Anthony van Dyck, for example, cannot have failed to make an Cat. II 24, pl. 470 impression on De Gheyn; this is evident in the latter's design for a composition consisting of sever- al three-quarter-length figures. The squaring shows it was intended for a painting, or at least for a larger format. The theme, a young woman and an old one holding lilies and meeting amidst bystand- ers points to an unusual version of the *Visitation*. The composition is similar to that of Van Ill. 112 Dyck's *Mystic Marriage of St. Catherine* (Madrid), or one of the many preliminary designs for it, now in the Pierpont Morgan Library, New York[79]. The compositional scheme adopted by De Gheyn was therefore ultimately of Venetian origin. The remarkable thing about this adaptation is that it follows Van Dyck in the arrangement of the principal characters and that Mary is similar to

110. Hendrick Goltzius. *The Man with the 'potato' nose.* Pen. One of his late drawings in the manner of Jacques de Gheyn II. Museum Boymans-Van Beuningen, Rotterdam

111. Hendrick Goltzius. *Portrait of Jacob Matham.* Pen drawing. Kupferstich-kabinett, West Berlin

112. A. van Dyck. *The Mystic Marriage of St. Catherine.* Cf. cat. II24 Pierpont Morgan Library, New York

Van Dyck's type of pyramidal Catherine with brilliant highlights on her long neck. The characters, however, now play totally different parts. The background is also relevant: the flat wall with its heavy hatching points to a process that appears to have been borrowed from young Jacques, whereas the sparkling sketches of small figures bear the unmistakable imprint of the elder De Gheyn's hand.

It may well be that the close collaboration between the two of them also led to the son producing one of the prints which follows his father's sketch of the *Vreedsamich paer* (Pious couple). This rendering in black and white includes features that appear in his graphic work as well. The first print has been attributed to Jan van de Velde, which makes an origin about 1625 probable. In the sketch, the long looped pen-lines indicate very rapid draughtsmanship. In addition to these parallel, modelling loops, later drawings frequently have multiple straight parallels for rapidly shading large sections of a composition. Examples of this may be seen in the *Death of Seneca*. Scribbles like these, intended for De Gheyn's personal use and certainly not for the market, would have been of some value to his son as a practising artist; they owe their preservation for posterity to him, and herald the easy draughtsmanship of Rembrandt's generation. The ultimate in this kind of sketchy description is to be found in the *Buskers*. The subject itself has a topical flavour; and the bustle of the street scene is rendered naturally with a rather untidy technique to correspond with the picturesque disorderliness of the costumes. This was a field in which such varied graphic artists as Jacques Callot, Adriaen van der Venne and Pieter Quast were to be active, and, if one considers the very greatest, Rembrandt or Adriaen Brouwer, one again finds an interest in what are euphemistically called everyday things, coinciding with a technique which is the very opposite of cold precision. In the *Buskers* we therefore have a supreme example of the draughtsman's last style. Fortunately this drawing is on a page which was glued, probably by himself, to a separate sketch showing two portrait busts of a young woman. The technique of these links them closely with a whole group of small sketches as well as with the *Visitation* based on Van Dyck's composition discussed above. This outstanding sheet of studies therefore occupies a key position in any attempt to distinguish between the late drawings of Jacques II and those of Jacques III.

Before passing on to a final group of drawings, I must also mention the *Bust of a youth* with a complicated turban wound round his head, since, by way of exception, this drawing bears a date: 1624. To provide a clear record of the head-gear, the figure was rendered with firm strokes of the pen and nothing is blurred. De Gheyn's unimpaired engraving line could still serve a purpose. In contrast, the broken pen-strokes on two small sheets with surrealistic heads, probably produced at around the same time, are comparable to the finest etching process. Strong contrasts in technique therefore continued to occur until the end.

Several sheets with a religious subject show how memories of older works of art enabled De Gheyn to reconsider certain popular themes and occasionally even to give them more profound content. An example of this is the sketch of the Holy Family where Joseph holds up an apple to the Child who is leaning against the seated Mary, with Joseph bending over from behind them: symbolism and genre at one and the same time. The child John is seated on the ground playing with a lamb. All these are traditional elements, but freshly combined. As Mary is sitting on a grassy seat and roses bloom beside her against a fence, the scene is clearly reminiscent of Dürer's Madonna engravings, of which the sketch is an attractive late variant.

*The Archangel St. Michael* trampling on Satan and raising his sword is also a traditional theme. In this version, De Gheyn makes him twist his body into an S-curve while performing a ballet step on top of the pedestal consisting of the belly of Lucifer who is bent over backwards; the result is an elegant, acrobatic group, balanced in an unstable equipoise, and floating in space above the fires of

Cat. II 199, pl. 456

Cat. II 144, pl. 435

Cat. II 500, pl. 484

Cat. II 780, pl. 458

Cat. II 529, pl. 446; 531, pl. 445

Cat. II 46, pl. 483

Cat. II 85, pl. 414

150

Hell. More than in some of Rubens' works, we can here imagine ourselves in the atmosphere of the late Munich Mannerism of Christoph Schwarz, Candido and Sustris. Whether De Gheyn borrowed it from a print or from a group in bronze or silver cannot be established.

Extreme economy of means was adopted in a frieze-like *Mocking of Christ* which includes Mary, a Goyesque evocation in which two traditional themes — on the one hand the antithetic busts of the Man of Sorrows and the Mater Dolorosa, and, on the other, the Mocking of Christ — were interwoven and summarised as a single unit ready for transfer to a larger scale. In the same visionary manner, there is a bust of Christ with the globe raising his right hand in blessing which I found in Brussels under Andrea Sacchi's name, not really a strange attribution, since the Italians were also in the habit, although mostly at a later date, of recording similar fleeting ideas on scraps of paper.

Cat. II 52, pl. 491

Cat. II 63, pl. 490

Dating from the very last years, to which the above sketches also belong, there is a grandiose sketch for a *Deposition,* with a variant in reverse on the back of the paper. The eight figures are riveted together with a scratching of lines filling the entire sheet, and so form a balanced composition. The desperate sorrow overwhelming all the mourners as the lifeless body sinks to the ground is highly evocative. The undulation of their stances is continued in the quivering pen-lines that everywhere allow for light interspaces. One is made aware of how little the inspiration of the artist, now over sixty years old, had waned.

Cat. II 57, pl. 486, 487

The sheets of studies belonging to this final period show how the most diverse ideas welled up in his imagination. A huntsman, only just managing to keep his hounds under control — a scene connected with a wild chase by Diana — occurs side by side with a recollection of a portrait resembling the *Gioconda;* two views of a bust with a long beard and deep-set eyes next to that are reminiscent of Leonardo's appearance. At one time[80] I wondered to what extent De Gheyn could have formed an idea of Leonardo's art; the vast variety of his themes — in this respect he differed so greatly from his contemporaries — even led me to consider whether it would have been possible for De Gheyn to have seen one of Leonardo's codices, *in casu* the one now at Windsor. Extensive researches conducted at the time showed there was also reason to believe that, in view of the choice of subjects in his drawings and the similarities in ideas and styles of drawing, Leonardo had in turn been familiar with the collection of Pisanello's drawings still preserved in the *Codex Vallardi* (Louvre), and that De Gheyn's work had at least as many points of contact with Pisanello, whose medals he also paraphrased, as with Leonardo[81]. Surveying his work produced after 1600, one would like to venture the suggestion that he was the sole artist who, in contrast with his contemporaries, took the line adopted only by these two great predecessors, and that, as a draughtsman, he owed his unique position among his contemporaries to this.

Cat. II 497, pl. 474; 120, pl. 475

The problem is highly complicated. De Gheyn was the pupil of Goltzius who, as a draughtsman, had led the way in constantly tackling fresh problems. He undoubtedly stimulated De Gheyn's powers of imagination. But where Nature was concerned, and in particular the world of animals, flowers and plants, De Gheyn's powers were far more penetrating and extensive. Through Van Mander's *Leerdicht,* the attention of artists about to learn their craft had been methodically directed towards an all-round range of themes. The result of this may be seen in the *Groot Teekenboek,* set out systematically by Abraham Bloemaert later on. But, as educationists, both Van Mander and Bloemaert regarded the art of painting as the ultimate goal and drawing as a means to an end, whereas De Gheyn thought drawings and paintings were at least equally valid; this is quite clear from the consignment he sent on approval to Gustavus Adolphus. In the eyes of posterity, it is his drawing output which remains such an impressive phenomenon. It could well be that seeing the *recueils* of Pisanello and Leonardo shortly after he had started painting — around 1600 — was

enough to provide the impetus that finally made him the great draughtsman which, to us, he appears above all to have been.

Leonardo's *codex* came into the possession of the Earl of Arundel between 1603 and 1630[82]. It is quite probable that young De Gheyn had an opportunity to look through it in London in 1618. The *codex Vallardi* has an uncertain pedigree. It is known, however, that the original binding was similar to those of the Leonardo drawings which were bound in the sixteenth century[83]. The binding was only replaced in the 19th century and I made every effort to find it in the Louvre, but in vain[84]. There were pages from our silverpoint sketchbook in the *codex Vallardi;* they may have been added by Arundel[85]. If the latter owned the codex he would have taken it with him to Italy, where he died. It may then have come into the possession of the Anguisciolas which would give it an uninterrupted pedigree[86]. These were all arguments for which there was no definite proof. I have therefore had to leave the hypothesis for what it is and can only hope that one day a conclusive argument for or against it will be found. At the moment the latter alternative seems more likely[87], and it would provide another instance of how, throughout the ages, the greatest artists can show a surprising affinity to each other even when working quite independently.

Cat. II 668, pl. 488

A small pen-and-ink portrait I purchased for the Museum Fodor is, I believe, a likeness of De Gheyn, now very much aged. He has the appearance of a deeply troubled man who has borne his suffering in silence. Is it this portrait we should think of when reading Huyghens' comment in *Le revers de la Cour,* a light-hearted poem he wrote in 1626, *Que De Gheyn mesprise soy mesme*?[88] Was he embittered by the feeling that, despite his immense application, he had not received the recognition due to him? Or did the quotation refer to his son's awareness of not having made the best use of his talents? It is impossible to decide, but it looks as if there was some tragic element in the lives of the two men who were now independent of each other.

Cat. II 283, ill. 105

It is uncertain whether Jacques de Gheyn's creative imagination failed him shortly before his death or much earlier. The *Title-page* for an historical work engraved posthumously after a design by his own hand, suggests the former. His end was reported only by Huyghens at the beginning of the reminiscences about the artist which he wrote for himself shortly after the event[89]. 'In the first place I had the greatest respect for De Gheyn, the father, as an artist. Perhaps I failed to show my special affection by constant acts of friendship whilst he was alive, but I certainly did so adequately when he was dying. For when he was in bed during his final illness, and was soon devoutly to return his precious soul to his Maker, I attended him with a care that was neither assumed nor forced, and as a Christian I held up to him such things as are fitting in the circumstances'. It looks as if Huyghens was called suddenly to the dying man, either because his son, unsuspecting, was elsewhere, or possibly even by young Jacques himself. The absence of a priest shows that, perhaps unlike his wife, De Gheyn did not adhere to the Catholic faith as a member of a parish. 'He possessed', Huyghens continues, 'despite whatever those envious of him may say, the greatest possible skill in his art, and I believe it would not be easy to find anyone else with such a universal knowledge of the entire art of painting and everything connected with it. In simple drawing, whether he chose to use a pen, or crayon, or charcoal, he was inferior to none. In the art of engraving, which he had practised in his youth but abandoned at a more mature age, he, more than anyone else, emulated his teacher Goltzius, and if I look at the prints made by the two men it is not easy for me to decide which one of them surpassed the other. By his own graceful works .... he paved the way for the elegant new art of etching and quite alone added lustre to it. .... In painting miniatures .... he was in no way inferior either to my kinsmen the Hoefnagels, or to any one of the Italian masters, or to Oliver, the famous Englishman, a fair number of whose wondrously beautiful paintings I saw in London at the home of his son, who equalled his father, as well as elsewhere. He succeeded in ren-

dering flowers and leaves, and also the lineaments of people and many other things, with accuracy and unbelievable grace, charm and naturalness. Finally reaching the summit of his art by means of his inborn talents, he excelled so greatly in painting in oils, as is the custom these days, that innumerable and, I must add, mostly incomparable paintings prove him to have been inferior to but a few. I admit that in rendering human beings and other living creatures he did not always come up to my expectations or those of more competent judges of art than myself. But where inanimate things were concerned, such as books or paper or other objects used by man, he was master of them all. When he painted flowers, a subject that particularly attracted him, no one could even approach his fame, and he for ever snatched the palm of honour from Brueghel and Bosschaert, who, after all, are both equally famous. Besides this, he applied himself to the principal part of the science of light and to the rules for painting distance, usually called perspective, which a perfect painter ought to know. He had himself either observed or discovered most of the secrets of the art which were of practical use, but, as I mentioned above, he was not the man lightly to pass these on to anyone else, whosoever he might be. He was thoroughly conversant with the laws of architecture as passed on to us by the ancients — I offer no opinion as to what value should be attached to these' — but we know very well how much value Huyghens attached to them when Jacob van Campen was building his house — 'and, gifted as he was by nature, he applied them with correct judgment and grace, so that mainly for that reason he gained the favour of Prince Maurice at an advanced age, although still fresh and vigorous...'. We may conclude from these lines written shortly after De Gheyn's death that Huyghens was well acquainted with the art of Jacques de Gheyn, but that they had stood aloof from each other for some time before they became neighbours. It should not be forgotten that Huyghens was much younger, just as Hugo de Groot had been when he occupied a similar place in De Gheyn's life earlier on. There was, however, one essential difference between them: De Groot's contribution to the art of De Gheyn was purely one of ideas. Even if he had any understanding of the visual arts, he lacked a vocabulary for them that was based on aesthetic concepts. In this respect Huyghens, with his intuition for more than just literary values, must have been closer to De Gheyn, although he may only have become fully aware of this after the latter's death.

Everything suggests a fairly short sickness which took Huyghens by surprise as well. Perhaps the admission he begins with points to a deliberate avoidance of friendly relations with the Catholic Stalpaerts, an attitude which had been passed on by his Protestant parents and had disappeared but gradually. De Gheyn, moreover, was a reticent person and not easily accessible to all and sundry; he was also a man who closely guarded the secrets of his trade. At the time of Maurice's death he must in any case have been *vegeta senectute*. By his presence at the time of De Gheyn's death as well as afterwards, Huyghens may also have been a help to the rather indolent son who from now onwards would have to do without his father's support.

The end came on March 29th, 1629. *Obiit Jacobus de Gheyn pater,* Huyghens recorded the evening after he had stood by his death-bed[90]. The bells of the great church were rung and, on April 2nd, eleven strokes sounded again when the funeral took place[91]. In our imagination we can picture a procession of Hague citizens, relatives and artists, dressed in flowing mourning robes, gathered together from far and wide, with Jacques at its head and fellow members of the fraternity bearing the coffin, hung with the silver shields of the Guild, from the Houtstraat to the church of St. James. There, to the sounds of the organ, De Gheyn was interred in a tomb belonging to the Stalpaert van der Wieles[92].

One solitary Jacques, the third, aged thirty-two, was left.

# CHAPTER VII

## *After the death of Jacques II: oblivion and rebirth*

It would have seemed natural if, after De Gheyn's death, his contemporaries had described his work and reflected on his art and on the manner of his passing, but this did not happen. We do not know of a single *In Memoriam* published about him. The lines from Huyghens quoted in the last chapter and expressing such a balanced opinion of his merits were written around 1630 but remained among his papers until they were published, for the first time and in part only, in 1891[1]. The author of the Description of the City of Leyden, J. Orlers, who had known De Gheyn, thought fit only to mention him as the teacher of David Bailly who was a native of the town, whereas De Gheyn himself had merely lived there for some years[2]. Cornelis de Bie confined himself too much to the Southern Netherlanders who had not emigrated to include a Life of a refugee. It may well be that he, and also Houbraken, thought Van Mander had already described De Gheyn's life in detail, and so they would not have realised how much the artist had achieved since 1604. Only Theodorus Schrevelius referred to De Gheyn posthumously in his *Harlemias of Eerste Stichting der Stad Haarlem*[3], when writing about Hendrick Goltzius' pupils. He appears only to have had De Gheyn's prints in mind, referring particularly to official commissions for engravings relating to the country's defence. Schrevelius also knew that Goltzius and De Gheyn had always remained in touch. It may be assumed that he knew De Gheyn personally, if only because of his letterpress for the Anatomical Demonstration by Professor Pauw. Finally, Joachim von Sandrart included an extract from Van Mander's *Life* in his biographies of artists, clearly showing that he had not fully understood the text[4]. Apart from these four, it was only in the nineteenth century that writers started devoting some scant attention to De Gheyn.

In this chapter it will therefore be necessary to concentrate primarily on what happened to him and his artistic heritage, and why this aroused so remarkably little publicity. One is struck, first of all, by the ties, forged shortly before his death, which linked him and his son with Jan Lievens and, more closely even, with Rembrandt. Jacques III was surely a go-between here. He was ten years older than the two up-and-coming Leyden artists and, as the sole heir of a wealthy father, he must have been one of their first patrons. It is quite likely that Houbraken's tale of how Rembrandt sold 'a certain small piece' to a purchaser at The Hague for a hundred guilders, refers to Jacques II or III and to Rembrandt's *Two Greybeards in Dispute* (Melbourne), which was painted in 1628[5], rather than to Huyghens. The latter did not own any of Rembrandt's early works, whereas this particular painting formed part of Jacques III's estate[6]. Subsequently either he or his father also bought the *Old Man asleep by a Fire* (Turin) which was painted in 1629, and a study of an old man 'wearing a cap of violet-coloured velvet lined with cloth of gold'[7]. Finally, Maurits Huyghens and Jacques III both had their portraits painted by Rembrandt in 1632 (reproduced as the frontispiece of our second volume). The following year Huyghens wrote eight epigrams or satires on De Gheyn's portrait. He

Ill. 113

Ill. 114

113. Rembrandt. *Two Greybeards in Dispute.*
This painting was once owned by Jacques de Gheyn III.
National Gallery of Victoria, Melbourne

114. Rembrandt. *Old Man asleep by a Fire.*
This painting was once owned by Jacques de Gheyn III.
Galleria Sabauda, Turin

praised Rembrandt as a painter, but scorned the work as a likeness. Jealous of De Gheyn's patrimonial fortune, the artist had portrayed him, but because of the lack of resemblance he had 'changed him into a posthumous brother'. The intricate allusions might lead one to infer that De Gheyn had, for that reason, paid only half the artist's fees and that Rembrandt had accepted this[8]. I think they provide evidence that De Gheyn Senior had already bought two other paintings, and rewarded Rembrandt with double the amount his son had paid him, or, alternatively, that Jacques had paid the double amount before his father's death and therefore no longer resembled himself when he halved the price. De Gheyn left his portrait — now at Dulwich College — to Maurits, whereupon the two portraits, which were of equal size, remained together for a long time[9]. From Lievens De Gheyn bought 'a beautiful wife's head with an old woman at her side', presumably the painting known as *Vertumnus and Pomona* from the Thürling Collection[10], and also one of his heads of a *Young girl* with fair hair, and with a strong light cast on her face[11]. This is related to the previous work and both were painted in the same years as the Rembrandts. It was surely no accident that Huyghens instanced only Rembrandt and Lievens among the younger painters; in any case he shared this preference with the De Gheyns. Certain heads chosen as models by Rembrandt and Lievens are closely linked with studies by the elder De Gheyn. An example of this is one of their grey-haired old men, this time by Lievens (at Lütschena)[12], which might well be placed alongside cat. 740 or 741. Both artists owed their predilection for elderly, wrinkled models to the De Gheyns. As mentioned earlier on, this is also true of Rembrandt's beggars and, as far as working-methods are concerned, of his love of rapid note-taking. In developing his clair-obscure, Rembrandt followed the course taken by Jacques III, and foreshadowed by the elder Jacques in a number of masterly drawings. Examples such as the much earlier *Eva de Gheyn and her small son looking at a picture book* have already been referred to in this context. The layout of Rembrandt's first sheet of studies,

Ill. 115

Ill. 116

Cat. II 740, 741,
pl. 401, 403

Cat. II 672,
pl. 164

155

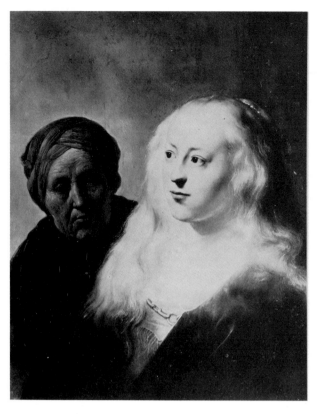

115. Jan Lievens. *Vertumnus and Pomona*.
On the Berlin art market in 1939

116. Jan Lievens. *Head of a Young Girl*.
On the London art market in 1953. Both this painting and ill. 115 were once owned by Jacques de Gheyn III

117. Hendrick Goudt. *Sheet of Sketches* after works by Jacques de Gheyn II. Musée des Beaux-Arts, Rennes

156

118. Signed 'Petterschmidt A° 1618'.
*St. Jerome chastising himself.* Pen drawing.
I. Q. Van Regteren Altena Collection, Amsterdam

119. Simon Frisius. *Head of St. Jerome* (?). 1624.
Pen drawing.
Prentenkabinet, Leyden University

the etching with three views of the head of an elderly man, harks straight back to De Gheyn's small sketch-book. In a separate study, Judson has listed a number of similarities between works by De Gheyn and Rembrandt[13]. B. 374

Cat. II 738-748,
pl. 399-406

In spite of all this, there were definite limits to such an influence. Neither of the De Gheyns had the ability to render a suggestion of space around their figures as easily as Rembrandt and Lievens managed to do with very simple means, and the starting-point for De Gheyn's creation of wide expanses of scenery is essentially alien to the landscapes based on his own immediate environment, which Rembrandt was to start producing. The exploration of the small wonders of Nature, in which De Gheyn so greatly excelled, was not shared at all by Rembrandt in the earlier stages of his career, and only by exception at a later date.

There were other artists as well who happened to come within De Gheyn's sphere of influence during his lifetime. In any discussion on the heads of elderly men as a source of inspiration to Rembrandt and Lievens, the name of Simon Frisius also needs mentioning, since his long-haired, bearded old man (Printroom, Leyden) who, seen by candlelight, is holding his hand to his chest, links up entirely with works by Jacques III such as, for example, the elderly man writing in Hamburg[14]. Frisius' drawing dates from 1624 and was sketched at The Hague in an engraving-like technique even more severe than that of the young pen-virtuoso. Frisius appears to have based his work entirely on that of his fellow-citizens, the De Gheyns. He may have been a pupil of Jacques II. Ill. 119

Cat. III 7,
pl. 11

157

120. H. Goudt. *Four Figures*. Pen drawing. Städelsches Kunstinstitut, Frankfurt

121. H. Goudt. *Three Gentlemen in Conversation*. Pen drawing. From the 'Elsheimer Volume'. Städelsches Kunstinstitut, Frankfurt

122. H. Goudt. *Study from the Nude*. Museum Boymans-Van Beuningen, Rotterdam

Ill. 118

Ill. 120

In his etchings too it is possible to observe trends which had previously featured in the works of De Gheyn and his son. It cannot be ruled out that H. Hondius and A. Stock also served an apprenticeship with De Gheyn. An analysis of *St. Jerome chastising himself,* by a certain Johann Petterschmidt[15], leads one to assume the latter was similarly inspired. A signature on a drawing now in Leningrad shows that this artist came from Lichtenberg[16], a name which occurs frequently in Gelderland and Limburg as well as in many parts of Germany. He may have spent some time in the western part of the Netherlands. Like Frisius' drawing, the one by Petterschmidt stresses the great age of the figure portrayed, and both studies clearly demonstrate their creators' familiarity with the technique of engraving. One of the few artists who at one time may have seen a number of drawings by De Gheyn is Jan van de Velde. A small landscape with hills and trees bordering on a bay with the sun rising out of the water, is entirely in the style of De Gheyn in view of the treatment of the trailing clouds[17]. In fact, one would think of De Gheyn himself, were it not that the technique — a red prepared ground — is indissolubly linked with authentic Van de Veldes. Van Gelder rightly dated it around 1626, when Van de Velde was collaborating with De Gheyn on the *Funeral Procession of Prince Maurice.*

Far more significant is the link with Hendrick Goudt who, as we have seen, may have been an apprentice in De Gheyn's workshop. This talented draughtsman returned to Utrecht around 1610 after spending several years in Rome working for Adam Elsheimer, some of whose works he may well have brought home with him. An important bundle of sketches now in Frankfurt was, from an early date, believed in the Netherlands to be the work of Elsheimer, until it became increasingly evident that almost all the drawings were by Goudt[18]. As early as 1600, Goudt had drawn, with a fine pen, a perfect copy on parchment of Lucas van Leyden's *Virgil in a Basket*[19]. His apprenticeship had obviously started long before then, but Van Mander does not mention him as one of De Gheyn's pupils. However, in the years following, he must have made friends with De Gheyn and would have become familiar with his drawings. At first he showed a preference for types and costumes from an earlier age which he executed in the manner of De Gheyn[20]. His important *Ecce Homo* also bears a close relation to this[21]. It is possible he was present at the departure of the land-

158

yacht and, on that occasion, drew two horsemen on the beach[22], a group consisting of two <span style="float:right">Ill. 64, 63, 121</span>
fashionably dressed ladies and a gentleman[23], and a group of three gentlemen in heavy coats[24]
which may be compared with figures in De Gheyn's large print. To indicate the shadows in these
drawings, he adopted a system of parallel corkscrew curls consisting of a single line, a technique
borrowed from De Gheyn, as the latter's *High Priest and Servant* clearly shows. Goudt's draughts- <span style="float:right">Cat. II 53,<br>pl. 306</span>
manship, in which he had received such a thorough grounding in Holland, may well have inspired
Elsheimer. Conversely, Elsheimer's influence led to a simplification in his own style, which is appar-
ent in sketches, made after his return, on paper giving his Utrecht address in verso[25]. Goudt man-
aged so easily to fuse his landscapes into unified compositions[26] that he may even have influenced
De Gheyn to avoid disturbing detail and so to strengthen the overall conception.

One drawing signed by Goudt merits special attention here, since it provides an argument for <span style="float:right">Ill. 117</span>
dating several of De Gheyn's drawings[27]. It includes details derived from drawings by Jacques de
Gheyn and, since Goudt left for Rome not later than 1606, they must all have been executed prior
to his departure, a fact to be taken into account in dating these works. For different reasons, an
early date has already been established for cat. 30-32, but not for cat. 112, 535 and 945 which were
paraphrased in the drawing at Rennes.

Finally, the female nude in Rotterdam, whose pseudo-De Gheyn signature misled Möhle into <span style="float:right">Ill. 122</span>
attributing it to Jacques III[28], is a typical Goudt and may be compared with a sheet in Frankfurt[29].

In my *Introduction,* I also mentioned some other younger contemporaries whose characteristics
may have been more or less the result of De Gheyn's example[30]. Such influence, however, was ex-
tremely limited, and it is sufficient to refer the reader to the relevant passage. The majority of
Dutch 17th century artists could never have been inspired by De Gheyn, as his work was hardly
accessible to them.

As a painter, Jacques II did not form any school, except perhaps with his flower-pieces which
appear to have been popular from the very first. Since most of the earliest of these are lost, it is
impossible to establish whether artists like the Bosschaerts and Christoffel van den Bergh of Mid-
delburg and Jacob Woutersz Vosmaer of Delft[31] based their work on a type first created by De
Gheyn. I am inclined to believe this was particularly true of the latter painter.

The sole artist to reap the full benefit of De Gheyn's work was therefore his only son, Jacques
III. Although researches into his early work led to such satisfactory results, not much is known
about what he achieved after his father's death. His work appears to include very little that points
to the continuation of any particular tradition. In fact, it is very much open to question whether
Jacques applied himself to his art with as much energy as he had done previously. The extensive
passage Huyghens devoted to him after praising his father makes this seem doubtful. It reads as
follows. 'The latter, who from his earliest youth was initiated in the arts practised by his father, has
already, although he has not yet left his boyhood behind him, furnished such brilliant evidence of
his talents, both in drawing with pen and crayon and, to some extent, also in painting, that to the
amazement of his contemporaries he already equals the great masters; the expectations cherished
about him, moreover, may well be the envy of all Italy. And whenever I consider these beginnings,
which appeared to justify the hope of such fruitful industry, I am unable to conceal my vexation at
it being possible for these beginnings, through indifference, to result in so very little, and for a
man, who had clearly been born to the Netherlands to be an adornment to his fatherland, so to
bury his talents and to fall into an unfruitful and unpraiseworthy slumber. But these are, I would
almost say, the fruits of domestic circumstances which were far from restricted. Until now I be-
lieved that Poverty alone could stand in the way of talent, but now it is also choked by too much
prosperity. And yet I do not despair, my famous friend, of your once again disseminating your

fame, I mean putting to advantage your glorious gifts, and of your starting to practise that noble art for relaxation at least, when you, wiser than you are now, will come to consider how much better it is to make use of the idle hours than to do nothing'[32]. It is unlikely that Huyghens failed to give the friend who had so deeply disappointed him, a milder version of the advice he wrote down for his own eyes only.

A letter written to Huyghens by J. Brosterhuisen in 1630 shows that it was not only Jacques' father who was interested in coins. He asked him, *et à propos, Mons. de Gheyn a quantité de copies de plombs de très belles médailles antiques. Serait-il bien homme de laisser prendre 'exiguum lumen de lumine'? Mons.r vostre frère luy est grandement familier. Si par son intercession il me les veut prester, je vous en envoyeray en récompense de très nettes copies de plastre*[33] ('and, by the way, Mons. de Gheyn has a large number of lead copies of very fine antique medals. Would he be kind enough to let me take 'exiguum lumen de lumine'? Monsieur your brother knows him well. If, at his request, he would be prepared to lend them to me, I would send you some very clear plaster copies in return'). We do not know whether the request was granted.

In 1634 Jacques broke away from The Hague and bought himself into a canonry at the Church of St. Mary in Utrecht. Apparently, the De Gheyns had never severed their ties with Utrecht families, and Jacques had friends or relatives there. After the Dissolution *(Alteratie),* when churches and monastries had become the property of the State, a canonry still entitled the beneficiary to draw prebends, and persons favoured with such an office covered themselves for life, purchasing, as it were, a form of life insurance. The Chapter decided on who was to be admitted. De Gheyn was granted the 19th prebend, which had belonged to Ernest van Yttersum until the latter's resignation[34]. Three years later, in 1637, he was granted full capitular rights. He had a room in the chapter-house, but lodged with Meester Gerrit van Helsdingen, and was waited on by a man-servant and two maids. This in itself is proof of the state he kept, which is also abundantly clear from the rich household effects described in his will.

After searching for paintings produced by Jacques III during his years at Utrecht, I believe it is possible to attribute five works to him with almost complete certainty. These are, firstly, four octagonal canvases which may have adorned the lantern of St. Mary's. They represent the *Evangelists,* each one seated and holding a heavy folio volume, and accompanied by his symbolic beast or the angel. Two of them, *St. Matthew* and *St. Luke,* are now in the Municipal Museum at The Hague, the others are in a private collection in Belgium. The artist managed to fit the three-quarter-length figures into the octagon in diverse attitudes, and also varied their appearance. They still faintly echo the seated old men of his youth, but on this occasion he had to design large-scale figures which would be clearly visible from a distance. In this the artist was successful, but he had to exchange his careful technique for a more slipshod process consisting of broad brush-strokes, although this applies to a lesser extent to the figure of St. John. One of the considerations which originally led me to make the attribution[35] was the fact that the ox of St. Luke is clearly reminiscent of the *Cow's Head,* painted from life, which has Jacques II's monogram inscribed on its horn.

The model for the large-scale Evangelists must be sought in Italian painting, perhaps among the works of Ribera which had been brought into the Netherlands not long before. However, it was more likely Terbrugghen who inspired De Gheyn. From him, Jacques learned how to set up large figures and avoid distracting detail. The affinity to Terbrugghen may explain why, when considering several of the scenes attributed to him, I wondered whether De Gheyn III might not have painted or copied them. One example is *David playing the Harp,* a theme more obvious for De Gheyn than for Terbrugghen. Several versions of this are known, the best one being in the Atheneum at Hartford. It includes the figure of an angel in the same attitude as the one in a drawing by the elder

Cat. III P 2-5, pl. 3-6

Cat. II P 25, pl. 25

Ill. 95

Cat. II 95, pl. 366

160

De Gheyn, and casts fresh light on the copied drawing of a harp in the *silverpoint sketchbook*. The subject, although not identical, is similar to the one for which Huyghens requested a text when he wrote to Calandrini in 1617. But it may also reflect the influence De Gheyn's thematic range had on Terbrugghen. The presence in a Roman collection of a second version of the *Saint John,* who is treated differently from the other *Evangelists,* requires special, more profound study.

The fifth and final canvas that may be attributed to Jacques III is a life-size, fallen *Prometheus* in the St. Eloyen Gasthuis at Utrecht which was presented to the institution in 1643, shortly after the death of the artist, by the *Deekens ende Busmeester* (Deans and Treasurer) *G. van Gent-G. v. Bemmel-A. v. Kuyck* (inscription on the old frame). The theme was familiar at Utrecht and had been illustrated in 1623, in one of the best paintings by Dirck van Baburen[36]. There, Prometheus is represented as having fallen on his back, his hands raised, and brilliantly foreshortened. De Gheyn portrayed a side-view, with manacled hands raised above his head. The earlier drawings of birds stood him in good stead when painting the eagle's plumage. The execution of this painting, which is even more slipshod than that of the *Four Evangelists,* demonstrates his loss of mastery to an even greater extent, and it is therefore reasonable to assume that, through lack of practice, Jacques III's skill had deteriorated greatly since his father's death. Perhaps his interests had taken a totally different turn over the past few years. Since he owned a great many books it might be assumed that only the scholar and connoisseur in him had developed any further. The fact that the book St. Mark is reading is not a Gospel, but Cicero's letters to Atticus — as appears from the title on the open page — suggests that his thoughts were occupied with the classical authors rather than with the Evangelists. The text implies that St. Mark may have taken Cicero as his model, which, as far as I know, has not been suggested elsewhere, or that St. Mark was generally familiar with Latin literature, which cannot be ruled out. I have been unable to discover whether De Gheyn had any particular pronouncement from Cicero's letters in mind. The latter's lament on the death of his brother Lucas (I,5) might conceivably be interpreted as an admission that De Gheyn could no longer provide St. Luke, the patron saint of artists, with the evidence of the artistic talents to be found in his earlier work, in which case the allusion was a *cri de cœur* expressing an awareness of his own incompetence. Such an explanation, however, definitely seems far-fetched.

Two paintings long occupied my attention in connection with Jacques III. They are the so-called *Sibyl* which has now found its way to the National Gallery in Washington, and the *Young woman offering an apple,* now in Amsterdam, both attributed to Paulus Bor, the one by Roberto Longhi, and the other by Vitale Bloch[37]. It is true that the type of small head which occurs in the Amsterdam painting points to a characteristic of Paulus Bor, but I believed that, in the large flat surfaces and the shape of the still lifes and decorated altars[38], I had found a particular affinity to the prints of the *Seven wise men* by Jacques III. However, it may now be considered an established fact that, from around 1635 onwards, Bor managed to raise the standard of his work and that these paintings are among his masterpieces. Their quality is certainly superior to that of the late De Gheyns as we know them at present. On the other hand, some association with Amersfoort, with De Gheyn in the part of a donor, cannot be ruled out, particularly since we learn that in his will he left 'the poor orphans at the orphanage there' the sum of 1200 guilders, and therefore must have stayed there regularly.

There is a different link with three somewhat strange drawings, which in my *Introduction* I attributed to the so-called Pseudo-van de Venne. They represent: *Three vagabonds and a child*[39], *Seated elderly people mourning a dead child*[40], and *Three women and a child*[41]. The style of these drawings is wholly individual, with the pen bestowing vibrating life upon every detail. The heavy heads, particularly the profiles, are reminiscent of the Pseudo-van de Venne who is, as yet, unidentified

Cat. III P 6, pl. 7

Ill. 123-125

161

123. 'Pseudo-van de Venne'. Attribution.
*Three vagabonds and a child*. Drawing.
Rijksprentenkabinet, Amsterdam

124. 'Pseudo-van de Venne'. Attribution.
*Seated elderly people mourning a dead child*. Drawing.
Formerly in the Hofstede de Groot Collection

125. 'Pseudo-van de Venne'.
Attribution.
*Three women and child*.
Drawing.
I.Q. van Regteren
Altena Collection,
Amsterdam

162

and unlocated. The possibility of some relationship with the two De Gheyns cannot be excluded, but the drawings must belong to the generation of the younger Jacques. In theme, his painted *Gipsy Camp*[42] also points to a connexion with Jacques III. The most likely assumption would be to regard him as an artist from South Holland who was active between 1620 and 1635.

A signature, *J.D. Gheyn 1638,* appears on three etchings airily sketched with a fine needle and showing a large number of human and animal heads fused together and transformed into overgrown clods of earth. It is the mark of the elder, not the younger De Gheyn, so we must think in terms of copies of works of his. This, in fact, is what they appear to be: combined borrowings from three drawings representing this kind of fantasy, two of which still exist. The models must have been drawn at the time when De Gheyn was working on the large design for the grotto fountain. Adam Bartsch was emphatic in claiming the small etchings to be the work of Barth. Breenbergh, but I am reminded more of Stefano della Bella, who may have lived in Amsterdam in 1638. He would not have drawn his entire annual salary unless he had a long journey ahead of him that year, and he may have produced the etchings at Utrecht before settling in Paris[43].

On April 3rd 1635 Arnoud van Buchell visited Jacques de Gheyn at Utrecht[44]. His purpose was, apparently, to view Jacques' extensive collection. In his diary, he praised the many rare shells and minerals De Gheyn may have inherited from his father, or else retained from his work on the pavilion in Prince Maurice's garden. Buchelius also saw the father's large flower still life which was to pass to Johan Wttenbogaert after Jacques' own death. Then there was a panel painting of a horse, perhaps the sketch of a horse's head mentioned earlier, and a large number of pen-drawings and small silverpoint portraits, some of them by Goltzius. There were a great many portraits by the Sadelers[45], Goltzius, Kilian, Muller, Delff and others, and paintings by Rembrandt and Lievens are also mentioned. The conversation between Buchelius and Jacques about Goltzius' Laocoon was discussed above. The will Jacques made some years later, from which so many conclusions have already been drawn, provides an even better record of his art collection. It included paintings by Lucas van Leyden, Hans Holbein, Adriaen Brouwer, a portrait of Walraven (?) van Brederode by Roelof Willemsz (of Culemborg)[46], a *storm at sea* by Porcellis, three landscapes by Cornelis Vroom, two companion paintings by Mozes van Wttenbroeck and other landscapes by Charles de

Ill. 126-128

Cat. 529-531,
pl. 445, 446

126-128. Stefano della Bella (?). *Fantastic Heads.* Etchings. 1638. After Jacques de Gheyn II.
Printroom, British Museum, London

Hooch and Cornelis Poelenburg, mostly Utrecht masters, which he probably acquired in the years following 1634. De Gheyn obviously owned a valuable collection which was carefully maintained. A small chest of drawers made of exotic wood and adorned with gold rings, and two bronze leaping horses on pedestals tell of a taste in furniture and 'objets d'art' as discerning as his love of choice paintings.

On the 4th or 5th June 1641, the death occurred of 'the Honourable Jacob de Gaing, canon of St. Marie's, the great bell tolling for two hours... 22 f. 10 st.'[47]. His will had been signed in the presence of Notary Vastert of Utrecht two days earlier. The legacies were soon to be distributed among the beneficiaries. Huyghens received the news, probably from his brother Maurits, while he was encamped at Gennep with the Prince. He jotted down the following comment on the message: 'The famous painter Jacobus de Gheyn has died at Utrecht and, by his legacy, has lost eight thousand florins to our van der Burgh; his sister, a widow and the very model of a meticulous matron, benefits by a similar amount. It makes me laugh to think how elegantly he has disposed of the matter'[48]. There is undeniable humour in the last remark. Written documents connected with a court case in 1661 concerning the shares of Anna Wijntges and her children in the estate have come down to us and show that they still owned a considerable amount of landed property near the western Meuse, as well as at Alphen and at Ruiven near Delft[49]. In 1642 Huyghens added the following original distich to a *self-portrait* of the youngest De Gheyn, now lost:

> *Geiniadae caput impense pretiosa tabella est:*
> *Quid si geiniadae sit caput atque manus?*[50]

On Wttenbogaert's initiative, Jacques' friends probably asked Professor van Baerle, an old Leyden acquaintance, to compose the text which was to be engraved on a plaque above his tomb in the former Cathedral:

> *Praxitelem Xeusinque duplex discriminat urna,*
> *Hic una Xeusis Praxitelesque iacent.*[50a]

His fame as a painter and as Prince Maurice's sculptor had not faded entirely during his lifetime, and we may safely guess that other sculptures by his hand had existed.

The persistent silence surrounding the famous father and son throughout the seventeenth century is oppressive. Huyghens alone was to commemorate the father on one further occasion when, in 1661, he thanked Adriana la Thor for giving him a flower limned on parchment by De Gheyn[51]. The 1641 will shows that Jacques' collection of drawings and prints had been bequeathed to Nicolaes den Otter (Floriszoon), son of Anna Wijntges, who later married Jonkheer Bucho van Schroyenstein (Joostzoon). Anna was the daughter of Caspar Wijntges and Maria Stalpaert van der Wiele and therefore a cousin of Jacques III. The contents of a clearly described chest, the one exception to this bequest, were, however, left to Meester Johannes Wttenbogaert (1608-1680). At a later date, the latter owned Jacques III's drawings of classical works of art, which therefore must have been in the mysterious chest, unless Wttenbogaert, who is supposed to have been very wealthy and to have had an important collection, ultimately acquired the share left to Nicolaes den Otter. The records at Utrecht, however, prove that Den Otter never really possessed this part of the inheritance. It seems all the more likely therefore that Wttenbogaert took the entire collection after all and compensated the branch of the family which was less specifically interested, or which would have been better served by financial support.

S.A.C. Dudok van Heel, who had already solved so many problems, agreed that this large collection might have passed to Wttenbogaert's daughters and sons-in-law and was then disposed

of in the first quarter of the eighteenth century, if not before. His recent discovery of the catalogue of the P.J. Zoomer sale (1725) is one reason for believing that a large part of the De Gheyn legacy found its way to one of the most important art-dealers of the time who, in his old age, was enjoying the large collections of drawings he had judiciously selected from the sales for which he acted as broker. He must have kept some hundreds of De Gheyns including, as a case in point, the complete *Riding-School* and *Exercise of Arms*. Afterwards Jan Goeree appears to have owned, until his death in 1731, the latter series in a single volume kept in, and completely filling, a parchment cover. It was not until the B. Hagelis sale (1762) that 108 drawings from it were divided into lots of two. The collection of another early owner of what seems to have been De Gheyn's bequest was sold at Dordrecht on June 18th, 1743, along with the effects of Carel Borchard Voet, painter of flowers and insects. There were between 150 and 200 drawings and it would be pleasing to think that if Voet chose them, he would have specialised in the artist's landscapes, animals and particularly small creatures which would benefit his art. There are further indications that the drawings were arranged systematically according to subject.

By the end of the 17th century, the attraction of systematically collecting prints and drawings had undoubtedly become more general in the Netherlands, where so many more recent artists had left voluminous opera, and where the high level of prosperity had created far more opportunity for the acquisition of private property. However, few detailed inventories of prints and drawings are known apart from the one giving a reasonably good description of Rembrandt's collection. The London sale of Sir Peter Lely's vast collection of drawings between 1688 and 1694 aroused much enthusiasm among English *virtuosi* for collections of this nature[52]. In the Netherlands too, a market for this kind of art had been created, and it must have been in the following years that the comparatively few large old collections were broken up to feed a great many new ones. How this came about in the De Gheyn's case is unknown. The note on the back of Cat. 50 certainly dates from this period, *Hier In Leggen 50 Stukx Tekeningen van gacus de geyn. Wonderlijk met de pen getekent. In veel verbeeldinge seer konstig. En raar* (Herein lie 50 drawings by Jacques de Gheyn. Wonderfully drawn with a pen. Many of the subjects are very artistic and rare). The writer must have owned some of the most beautiful works produced by De Gheyn. The same handwriting occurs in a note on the back of cat. 531, one of the sheets that were turned into etchings in 1638 and therefore probably formed part of this lot, which had certainly belonged to Jacques III. The drawings were apparently not stuck into a book, but kept loose. However, apart from the three volumes of designs for the *Exercise of Arms,* large quantities such as these only featured in a very few of the auctions of which it has been possible to study the catalogue. The provenance of two male portrait drawings on yellow prepared paper, now in Amsterdam, can also be traced back as far as the end of the seventeenth century. They were bought by Valerius Röver, along with a large number of small silverpoint drawings by Goltzius, when the collection of Burgomaster de Vries was sold.[53] It may be assumed that Röver did not acquire his other De Gheyns in a single purchase. At the auction of the collection of S. Van Huls, a burgomaster of The Hague who had been collecting for 50 years, there was a complete portfolio with 114 drawings by De Gheyn. They are described in a manner which gives us some idea of the diversity of the subjects represented. Part of the De Gheyn inheritance must therefore have been split up long before 1738. However, the descriptions are too summary to enable us to identify many of the sheets. Van Huls also owned some Hendrick Goudts which may have belonged to De Gheyn. In the first half of the eighteenth century drawings by De Gheyn were rarely mentioned in other sales catalogues, and we do not know where Jacob Folkema made faithful copies of some of his drawings in 1705. In the second half of the eighteenth century the numbers increased considerably. Dirk Muilman, Jacob van der Marck and Cornelis Ploos van Amstel

owned many drawings for the *Exercise of Arms*. Two groups of animal drawings appear to have remained intact for some time. There were twelve among the possessions of the artist A. Schouman[54], and a further twenty-two featured at an Amsterdam auction in 1843[55]. Sebastiaan Heemskerk seems to have owned seven landscapes, including two which were of prime importance[56]. Several of the nudes are now in Brunswick. These facts suggest that De Gheyn himself had arranged his works according to genre, just like Rembrandt was to do later on.

There was only one further occasion when a group of Jacques de Gheyn's drawings came to light which, perhaps, had never been split up since his son bequeathed them. They had been placed loose between sheets of plain blue paper in an old cover with a leather back painted red[57]. The serial numbers on the drawings ran consecutively from no. 1 and were written in late seventeenth century handwriting. The De Gheyns were followed by an even larger series of drawings from the nude by Govaert Flinck, with the numbers, written in the same hand, following on the one on the last sheet by De Gheyn. Since Johan Wttenbogaert had his portrait painted by Govaert Flinck[58] on several occasions, I believe it is reasonably certain that the album had belonged to him and was probably a share in his estate bequeathed to one of his, or his relatives', children. It is impossible to establish whether these drawings formed part of the fifty which have already been mentioned, but the latter works lack the annoyingly large, early numbers written on them.

Only one short ditty, one cursory remark has come down to us since the days when Huyghens kept his diary as vividly as if he were talking to us. In 1754 A. Vosmaer reported that 'his drawings are of wonderful strength, but his subjects generally lack grace'. It is true that to an artist working at the beginning of the seventeenth century elegance would but rarely have been the proper aim to pursue. The rendering of persons and objects in light and shade was required above all and called for quite enough energy.

De Gheyn's prints must obviously have been dispersed in the seventeenth century. In the first half of the eighteenth century auction catalogues rarely give good descriptions of them, presumably because they were still usually sold by the portfolio and were frequently classified either by designer or by theme. In the second half of the eighteenth century, prints as well as drawings gradually started turning up with greater frequency. Examples of *opera* that have remained intact since then are the magnificent series in Amsterdam — formerly belonging to Baron van Leyden — and in Vienna, particularly the volume compiled by Mariette for Duke Albrecht von Saxen-Teschen. The fact that the prints also featured in Amsterdam collections proves that dilettanti were responsible for passing on knowledge of De Gheyn the engraver. But the first to describe a small number of prints by Jacques de Gheyn was a Frenchman, Basan[59]. How little they were known is apparent from an incident in 1771 when the Paris artist and expert J.G. Wille had to put right a Danish diplomat and point out that the print he had sent him was not a Rembrandt but a De Gheyn[60].

Adam Bartsch described the graphic *œuvre* of several of Hendrick Goltzius' other pupils along with his own[61]. He was able to do so owing to the presence in the Albertina of two almost complete *opera,* including Mariette's mentioned above. However, he failed to record De Gheyn's engravings when cataloguing those by Goltzius and his principal followers in 1803. But the year 1801 saw the appearance at Zürich of the *Manuel des curieux et des Amateurs d'art,* in which M. Huber and C.C.H. Rost made a first attempt to compile such a catalogue[62]. They only described 85 items, accidentally including Jacques III's *Laocoon,* but they were familiar with more than 170 in all. The list was, therefore, a selection of De Gheyn's prints rather than a catalogue. Of Jacques III's work[63] only the Tempesta series received a mention[64]. De Gheyn was said to have died in 1615, and Haarlem was given as Jacques III's birthplace. The latter was supposed to have travelled to Italy in 1610, apparently because of the Tempesta copies. Their critique on the engraver De Gheyn, *qu'on*

129. Jean Baptiste de Gheyn.
*A Bouquet of Flowers.* Signed.
Painting.
Kunsthandel P.de Boer,
Amsterdam, 1977

*le trouve un peu sec* may have been the reason why Bartsch refrained from publishing his work. In spite of this, later writers proceeded to add to Huber and Rost's list, Ch.Leblanc[65] reaching 182 items, Ch.Passavent[66] 209 and A.von Wurzbach[67] 335, until F.W.H.Hollstein[68], who published the relevant volume of his catalogue in 1952, finally arrived at a total of 433. This number would have to be reduced considerably if, for example, the *Exercise of Arms* were found not to have been engraved by De Gheyn himself, and the figures therefore give merely a relative indication of De Gheyn's craft output which, in any event, rivals that of the most productive of his fellow engravers. It would only be possible to make a few minor amendments to Hollstein's highly conscientious editing and, since the book is almost fully illustrated, it will retain its authority for a considerable number of years.

Wurzbach and Hollstein also refer to the engraver Willem de Gheyn who worked for Johan Le Blon around 1650 and engraved a number of portraits. It is possible that he was descended from one of Jacques' relatives, but nothing is known about this. Kramm[69] also mentions a certain Jan de Gheyn who had published a book on *Kleedingen, Zeeden en Plechtigheden der Volkeren door*

*hemzelfs gesneeden en gedrukt* (Costumes, Customs and Ceremonies of the Nations, engraved and printed by himself) at Liège in 1601. This appears to be based on an error of fact: the author's name is 'de Glen'[70], and he was certainly not in any way associated with the De Gheyns. Nor was there a Jacques de Gheyn IV, for his existence was inferred from a print of 1693, which in reality is one dating from 1593 by Jacques II. We can only accept Jean Baptiste de Gheyn as the last known namesake. He painted *Flowers* in 1666 and a *Judgment of Paris* in the manner of Netscher in 1689.

Ill. 129 I reproduce a panel by his hand, which was at the Kunsthandel P. de Boer, Amsterdam, in 1977[71].

Throughout the nineteenth century, no proper distinction was made between the prints of father and son. Huber and Rost drew the inference that Jacques III had existed from the *'Jac. de Gheyn junior'* read on one of the prints in the Tempesta series. As early as 1832 Brulliot[72] illustrated four different monograms of Jacques III, which did not prevent several of his prints from being included among his father's for long afterwards. Leblanc[73], however, arrived at 21 items produced by him, but two of these were counted twice, four were engraved by C. Boel, and one item consisted of the three etched copies, dated 1638, of heads concealed in rocks, so that, in fact, only 14 items are acceptable.

With his sharp eye, Jules Renouvier, a contemporary of Leblanc's, was the first to try and summarise his knowledge in an article on both the De Gheyns. However, when comparing Jacques II with his master Goltzius he showed a remarkable indifference to the drawings *Il suivit une voye analogue, ayant autant d'excentricité, moins de portée comme dessinateur et plus de sécheresse comme graveur...,* whereas he commented on the most important prints *La fermeté et la verve de son travail y éclatent en toute liberté.* He was the first to spot a different character in Jacques III, who *trouva moyen de donner un degré de plus à la bizarrerie de ses figures allégoriques; il idéalisa la pesanteur*[74].

The sole painting by Jacques II mentioned at an early date was the *Meeting between Christ and the Empress Helena,* which Descamps[75] saw in the course of his journey through Flanders in 1769. *Il y a du mérite,* he considered, *même de la finesse dans la couleur; mais tout y est dur, sec et tranchant sur les bords.* For a Frenchman of the time of Boucher this statement was remarkably objective. I found a first mention of still lifes with flowers in Hymans' *Commentary* on Carel van Mander, but that was merely because he had come across them in sales catalogues[76]. It was only in the twentieth century that their appearance became familiar. The basic elements of our knowledge of Jacques de Gheyn had therefore scarcely been gathered before the nineteenth century, by which time the study of public records was under way. Both Immerzeel and Kramm worked systematically at the knowledge of 17th century artists, and stimulated the researches of others who incidentally came across the name of Jacques de Gheyn among the records. And so, little by little, a picture emerged which differed from the one Van Mander had presented in 1604 and on which H. Hymans had based his *Commentary*[77]. Since the research work stemmed entirely from a reviving interest in the national past, this picture was initially confined to facts of what might be considered an historical rather than an art-historical nature. However, by the end of the century and the beginning of the twentieth century the development of a new phase in the art of painting, the early 'Hague School', was accompanied by the expansion of our museums led by the Rijksmuseum and the Dordrecht Museum. In addition to the emotional reaction which spread like a wave of aesthetic rapture, a more objective attitude came into being at the same time and greatly stimulated the study of the history of art as an independent discipline. The first expression of the now widespread admiration for De Gheyn's drawings came from no less a person than Wilhelm Bode. In his description of the museum at Darmstadt in 1880 he wrote: *Auf eine Reihe vorzüglicher Studienblätter von Jacob de Gheyn mache ich besonders aufmerksam, weil dieser als Stecher geachtete Künstler in seinen*

*Zeichnungen, in denen er der direkte Vorläufer des Rubens und unter seinen Zeitgenossen unvergleichlich ist, keineswegs nach Gebühr beachtet wird*[78]. (I would like to draw particular attention to a series of excellent sheets of studies by Jacob de Gheyn, since this artist, who is held in such esteem as an engraver, is not given the credit due to him for his drawings, in which he is the immediate forerunner of Rubens and without an equal among his contemporaries.) Having read this comment, one need hardly wonder how it came about that over the subsequent decades the Berlin Printroom managed to collect the world's second-best collection of De Gheyn drawings, if not quite the most important one!

In making Goltzius the focal point of his researches, O. Hirschmann also created a fresh basis for our knowledge of De Gheyn. Mannerism became recognised as a stylistic phase, its origins were examined, and Goltzius and his studio were seen to have occupied a central position in its development. Hirschmann's article on Jacques de Gheyn I, II and III[79], which appeared in 1920, laid the definite foundations for our knowledge of the three generations of De Gheyns and served to disseminate this knowledge. They were based on the study of public records carried out to date, the existing publications—which were listed in the articles—and a great deal of personal research. For the first time the three generations were carefully identified and individually assessed, and for the first time attention was paid to the work produced after van Mander's publication and to the categories of which it is made up, that is to say engravings, drawings — these were praised as being extremely 'original and lively'—and paintings, a number of which had by now come to light. For the first time advantage was taken of the youthful memoirs of Constantijn Huyghens which had been published by Worp in the meantime. It was, however, not quite the first time: Jacques III had already been studied and discussed by L. Burchard in his pioneering work, *Die holländischen Radierer vor Rembrandt*[80], which was published in 1917. It was Burchard who consistently distinguished Jacques III's etchings from the work of his father. He did not come to write the book without also making a thorough study of Jacques II, the results of which were included in the text. The actual reason for this was that Jacques II had been one of the first etchers of the new generation. Burchard was firmly convinced that the etching which corresponds, in reverse, to the *Landscape with a farmhouse,* had been etched by Jacques himself, although this was later questioned on account of the paper on which it is always found. His publication was otherwise revolutionary and its value was slow in making itself felt. Not until much later did new initiatives point to the need to study the pre-Rembrandt artists far more extensively in relation to each other. The first to observe De Gheyn's influence on Rembrandt was A. Bredius. He wrote in 1915, 'Something I believe has not yet been pointed out is the similarity in technique between De Gheyn's pen-drawings and those of Rembrandt'[81]. J. Richard Judson illustrated this facet with a number of examples in 1973[82].

One should beware of drawing the conclusion that J. de Gheyn's drawings were not cherished because they had scarcely featured in any publications before my *Introduction* came out. The admiration they evoked must have passed gradually from collectors to the keepers of Printrooms. It was frequently those with the best, and best-trained eyes who proceeded to buy De Gheyn's drawings because of their outstanding attractiveness. In Berlin, it must have been F. von Beckerath as well as Bode who stimulated such purchases, while in Amsterdam it was J. Ph. van der Kellen and F. J. Waller who did so. The composition of the two largest collections of Jacques de Gheyn's drawings, those in Amsterdam and Berlin, is an indication as to where they were most eagerly preserved until our own times, and it is therefore understandable that the comment, *Tatsächlich gehören seine zahlreich erhaltenen Zeichnungen... zu den allerköstlichsten holländischer Kunst* (In fact his numerous extant drawings... form part of what is most precious in Dutch art) comes from Ludwig Burchard, who studied in Berlin and travelled to the Netherlands to write his book. He even spoke

Cat. II 950

of his intention, *in nächster Zeit eine ausführliche Würdigung des Jacques de Gheyn an der Hand der Zeichnungen zu veröffentlichen* (in the near future to publish a detailed appreciation of Jacques de Gheyn based on the artist's drawings). Unfortunately, Burchard never carried out this plan.

My *Jacques de Gheyn, Introduction to the study of his drawings,* was published in 1936, and I have been obliged to refer to this work with immodest frequency throughout the present book, as well as in the text of my catalogue. I was in a position to travel a fair amount, visiting foreign print-rooms and collecting material for a catalogue which I am now finally publishing as Part Two of the present book. Nothing came of this earlier on, as I was soon given appointments which were to make more and more demands on my available time. Only on the approach of my retirement was I once again able to take up the material which, meanwhile, had been increasing. The *Introduction* was received kindly by the press at the time, and I recall appreciative reviews by F.W. Hudig and Campbell Dodgson, the latter writing in the *Burlington Magazine*[83]. Because of its references to Goltzius, the book was mentioned again by E.K.J. Reznicek[84] who rightly added to his comments that, with regard to Goltzius, *die Vorstellung der Chronologie ist auch bei ihm* [v.R.A.] *nicht ganz befriedigend, während einige anfechtbare Zuschreibungen es wieder deutlich werden lassen, dass wir uns auf dem Gebiet der Stilkritik bewegen, auf dem man einfach nicht vorankommt, ohne zu straucheln* (his — v.R.A.'s — chronology is not entirely satisfactory either, since some disputable attributions again make it clear that we have entered the field of style criticism where one simply cannot make any headway without stumbling). The three inaccuracies mentioned were quite correctly observed and were an indication that my book might need revision with regard to De Gheyn as well. How true this proved to be when I was compiling my catalogue! The *Introduction* is therefore not a faultless book, but I believe it can still serve as a reliable guide.

Burchard was the first scholar who rightly attributed two drawings to Jacques III. When I wrote my *Introduction,* I had already added a number of others. As a result of detailed work on the *Catalogue,* the number has now risen to 104 items. Meanwhile, H. Möhle also made an attempt to add to young Jacques' œuvre[85]. Unfortunately, he was not entirely successful in this: in addition to unquestionable sketches by Jacques III he included drawings by a different artist and even an etching which was formerly attributed to Elsheimer and does not in any way reveal the hand of Jacques. However, he was responsible for adding to the list one work which was still unknown to me.

Not only the catalogue, but also the reproductions belonging to my *Introduction* were omitted almost entirely in 1936. They were supposed to appear simultaneously with the catalogue. This meant that from 1936 onwards only the thirteen heliotype plates included in the *Introduction* were available to assist students in their reading. It was therefore a happy idea of J.R. Judson to publish — in 1973 — a selection of De Gheyn's drawings accompanied by an introduction in an outstandingly well-produced volume[86]. It is true that to some extent he anticipated the present book, using negatives made almost exclusively for it, but the results entirely justify the attractive publication. I regard this choice of drawings as highly representative and would only make reservations for pl. 65-67 (more likely to be by Jacques III) and pl. 72 (by a different artist?). Plates 66 and 67 should be reversed. Judson approached De Gheyn with a fresh, unprejudiced eye and wrote an introduction touching on several points I had overlooked. He also had the benefit of a great deal of recent literature.

Following a study of auction catalogues, a very summary account of the rising prices paid for De Gheyn's drawings over a period of three centuries may be added to this survey. With regard to the seventeenth and first half of the eighteenth century, when there was hardly a regular market to study, we know only that particularly fine drawings never fetched more than approximately *f* 20:—

a piece, and that more ordinary drawings were sold for around one guilder. The latter price level was more or less doubled in the second half of the eighteenth century, and by 1780 we find an occasional mention of sums like *f* 40:—, *f* 60:— and even *f* 100:—. The larger *landscapes* and, in particular, the *small portraits* on tablets must have fetched the highest prices. Little more can be said about differences in aesthetic appreciation. In the course of the nineteenth century prices rose gradually. From 1874 onwards prices were realised in Amsterdam — where Van der Kellen took the initiative — and in Berlin, — where Bode did the same — which rose to *f* 100:— and even to *f* 225:— for the *Mother and her small son looking at a picture-book,* a drawing which, quite rightly, had already aroused a great deal of admiration. The final breakthrough occurred around 1910 when the presence of a representative of Baron Edmond de Rothschild raised the prices realised for the Von Lanna Collection to a new level. On this occasion, a small silverpoint drawing was sold for M 860

The two World Wars had an up-and-down effect on the market, but between 1960 and 1970 the most spectacular upward trend occurred. In 1967, £ 6300 was paid at a London auction for the landscape drawing which finally found its way to the Pierpont Morgan Collection. Only once since that year, when cat. II 957 was sold privately, has this price been greatly surpassed. A more common type of De Gheyn drawings is now rarely sold for less than *f* 1000:—, and prices for elaborate specimens run into several thousands of guilders. This short survey may be of some value to economic historians. It would be possible to make a far more detailed study with the aid of my catalogue.

The above account proves that, in his own day, De Gheyn was only relatively well known, that he was rapidly forgotten, and that three centuries were to pass before his exceptionally fine drawings became more widely appreciated. His lack of fame is evident from the sporadic mention of his

131. J.E.van Varelen. *A Duck.* Etching.
After Jacques de Gheyn's drawing cat. II 879.
Rijksprentenkabinet, Amsterdam

130. François Boucher. *A boy wearing
a broad-brimmed hat.* Etching.
After Jacques de Gheyn's drawing cat. II 535.
Rijksprentenkabinet, Amsterdam

name in relevant literary publications, and there is further proof of this in the fact that prior to 1900 his work had never really been reproduced. Some change occurred when positions from the *Exercise of Arms* were included in historical picture-books and treatises. If one excludes the etching of the *Farmhouse*, only five prints were made of his drawings before 1900: the three 'hidden heads' <span>Cat. II 535, pl. 298 Ill. 130</span> of Della Bella (cf. cat. 529-531), one which appeared in a Miscellany by François Boucher, the fashionable French painter who, around 1750, was also greatly interested in Bloemaert, while the fifth, <span>Cat. II 879, pl. 448 Ill. 131</span> a small etching of one of the *Four ducks on one page,* was made by the forgotten Haarlem etcher Jacob Elias van Varelen in 1821. Only De Gheyn's prints were known, and they managed to obscure his entire output of paintings and drawings for almost three centuries.

To sum up, the almost 500 drawings by Jacques de Gheyn now described and reproduced will show for the first time how productive and inventive he was as a draughtsman, and how conscious of what he was doing. These works look very different in character from the engravings and paintings and show such variety that it is likely he himself believed them to be his most personal creations. If more of his paintings come to light this opinion may ultimately require some revision. Until such time, however, one can merely observe that his flower-pieces are superior to those of his contemporaries, but do not stand out among other flower-paintings on account of any particular individual quality. The drawings, on the other hand, are in a class of their own and not all of them are directly linked with the work either of his predecessors or of the artists who came after him. To me, they still seem to justify the analysis I attempted in my *Introduction*.

Taken as a whole, the drawings display a tendency towards perfectionism, towards achieving the ultimate in clarity of expression which is also found in the work of Dürer and Rembrandt. They bear never-ending witness to the perfection of his visual observation. It was in them that the artist revealed himself most completely. On the other hand, the existing dates belie the conception that in reaching a next stage or phase, the preceding one loses something of its validity. This compels us again and again to regard the question of whether or not a drawing was the work of De Gheyn himself as the most lasting problem and the one most vital to our understanding. Anyone who, like De Gheyn, is able to take stock of the world and of the life and environment of man, and who can render a visual account of this which is based on ceaseless observation, ultimately creating a world of his own out of such sources of inspiration, still has something to convey to us after the elapse of more than three and a half centuries. It is the aim of this book to do full justice to him, but above all to allow him to communicate with us through his now completely reproduced work.

172

# Notes

## CHAPTER I

1 Van Mander 1604, folio 293 verso - 295 recto; 1618, folio 207 verso - 208 recto.

2 Huyghens, *Autob.* Hist. Gen., pp. 64-69, 79, 81-84, 106, 120, 121; Huyghens *Autob.* Oud Holland, pp. 106-136; Huyghens *Autob.* Kan., pp. 66-71, 81, 83, 84, 86, 107, 108, 122.

3 Hirschmann, *Graph.* pp. 5-6, 24-25.

4 I.Q. Van Regteren Altena, *Jacques de Gheyn, An Introduction to the study of his Drawings,* Amsterdam, 1936. p. 1.

5 Municipal Archives, Antwerp: in the *Certificaatboek* n. 20, 1564 folio 15 verso - 16 recto.

6 *Introduction,* p. 128. Both Jacques III — in his will — and Johan Wttenbogaert — in his *Paradigmata Graphices* — mention that they were 'cousins'.

7 *Introduction,* p. 1 note 3, where this is argued in more detail.

8 Municipal Archives, Antwerp. Records of parish n. 6, O.L.Vrouw (the Cathedral) folio 109 2°: *25 September 1567 Isaac: Jacques van der Gheyn, mother Cornelia.* The godparents were Nicolaes Bloemsteen and Joachim Beukelaer, the well-known painter, Grietken van Santvoort and Steefken van der Gheyn, probably the father's sister.

9 Van Mander gives the year.

10 On the 4th December, 1593 Anna testified that she was 25 years old (*De Navorscher,* vol. V, 1855, p. 328).

11 Between 1574 and 1577 according to his own contradictory statements (Hirschmann in Thieme Becker, vol. XIII, p. 535).

12 Cf. J.G. Frederiks, 'De Zeeusche Nachtegael', in *Oud Holland,* vol. XIV, 1896, pp. 29-30. She may equally well have been a daughter of Steven de Gheyn's, in which case she belonged to the next generation.

13 *Liggeren,* vol. I, 1872, p. 202.

14 *Liggeren,* vol. I, 1872, p. 242.

15 *Catalogus illorum qui figuras diversas aeneas sive ligneas Antverpiae distrahunt, sive etiam sculpunt,* see *Plantin-Archives* XLI, 2v. quoted by A.J.J. Deelen, *Histoire de la gravure...,* vol. II, 1935, p. 150.

16 According to Carel van Mander.

17 J. Wagenaar, vol. II, p. 95.

18 A. van der Boom, *Monumentale glasschilderkunst in Nederland,* The Hague, 1940, p. 216.

19 Attributed to Robrecht van Olim and reproduced, in a detail only, by J. Helbig, *Oud-Antwerpsche School van Glazeniers,* Antwerp, 1943, pl. VI.

20 'Jacques de Gheyn de Oude als tekenaar', in *Miscellanea Jozef Duverger,* Ghent 1968, vol. II, pp. 464-468.

21 J.Ph. van der Kellen, in *Oud-Holland,* vol. XXXIV, 1916, p. 94 ff.; Fred. Muller, ns. 723[101] (ex coll. Munniks van Cleef, later Atlas van Stolk, n. 606), 746 and 749 (2 sheets), therefore 4 in all.

22 H. Mielke in the exhibition catalogue *Pieter Bruegel d.Ä. als Zeichner,* Kupferstichkabinett, Berlin (West), 1975, pp. 124-125, n. 162, ill. 181.

22a Cf. D. de Hoop Scheffer, in *Bulletin van het Rijksmuseum,* vol. 26, 1978, pp. 99-105.

23 *J. Garff, Tegninger af Maerten van Heemskerck,* Copenhagen, 1971, passim.

24 For a window in the Carmelite church at Haarlem commissioned in 1540 and paid for in 1544 (A. van der Willigen, *Les artistes de Harlem,* Haarlem, 1870, p. 42). However, L. Preibisz, *Martin van Heemskerck,* Leipzig, 1911, p. 54, may be right in minimizing Heemskerck's work as a glass-painter, for the first and only mention of him in this capacity is made by Houbraken.

25 J.Ph. van der Kellen, in *Oud Holland,* vol. XXXIV, 1916, p. 94 ff.

26 *Abrahami Ortelli... Epistulae.* Ed. by J.H. Hessels, Cambridge, 1887, p. 261.

27 When Jacques had to act as guardian to his sister Anna who was to marry Adriaen van der Burch.

28 Cf. I.Q. van Regteren Altena, 'Klein glas van Dirck Crabeth', in *Oud Holland,* vol. LVII, 1940, p. 200 ff.

29 Joost (de) Bosscher of Antwerp was registered as a *poorter* (burgher) of Amsterdam on Dec. 9th, 1587; he must have died shortly afterwards, as his widow was mentioned on Sept. 20th, 1591. Communicated by Dr. I.H. van Eeghen.

30 Amsterdam Historisch Museum, Amsterdam, our cat. II 665. The most convincing argument for its having been copied from an early portrait is provided by the fact that the paper on which the goat was drawn on verso must originally have been larger; this suggests that the portrait was executed after the paper had been cut, *i.e.* after the much later goat had been drawn.

31 S. Muller Fz., *Schildervereenigingen in Utrecht,* Utrecht, 1880, p. 14, note 1.

32 I. Jost, *Studien zu Anthonis Blocklandt,* Cologne, 1960, pp. 136-144.

33 Hirschmann, *Verz.* 293: *Loth leaving Sodom.*

34 Hirschmann, *Graph.,* pp. 7-10.

35 A. Pinchart, *Archives des Arts, Sciences et Lettres,* Brussels, 1881, part III, pp. 320-321.

36 E. Bronckhorst, *Diarium,* The Hague, 1898, pp. 112-120.

37 This period continued until his departure for Amsterdam around 1591, but his marriage contract of 1595 still refers to his 'fixed abode' as being Haarlem.

38 Hirschmann, *Verz.* 246-255.

39 H. 353-364. The portrait of the army clerk, unknown to Hirschmann, should be added to this series. With the help of J. Rowlands, I found a copy at the British Museum. It is described by Bartsch, vol. III, p. 114, n. 95, and entitled *Erasmus Gleiobus.* I believe it to be by De Gheyn after a drawing by H. Goltzius, at least as far as the actual portrait is concerned. Like the first state of De Gheyn's H. 360, it bears the inscription *H. Goltzius excu.*

40 Art market, Amsterdam (ill. 15) and, less clearly, in Ingrid Weber, *Deutsche, Niederländische und Französische Renaissance-plaketten,* 2 vols. Munich, 1975 under n. 670 *Quos Ego,* on pl. 182. The author, who quotes more than one repeat of this circular plaque, failed to recognise Tetrode as the obvious artist.

41 Goltzius, among others; see Hirschmann, *Verz.* 316-322.

42 *Vide* H. 308, 427, 428 published by J. de Bosscher.

43 H. 353-364, published by Goltzius.

44 The copy in the Albertina, Vienna, lacks the name of the designer since it is incomplete. A complete copy is in London.

45 The paintings date from Sprangers's first Prague period (K. Oberhuber, *Die stilistische Entwicklung im Werk B. Sprangers,* Vienna, 1958, n. 28). The print is produced in reverse. There is a copy at Rotterdam. At a later date, Spranger designed a *Saint Martin* with the beggar in the same relative position and in a similar niche, but facing in the opposite direction to that of St. Elizabeth, as if the two were intended to form a pair. The drawing is in Amsterdam (reprod. I.Q. van Regteren Altena and L.C.J. Frerichs, *Selected Drawings from the Printroom,* Amsterdam 1965, pl. 33) and was engraved in reverse by Zach. Dolendo (Oberhuber, n. 255).

46 H. 305-306. These will be discussed later.

47 Miedema-Van Mander, vol. II, p. 319, 8 v.

48 Reznicek, 165.

49 Cf. for example the painting in the Museum Boymans-Van Beuningen, Rotterdam, dated 1603 where his age is given as 58.

50 Reznicek, 70.

## CHAPTER II

1 According to the registration of his intended marriage on April 1st, 1595, Amsterdam (*Register huwelijksche saecken,* Amsterdam Archives).

2 Buchelius, *Res Pictoriae,* pp. 7, 8.

3 Boonhof was 32 at the time, and lived in the famous Calverstraat, as one might expect of a fashionable silversmith.

4 J. Razet is frequently mentioned by Van Mander on account of the paintings by contemporary artists in his possession. Cf. H.E. Greve, *De bronnen van Carel van Mander,* The Hague, 1903, pp. 156, 157.

5 See the references to him in N. de Roever's 'De Amsterdamsche Doolhoven', in *Uit onze oude Amstelstad,* Amsterdam, 1902, pp. 72-76.

6 A. Pinchart, *Archives des Arts, Sciences et Lettres,* 1st Series, vol. 3, Ghent, 1881, pp. 330-331; Max Rooses, 'De Plaatsnijders der Evangelicae Historiae Imagines', in *Oud Holland,* vol. IV, 1888, p. 277 ff.; Hirschmann, *Graph.,* pp. 7-10.

7 In a letter to François van Ravelingen, reproduced by Hirschmann, *Graph.,* pp. 9-10.

8 A.S. Miedema, *Was de beroemde graveur Hendrick Goltzius blijkens zijn schilderij De Alchemie (1611) een Rozekruiser?,* 1934; id. in *Jaarboek Vereeniging 'Haerlem',* 1941, pp. 22, 32, and 1942, pp. 115, 116. A. Bredius thought Goltzius had already become involved in alchemy by 1605 (*Oud Holland,* vol. XXXII, 1914, pp. 139-140).

9 The folio prints satirizing Roman Catholic rites (Passavant, vol. 111, 126; Fred. Muller 432), published by *D.G.* are not proof of De Gheyn's antipapism, because this is not his monogram.

10 However, we do not know when exactly he began to receive instruction at Flushing.

11 See cat. II 275 and A.K.H. Moerman, *Daniel Heinsius, zijn 'Spiegel' en spiegeling in de literatuurgeschiedschrijving,* Leyden, 1974, passim.

12 Through the Amsterdam Notary S. Henrix, published by A.D. de Vries Azn., *Oud Holland,* vol. III, 1885, p. 144.

13 Register of Marriages, Amsterdam Municipal Archives; in dato. See: *De Navorscher,* vol. V, 1855, p. 328.

14 J. Orlers, pp. 371-372: see J. Bruyn, in *Oud-Holland,* vol. LXVI, 1951, p. 151. Pieter Bailly, David's father, was the University bedel and a calligrapher; it was he who printed De Gheyn's plates engraved

for the Leyden Chamber of Rhetoric in 1596 (see J. Bruyn, *op. cit.*, p. 150 and J. Prinsen, in *Bijdragen Historisch Genootschap,* vol. XXV, p. 474). In the inventory of Jan Jansz Orlers drawn up in Leyden in 1640 (Archives of Orphans' chamber n. 3049 g. fol. 4 v. 8), Orlers mentions his portrait and that of his wife painted by Mr. Adriaen Verburch in 1600 (*f* 20:—) and a *History of Loth* by the same (*f* 8:—).

15 Documents in the Municipal Archives at Amsterdam, spotted by S.A.C. Dudok van Heel.

16 J.Z. Kannegieter, 'Pest te Amsterdam in 1602', in *Maandblad Amstelodamum,* vol. 51, 1964, p. 197 ff.

17 A.D. de Vries, in *Oud Holland,* vol. III, 1885, p. 145.

18 I. Willemsen may have been a brewer: either Ysbrant Willemsz Brouwer, who died in 1610 and lived in the Rokin, or, even more probably, Ysbrant Willemsz Kieft, called Brouwer, who died in 1638 and owned the brewery *het Hart,* as was suggested to me by Dudok van Heel. Kieft was married to a daughter of burgomaster Boelens.

19 For another extensive example see cat. II 896. Besides the old script in the above letter, De Gheyn used the flowing newly introduced French script for special occasions and for most of his signatures.

20 H.396-409. They are illustrations of the *Credo Apostolorum.* According to the address on the second states, the copper plates had passed to H. Hondius in 1607.

21 A. van Buchell, *Diarium,* p. 324; Buchelius, *Res Pictoriae,* p. 36, where Buchelius erroneously states that the Sibyls were based on sculptures instead of on paintings.

22 Extensive file in the Leyden Public Records: weeskamer 1643 m. Cf. Bredius, K.-Inv., vol. VI, pp. 2017-2024.

23. According to Mr. Dudok van Heel.

24 Th. Schrevelius, *Harlemias,* Haarlem, 1648, p. 318.

25 Writings about Drebbel include: F.M. Jaeger, *Cornelis Drebbel en zijn tijdgenooten,* Groningen, 1922, and G. Tierie, *Cornelis Drebbel,* Amsterdam, 1932.

26 Listed by Hollstein, vol. VI, p. 2.

27 A. Bredius, in *Oud Holland,* vol. IV, 1896, p. 131.

28 H. 327. Judson, *Dirck Barendsz,* n. 62, fig. 30, believes the print to have been made after the death of Barendsz after a design of the late sixties.

29 H. 328. Judson, *Dirck Barendsz,* n. 106, fig. 66, suggests that the drawing dates from about 1581, and was only engraved after the death of Dirck Barendsz. Both drawings may have been placed at his disposal by a collector who then owned them.

30 In 1593 the Board consisted of Jan Cornelisz Hooft, Syvert Jansz van Crommendijk and Hendrik Willemsz Verbrugge.

31 Accounts from the Archives of the Admiralty of Amsterdam dated Nov. 26th, 1593, the States General dated Oct. 29th, 1593, and the Municipality of Utrecht during the same year and id. of Gouda. See, *inter alia,* Kramm, p. 570.

32 *Viz.* P. Nolpe, *Beschrijvinge van de Blijde Inkoomste, Rechten van Zeege-bogen en ander toestel op de Wel-koomste van Haare Majesteit van Groot Brittannien, Vrankrijk en Ierland tot Amsterdam, den 20 May 1642,* Amsterdam, 1642, pp. 7-8; O. Dapper, *Beschrijving der stad Amsterdam,* p. 237; Wagenaar, vol. II, p. 397.

33 J. Pontanus, *Hist. Beschr. der seer wijt beroemde Coop-stadt Amsterdam,* Amsterdam 1614, pp. 148-149.

34 The supposition was made by Dr. J.C.J. Bierens De Haan.

35 In the *Kunstkronyk,* nieuwe serie, vol. VIII, 1867, p. 83, Th. van Westrheene refers to his admission in 1594. This does not appear to be based strictly on the existing register, which only shows that the entry referring to De Gheyn preceded that of the next artist admitted in 1598. I learned this in 1935 from Mr. W. Moll, then City Archivist of The Hague.

36. A.D. de Vries, in *Oud Holland,* vol. III, 1885, p. 145; Register of Marriages, Mun. Arch., The Hague.

37 And more in particular his mythological scenes, Reznicek, ns. 99-103, 107, 135-136, all of them engraved by different engravers.

## CHAPTER III

1 The genealogy *Het geslacht Stalpert van der Wiele* by W.J. van Harn, Vianen 1854, contains too many inaccuracies to be of any use now. A positive attempt to improve matters was made in: B.A. Mensink, *Jan Baptist Stalpart van der Wiele,* Bussum, 1958, doct. thesis, but there are some pitfalls here as well. I am indebted to Jonkheer P. Beelaerts van Blokland for a correction to the family tree in my *'Introduction'* (pp. 120-121); thus, one may assume that Eva's grandparents were Adriaen Stalpaert van der Wiele and Eva van Mierop, her parents Jan Stalpaert van der Wiele and Elizabeth van Lambroeck, and that the latter couple had five children, viz. 1 Digna, who married Hugo Doens, Pietersz, 2 Catherina, wife of Cornelis Duyn, 3 Hester, wife of Jan van der Linden, an army captain, 4 Eva, wife of Jacques de Gheyn, and 5 Maria, wife of Caspar Wijntges, Master of the Mints of West Frisia.

2 *Het leven... schilders door Karel van Mander,... overgebracht...* door wijlen Jacobus de Jongh, vol. II, Amsterdam, 1764, p. 171.

3 By Hirschmann, in Thieme Becker, vol. XIII, p. 533.

4 R.E.O. Ekkart, in *Leids Jaarboekje,* 1974, p. 112 ff. with ill. De Gheyn received 84 guilders for it. On the basis of this design, the drawing of a paviour and his overseer in the collection of the Kon. Oudh. Genootschap may, in my opinion, also be attributed to Swanenburgh.

5 Not included in Hollstein's catalogue; a copy is kept at the Teyler Museum.

6 On *a leaf with copies after De Gheyn drawings* by H. Goudt, at the Rennes Museum (our ill. 117).

7 According to an instrument of Sept. 16th, 1622, Jacques III obtained from the States of Holland and West Frisia the combined fiefs of Woutersland in Noordwijk, partly inherited from his mother and

partly purchased by his father, Jacques II (Archives of Leen- en Registenkamer van Holland, inv. n. 143, reg. 'Hooghe Overicheit F. cap. Noortholland fol. 60 recto-61 verso). Kindly communicated by J. Fox, State Archivist.

8 To date, hardly any attention has been paid to these texts, perhaps the earliest examples of his conversancy with Latin. The vast quantity of generally short texts in Latin and other foreign languages accompanying the prints of this period have, for that matter, rarely been studied in any depth, either as a general phenomenon, or in regard to the various forms in which they appeared.

9 Eight repentant sinners from Israel; H. 411-418 (where n. 7 is entitled *Christ* instead of *St. Peter*). Cf. E. Valentiner, *K. van Mander als Maler,* pp. 98-99. The drawing for n. 4 St. Mary Magdalene, is in the British Museum in London (Popham, under C. van Mander, n. 1)

10 A similar festivity was recalled in the *Diarium* of Professor Everard Bronckhorst on March 7th, 1593.

11 This 'breloque' with the likeness of the King is still in the possession of the Groeninx van Zoelen family.

12 Whoever added the false Goltzius monogram, must have thought the same. In view of the inscription on the verso, this was presumably Cornelis Ploos van Amstel.

13 Under the *Mount Calvary,* engraved by Z. Dolendo, cat. II 54.

14 G. Tierie, *Cornelis Drebbel,* Amsterdam, 1932, p. 17, according to the statement by his son-in-law Kuffeler.

15 J. Prinsen J. Lzn., *De Nederlandsche Renaissance-dichter Jan van Hout,* Amsterdam, 1907, pp. 109ff.

16 Printed at the end of Roemer Visscher's *Brabbelingh,* Amsterdam, 1669, p. 203.

17 See J.R. Judson in *Bulletin des Musées Royaux,* Bruxelles, vol. 11, 1962, pp. 98 ff.; W. Stechow in *The Art Quarterly,* 35, 1972, pp. 165-175.

18 In the *Vita* of Hendrick Goltzius.

19 The twelve original drawings plus title-page are kept at the Museum Boymans-van Beuningen, Rotterdam.

20 Goltzius' drawings are now in Leipzig. See Reznicek 33-44.

21 Not the one mentioned by Bartsch.

22 Th. Schrevelius, *Harlemias,* Haarlem, 1648, p. 318.

23 The series of *Patriarchs of Israel,* which De Gheyn published on his own, also dates from 1596; Zacharias Dolendo was the engraver (H. 366-377). The *Temperaments* bear the same date; these will be discussed later on.

24 He far surpassed his prototype, engraved by J. Matham after Goltzius in 1593 (H. *in nomine* Matham, 281).

25 Now in the Museum Boymans-van Beuningen, Rotterdam.

26 A. van Buchell, *Diarium,* p. 462.

27 I quote from the MS in the Herzog August-Bibliothek at Wolfenbüttel, Cod. Guelf. 60.21 Aug. 8°, which Prof. Scheller kindly brought to my attention. The text has been provisionally established by him and the librarian Dr. Wolfgang Milde.

28 Hahlweg, passim.

29 As appears from a letter (State Arch. Wiesbaden, K.925, fol. 53-55), reproduced in my *Introduction,* pp. 125-128.

30 Koninklijke Bibliotheek, The Hague, MS 73 J 25; Hahlweg, pp. 126-199.

31 *Inter alia* a copy with the armorial bearings of Louis XIII on its cover, now at the Bibliothèque Nationale Paris.

32 Burchard, pp. 29-31; Huyghens *Autob. Oud Holland,* p. 112.

33 H. 338. For the original drawing see Ch. de Tolnay, *The Drawings of Pieter Breugel the Elder,* London, 1952, p. 63, n. 36.

34 See Huyghens *Autob. Oud Holland,* p. 112.

35 According to the text of the record of payment by the Town Treasurer of The Hague.

36 Ed. van Biema, in *Oud Holland,* vol. XXX, 1912, p. 61.

37 In his will, drawn up by Notary W. van Oudenvliet, 1599, folio 204 verso-206 verso; reproduced *in extenso* in my *Introduction,* pp. 122-125.

38 On January 1st, 1601, as an 'engraver in Leyden' before Notary J. van Tethrode. Another witness was Barth. Ferreris, the well-known collector often mentioned by C. van Mander.

39 According to the Archives of the *Rekenkamer* of Holland, he paid *f* 78:— that year. He had a 'hard roof'' renewed (A. Bredius, in *Nederl. Kunstbode,* vol. III, p. 421).

40 *Jaarboekje Die Haghe,* 1934, p. 122.

41 If there had been no mention of 'stone' statues, it would have been natural to identify them with the casts of two of Michelangelo's figures of *Dawn, Day, Dusk* and *Night* which had been made for Goltzius in Florence. According to Buchelius, these casts finally came into the possession of Bloemaert after being owned by 'alium et alium' which might mean Jacques II and III (*Res Pictoriae,* p. 94). I therefore do not exclude the possibility of an error in the qualification 'of stone'.

42 Cf. de Tolnay, *Michelangelo,* vol. III, Princeton, 1948, p. 152.

43 His masterpiece is the *Mountainous landscape* of 1594, entirely built up by pen-lines (Reznicek, n. 396, II, pl. 239).

44 Reznicek, n. 394, II, pl. 237. This sketch is perhaps of later origin.

45 Hirschmann, *Verz.* 242.

46 The mill in the foreground appears to be newly built, whereas the one in the distance on the left seems to be older.

47 Alternatively, De Gheyn took the galley from the print in R. Van Bastelaer n. 2 or 96.

48 R.A. Koch, in *Gaz.d.B.-A.*, vol. LXVI, 1965, pp. 273-282.

49 On December 29th, 1600, the States General decided to have a gold medal struck, at a total cost of 100 guilders, in which all the provinces were to share (Japikse, *Resolutiën der Staten-Generaal etc.*, vol. XI, 1926, p. 78).

50 In numismatics hands are only sporadically added to the head, *e.g.* on a coin showing the portrait of Constantine the Great, ill. in F. Imhoof-Blumer, *Porträtköpfe auf römischen Münzen,* Leipzig-Berlin, 1922, pl. 117. De Gheyn may have learned about them from Hubert Goltzius, *Les Images de presque tous les Empereurs...,* Antwerp, 1557.

51 A. van Buchel, *Diarium,* p. 442.

52 Huyghens *Corr.,* vol. I, p. 302.

53 Bredius, *K. - Inv.,* vol. IV, p. 1457.

54 The affinity of his crayons with those of Fed. Zuccaro is best seen in the portrait at Chatsworth illustrated in the catalogue of the Chatsworth exhibition in London 1969, n. 75.

55 We instance Beuckelaer's *Larder* in the Naples Museum (ill. 52).

56 See *Oud Holland,* vol. XIV, 1896, p. 179. The inventory of Constantijn Huyghens' last direct descendant, Susanna Louise Huyghens, Lady of the Manor of St. Annaland and Zeelhem, Dowager of Willem van Wassenaer, who died at The Hague in 1785, mentions five flower and fruit still life paintings by Hoefnagel, one of which was 'in a frame with glass', a novelty in Huyghens' day. There was also a 'Bottle with Flowers' and 'a small rose by Susanna van Baerle after Hoefnagle'. De Gheyn must have seen all of these works by Hoefnagel at the Huyghens' shortly after 1602.

57 These appear always to have remained with cat. II 895 of 1600. They may have been done at the same time, but there is the alternative, that De Gheyn took up the theme of small creatures once more towards the end of his life.

58 J.G. van Gelder, *'Van Blompot tot Blomglas',* in *Elsevier's geïllustreerd Maandschrift,* vol. XLVI, 1936, p. 160.

59 Bergström, pp. 50, 52.

60 This motif is repeated in a painting in the Stichting P. en N. de Boer in Amsterdam. If this was by his own hand, Brueghel could have taken it home with him. But I consider a later date more likely for both items. Cf. also Hairs, pp. 360, 361.

61 M. Vaes, 'Le Journal de Jean Brueghel II', in *Bull. de l'Institut Belge de Rome,* 1926, pp. 172-173.

62 As Mr. R.E.O. Ekkart informed me, De Gheyn may have known the *portrait of Prof. Jac. Ramsaeus (ca. 1560-1593) on his deathbed* painted by Is.Cl. Swanenburgh, and now in the University Library at Leyden under the erroneous name of Hugo Donellus (*Icones Leidensis,* Leyden, 1973, n. 46). Although this wooden likeness is remarkable in view of its date, the gulf between it and De Gheyn's deathbed portrait is unbridgeable.

## CHAPTER IV

1 We may assume that other artists were also working on flower-paintings in that same year. In 1598 Buchelius, for example, was at the house of the painter Nic. Elias in Delft, whose *uxor monstrabat omnium fere florum vivas ab eo depictas imagines* (*Res Pictoriae,* p. 43). However, they may also have been watercolours. Cornelis Cornelisz and Carel van Mander are also known to have produced flower paintings, but possibly not until a later date.

2 Lat. 23640 in the Staatliche Bibliothek, Munich.

3 Ingvar Bergström, 'Flower-Pieces of Radial Composition in European 16th and 17th Century Art', in *Album Amicorum J.G. van Gelder,* The Hague, 1973, p. 23 (fig. 7); Coll. B. Koetser, London, 1971 (as by an anonymous artist).

4 Bergström, *op. cit.,* fig. 2.

5 Fr. Hartt, *Giulio Romano,* New Haven, 1958, vol. I, pp. 105-107, 112-115; vol. II, pl. 180-186.

6 E. Auerbach and C.K. Adams, *Paintings and Sculpture at Hatfield House,* 1971, n. 58.

7 It is impossible to think of any particular bronze. We do not know when Susini produced this type of fairly small bronzes after Gian Bologna's model. The small bronzes made by the Hague-born Adriaen de Vries in Prague were presumably produced in 1607 and 1610 only, and copied after that. De Gheyn's drawing of a trotting horse (cat. 848, pl. 252), does show precisely the same position viewed from the opposite side, but the style of this sketch is more in keeping with a later date. It is therefore impossible to verify this hypothesis.

8 Cf. cat. 840-855, which, however, appear to date from different periods.

9 Duyck, p. 290.

10 Staedelsches Kunstinstitut, Frankfurt, W.n. 135 in Weizsäcker's 'Elsheimer' volume (Weizsäcker 1923).

11 Ecole des Beaux-Arts, Paris, inv. 12083; Möhle, *Elsheimer,* repr. G.20.

12 J. Rowlands, in *Master Drawings,* vol. 10, 1972, pp. 284-286, with all necessary references.

13 Hirschmann, in *Oud Holland,* vol. XXXIII, 1915, p. 130, 131 (repr.) and the same author's *H. Goltzius als Maler,* The Hague, 1916, p. 73, n. 5, pl. 7.

14 In *Oud Holland,* vol. LXXXV, pp. 143-157, and *l'Oeil,* n. 190, Oct. 1970, pp. 12-15. It is unlikely to have been earlier than the painting seen by Van Mander. A lapse of memory on the part of Van Mander is a more likely assumption.

15 B. 180, H. 34.

16 Van Mander must have produced flower paintings at a later date.

17 Van Mander, *Schilder-Boeck,* 'Leven van Ketel', fol. 193 verso-194 recto; A. Blankert in *Kunsthistorisch Jaarboek,* vol. 18, 1967, pp. 43-44.

18 I owe this detail to an unpublished paper written by Miss M.H. Schenkeveld, 1953, which the author kindly placed at my disposal.

19 I regard the tree in this scene as a mask or *persona.*

20 Modern scholarship has been late in recognizing Paracelsus as a major scientist. A good summary of his system is given in Robert-Henry Blaser's *Paracelse et sa conception de la Nature,* Geneva-Lille, 1950. One learns from it the place he assigned in his system to occult knowledge and astrology.

21 The best and most detailed survey is to be found in R.J.W. Evans, *Rudolf II and his World,* 1576-1612, Oxford, 1973, see in particular Chapter 6 (*Rudolf and the Occult Arts*), pp. 196-242, but also Chapter 7 (*Prague Mannerism and the Magic Universe*). There was often controversy with the universities and official medical teaching.

22 A.G. Demus, *The Chemical Dream of the Renaissance.* The title *Chymische Hochzeit* could cover a multitude of meanings. To confine ourselves to De Gheyn's circle: in his *De occulta philosophia, Epistola cuiusdam Patris ad Filium,* published by Thomas Basson in 1601, Nicolaus Barnaud kept to purely chemical precepts, whereas it was linked as an allegorical tale to the *Fama Fraternitatis* and therefore must have reached the Rosicrusians in Haarlem, who are supposed to have included Goltzius; it certainly reached Torrentius. Mr. R.B. Knottnerus went to a great deal of trouble to procure a facsimile of the Oxford copy (Bodleian) of the former, extremely rare, publication for the Amsterdam University Library. On the *Fama Fraternitatis* (Strasbourg, 1616) see Chapter IX in Paul Arnold, *Histoire de la Rose-Croix,* Paris, 1955, pp. 179-188. The author establishes a remarkable parallel with the tenth *canto* of Edmund Spenser's *The Faerie Queene,* the literary roots of which are undoubtedly ancient. In 1606, Theobald van Hooghelande, an early adept from Leyden University, changed the title of his alchemist treatise of 1600 into a warning against practising this science which harboured so many perils. (F.M. Jaeger, in *N.N.B.Wk.,* vol. VI, col. 791-792).

23 The clearest, breath-taking analysis of the entire phenomenon was given in H.R. Trevor-Roper 'Witches and Witchcraft' in *Encounter,* vol. XXVIII, 1967, May, pp. 3-25, and June, pp. 13-34. In the catalogue of the Paris exhibition *Les Sorcières* of 1973, Bibliothèque Nationale, M. Préaud supports Trevor-Roper in many respects, but with some reservations on his generalisations. The difference appears to arise from their divergent opinions on J. Bodin. It should also be noted that Trevor-Roper erroneously quotes Grotius as being an advocate of the persecutions. This can be rectified in the light of A.H. Haentjens' *Hugo de Groot als godsdienstig denker,* Amsterdam, 1956, p. 150. The matter is of importance to us, as it invalidates an argument in favour of De Gheyn's approval of the Inquisition. The only other argument, if it may be called one, is his contact with the Dominicans at Bruges in 1612. Another question is whether, as suggested by Judson, there were actual gatherings and, if so, whether De Gheyn attended them. I am inclined to think something like this may be true, particularly in view of cat. 526. But in *Europe's inner Demons* (London 1975), Norman Cohn assures us that there is no reason to believe in established, organised bodies of witches, or any historical foundation for the assumption that sabbaths were held by them.

24 J. Scheltema, *Geschiedenis van de heksenprocessen,* Haarlem, 1828, passim, p. 239. Executions like those of Elisabeth Vlamyncx and others in 1598, Can Beverwijck in Ghent in 1598, Clara Goossen in Antwerp in 1604, and 70-year-old Elisabeth Grutere, again in Ghent, in 1604, cannot have left De Gheyn unmoved by the horrors perpetrated in his native Flanders.

25 Van Dorsten, pp. 49-51, 96.

26 The procedure followed by the Dominicans is explained by Trevor-Roper, *op. cit.,* pp. 8, 14 and 15.

27 This is also the view of M. Préaud, as expressed in the exhibition cat. *Les Sorcières,* Bibliothèque Nationale, Paris, n. 41: 'De Gheyn insiste sur le côté érotique de la sorcellerie'.

28 *E.g.* in the painting *Christ at Emmaüs,* Musée Jacquemart André, Paris.

29 Not only was De Clerck the publisher, but the engraving is adorned with a calligraphic legend by the same hand as the one in the *Fortune-teller,* cat. II 534, which suggests that the dates of the two prints were closer together.

30 Meaume, n. 139; the drawing for this engraving is in Stockholm.

31 One of these, cat. II 867, dates from 1609.

32 See Orlers, p. 370.

33 Orlers, pp. 369-370.

34 The dates are based on information kindly given to me by Mr. R.E.O. Ekkart, just before I finished my manuscript.

35 *Introduction,* pp. 34-35 and Preface p. XIII. Since then several more paintings by Van Swanenburgh have come to light.

36 See *The Torments of Hell,* the larger of the two paintings at Leyden; the same subject in Amsterdam and Gdansk.

37 At least in detail; the compositions, however, are more confused and less clearly arranged.

38 See the paintings at Rome (Palazzo Doria, photograph Alinari n. 29541) and the smaller one at Leyden.

39 See the paintings at Gdansk and the larger one at Leyden.

40 Bode-Museum, Berlin (East), n. 709.

41 The history of the legal status of gipsies in the Netherlands has been studied by O. van Kappen, Assen, 1965.

42 One should compare several studies of trees by Bloemaert, such as those in Darmstadt (Gernsheim 24223), Hamburg (21725 verso, Gernsheim 17170) and two sheets in the author's possession, all drawn from nature. In 1605 large trees already featured in Bloemaert's compositions (cf. Brit. Mus., n. 1877-5-12-266, Gernsheim 13574).

43 The theme occurs, *inter alia,* in a coloured drawing by Hans Bol in Amsterdam, illustrated in Moes, vol. 1, n. 13.

44 This is the name originally given to the copy of the print at Veste Coburg (Burchard, p. 30, footnote 2).

45 Buytewech: E. Haverkamp Begemann, *Willem Buytewech,* Amsterdam, 1959, passim. It is assumed that Buytewech hardly knew De Gheyn's landscapes; Hercules Seghers: K.G. Boon and E. Haverkamp Begemann, *Hercules Seghers,* Amsterdam, 1973, passim. There is no relation between Seghers' art and De Gheyn's.

46 See detailed analysis in cat. II 1049.

47 For Van Stinemolen see I.Q. van Regteren Altena in *Oud Holland,* vol. XLIX, 1932, p. 107. There are some parts where small changes can be observed, especially in the number of houses in the town on the rock.

48 Reznicek, n. 396.

49 According to J. Rosenberg's interpretation.

50 They may, however, still be later.

51 This, however, is not a conclusive argument, since the optical problem had also been treated at an earlier date.

52 There are two versions of the same subject, both possibly by his own hand. See cat. II 865 and 866, pl. 341 and 340.

53 It consists of 166 prints, first published by Nic. Visscher, and, after the copper plates had been acquired by Bernard Picart, re-issued in Amsterdam in 1740 as a book in eight sections. Some of the drawings are now in Cambridge.

54 An extensive search, kindly carried out by M.R. Pierrot in the Bibliothèque Nationale, Paris, in order to find this copy, was unsuccessful.

55 In a letter published by J. Bernays, *Joseph Justus Scaliger,* Berlin, 1855, pp. 118-119.

56 *Icones Leidenses,* pp. 29-32, and in particular the ill. pp. 29 and 32 (the latter dating from 1608).

57 A.W.F.M. Mey and J. Giltay cite *The Three Magi* drawn by Goltzius (Reznicek 160, pl. 330) as a prototype for a composition with three half-length figures in front of a wall (dating from 1598; exh. cat. Paris 1974, n. 39).

## CHAPTER V

1 Resolutions of the States General, publ. by 'Laboranter' in *De Navorscher,* 1872, p. 23.

2 The mark of King William III of Orange is burnt into the panel.

3 We know from his son's will that he had a collection of *coquilien ofte zeeschelpen, soe rare suyvere als ruwe onsuyvere... en zeegewassen* (sea-shells, both rare, pure ones and rough, impure ones... and sea-plants) (*Introduction,* p. 129).

4 *Schilder-Boeck,* fol. 16 recto. It is assumed that Van Mander used the word *dictator* in the sense of 'dictating his orders'.

5 'The Bosschaert type of flower still life is a botanical flower-piece; it has nothing to do with the symbolic flower bouquet of the devotional paintings.' L.J. Bol, *Holländische Maler des 17. Jahrhunderts,* Brunswick, 1969, p. 22.

6 *Inter alia* by B. Berenson, even with regard to Siennese art of the fourteenth century, by Ch. Sterling with regard to the landscape of the Italian Renaissance (in *L'Aurore de l'art,* vol. XII, 1931, p. 9ff

and 101ff), and by the present author with regard to the landscapes by Jan van Stinemolen (*Oud Holland,* vol. XLIX, 1932, p. 91ff.).

7 Coll. W. Bartlett of Brockley, repr. in exh. cat., *La nature morte et son inspiration,* Paris, 1960, n. 46.

8 Tulips had been imported from Syria and cultivated since the late 16th century. Nicolaas van Wassenaer reports in his *Historisch Verhael,* Haarlem, vol. III, April 1625, that the first person to have had them was the chemist Walich Zieuwertsz in Amsterdam, from whom Clusius acquired some for the Leyden *Hortus,* which started to sell bulbs. After bulbs had been stolen on several occasions and cultivated by others, dealing in them was stopped at Leyden.

9 Painted in 1624; Centraal Museum, Utrecht (cat. 1933, p. 68, n. 163).

10 Ch. Ruelens-M. Rooses, *Correspondance de Rubens,* Antwerp, vol. II, 1898, pp. 120-122.

11 K. Bauch, *J.A. Backer,* Berlin, 1926, p. 72, n. 31.

12 Since the ray of light does not occur in the painting of the same theme by J.A. Backer (Bauch, *Backer,* p. 81, n. 57, pl. 11) I do not share the opinion that the initials of Lambert Jacobsz were accidentally added to this description. Backer is likely to have borrowed the theme from his master and to have adapted it.

13 On July 15th, 1613, De Gheyn was a witness at the marriage of Andries Stock (before Notary Ketting, arch. IV, fol. 146). Stock may have been a pupil of his.

14 In *Rembrandt's Anatomy of Dr. Nicolaas Tulp,* New York, 1958, p. 26. The rich contents of this poem might have provided support for several passages in Heckscher's book. Scriverius must have used the *Fabrica* by Vesalius and the woodcut illustrated by Heckscher on p. 44, fig. 6, for his description of the instruments used by Professor Pauw.

15 The registers for the relevant years have not been preserved.

16 These show Tempesta's unreversed designs, seven of which are in Edinburgh, see K. Andrews, *National Gallery of Scotland, Cat. of Italian Drawings,* Cambridge, 1968, vol. I, p. 118, ns. D. 796, 799, 790, 801, 803, 793a and 792, repr. vol. II on pp. 138-140.

17 Bredius, *K.-Inv.* vol. VII, pp. 84, 85.

18 C. Hofstede de Groot, *Die Urkunden über Rembrandt,* The Hague, 1906, pp. 199, 207.

19 Judson, *De Gheyn,* p. 30.

20 *Introduction,* p. 129.

21 See I.Q. van Regteren Altena in *Oud Holland,* vol. XLIV, 1927, pp. 269-274, with full references.

22 Huyghens *Autob. Oud Holland,* p. 108; id. Kan, pp. 66, 67.

23 *E.g.* ed. Bordeaux, 1604, cap. 228-231.

24 *Introduction,* p. 107 ff.; Möhle 1963, passim, has unfortunately confused the issue in his attempts following this. I consider the attribution of Pl. 5, the *Stable Boy,* previously regarded as by Elsheimer, to be untenable; Pl. 6b, *Female nude,* definitely to be by

H. Goudt (cf. H. Möhle, *Die Zeichnungen des A. Elsheimer,* Berlin, 1966, pl. G.22); pl. 6a *Head of a woman* probably by Goudt; pl. 7a definitely to be a late work by Jacques II (see cat. 560); this also applies to pl. 7b (see cat. 720). Judson included three works by Jacques III in *The Drawings of Jacob de Gheyn II* (see his pl. 65-67).

25 Cf. K. Bauch, *Der frühe Rembrandt und seine Zeit,* Berlin, 1960, passim.

26 Huyghens, *Corr.* n. 36.

27 Huyghens, *Corr.* ns. 37, 38.

28 Illustrated in Ben Nicholson, *Hendrick Terbrugghen,* The Hague, 1958, n. A.18.

29 J. Müller Hofstede, 'Abraham Janssens', in *Jahrbuch der Berliner Museen,* vol. XIII, 1971, Pl. 29. The upright panel with half-length figures existed already with Quinten Matsys.

30. I.Q. van Regteren Altena, in *Album Amicorum J.G. van Gelder,* The Hague, 1973, pp. 255, cf. cat. II P 3.

31 The triptych is discussed in detail in Van Regteren Altena, 1973.

32 Their introduction in Holland cannot be dated precisely, but if *ER* on the still life by Torrentius means *Eques Rosaecrucis,* the earliest year known would be 1614, when it was painted. The letters, however, have also been explained as an abbreviation of Erasmus (Van Riemsdijk, p. 248).

33 B. Gerbier, *Eer ende Claght-Dicht Ter eeren van... Hendrick Goltzius, etc.* The Hague, 1620. Only two copies of this poem are known, one of which is in the Municipal Library at Haarlem. Described by O. Hirschmann in *Oud Holland* vol. XXXVIII, 1920, p. 104 ff.; see pp. 105, 112 and 115-116.

34 All described in great detail in Bachrach, passim. Perhaps he is somewhat too positive in his statement (p. 112). 'With him went Jacques de Gheyn...', which would imply that the latter travelled with him from Den Briel early in June in the retinue of Sir Dudley Carleton, for which I have found no evidence so far. The matter is important since the attribution of the *silverpoint sketchbook* stands or falls with it. De Gheyn certainly returned independently. See Huyghens, *Corr.,* letters 45 and 51 and Bachrach, passim.

35 Bachrach, p. 142; *Introduction,* p. 16.

36 O. ter Kuile, 'Daniël Mijtens', in *Ned. Kunsthist. Jaarboek,* vol. 20, 1969, pp. 43-45, pl. 11. A letter written by Mijtens to Sir Dudley Carleton on August 18th, 1618 (reproduced in ter Kuile, p. 25) reveals that the portraits were commissioned by Carleton, but kept by Lord Arundel with the idea that Mijtens would produce copies of them for Carleton. Mijtens' arrival in London must also have been due to the sponsorship of Carleton and Caron.

37 M. Rooses, *Rubens' Leven en Werken,* Amsterdam-Antwerp, 1903, pp. 253, 255, 266.

38 Now in the Louvre; drawn by Rubens in the Palazzo Borghese. The head of Seneca is placed on the body of an elderly fisherman.

39 See Poulsen, in *Acta Archeologica,* vol. XI, Copenhagen, 1940, p. 154, and Denys Haynes, in *Paul Getty Museum Journal,* 1974, pp. 73-80.

40 See cat. III, 89-104. The drawings may have been in the trunk that was left to Wttenbogaert in Jacques' will (*Introduction,* p. 129).

41 Bachrach, p. 219.

42 Pp. 149-161.

43 A. van Buchel, *Description de Paris,* Paris 1900, p. 161.

44 Cat. of the exh. *La collection de François Ier,* Paris, Louvre, 1972, p. 17, n. 15. This would explain the motif in cat. II 497.

45 *Ibid.* pp. 45-46, n. 57; A. van Buchel, *op. cit.,* p. 162.

46 Ch. Ruelens-M. Rooses, *Correspondance de Rubens,* vol. II, Antwerp, 1898, p. 201; R. Magurn, *The letters of P.P. Rubens,* Cambridge, Mass., 1955, p. 36. The latter assumes that Rubens meant De Gheyn II whom he is only likely to have met around 1612; cf. J.G. van Gelder, 'Rubens in Holland in de zeventiende eeuw', in *Ned. Kunsthist. Jaarboek,* 1950-51, p. 120.

47 Catalogued separately. When dealing with the sketchbook in my *Introduction,* I only knew of eleven leaves. The connection with the cut pages is clear from the lines framing several of them and drawn with the same chalk. At the time I believed they were by Jacques II, but there appears to be no evidence at all in favour of his having been in London, which was wrongly assumed on the basis of the incorrect translation of a word in a letter by C. Huyghens.

48 When I raised the matter with him a year before his death, he kept to his opinion, which is certainly defensible.

49 Buchelius, *Res Pictoriae,* p. 93.

50 Vasari, *Milanesi,* vol. IV, pp. 145, 146.

51 Casts of the three heads of the group must also have come into the country by other means. We shall see that De Gheyn owned at least one of them. Another one features in a still life by J.D. de Heem (Pommersfelden). At the auction of the Lambert ten Kate Collection in Amsterdam on June 16th, 1732, four casts of a head appeared under the heading *Sculpture* (ns. 10, 21, 22, 66, the last n. by Duquesnoy).

## CHAPTER VI

1 For a detailed account of the events see: J. den Tex, *Oldenbarnevelt,* vol. III, 1973, passim.

2 In the *Poëmata* by Janus Secundus, Basson printed the Latin verses in which Scriverius informed De Groot and Hogerbeets about the progress of their trial and which Maria van Reigersberg sent to them secretly. See G. Brandt, *Historie van het leven van H. de Groot,* Dordrecht-Amsterdam, 1727, pp. 165 ff.

3 *Introduction,* p. 123. I have been unable to obtain any information on the property in Brabant, and whether it was situated to the south of the western Meuse, opposite Strijen, or elsewhere.

4 *Transportregisters,* Municipal Archives, The Hague.

5 High Court Order of November 24th, 1601; record of June 11th, 1603 in the *Register van appointementen* of the Rekenkamer der domeinen (Audit Office of the Domains), both in the Rijksarchief, The Hague.

6  For example at Cromstrijen, where land was divided between his son and van Ylem's widow, as appears from the deed executed on April 25th, 1631 before Notary Rietzaet at The Hague.

7  When he made a profitable sale of clay from his land to the City of Leyden: deeds of October 5th, 1611, executed before Notary C. van der Laan, Leyden, and Jan. 1st, 1621, executed before Notary J. van Huyck, Leyden.

8  Sale of land near Spijkenisse for 1667 guilders; deed of Jan. 5th, 1627, executed before Notary Egb. de Witthe at The Hague (Obreen's *Archief*, V, pp. 40-41).

9  Sale of land near Strijen for 4400 florins; deed of Feb. 24th, 1627, executed before the same Notary, but on this occasion Jacques II witnessed his son's signature. Just before his death he had verbally sold more land at Strijen, partly on behalf of the heirs of his deceased brother-in-law, Caspar Wijntges; this was confirmed by deed executed by his son on May 6th, 1629, before the same Notary.

10  On June 18th, 1630, Jacques Junior, still acting on behalf of relatives, sold land at Hendrik Ydo Ambacht, appearing before Notary Johan van der Lisse at The Hague for the purpose. In a deed dated April 25th, 1631, and executed at The Hague before Notary Lambertus Rietzaet, De Gheyn's land at Cromstrijen is described as adjoining an estate belonging to Adriaen van Ylem. On Jan. 7th, 1632, Jacques Junior, of The Hague, let some land near Soeterwoude for 120 florins per annum (Notary D. Fraudenius of Leyden).

11  Mentioned in his will, *Introduction*, p. 131.

12  *Jaarboek Die Haghe*, 1913, p. 53.

13  It is situated next-door to the present Ministry of Foreign Affairs, and is the fourth house in the Casuariestraat facing North.

14  J.A. van Dorsten wrote about the Bassons in *Thomas Basson, 1555-1613*, Leyden, 1961, passim. See also *Poets, Patrons and Professors*, Leyden, 1962, by the same author, passim.

15  For Van der Burch, see J. Prinsen J.Lz. in *N.N.B. Wk*, vol. IX, col. 114-118.

16  Drawing dating from 1624, Teyler Museum, Haarlem, in *Panpoëticon Batavum*, no. 203 (I).

17  S.J. Gudlaugsson, *Die Gemälde des Gerard Ter Borchs*, The Hague, 1959-60, vol. I, pl. 49, vol. II, p. 78, ns. 49, 82.

18  *Introduction*, p. 130.

19  *Introduction*, p. 130; notice of their marriage dated April 8th, 1628, in the *Puiboek*, Municipal Archives, Amsterdam.

20  Henri de la Tour d'Auvergne, Duke of Bouillon, had married Elizabeth, daughter of William the Silent and Charlotte de Bourbon.

21  Claude de Thouars, Duke of La Trémouille married Charlotte Brabantine, daughter of William the Silent and Charlotte de Bourbon.

22  François van Aerssen, later Ambassador in Paris and adversary of van Oldenbarnevelt, was at that time still serving Philippe du Plessis-Mornay.

23  Nicolas III de Neufville, Seigneur de Villeroy, had been *Secrétaire d'Etat* since 1594.

24  In the first portfolio of portraits of the House of Orange: *Généalogie des très-illustres Comtes de Nassau,* published by J. Orlers. In the first state, Prince Maurice's coat of arms lacks the emblem of the Order of the Garter, and the print is therefore prior to 1613.

25  Fred. Muller, vol. III, no. 898a.

26  Documents about Steven are listed in Thieme Becker, vol. XIII, pp. 534-535.

27  Abraham married Catharina van Vollenhoven of Nieuwe Nierop in Amsterdam in 1639 and so became a cousin by marriage to Jan Steen (W.I.C. Rammelman Elsevier in *De Navorscher*, vol. V, 1855, p. 328).

28  *Introduction*, p. 130.

29  *Zeeusche Nachtegael*, Middelburg, 1623, Tafereel van Sinne-mal, pp. 11-57.

30  In 1621 Huyghens had published his *Voorhout*, in which he described what the seasons brought to the part of The Hague where the De Gheyns lived.

31  *Introduction*, pp. 130-131.

32  Ovid, *Metamorphoses*, XI: 592 ff. This interpretation was first given by Dr. E. Holzinger.

33  Ovid, *ibidem*, XI: 586.

34  Huyghens *Autob. Oud Holland*, p. 115; *id*. Kan, p. 71.

35  Resolutions of the States General of September 19th, 1620. The Stockholm archives reveal nothing about any transaction.

36  For Stap see *Introduction*, p. 31; A. van Schendel, in *Oud Holland*, vol. LIV, 1937, pp. 269-281. He calls Stap's art 'a rare phenomenon of archaism'.

37  Drebbel belonged to the kind of magician not uncommon in those days. Whether he posed as such himself is open to question. What the inventions were, and to what extent they were his own, was discussed critically by F.M. Jaeger in his *Cornelis Drebbel en zijn tijdgenooten*, Groningen, 1922, which perhaps unduly minimizes the reasons for his fame. G. Tierie subsequently produced a more balanced biography, *C. Drebbel, 1572-1633*, Amsterdam, 1932. See also W. Ploeg, *Const. Huyghens en de natuurwetenschappen*, Thesis, Rotterdam 1934, passim.

38  See Tierie pp. 50-52, and the passage in the Autobiography of Huyghens in which he deplores the defect (*Autobiogr.* Kan, p. 121).

39  A. Bredius, *Johannes Torrentius*, The Hague, 1909, providing the complete documents. For his use of the *camera obscura* see: W.B.F. van Riemsdijk, 'Een schilderstuk van Joh. Torrentius', in *Feestbundel voor Dr. A. Bredius*, Amsterdam, 1915, p. 243 ff., pl. 97.

40  Huyghens *Autob. Oud Holland*, pp. 131-136; *id.* Kan, pp. 83-86. He may also have known the magic lantern, with which Huyghens entertained his friends as well (Tierie, pp. 49-50).

41  *Corr.*, n. 138; of March 17th, 1622. On the following April 13th, he wrote: *Les Degheyns s'y plairont merveilleusement.* Prof. A.G.H. Bachrach kindly informed me that the MS does not say *s'y plaisent*, as Worp stated. This provides further confirmation of the

fact that the De Gheyns were certainly not in London in 1622. Huyghens' mention of a grisaille providing evidence of his magic art, may refer to Drebbel and not to De Gheyn.

42 Tierie, *op. cit.*, pp. 53-58, notes to paragraph 3; W. Ploeg, *C. Huyghens en de natuurwetenschappen,* 1934, p. 26.

43 Huyghens *Autob. Oud Holland,* pp. 119-120; *id.* Kan, pp. 121-122.

44 It is doubtful whether De Gheyn would have benefited from a microscope. A magnifying glass was quite adequate. He could have acquired these in Middelburg, where Govert van der Haghen had an important glass-works, with which Sacharias Janssen was connected. Drebbel too visited the works. Moreover, De Gheyn may, at an early date, have met Jacob Metius, brother of Adriaan, whom he portrayed, and who was one of the pioneers in this field.

45 R. Oldenbourg, *P.P. Rubens,* Munich-Berlin, 1922, pp. 182-192; cat. of Charlottenburg Museum, ns. 1-12, with complete bibliography.

46 Huyghens *Autob. Oud Holland,* p. 67; *id.* Kan, p. 69.

47 The fine portrait drawing by P. Soutman in the Amsterdam Printroom is also based on Miereveld's likeness.

48 Van Regteren Altena 1970.

49 A. Staring believes that a mixture of plaster and ground marble was already in use in Holland during the XVIIth century (*Oudheidk. Jaarboek,* 1943, pp. 27-30).

50 D.F. Slothouwer, *De Paleizen van Frederik Hendrik,* Leyden, 1945, pp. 301, 735, fol. 409.

51 *Gedichten,* vol. II, p. 148, of April 20th, 1631. Martial had long provided inspiration, see an analogous distich by a Spanish monk: *Praeda licet mundi not sit satis ampla Philippo* (*sc.* Philip II), *Ampla satis mundo praeda Philippus erit.*

52 Jacob van der Does, *'s-Gravenhage,* The Hague, 1668, pp. 124-125.

53 Van Regteren Altena 1970.

54 Coloured drawing in the Printroom in Amsterdam. Van de Venne settled permanently at The Hague in the same year.

55 Musée Jacquemart-André, Paris.

56 See Fred. Muller, ns. 894, 1305 and suppl. 1499ᵃ.

57 Fred. Muller, n. 1537; J.G. van Gelder, *Jan van de Velde,* The Hague, 1933, p. 10.

58 Compare the technique — *i.e.* the use of very fine parallel hatchings — of the print with *St. Peter* by Bellange (Walch n. 40) with that of Jacques III, *e.g.* in his *St. Peter* (cat. III 4), and also their eye-sockets, but Jacques III's men are seated, whereas Bellange's usually stand.

59 Exh. cat. Georges de La Tour, *Orangerie des Tuileries,* Paris, 1972, n. 2.

60 Burl. Mag. vol. CXV, 1973, p. 576.

61 A. Bredius and N. de Roever in *Oud Holland,* vol. IV, 1886, pp. 15-16. The inventory dates from 1632.

62 According to Huyghens, Maurice had already richly rewarded both father and son.

63 J. Denucé, *Brieven en Documenten betreffend J. Brueghel I en II,* Antwerp, 1934, p. 150.

64 This was first pointed out to me by my brother, A.D. van Regteren Altena. The passage occurs in *De bello* (sive *Pharsalia*) c. II, vv. 380-384. *Tueri* does not appear to occur in the old versions, which read *tenere,* or sometimes *teneri. Finesque tenere* is found as well as *finemque tenere.* As H. Grotius' edition of 1614 has *finemque tenere,* we may assume that De Gheyn used that one, all the more so as he may have been given a copy by Hugo de Groot himself. The entire quotation on the label has been heavily retouched, and letters may have been wrongly substituted.

65 Huyghens *Autob.* Kan, p. 85; *id. Oud Holland,* p. 133.

66 Huyghens *Autob.* Kan, pp. 83-84; *id. Oud Holland,* p. 132.

67 *Naturam sequi* has the specific meaning the Stoics gave to this phrase, *i.e.* not to go against one's inborn nature and destiny, but to let oneself be guided by reason. It is not plausible that De Gheyn was thinking of a painter following nature. The current Dutch expression for that was following 'life' — *het leven* — (Miedema-van Mander, vol. I, pp. 436-437, II 15b), and the entire text would then fall apart into heterogeneous components, unless it were to apply solely to the execution of a work of art, and this would seem impossible here.

68 The problem lies in De Gheyn's ideas on Eternal Salvation. We may point to Hugo de Groot, to whom, according to Troeltsch, it meant Stoic peace of mind; this, however, was refuted by A.H. Haentjens. In 1583 De Groot defended the tenet that Death was the way to Resurrection, and therefore to the assumption of a heavenly body. He again confirmed this in one of his last writings (*Hugo de Groot als godsdienstig denker,* Amsterdam, 1956, p. 101; E. Troeltsch, 'Protest, Christentum und Kirche in der Neuzeit' in *Kultur der Gegenwart,* 1906, Heft B 4, p. 424). The author, however, could find no predominantly Stoic influence on Grotius' theology.

69 In *Feestbundel Dr. A. Bredius aangeboden,* Amsterdam 1915, pp. 249-253.

70 Unexplained abbreviation, unless it means *Eques Rosaecrucis.*

71 The two panels belonged to an oak felled in the year 1626 (with a standard deviation of ± 5 years), according to a dendro-chronological analysis in 1974 by Dr. J.A. Brongers of the State Archeological Survey (de Rijksdienst voor het Oudheidkundig Bodemonderzoek) at Amersfoort.

72 The authorities on country customs in the seventeenth century can neither confirm nor refute this suggestion.

73 Louvre, Paris, inv. 10355, ill. in vol. II, p. 19.

74 Reznicek, 437, pl. 232.

75 Brunswick, Reznicek 394, pl. 237, and Fondation Custodia, Paris, Reznicek 401, pl. 311.

76 Rotterdam, Reznicek 338, pl. 366.

77 *Ubi?* Reznicek 447, pl. 450.

78 Berlin, inv. 5414.

79 Cf. Horst Vey, *Die Zeichnungen Anton van Dijcks,* Brussels, 1962, n. 54, pl. 74.

80 In a lecture for the Koninklijk Oudheidkundig Genootschap, Amsterdam, on Feb. 23rd, 1948.

81 The number and variety of animals illustrated in Pisanello's work is striking. Pisanello, Leonardo and De Gheyn all applied themselves with equal zest to studies of horses. One example may suffice: De Gheyn's horses' heads on one sheet (cat. 854, pl. 371), and Pisanello's (cod. Vallardi, Louvre 2354; illustrated in Degenhart, *Pisanello,* Vienna, 1941, pl. 76); there is great affinity between De Gheyn's *studies of brambles* (cat. II 1007, pl. 226) and Leonardo's black berries (Windsor, ill. in vol. II, p. 153); a gun (cat. II 497, pl. 474) is a favourite subject on sheets of miscellaneous sketches by either Pisanello or Leonardo. The layout is sometimes very similar, although there are no exact repetitions. I assumed De Gheyn had seen the codices on one occasion and that the memory inspired him to take up a large number of the themes he had then observed, and work on them in a similar manner.

82 In 1603 the codex was still in Spain, where Pompeo Leoni had taken it; Vorsterman made prints from it not later than 1630, the year he left England for good.

83 J.P. Richter, *The literary works of Leonardo da Vinci,* London, New York, Toronto, 1939, vol. II, appendix I, pp. 393-399; and G. Vallardi, *Disegni di Lionardo da Vinci, posseduti da Giuseppe Vallardi,* Milan, 1855.

84 The late M. Rouchès carried out this investigation for me, but found only the nineteenth century binding.

85. *I.e.* cat. silverpoint sketch-book ns. 12, 13 and 16. Another (n. 15) came from Arundel via Zanetti.

86 F. Lugt, *Marques de collections,* Amsterdam, 1921, p. 214.

87 R.W. Scheller, *A survey of mediaeval Model Books,* Haarlem, 1963, pp. 186-187, leans towards this view and provides fresh material.

88 *Gedichten,* vol. II, p. 148. Perhaps it is more likely to have applied to the son.

89 Huyghens *Autob. Oud Holland,* pp. 111-112; *id.* Kan, pp. 68-70. For Huyghens' artistic sense see H.J. Eymael in *Oud Holland,* vol. XIV, 1896, p. 185 ff.

90 *Dagboek van Const. Huyghens,* ed. by J.H.W. Unger, app. in *Oud Holland,* vol. III, 1885, p. 14.

91 A. Bredius in *Nederlandsche Kunstbode,* 1881, p. 421.

92 *Introduction,* p. 21 and foot-note 1. The Stalpaerts owned several tombs in the Sint-Jacobskerk, including some in the choir. Where De Gheyn and his wife were buried is unknown.

# CHAPTER VII

1 By J.A. Worp in *Oud Holland,* vol. IX, 1891, p. 106 ff.

2 J.J. Orlers, *Beschrijvinghe der Stadt Leyden,* Leyden 1643, folio 371.

3 Th. Schrevelius, *Harlemias of Eerste Stichting der Stad Haarlem,* Haarlem, 1754, vol. 2, p. 441.

4 J. von Sandrart, *Der Teutschen Academie Zweyter Teil,* Nuremberg 1675, pp. 287-288.

5 J. Houbraken, vol. I, p. 25; cf. C. Hofstede de Groot, *Die Urkunden über Rembrandt,* The Hague, 1906, pp. 462, 474.

6 *Introduction,* p. 192.

7 *Ibidem.* The artist's name is not mentioned, but the reference follows one concerning Rembrandt.

8 Huyghens, *Gedichten,* vol. II, p. 245.

9 H.E. van Gelder, in *Oud Holland,* vol. LX, 1934, p. 33; also see *Introduction,* p. 102. The portrait of Maurits Huyghens is now in the Kunsthalle, Hamburg.

10 Repr. in H. Schneider, *Jan Lievens,* Haarlem, 1932, pl. 12.

11 H. Schneider, *op. cit.,* pp. 142-143, n. 217 (Leipzig) or the almost identical n. 216.

12 Speck von Sternburg Collection, ill. among the reproductions of works from this collection, pl. XVI.

13 J.R. Judson, 'Rembrandt and Jacob de Gheyn II' in *Album Amicorum J.G. van Gelder,* The Hague, 1973, pp. 207-210.

14 Cat. III 7, pl. 11. Cf. *Introduction,* p. 105, written before the differences between Jacques II and III had been adequately analysed.

15 Dated 1618. Cf. *Introduction,* p. 112.

16 Information kindly supplied by Dr. H. Geissler. Petterschmidt is otherwise entirely unknown.

17 J.G. van Gelder, *Jan van de Velde,* The Hague 1923, p. 60, 61, cat. 44, pl. XXIX.

18 Möhle, *Elsheimer,* pp. 52-96; J.G. van Gelder and Ingrid Jost in *Simiolus,* vol. I, 136, II, 23.

19 Möhle, *id.* p. 95, G. 117, ill. p. 47. This copy owned by the Huyghens family, was framed in walnut and glazed.

20 Möhle, *id.* G.18, ill. p. 11; four figures from the Frankfurt Goldschmidt Coll. 1917 (ill. in W. Drost, *Berliner Museen, Berichte, etc.* vol. LI, 1930, p. 73, ill. 2) and also Staedelsches Kunstinstitut, Frankfurt, inv. 5998 (album n. 103) and inv. 5999 (album n. 104).

21 Drost, *op. cit.,* p. 72, ill. 1 (now in the Bode-Museum, Berlin (East)); Möhle, *id.* G. 19, ill. p. 10.

22 Möhle, *id.* G.20, ill. p. 11, our ill. 64.

23 Frankfurt, inv. 5879, album n. 135, our ill. 63.

24 Frankfurt, inv. 5855, album n. 132, our ill. 121.

25 Möhle, *id.,* G.1, 2 and 3, and in general G.1-10, ill. pp. 3-6.

26 Cf. Weizsäcker 1923, cat. 160, pl. 79.

27 Sheet of sketches at Rennes (ill. 117). *Introduction,* p. 113, and reprod. E. Haverkamp Begemann and A.M.S. Logan, *European Drawings... in the Yale Univ. Art. Gall.,* New Haven-London, 1970, vol. I, p. 207, pl. 37.

28 Möhle in *Master Drawings,* vol. I, n. 2, pl. 6ᵇ.

29 Möhle, *Elsheimer,* G.22, ill. p. 12.

30 *Introduction,* pp. 109-115.

31 See L.J. Bol, *Holländische Maler des 17. Jahrhunderts,* Brunswick, 1969, pp. 51-56, with ills. and pp. 43-46, with ills.

32 Huyghens *Autob. Oud Holland,* pp. 114-115; *id.* Kan, p. 71.

33 Huyghens *Corr.,* vol. I, p. 302, Nov. 1630.

34 *Register van prelaten, kanunniken en Turnarissen van S. Marie,* Archives of St. Mary's in the Rijksarchief, Utrecht, n. 21, folio 136. The resignation took place on October 30th, 1634.

35 *Introduction,* p. 108.

36 Rijksmuseum, Amsterdam, inv. A 1606.

37 *Proporzioni,* vol. I, 1943, p. 29, fig. 66; *Oud-Holland,* vol. LXIV, 1949, pp. 107-108 (with reprod.).

38 *Oud Holland,* vol. LXIV, 1949, pp. 108-109.

39 *Introduction,* p. 114. In the Amsterdam Printroom as by Badens.

40 Hofstede de Groot Collection, sold Nov. 4th, 1931, n. 96, as by J. de Gheyn, but already attributed by the author to the Pseudo-van de Venne.

41 Purchased by the author at the sale in London on June 27th, 1974, n. 80, repr. p. 54.

42 *Inter alia* in the Brunswick Museum, see A. Heppner in *Oud Holland,* vol. XLVII, 1930, p. 81, fig. 3. The author wrongly identified the artist as S. de Vlieger.

43 A. de Vesme-Ph.D. Massar, *Stefano della Bella,* New York, 1971, p. 6.

44 *Res Pictoriae,* pp. 92-93.

45 There were eleven signed portraits by Sadeler in the Röver Collection, Röver having acquired them from Burgomaster de Vries. Perhaps they had belonged to De Gheyn (MS Röver, Univ. Libr. Amsterdam in portf. II, page 79).

46 See E. Pelinck in *Oud Holland,* vol. LXIII, 1948, p. 110-111.

47 Entry in the Register of Deaths, Utrecht, for June 15th, 1641; in the Cathedral accounts, for tolling the bell, on June 5th, 1641; Utrecht Archives.

48 *Corr.,* vol. III, p. 192. He immediately also composed a Latin epitaph.

49 Cat. 2ᵈ division of Utrecht Archives ns. 2475 and 2476.

50 *Gedichten,* vol. III, p. 173.

50a *P.C. Hooft's Letters,* part IV, Leiden, 1857, p. 304.

51 Huyghens, *Letters,* vol. VI, pp. 311-312.

52 F. Lugt, *Marques de collections,* Amsterdam, 1921, p. 388.

53 Auctioned in Amsterdam on October 13th, 1738.

54 Perhaps originally from the Dordrecht sale of C.B. Voet, June 18th, 1743. Auctioned at The Hague on December 10th, 1792 as Lot 869.

55 Cat. W.G. van Klinkenberg *et alii,* March 6th, 1843, in Cover G.

56 Sold in Amsterdam on March 31st, 1749 in Lots D 4-9.

57 This cover, which probably dates from around 1700, is still in the possession of the broker Paul Brandt of Amsterdam. It does not bear any other mark, and was acquired by him, along with the drawings, in 1939-1940 from possessions handed down from generation to generation in a family whose name is unknown to me.

58 J.W. von Moltke, *Govaert Flinck,* Amsterdam 1965, pp. 114-115 and 241-242.

59 F. Basan, *Dictionnaire des Graveurs,* Paris, 1767, pp. 223-224.

60 *Mémoires et Journal de J.G. Wille,* Paris, 1857, vol. I, p. 474.

61 In vol. III of *Le Peintre-graveur,* Vienna, 1803.

62 M. Huber and C.C.H. Rost, *Manuel des curieux et des amateurs d'Art,* Zurich, 1801, pp. 197-200.

63 *Ibidem,* pp. 200-201.

64 H., *J. de Gheyn III,* 1-9.

65 *Manuel de l'amateur d'Estampes,* Paris, vol. II, 1856, pp. 287-289.

66 *Le Peintre-graveur,* Leipzig, 1860-1864, vol. III, p. 115.

67 *Niederländisches Künstler-Lexikon,* Vienna-Leipzig, 1906, vol. I, pp. 583-584.

68 *Dutch and Flemish etchings, engravings and woodcuts,* 1450-1700 Amsterdam, n.d. vol. VII, under *de Gheyn,* pp. 109-190.

69 Part I, p. 572.

70 Information kindly supplied by the City Archivist of Liège.

71 Thieme-Becker, vol. XIII, p. 530; Hairs, pp. 263, 339 and 377.

72 *Dictionnaire des monogrammes,* etc., Munich 1832, vol. I, p. 197.

73 *Manuel de l'amateur d'Estampes,* Paris, 1856, vol. II, p. 289.

74 J. Renouvier, *Des types et des manières des maîtres graveurs,* Montpellier, 1853-56, vol. XXV, pp. 5, 6.

75 J.B. Descamps, *Voyage pittoresque de la Flandre et du Brabant,* 1769, p. 292.

76 Hymans-van Mander, vol. II, Paris 1885, p. 265.

77 Hymans-van Mander, vol. II, pp. 262-270.

78 *Repertorium für Kunstwissenschaft,* vol. III, 1880, p. 320.

79 In Thieme-Becker's *Künstlerlexikon,* vol. XIII, 1920, pp. 530-533.

80 Berlin, 1917, pp. 29-31 (Jacques II), 71-72 (Jacques III), 105-111 (dates for Jacques II), 112-114 (text C. Huyghens), 119-120 (dates for Jacques III), 171-175 (catalogue of Jacques III's etchings).

81 *Oud Holland,* vol. XXXIII, 1915, p. 126.

82 *Album Amicorum J.G. van Gelder,* The Hague, 1973, pp. 207-210.

83 Vol. LXX, 1937, p. 308.

84 Reznicek, p. 44.

85 In *Master Drawings,* vol. I, Number 2, Summer 1963, pp. 3-12.

86 J.R. Judson: *The Drawings of Jacob de Gheyn II,* New York, 1973.

# Index of persons

188

189

190